Cindy Sherman

Eva Respini

With contributions by

Johanna Burton

and

John Waters

Cindy Sherman

The Museum of Modern Art,
New York

Published in conjunction with the exhibition *Cindy Sherman*, at The Museum of Modern Art, New York (February 26–June 11, 2012), organized by Eva Respini, Associate Curator, with Lucy Gallun, Curatorial Assistant, Department of Photography.

The exhibition will travel to the San Francisco Museum of Modern Art (July 14–October 7, 2012); the Walker Art Center, Minneapolis (November 10, 2012–February 17, 2013); and the Dallas Museum of Art (March 17–June 9, 2013).

Major support for the exhibition is provided by Jerry I. Speyer and Katherine G. Farley; The Modern Women's Fund, established by Sarah Peter; and The William Randolph Hearst Endowment Fund. Additional funding is provided by David Dechman and Michel Mercure, Robert B. Menschel, Allison and Neil Rubler, Richard and Laura Salomon, The Robert Mapplethorpe Foundation, Glenstone, Michèle Gerber Klein, Richard and Heidi Rieger, Ann and Mel Schaffer, and The Junior Associates of The Museum of Modern Art.

Produced by the Department of Publications, The Museum of Modern Art, New York

Edited by Kate Norment, with Jason Best
Designed by Beverly Joel, pulp, ink.
Production by Marc Sapir
Color separations, printing, and binding by Trifolio S.r.l. using their extended gamut printing system AreaW4

This book is typeset in Plan Grotesque. The paper is 170 gsm MultiArt Silk.

Published by The Museum of Modern Art, New York
11 West 53 Street
New York, NY 10019
www.moma.org

Library of Congress Control Number: 2011936200
ISBN: 978-0-87070-812-1 (hardcover)
ISBN: 978-0-87070-813-8 (paperback)

Distributed in the United States and Canada by
ARTBOOK I D.A.P.
155 Sixth Avenue, 2nd Floor
New York, NY 10013
www.artbook.com

Distributed outside the United States and Canada by
Thames & Hudson, Ltd.
181 High Holborn
London WC1V 7QX
www.thamesandhudson.com

A French-language edition of this book has been published by Éditions Hazan, Paris (www.editions-hazan.com).

A German-language edition has been published by Schirmer/Mosel, Munich (www.schirmer-mosel.com).

A Spanish-language edition has been published by La Fábrica Editorial, Madrid (www.lafabricaeditorial.com).

Printed in Italy

Front cover: Details of Untitled #88, 1981 (see plate 93), and Untitled #197, 1989 (see plate 119)

Back cover: Details of Untitled #465, 2008 (see plate 170), and Untitled #411, 2003 (see plate 146)

Endpapers: Detail of Untitled, 2010 (see plates 173, 174, 177, and 178)

Frontispiece: Detail of Untitled #354, 2000 (see plate 160)

Page 81: Detail of Untitled E, 1975 (see plate 8)

Page 93: Detail of Untitled Film Still #5, 1977 (see plate 26)

Page 122: Detail of Untitled #458, 2007–08 (see plate 86)

Page 134: Detail of Untitled #95, 1981 (see plate 101)

Page 152: Detail of Untitled #74, 1980 (see plate 108)

Page 161: Detail of Untitled #177, 1987 (see plate 118)

Page 174: Detail of Untitled #197, 1989 (see plate 119)

Page 186: Detail of Untitled #417, 2004 (see plate 145)

Page 199: Detail of Untitled #351, 2000 (see plate 153)

Page 210: Detail of Untitled #463, 2007–08 (see plate 164)

Page 221: Detail of Untitled #465, 2008 (see plate 170)

Page 229: Detail of Untitled, 2010 (see plate 174)

Contents

Foreword

CINDY SHERMAN IS ONE OF THE MOST TALENTED and influential artists of our time, and it is our pleasure to present the first survey of Sherman's work to be shown in the United States in nearly fifteen years. Her work first entered the collection of The Museum of Modern Art in 1982, when the artist was twenty-eight years old. At that time, Sherman was one of the leading protagonists of a new generation of American artists who used photography in their work to radically rethink the medium in a world of increasing visual saturation. Since then she has continued to make stunning and intriguing pictures, winning her wide acclaim as one of today's most important and innovative artists. In 1995, Peter Galassi, then Chief Curator of Photography, spearheaded a landmark acquisition of the complete "Untitled Film Stills," Sherman's series of seventy photographs from 1977–80. We are the only museum in the world to own this pioneering body of work in its entirety, which we first exhibited in 1997 and subsequently published as a book in 2003. This acquisition and the Museum's robust collection of Sherman's work from a variety of other series, dating from the mid-1970s to recent work executed in 2008, has been overseen by the Trustee Committee on Photography and supported by its members and other important friends of the Museum, to whom I am most grateful.

I would like to express my deepest gratitude to Jerry I. Speyer and Katherine G. Farley; The Modern Women's Fund, established by Sarah Peter; and The William Randolph Hearst Endowment Fund for their support of the exhibition. I am also profoundly grateful to David Dechman and Michel Mercure, Robert B. Menschel, Allison and Neil Rubler, Richard and Laura Salomon, The Robert Mapplethorpe Foundation, Glenstone, Michèle Gerber Klein, Richard and Heidi Rieger, Ann and Mel Schaffer, and The Junior Associates of The Museum of Modern Art.

After its presentation in New York, this exhibition will be shown at the San Francisco Museum of Modern Art, the Walker Art Center in Minneapolis, and the Dallas Museum of Art. I would like to extend our thanks to Neal Benezra, Director, San Francisco Museum of Modern Art; Olga Viso, Director, Walker Art Center; and Olivier Meslay, Interim Director, Dallas Museum of Art. This cross-country tour is possible only because the lenders (listed on page 8) have been willing to part with important pictures for more than a year, and we owe an enormous debt of gratitude to them. On behalf of all our tour partners, I thank the individuals and institutions for their generous cooperation.

We are all in debt to Eva Respini, Associate Curator of Photography, for skillfully and thoughtfully organizing this exhibition and preparing this catalogue in close collaboration with the artist, assisted by the fine staff throughout the Museum. I also wish to thank Johanna Burton for her illuminating contribution to this book and John Waters for his informative and entertaining conversation with the artist.

Finally, I congratulate and thank Cindy Sherman for her grace and generosity in meeting the countless demands of such an ambitious project. She has enthusiastically given us the opportunity to organize this exhibition, and I am grateful for the time and effort she has devoted to it.

Glenn D. Lowry
Director, The Museum of Modern Art

Lenders to the Exhibition

Albright-Knox Art Gallery, Buffalo
Art Gallery of Ontario, Toronto
The Art Institute of Chicago
The Broad Art Foundation, Santa Monica
Dallas Museum of Art
Des Moines Art Center
Marieluise Hessel Collection, Hessel
 Museum of Art, Center for Curatorial
 Studies, Bard College, Annandale-on-
 Hudson, New York
Museum of Contemporary Art, Chicago
The Museum of Modern Art, New York
Philadelphia Museum of Art
San Francisco Museum of Modern Art
Solomon R. Guggenheim Museum,
 New York
Walker Art Center, Minneapolis
Whitney Museum of American Art, New York

Sandra and Stephen Abramson
Carol and David Appel
The Eli and Edythe L. Broad Collection,
 Los Angeles
Collection of Melva Bucksbaum and
 Raymond J. Learsy
Collection of John Cheim
Stefan T. Edlis Collection
Collection of Mandy and Cliff Einstein
Collection of Carla Emil and Rich Silverstein
Eric Fischl and April Gornik
The Doris and Donald Fisher Collection
Collection Glenn and Amanda Fuhrman,
 New York, Courtesy The FLAG Art
 Foundation
Glenstone
Holzer Family Collection
Collection of Linda and Jerry Janger,
 Los Angeles
Allison and Warren Kanders
Collection of Mike Kelley
Jane and Leonard Korman
Barbara and Richard S. Lane
Ellen and Richard Levine
Collection of Ninah and Michael Lynne
Collection Martin Z. Margulies
Collection Metro Pictures, New York
Collection of Nina and Frank Moore

John and Amy Phelan
Collection of Jean Pigozzi, Geneva
Rubell Family Collection, Miami
Collection of Pamela and Arthur Sanders
Collection of Larry Sanitsky, Beverly Hills
Ann and Mel Schaffer Family Collection
Collection Philippe Segalot, New York
Sender Collection, New York
Cindy Sherman, courtesy Metro Pictures,
 New York
Sibley Family
Collection Per Skarstedt
Collection of Jennifer and David Stockman
Collection Norman and Norah Stone,
 San Francisco
Meredith and Bryan Verona
Dorothy and Peter Waldt
Virginia and Bagley Wright Collection
Michael Young, New York
Neda Young, New York

Private collection, courtesy of The Heller
 Group
Private collections

Acknowledgments

I WOULD LIKE TO EXTEND MY PROFOUND appreciation to Cindy Sherman, whose remarkable art and generosity have been an inspiration. The work she has produced over the last three decades has shaped how I understand the role of art, the construction of identity, and the nature of representation.

Realizing an exhibition of this scale and scope and its accompanying catalogue would not be possible without the hard work and assistance of many dedicated and talented people, both within and outside The Museum of Modern Art. My heartfelt appreciation is extended to Glenn D. Lowry, Director of the Museum, who has been extremely supportive of this project from its inception.

I am honored by the very generous support provided by the exceptional sponsors of this ambitious exhibition—Jerry I. Speyer and Katherine G. Farley; The Modern Women's Fund, established by Sarah Peter; and The William Randolph Hearst Endowment Fund. I would also like to express my profound thanks to David Dechman and Michel Mercure, Robert B. Menschel, Allison and Neil Rubler, Richard and Laura Salomon, The Robert Mapplethorpe Foundation, Glenstone, Michèle Gerber Klein, Richard and Heidi Rieger, Ann and Mel Schaffer, and The Junior Associates of The Museum of Modern Art.

Cindy Sherman would not have been possible without the generosity of the lenders to this exhibition, who are listed on page 8. I would like to express my deepest gratitude to these individuals and institutions for their willingness to make such notable works available to a larger viewing public.

I salute our tour partners, the San Francisco Museum of Modern Art, the Walker Art Center, Minneapolis, and the Dallas Museum of Art. I have greatly appreciated the collaboration and input of my curatorial counterparts at these institutions: Darsie Alexander, Chief Curator, and Siri Engberg, Curator, Visual Arts, Walker Art Center; Sandra S. Phillips, Senior Curator of Photography, and Erin O'Toole, Assistant Curator of Photography, San Francisco Museum of Modern Art; and Jeffrey Grove, Hoffman Family Senior Curator of Contemporary Art, Dallas Museum of Art.

I would like to extend my deepest thanks to the contributors to this publication: Johanna Burton, Director of the Graduate Program, Center for Curatorial Studies, Bard College, for her revealing essay; and filmmaker and artist John Waters, for his fascinating conversation with Sherman. In the Department of Publications at MoMA, I am grateful to Christopher Hudson, Publisher, and Kara Kirk, Associate Publisher, and for the sage guidance of David Frankel, Editorial Director, and Rebecca Roberts, Senior Assistant Editor, and the expertise of Marc Sapir, Production Director. Kate Norment and Jason Best have done a superb job in editing the book, and my praise goes to Beverly Joel for her elegant and imaginative design for the publication. MoMA's Department of Publications joins me in thanking the publishers of the foreign-language editions: Éditions Hazan, Schirmer/Mosel, and La Fábrica Editorial. Thanks are also due to Janet Crowley for her transcription of the Sherman/Waters conversation.

A project of this scope would not have been possible without the aid of Metro Pictures gallery, which has faithfully represented Cindy Sherman since 1980. Helene Winer, Janelle Reiring, and Tom

Heman were generous in sharing their knowledge of Sherman's work and providing steady assistance throughout the project. James Woodward and Michael Plunkett at the gallery also ably provided assistance. The artist's assistant, Margaret Lee, was nothing short of remarkable, and she joins the artist in thanking Mike Vorrasi from Griffin Editions for his help in preparing the high-resolution image files for this book.

Throughout the development of this project, I have benefited from the expertise and suggestions of extraordinary colleagues and friends. For their acumen and invaluable input I thank Jessica May, Jacob Dyrenforth, Connie Butler, Roxana Marcoci, Sarah Meister, Mitra Abbaspour, and Kathy Halbreich. I am also grateful to those who shared their knowledge of Sherman's early work: Charles Clough, as well as Ed Cardoni and Carolyn Tennant at Hallwalls, Buffalo. I am particularly indebted to the writings of Douglas Crimp, Craig Owens, Johanna Burton, Jan Avgikos, Abigail Solomon-Godeau, Andy Grundberg, Laura Mulvey, Amelia Jones, Amada Cruz, Sarah Evans, and Peter Schjeldahl, and to Noriko Fuku's perceptive interview with the artist.

The organization of an exhibition requires the professional help of many people in the Museum. I owe a debt of gratitude to Peter Galassi, former Chief Curator of Photography, for his early support of the exhibition, and to Peter Reed, Senior Deputy Director for Curatorial Affairs, for his guidance through the execution of the project. I appreciate the contributions of Leslie Ureña, former Curatorial Assistant, in the early phase of the project; and the assistance of curatorial interns Haley Berkman, Joseph Gergel, John Minieri, Annie Stuart, Scott Valentine, and especially Kristen Gaylord. In the Department of Photography, Marion Tandé, Department Manager, and Megan Feingold, Department Assistant, also provided much-needed help.

Ramona Bannayan, Senior Deputy Director for Exhibitions and Collections; Maria DeMarco Beardsley, Coordinator of Exhibitions; and Jennifer Cohen, Associate Coordinator of Exhibitions, provided good counsel in terms of the logistics of organizing the show. Associate Registrar Allison Needle handled the transport and registration of the exhibition with professionalism. Jerome Neuner, Director of Exhibition Design and Production, and Lana Hum, Production Manager, conceived an elegant exhibition design. I am grateful to Rob Jung, Manager, Art Handling and Preparation, and all the preparators, who helped me with the show's physical implementation. My special thanks go to Lee Ann Daffner, Photography Conservator, and Karen Van Wart, Preparator, Department of Photography.

In the Department of Film, I salute Rajendra Roy, Chief Curator, and Anne Morra, Associate Curator, for their enthusiasm and assistance in organizing a film program selected by the artist on the occasion of the exhibition.

There are other professionals at the Museum who have helped bring Cindy Sherman's work to the public, and they deserve special acknowledgment: Kim Mitchell, Chief Communications Officer; Margaret Doyle, Director of Communications; Daniela Stigh, Assistant Director of Communications; Michael Margitich, Senior Deputy Director for External Affairs; Todd Bishop, Director, Exhibition Funding; Lauren Stakias, Associate Director, Exhibition and International Funding; Heidi Speckhart, Manager, Exhibition Funding; Wendy Woon,

Deputy Director for Education; Pablo Helguera, Director, Adult and Academic Programs; Laura Beiles Coppola, Assistant Director, Adult Programs; Sheetal Prajapati, Associate Educator, Adult and Teen Programs; Allegra Burnette, Creative Director, Digital Media; Shannon Darrough, Media Developer, Digital Media; Marc Kremers, designer of the exhibition website; Julia Hoffmann, Creative Director, Advertising and Graphic Design; Ingrid Chou, Assistant Creative Director, Advertising and Graphic Design; and Jesse Reed, Designer, Advertising and Graphic Design.

Very warm thanks are due to Lucy Gallun, Curatorial Assistant, Department of Photography, for her exceptional research assistance and invaluable contributions to the exhibition and catalogue. She was at the center of everything, working tirelessly to keep the project running smoothly, especially when I was not around.

My first thanks and final gratitude are reserved for Cindy, for the trust she put in me and for the privilege of studying and presenting her work. It has been an honor to collaborate with an artist whose work I so deeply admire.

This book is dedicated to my daughter, Skye, who shared her first year of life with this project.

Eva Respini
Associate Curator, Department of Photography
The Museum of Modern Art

TO EVA, FOR HER COMMITMENT TO MY WORK and her vision and dedication to this show; to Peter Galassi, for championing my work early on; to Margaret Lee, the hardest-working and most dedicated assistant for someone who doesn't want assistants; to Metro Pictures, the best and coolest gallery for over thirty years; to my various labs and printers over the years, but especially to Griffin Editions (Charlie, Mike, Eric, and Junko), whose entire staff has been phenomenal; to the rest of the staff at MoMA, especially Lucy Gallun; to my dearest, supportive friends, too numerous to list; and to Mister Frieda, the one constant in my life.

Cindy Sherman

Will the Real Cindy Sherman Please Stand Up?

Eva Respini

Fig. 1

Cindy Sherman. Untitled (*Art News* cover). 1983. Chromogenic color print, 15⅜ x 10¹¹⁄₁₆" (39 x 27.1 cm). The Museum of Modern Art, New York. Gift of Janelle Reiring and Helene Winer

CINDY SHERMAN'S PHOTOGRAPHS ARE NOT self-portraits. It is true that she is the model for her own pictures, but that is beside the point. As a matter of practicality, Sherman prefers to work alone. To create her photographs, she assumes multiple roles of photographer, model, makeup artist, hairdresser, stylist, and wardrobe mistress. With an arsenal of wigs, costumes, makeup, prostheses, and props, Sherman has deftly altered her physique and surroundings to create a myriad of intriguing tableaus and characters, from screen siren to clown to aging socialite. Through her skillful masquerades, she has created an astonishing and influential body of work that amuses, titillates, disturbs, and shocks.

The fact that Sherman is in her photographs is immaterial, but the ongoing speculation about her identity gets to the very heart of her work and its resonance. The conflation of actor, artist, and subject and Sherman's simultaneous presence in and absence from her pictures has driven much of the literature on her, especially in relation to debates about authorship in postmodern art. The numerous exhibitions, essays, and catalogues dedicated to her

career have contributed to the mythology around Sherman the artist, especially as her fame has risen. Time and time again, writers have asked, Who is the real Cindy Sherman? This is entirely the wrong question, although it's almost unavoidable as a critical urge. Curators and critics have suggested which photographs reveal the *real* Cindy Sherman,[1] and almost every profile on the artist includes an account of how unassuming she is "in person." But it is Sherman's very anonymity that distinguishes her work. Rather than explorations of inner psychology, her pictures are about the projection of personas and stereotypes that are deepseated in our shared cultural imagination. Even Sherman's public portraits are manufactured, such as the 1983 *Art News* cover (which carried the title *Who Does Cindy Sherman Think She Is?*) (fig. 1), featuring a bewigged Sherman in her studio, enacting the role of the "artist" and recalling figures such as Andy Warhol, Joseph Beuys, and Gilbert & George, whose personas loom large in their work. Sherman has acknowledged: "Hype, money, celebrity. I like flirting with that idea of myself, but I know because my identity is so tied up with my work that I'd also like to be a little more anonymous."[2]

Sherman's sustained, eloquent, and provocative investigation into the construction of contemporary identity and the nature of representation is drawn from the unlimited supply of images provided by movies, television, magazines, the Internet, and art history. Her invented characters speak to our current culture of YouTube fame, celebrity makeovers, reality shows, and the narcissism of social media. More than ever, identity is malleable and fluid, and Sherman's work confirms this, revealing and critiquing the artifice of identity and how photography is complicit in its making. Through a variety of characters and scenarios, she addresses the anxieties of the status of the self with pictures that are frighteningly on point and direct in their appraisal of the current culture of the cultivated self.

Sherman's work is singular in its vision, but infinitely complex in the ideas that are contained by it and radically original in its capacity for multiplicity. For more than thirty years, her photographs have encapsulated each era's leading ideas, striking a deep cultural chord with scholars, curators, artists, students, and collectors alike. Sherman's work has found itself at the crossroads of diverse theoretical discourses—feminism, postmodernism, and poststructuralism, among others—with each camp claiming the artist as a representative of their ideas. The contradictory and complex readings of Sherman's work reinforce its ongoing relevance to multiple audiences and, in fact, speak to the contradictory forces at play in our culture at large—the surface appearance of ideas in the form of fleeting images that are often mistaken for content and depth.

Like any retrospective of a working artist, this exhibition and the accompanying catalogue provide an unfinished account of a career that continues to flourish. Because she is a prolific artist (some five hundred pictures and counting) and a vast literature already exists on Sherman, I will not attempt here a comprehensive account of her entire career. Rather, I will try to trace how her work has been received and interpreted over the last three decades within a critical context, and to investigate some of the dominant themes prevalent throughout

Sherman's work—including artifice and fiction; cinema and performance; horror and the grotesque; myth, carnival, and fairy tale; and gender and class identity—in tandem with her techniques, from analog and digital photography to collage and film. Sherman works in a serial fashion; each body of work is self-contained and has an internal coherence. In acknowledgment of this working method, I also examine some of Sherman's major bodies of work in depth. Together, these transverse readings—across themes and series—map out the career of one of the most remarkable and influential artists of our time.

TO GRASP THE SCOPE AND INVENTIVENESS OF Sherman's work, it is worth revisiting her formative cultural and artistic influences. She was born in Glen Ridge, New Jersey, in 1954 and grew up in suburban Huntington Beach on Long Island, forty miles from Manhattan. Belonging to the first generation of Americans raised on television, Sherman was fully steeped in mass-media culture, and she recalls watching such TV programs as the *Million Dollar Movie* and the *Mary Tyler Moore Show* and such films as *Rear Window*.[3] Another activity that kept Sherman occupied was dressing up: "I'd try to look like another person—even like an old lady [fig. 2]. . . . I would make myself up like a monster, things like that, which seemed like much more fun than just looking like Barbie."[4] Even in childhood, Sherman's invented personas were unexpected, providing the seedlings for her diverse artistic oeuvre.

In 1972, Sherman enrolled at Buffalo State College in western New York, where she initially studied painting. She was adept at replicating details on canvas, but she soon became interested in photography, especially as it was being used by

Snapshot of Cindy Sherman (left) and friend Janet Zink dressed up as old ladies, c. 1966

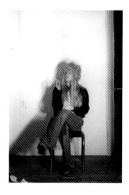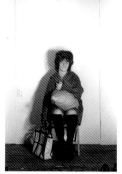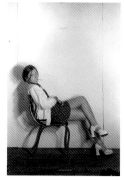

Fig. 3

Cindy Sherman. Left to right: Untitled #364, Untitled #365, Untitled #377, and Untitled #369. 1976. Gelatin silver prints (printed 2000), 7¾₆ x 5" (18.3 x 12.7 cm) each

conceptual and performance artists. Sherman failed a mandatory photography course because she wasn't proficient at the requisite technical skills. When she took the class again, her subsequent teacher, Barbara Jo Revelle, was less concerned with technical perfection and exposed her students to Conceptual art and other contemporary art movements. Sherman became aware of and interested in the work of feminist artists who performed for the camera, such as Lynda Benglis, Eleanor Antin, and Hannah Wilke,[5] as well as male artists such as Chris Burden and Vito Acconci, who used their own bodies as the locus for their art. Equally influential on Sherman was meeting fellow art student Robert Longo (whom she dated for several years) in her sophomore year: "Robert was really instrumental in opening my eyes to contemporary art, because in the first year of college, you study ancient history in art—and in suburban Long Island, where I grew up, I had no exposure to contemporary art. But I hung out with Robert and these other people, going with them to the Albright-Knox [Art Gallery], which is right across from the college, and I saw

contemporary art first-hand. That's when I started to question why I should paint. It just seemed not to make sense."[6]

Another influence on Sherman was the alternative space Hallwalls, located in a converted ice-packing warehouse, where many artists had studios. Hallwalls was established by Longo and Buffalo native Charles Clough, who both had studios in the building.[7] Their first collaboration was an impromptu exhibition of their own work on the wall of the hall between their studios (hence the name Hallwalls), and they soon conspired to renovate and establish the space as an artist-run gallery, which officially opened in February 1975 and hosted exhibitions, lectures, performances, and events. Grants from federal and state sources, such as the National Endowment for the Arts and the New York State Council on the Arts, which were keen to support arts outside New York City, helped the fledgling organization gain traction.

Hallwalls was collaborative in spirit and a social hub where performance, painting, photography, and sculpture commingled. Sherman wasn't at the forefront of the organization (though she served as

secretary for a while), preferring instead to focus on her work and learn from studio-mates and visiting artists. The programs at Hallwalls attracted a number of notable artists and filmmakers during Sherman's tenure there, including Vito Acconci, Martha Wilson, Lynda Benglis, Jack Goldstein, Dan Graham, Chris Burden, Bruce Nauman, Nancy Holt, Yvonne Rainer, Robert Irwin, Richard Serra, and Katharina Sieverding, as well as critics and curators such as Lucy Lippard, Marcia Tucker, and Helene Winer. When Winer, director of the New York City alternative gallery Artists Space, visited Buffalo, she saw the work of Sherman, Longo, Clough, Nancy Dwyer, and Michael Zwack, and offered an exchange exhibition of artists associated with Hallwalls at Artists Space in November 1977, marking the beginning of a long relationship with Sherman. Hallwalls also cosponsored events with local institutions CEPA and the Albright-Knox Art Gallery.[8] Buffalo was gaining a reputation for avant-garde art and becoming a destination on the conceptual art map, with Hallwalls at its center.

Sherman attended college at a time when attitudes about fashion and women's

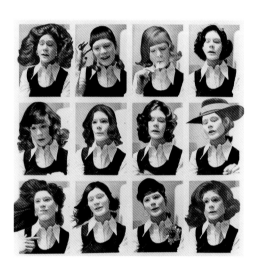

Fig. 4

Suzy Lake. *Miss Chatelaine*. 1973. Gelatin silver print (printed 1996), 20 x 16" (50.8 x 40.6 cm)

bodies were changing. Gone were the girdles and restricting undergarments of her mother's generation, replaced by a more natural approach to grooming. Yet Sherman remained fascinated with makeup and artificial beauty enhancers, even though as a student she wore scant makeup and few adornments. For fun, she would spend hours playing with cosmetics and clothes, sometimes dressing up as characters— such as a pregnant woman or Lucille Ball (see page 68)—to go to openings and parties, and she soon began making photographs of the characters she had been dreaming up for years.

Sherman has referred to Untitled #479 (plate 11), made for a class assignment exploring the passage of time, as her "first serious work."[9] Like the before and after of a makeover, it records the process of transforming a single character, from plain bespectacled girl to cigarette-smoking vamp. She recalled: "When I got the assignment to do the serial piece . . . I did this transitional series—from no makeup at all to me looking like a completely different person. The piece got all this feedback. It dawned on me that I'd hit on something."[10]

Similar to a storyboard or filmstrip, the twenty-three hand-colored photographs (one exposure short of the film roll's twenty-four) resemble other works of Sherman's from the same year, Untitled A–E (plates 4–8), a series of five head shots in which a coquettish young woman is transformed into a dopey-looking train conductor, who morphs into a young woman staring at the camera, who turns into a shy girl in barrettes, who finally changes into a self-assured woman (wearing the same hat, incidentally, as in image A). Reminiscent of casting photographs where an actor shows off a range of emotions and characters, the pictures possess a playfulness that can also be seen in her other early satires of genres or types, such as the bus riders (fig. 3), a succession of characters inspired by people she observed on Buffalo's public transportation. Sherman's exploration of stereotypes (especially in the head-shot format) is reprised in later works, most notably in the head-shot series of 2000–2002.

The serial description in Sherman's early photographs resonates with works by a number of other artists from the period.

16

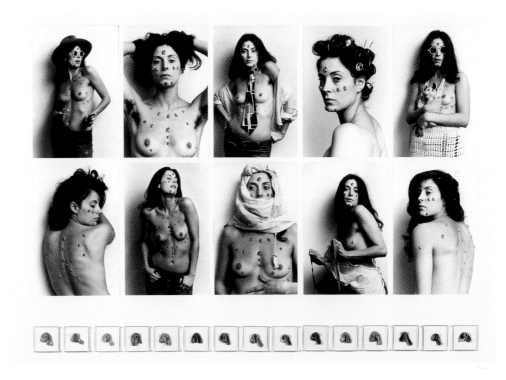

Suzy Lake, an artist whom Sherman has
cited as an influence,[11] produced gridlike
transformations, such as the 1973 *Miss
Chatelaine* (fig. 4), presenting multiple looks
of a single character. Eleanor Antin's land-
mark multipart work *Carving: A Traditional
Sculpture* (1972; fig. 6) and Hannah Wilke's
S.O.S. – Starification Object Series (1974–82;
fig. 5) each depict the transformation of the
artist recorded over a number of pictures
presented side by side. Wilke's parody of the
stock poses struck by fashion models in
S.O.S. – Starification Object Series is echoed
in the hyperfeminized characters who
appear at the end of the sequences in
Sherman's Untitled #479 and Untitled A–E.
While in many ways Sherman's work
represents a break from these artists' more
direct and political address of the camera,
the legacy of their performative experiments
and their exploration of surface appear-
ances as powerful signifiers of cultural
clichés and ideologies continues to resonate
with Sherman's art today.

It was during the early days of experi-
menting with the plasticity of identity and
photography that Sherman's ideas about art
began to take hold: "When I was in school

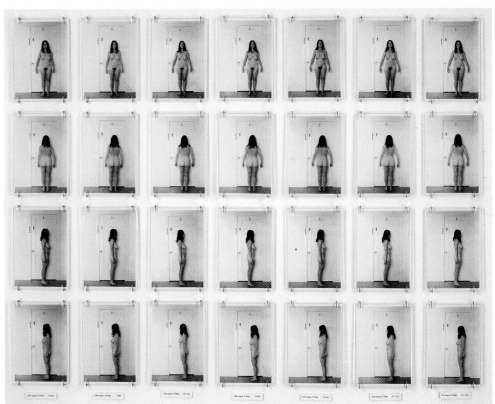

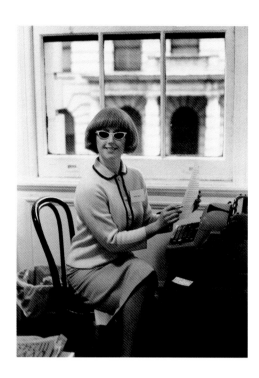

Fig. 7

Cindy Sherman. Untitled (Secretary).
1978. Gelatin silver print (printed 1993),
12½ x 9¼" (31.8 x 23.5 cm)

I was getting disgusted with the attitude of art being so religious or sacred, so I wanted to make something that people could relate to without having to read a book about it beforehand," she said. "So that anybody off the street could appreciate it, even if they couldn't fully understand it; they could still get something out of it. That's the reason why I wanted to imitate something out of the culture, and also make fun of the culture as I was doing it."[12] From the very beginning, Sherman eschewed theory in favor of pop culture, film, television, and magazines—inspirations that remain at the heart of her work.

Sherman stayed in Buffalo for a year after graduating from college, and in 1977 she moved to New York City, settling in a loft downtown with Longo. After a one-day stint as an assistant buyer for Macy's, Sherman was hired in 1978 by Winer as a part-time assistant at Artists Space, a job that she kept through the early 1980s, and to which she would occasionally come dressed up (fig. 7). Winer, previously the director of the Pomona College Museum of Art in Claremont, California, championed conceptual artists such as Chris Burden,

Bas Jan Ader, and John Baldessari, as well as a younger generation of New York artists working in the same vein. In 1980, together with Janelle Reiring of Castelli Gallery, Winer opened Metro Pictures gallery, which became the platform from which Sherman's career matured and exploded.

In the fall of 1977, at the age of twenty-three, Sherman began making pictures that would eventually become the "Untitled Film Stills." Any consideration of her career must address the "Stills," arguably one of the most significant bodies of work made in the twentieth century and thoroughly canonized by art historians, curators, and critics. This series established Sherman as one of the most important and influential artists of her time, and provided the foundation for a career that continues to thrive, provoke, and astonish.

The eight-by-ten-inch black-and-white photographs explore the stereotypes of a ubiquitous element of our common culture—film—and look like publicity pictures made on movie sets.[13] Taken as a whole, the "Untitled Film Stills" read like an encyclopedic roster of female roles inspired by 1950s and 1960s Hollywood, film noir,

B movies, and European art-house films, evoking directors such as Alfred Hitchcock, Michelangelo Antonioni, and Douglas Sirk. However, Sherman's pictures do not depict actual films: "Some people have told me they remember the movie that one of my images is derived from," she commented, "but in fact I had no film in mind at all."[14] Her characters resonate with the virtual catalogue of cultural references that we carry around in our heads and sample from a variety of postwar cultural icons and styles. Based on types made recognizable by Hollywood, her characters represent deeply embedded clichés (career girl, bombshell, girl on the run, vamp, housewife, and so on). Every picture stars Sherman as the protagonist and is staged—from camera angle and props to hair, makeup, poses, and facial expressions. In keeping with the rules of film, her characters don't address the camera, often looking out of the frame with blank expressions or seemingly caught in a reverie. The "Stills" are constructed rather than appropriated; they blur narrative, fiction, film, role-playing, and disguise. Without resorting to parody, they explore the complexity of

representation in a world saturated with
images and refer to the cultural filter of
other images (moving and still) through
which we see the world. But they *look* like
copies, further complicating the cycle of
representation in which they are enmeshed.

Before the "Untitled Film Stills"
Sherman was making a series of cutout
figures arranged into mini-narratives, such
as *A Play of Selves* (fig. 8), a melodramatic
allegory told through 244 cutouts of various
characters that interact with one another.
Although she wanted to continue making
narrative pictures, she found the process of
cutting too labor-intensive, and an idea
developed after she visited the loft of David
Salle, who had a stash of photographs from
the art department of the midtown soft-
core magazine where he worked. Cheesy
and retrograde, the pictures encouraged
Sherman to think about stock images. She
recalls: "They seemed like they were from
'50s movies, but you could tell that they
weren't from *real* movies. Maybe they were
done to illustrate some sleazy story in a
magazine. . . . What was interesting to me,
was that you couldn't tell whether each
photograph was just its own isolated shot,

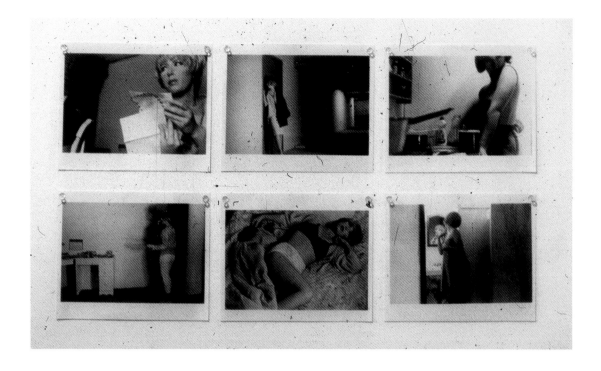

Fig. 9

Installation view of "Untitled Film Stills" in *WHERENWHEN*, Hallwalls, Buffalo, December 3, 1977–January 6, 1978

or whether it was in a series that included other shots that I wasn't seeing. Maybe there were others that continued some kind of story. It was really ambiguous."[15]

The first "Stills" she made were conceived as a distinct set of six images of the same blonde actress playing different roles, and in their first showing at Hallwalls in 1977–78 (fig. 9), some were cropped slightly differently than the prints today. Sherman has referred to the protagonist as a "trashy has-been,"[16] a type that she has explored in a number of other series (such as the murder mystery pictures and the head shots). In one, the blonde is looking over her shoulder at herself in a mirror (#2; plate 76); in another, she is splayed on a bed in bra and panties clutching a mirror (#6; plate 55); in another tight shot, she looks as if she has been interrupted while reading a letter (#5; plate 26). In developing the first six "Film Stills," Sherman purposely caused reticulation in the negatives, a grainy effect that results when one chemical bath is very different in temperature from the preceding one. There is a telling double paradox here: Sherman did this with the intent of making the

pictures look technically poor (although real film stills with such a flaw would never have been distributed), yet only someone with a knowledge of film developing would understand that such a flaw could be deliberately introduced. In some of the "Stills" the shutter release cord detracts from the illusion (see for example #6, #11 [plate 74], and #35 [plate 67]), while #4 (plate 50) reveals an incongruent detail: a Manhattan phonebook in the hallway, presumably placed there by someone other than the artist. Another "Still," #33 (plate 49), includes a picture within the picture— the portrait on the bedside table is of the artist in drag, similar to her portrait as a doctor (fig. 10). The layers of artificiality reveal that these photographs, and by extension all photographs, are constructed.

The series eventually grew to a total of seventy photographs made over three years,[17] encompassing a wide range of female character types that evoke a reper-toire of starlets, from Brigitte Bardot and Jeanne Moreau to Monica Vitti, Sophia Loren, and Anna Magnani. They refer to an ideal of beauty and femininity that belonged to Sherman's mother's generation; she was

Fig. 10

Cindy Sherman. Detail of Untitled
(Doctor and Nurse). 1980. One of two
gelatin silver prints, 9⁵⁄₁₆ x 8" (23.7 x
20.3 cm). The Museum of Modern
Art, New York. Gift of Janelle Reiring and
Helene Winer

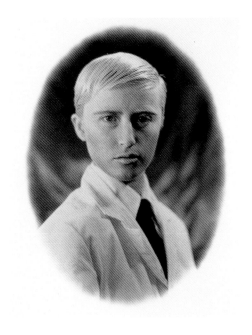

Fig. 11

August Sander. *Secretary at West
German Radio in Cologne*. 1931. Gelatin
silver print (printed 1995), 10¼ x 5¹³⁄₁₆"
(26 x 14.8 cm)

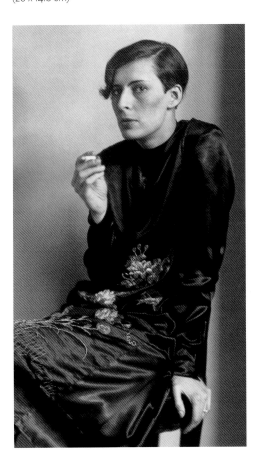

searching for the "most artificial looking
kinds of women. Women that had cinched-
in waists and pointed bras, lots of make-up,
stiff hair, high heels, and things like that."[18]
While the pictures can be appreciated
individually, much of their significance
comes in the endless variation of identity
from one photograph to the next. The series
is an inventory of types, an August Sander
catalogue for the media age. Where Sander
endeavored a comprehensive compilation
of the German people by occupation in his
ambitious project *People of the 20th Century*
(fig. 11), Sherman's index of women relies on
the persistence of recognizable manu-
factured stereotypes that loom large in the
cultural imagination.

After the first six pictures, in 1978 she
made more "Stills" at Longo's family's beach
house on Long Island and eventually
photographed all over New York City (near
the World Trade Center, on the West Side
piers, in Chelsea), as well as elsewhere.
Untitled Film Stills #42–44 (plates 28, 42,
and 53) and #48 (plate 62) were taken in
Arizona while Sherman was on a family trip
(the famous "hitchhiker" [#48] was snapped
by her father),[19] and #50 (plate #18) was

made in the Los Angeles home of Gifford
Phillips (of the Phillips Collection), where
her friend Nancy Dwyer was house-sitting
in 1979. While her earlier studio-based
proto-narrative works, such as the bus
riders and *A Play of Selves*, suggested little
storyline beyond the characters portrayed,
the locations in the "Stills" were key to the
success of their narrative potential. These
pictures show us how identity, and the
representation of it, relies not just on pose,
gesture, and facial expression, but also
on the arrangement of props, the choice of
clothing, and, of course, the location.

The "Untitled Film Stills" cost fifty
dollars each when they were first exhibited.
Their cheapness was important, as it evoked
the original referent—the film still. Rarely
printed anymore, film stills were usually
photographed on set and produced for
publicity and promotion; they were never
treated as artworks, and the photographers
were rarely credited. Sherman's "Stills"
mimic the publicity-still format—eight by
ten inches, glossy—and often look like
throw-away prints rather than precious
works of art. "I wanted them to seem cheap
and trashy," Sherman recalled, "something

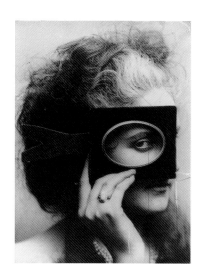 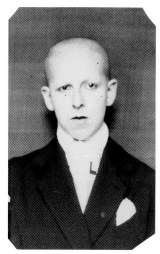

Fig. 12 (far left)

Pierre-Louis Pierson. *Scherzo di Follia (Game of Madness)*. 1861–67. Gelatin silver print from glass negative (printed c. 1930), 15¹¹⁄₁₆ x 11¾" (39.8 x 29.8 cm). The Metropolitan Museum of Art, New York. Gilman Collection, Gift of The Howard Gilman Foundation, 2005

Fig. 13 (left)

Claude Cahun (Lucy Schwob). *Untitled*. c. 1921. Gelatin silver print, 9⁵⁄₁₆ x 5⅞" (23.7 x 15 cm). The Museum of Modern Art, New York. Thomas Walther Collection. Purchase

Fig. 14 (right)

Man Ray (Emmanuel Radnitzky). *Marcel Duchamp as Rrose Sélavy*. c. 1920–21. Gelatin silver print, retouched by Duchamp, 8½ x 6¹³⁄₁₆" (21.6 x 17.3 cm). Philadelphia Museum of Art. The Samuel S. White 3rd and Vera White Collection, 1957

Fig. 15 (far right)

Gertrud Arndt. *Maskenselbstbildnis Nr. 22 (Mask Self-Portrait No. 22)*. 1930. Gelatin silver print, 9 x 6¹¹⁄₁₆" (22.9 x 17 cm). Museum Folkwang, Essen

you'd find in a novelty store and buy for a quarter. I didn't want them to look like art."[20] However, at this stage Sherman was already deeply invested in her art, and the dual status of the pictures—as works of art that *appear* to be cheap prints—contribute to the layered complexity of the series.

The "Untitled Film Stills" are irrevocably tied to the history of performance art, and Sherman has cited the influence of the work of 1970s artists such as Eleanor Antin, Hannah Wilke, and Adrian Piper.[21] Sherman's work also has affinities with a tradition of artists performing for the camera that predates the 1970s performative experiments. Although Sherman may not have been familiar with these precedents, photographers have exploited photography's plasticity from the dawn of the medium, posing, performing, and masquerading for the camera to create a multitude of personas, fictions, and narratives that probe the nature of the medium and the genre of self-portraiture. A year after photography's invention, Hippolyte Bayard's *Self-Portrait as a Drowned Man* (1840) was an open acknowledgment of photography's capacity to

create fictions. Twenty years later, the Countess de Castiglione, an extravagant French socialite, collaborated with court photographer Pierre-Louis Pierson to direct, stage, and photograph herself in costume, presenting a range of characters that reflected her fantasies (fig. 12). Pictorialist F. Holland Day assumed the persona of Jesus Christ for his 1898 series of pictures depicting the Crucifixion, after fasting for several months and scarring his body.

The Surrealist Claude Cahun's self-portraits have been cited as an important precedent for Sherman's exploration of the malleability of identity.[22] Cahun's gender-bending self-portrait in drag (fig. 13) recalls another significant exemplar known to Sherman, Marcel's Duchamp's female alter ego, Rrose Sélavy (fig. 14), photographed by Man Ray around 1921. An overlooked figure in this tradition is Gertrud Arndt, a Bauhaus student who masqueraded for the camera in a series of self-portraits taken in 1930 (fig. 15). Like Sherman, she enacted a series of stereotypes, such as the femme fatale, bourgeois lady, and widow—all interpretations of the multiplicity of female identity. These early examples ushered in the era

of set-up photography, best exemplified by the work of Paul Outerbridge and Edward Steichen and copied by countless anonymous professionals (fig. 16). They became the norm in the worlds of advertising and fashion as the picture press became the dominant mode of disseminating images. These would have been the kinds of images Sherman absorbed as a child, informing the female stereotypes in the "Film Stills" as much as the iconic characters from film did.

For Sherman, performing for the camera was always undertaken in relation to the act of photographing: "Once I'm set up, the camera starts clicking, then I just start to move and watch how I move in the mirror. It's not like I'm method acting or anything. I don't feel that I *am* that person," she has explained. "I may be thinking about a certain story or situation, but I don't become her. There's this distance. The image in the mirror becomes her—the image the camera gets on the film. And the one thing I've always known is that the camera lies."[23] Sherman acknowledges that we are conditioned by cinema and other media, and she uses these associations to steer her viewers in many narrative directions. The

Fig. 16

Photographer unknown. Advertising photo. c. 1950. Cabro print, 12³⁄₁₆ x 16⁹⁄₁₆" (31 x 42 cm). The Museum of Modern Art, New York. Gift of Richard Benson

cracks in the facade of the work (obvious makeup, ill-fitting clothes, repeated props, blank expressions) reveal the artificiality of her enterprise, and as viewers we become knowing participants in the fiction of photography. Sherman is interested in the disrupted narrative, the apparatus of it, and the process of the narrative structure, rather than a convincing performance.[24] The photographs are not seamless copies, nor were they ever meant to be. Rather, they are comments on images themselves. Seen as a whole, the series points to how we experience our media-saturated world, but also how contemporary identity (which is always shifting) is fractured and constructed by an evolving set of references.

It is difficult to divorce the "Untitled Film Stills" from the mountain of critical writing they stimulated, in which they were cited to illustrate postmodernism, feminism, psychoanalytic theories of the male gaze, and the culture of the spectacle. It is to Sherman's credit that the pictorial worlds she creates do not spring from any particular theoretical grounding, yet they tolerate and thrive on such varied, and sometimes conflicting, readings. Art

historian Craig Owens saw the women in the "Stills" as a critique of the construction of feminine identity seen in the media, positing: "Sherman's women are not women but images of women, specular models of femininity projected by the media to encourage imitation, identification; they are, in other words, tropes, figures."[25] For critic Arthur Danto they signaled something sexy and sinister: "The Girl [in each "Still"] is an allegory for something deeper and darker, in the mythic unconscious of everyone, regardless of sex. . . . Each of the stills is about the Girl in Trouble, but in the aggregate they touch the myth we each carry out of childhood, of danger, love, and security that defines the human condition where the wild things are."[26] The frequent use of frames within frames in the "Stills" (see #2, #14 [plate 44], #56 [plate 71], and #81 [plate 12]) led theorists such as Laura Mulvey to posit that the act of looking and photographing made the viewer aware of, even complicit in, the cycle of voyeurism.[27] In her 1993 book, art historian Rosalind Krauss wrote about the relationship of Sherman's work to theorist Jean Baudrillard's idea of the simulacrum: "The condition of

Sherman's work[s] . . . is the simulacral nature of what they contain, the condition of being a copy *without* an original."[28] The "Stills" are all this and more. They struck a deep nerve within critical art historical circles and became a talisman of many of the emergent ideas of the 1980s, when photography and art were commingling and the nature of photography's veracity was being debated. The "Stills" engender a number of different readings because they contain and support all those meanings— their strength is their mutability and elusiveness.

The "Stills" became a key example of the developing ideas of postmodernism, as articulated primarily by Douglas Crimp and Craig Owens.[29] Along with the work of Richard Prince, Sherrie Levine, Louise Lawler, Robert Longo, Laurie Simmons, Barbara Kruger, Jack Goldstein, and Troy Brauntuch (some of whom exhibited with Sherman at Metro Pictures), Sherman's photographs helped define this critical discourse. Postmodernism proposed a rethinking of the tenets of modernism, attacking the basic assumption of the original artwork and the genius artist. These

artists came to define postmodern artistic practices by creating art from existing material (such as news pictures, advertisements, television, and movies), suggesting the finiteness of the visual world and the depreciation of the primacy of a single image. They engaged with photography's capacity to examine and undermine the production of stereotypes and representations by acknowledging that in our dominant camera culture, pictures (moving and still) mediate our encounters in the world. The artist and critic Thomas Lawson wrote in his influential essay "Last Exit: Painting," "The photograph *is* the modern world," positing that natural perception has given way to photographic perception.[30] While his essay primarily addressed painting, he did make a point that artists in the late 1970s and the 1980s used photography as the main, if not dominant, tool with which to explore the nature of representation.

A hallmark of postmodern art was the influential *Pictures* exhibition organized by Douglas Crimp and presented at Artists Space in fall 1977. Sherman was not included in *Pictures*, which featured Troy Brauntuch, Jack Goldstein, Sherrie Levine, Robert Longo, and Philip Smith, but an expanded version of the exhibition's brochure text that Crimp later published in the journal *October* included a discussion of Sherman's "Untitled Film Stills."[31] *Pictures* signaled the emergence and recognition of the influence of media culture on a variety of artistic practices, and would become shorthand for referring to a generation of artists and their shared artistic concerns. The artists associated with the *Pictures* exhibition came to represent the spirit of criticism of the era and an involvement with images and ideas born out of mass culture. Referred to as postmodernists, appropriation artists, and "pictures" artists, they produced works (in a variety of mediums) that represented several strategies — including appropriation, approximation, pastiche, and recontextualization — that are loosely related and often lumped together in the assessment of the 1980s. Despite individual personalities and practices, these artists were all exploring similar ideas that worked against the modernist paradigm.

Although Crimp's theories would become the touchstone for the period, he was not working in isolation. Abigail Solomon-Godeau, Thomas Lawson, and Andy Grundberg were other leading voices in the development of postmodern culture and theory.[32] Additionally, French theorists such as Roland Barthes and Jean Baudrillard, whose writings were increasingly available through translation, were influential, particularly Barthes's 1967 manifesto "The Death of the Author." Another key text for postmodernists was Walter Benjamin's "The Work of Art in the Age of Mechanical Reproduction" (1936), where he asserted that photographs have rendered earlier forms of picture making, such as painting, obsolete.

Postmodern artists were the inheritors of the strategies and experiments of Conceptual art, in which photography began to play an increasingly pivotal role as traditional forms of painting and sculpture were rejected in favor of performance-based, ephemeral, and earth art practices. Postmodern artists coming of age in the 1970s were educated not as photographers but as fine artists. Many of them were influenced by the matter-of-fact attitude toward photography adopted by artists

Fig. 17

Richard Prince. *Untitled (Three Women Looking in the Same Direction)*. 1980. Chromogenic color prints, 16 x 23½" (40.6 x 59.7 cm) each. The Art Institute of Chicago. Gift of Boardroom, Inc.

such as John Baldessari and Ed Ruscha, perhaps best encapsulated in Baldessari's wry painting *An Artist Is Not Merely the Slavish Announcer* (1966–68; fig. 18), which challenges the conventions of "good" (i.e., traditional) photography. Richard Prince (fig. 17) and Sherrie Levine appropriated freely from the plethora of images in our culture, and Jeff Koons engaged in similar practices with sculpture. It's not as if artists hadn't borrowed from pop culture in the past, but the 1980s ushered in a new way of thinking about it. Marcel Duchamp's ready-mades and his incorporation of everyday objects as art were important precedents for how postmodernists would come to use life and "low" culture as material for their art. Robert Rauschenberg, Jasper Johns, and Andy Warhol were equally significant for how they utilized popular photographic images in their work. Other lesser-known precedents included Robert Heinecken's *Are You Rea* (1964–68; fig. 19), in which he exposed magazine pages to light against photographic paper, collapsing the verso and recto into a single image and melding advertising and editorial texts and images. Moreover, traditional photographers like

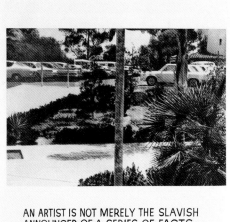

Fig. 18

John Baldessari. *An Artist Is Not Merely the Slavish Announcer*. 1966–68. Photoemulsion, varnish, and gesso on canvas, 59⅛ x 45" (150.2 x 114.3 cm). Whitney Museum of American Art, New York. Purchase with funds from the Painting and Sculpture Committee and gift of an anonymous donor

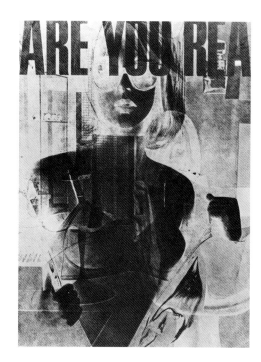

Fig. 19

Robert Heinecken. *Are You Rea #1*. 1964–68. Lithograph, 10¹³⁄₁₆ x 7⅞" (27.4 x 20 cm). The Museum of Modern Art, New York. Mr. and Mrs. Clark Winter Fund

Fig. 20

Lee Friedlander. *Tampa, Florida*. 1970.
Gelatin silver print, 6 x 9⅛" (15.3 x
23.2 cm). The Museum of Modern Art,
New York. Purchase

Walker Evans, Robert Frank, and Lee
Friedlander (fig. 20) had also expressed an
interest in pop culture, photographing signs
and window displays and celebrating the
poetry of the everyday. However, by the
1980s a different set of rules had come
into play, partly because modern art (which
was largely defined as the rarefied art of
painting) had itself become a commodity,
and artists were looking to other sources
and material for inspiration to work against
the modernist paradigm. In addition, the
late 1970s and 1980s marked a shift to new
operational modes, where hip hop, DJs,
mix tapes, and other forms of sampling
became the norm in culture at large. Music,
art, film, and theater were increasingly
cross-pollinating each other in New York,
contributing to the rich artistic boom of
the era.

Women played a leading role in the
formation of postmodernist work. Photog-
raphy was still regarded as a second-class
citizen, and as such it held an appeal for
artists like Laurie Simmons, Louise Lawler,
Sherrie Levine (fig. 21), Sarah Charlesworth,
and, of course, Sherman. Working in
an era that celebrated a return to painting,

Fig. 21

Sherrie Levine. *President Collage: 1.*
1979. Cut-and-pasted printed paper on
paper, 24 x 18" (61 x 45.7 cm).
The Museum of Modern Art, New York.
The Judith Rothschild Foundation
Contemporary Drawings Collection Gift

specifically the expressionist and figurative works of a group of "bad boy" painters who operated on an overtly macho public stage—Julian Schnabel, Eric Fischl, and David Salle (the rising stars of the Mary Boone Gallery)—these women claimed photography for themselves. It is perhaps partially due to this context that Sherman's work appealed to feminist theorists, but also because it emerged with some of the most ambitious and challenging photography made by women since Diane Arbus. Sherman recalled, "In the later '80s, when it seemed like everywhere you looked people were talking about appropriation— then it seemed like a thing, a real presence. But I wasn't really aware of any group feeling. . . . [W]hat probably did increase the feeling of community was when more women began to get recognized for their work, most of them in photography: Sherrie, Laurie, Sarah Charlesworth, Barbara Ess. I felt there was more of a support system then among the women artists. It could also have been that many of us were doing this other kind of work—we were using photography—but people like Barbara Kruger and Jenny Holzer were in

there too. There was a female solidarity."[33]

Sherman's work bloomed alongside, and was partly responsible for, photography's entrée into museum, gallery, and critical circles. Painting and sculpture were no longer perceived by the art market and museums as the only legitimate modes of art production. Sherman insists, however, that she is not a photographer but, rather, an artist who uses photography. Critics and curators debated what it meant to "use photography" to make art, as opposed to making photographs *as* art, in the new discourse on the medium that engaged histories and referents other than the modernist history of photography.[34] The work of postmodern photographers can be read as a tacit rejection of the ideals of modernist photographers like Alfred Stieglitz, Paul Strand, Edward Weston, and Ansel Adams, a refusal of form in favor of content. Sherman and her contemporaries cared little about the perfect print or correct exposure; they were more interested in how vernacular pictures reverberated in their art, how photography shaped the world and raised issues about power and representation. These photographers were

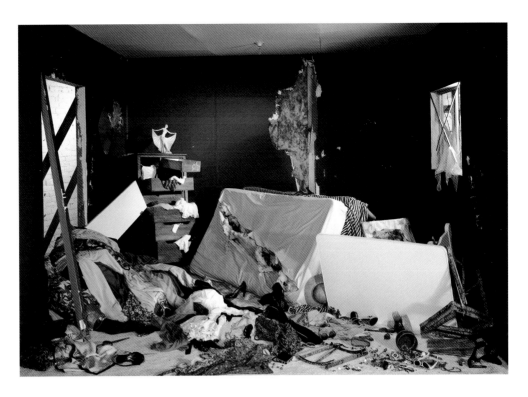

also creating work alongside the rising mode of fictional photography by artists like Philip-Lorca diCorcia and Jeff Wall (fig. 22), who were producing elaborately constructed tableaus and cinematically staged pictures. It was a groundbreaking era for photography, and Sherman's work was at the center of this fertile and radical repositioning of the medium.

The vast majority of the figures in Sherman's photographs are women, so inevitably the discourse on her works must acknowledge gender as an important element in their meaning and reception. The construction of female identity, established through visual codes like dress, hair, and makeup, had been rejected by feminist artists in the 1970s. Sherman's reappraisal of these roles was both an embrace and a rejection, establishing a complex relationship to feminism. Furthermore, her role as both subject (and object) and producer of images of women put her in the unique position of enacting the traditionally male viewpoint of photographer while also undermining it. Sherman's types, especially in the "Stills," are representations of representations—

stereotypes that critique feminine roles and conventions. Later series, with increased suggestions of violence and mutilated bodies, inspired further feminist discourse on the polemics of gender and sexuality in contemporary culture.

Feminist readings of Sherman's work emerged mostly after postmodernism was established, partly as a response to the male-dominated postmodern discourse but also as a by-product of it, as feminist perspectives offered an alternative to the male-centric modern tradition. Essays by theorists Laura Mulvey and Judith Williamson were particularly influential in this regard.[35] In her 1983 essay "Images of 'Woman,'" Williamson related the image of femininity to the constructed image of photography and film. She argued that Sherman's work invited the viewer to see the manufactured feminine image in tandem with the constructed photographic one: "In the 'Untitled Film Stills' we are constantly forced to recognize a visual style (often you could name the director) simultaneously with a type of femininity."[36] While Sherman didn't necessarily see the "Film Stills" through a feminist lens, she

Fig. 22

Jeff Wall. *The Destroyed Room*. 1978. Transparency in light box, 62⅝" x 7' 6⅛" (159 x 234 cm). National Gallery of Canada, Ottawa. Purchased 1979

Fig. 23

Lynda Benglis. Photograph for advertisement in *Artforum*, November 1974. The Museum of Modern Art Library, New York

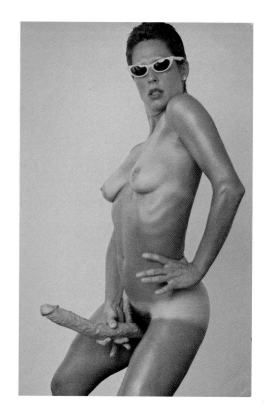

also didn't negate this reading of her series: "I know I was not consciously aware of this thing the 'male gaze.' It was the way I was shooting, the mimicry of the style of black and white grade-Z motion pictures that produced the self-consciousness of these characters, not my knowledge of feminist theory." She continued, "I suppose unconsciously, or semiconsciously at best, I was wrestling with some sort of turmoil of my own about understanding women. . . . I definitely felt that the characters were questioning something—perhaps being forced into a certain role. At the same time, those roles are in a film: the women aren't being lifelike, they're acting. There are so many levels of artifice. I liked that whole jumble of ambiguity."[37]

The debates over Sherman's work in relation to feminism really exploded with her 1981 series known as centerfolds (sometimes referred to as horizontals).[38] The twelve color horizontal photographs (measuring two by four feet) that comprise the series sent ripples throughout the art world when they were first shown at Metro Pictures in November 1981. One impassioned critic wrote that the show "cracked

my personal top-ten list of life-changing art epiphanies."[39] Commercially and critically, this provocative body of work ushered in a new era in Sherman's career, catapulting her to art stardom and engendering a new round of vigorous critical debate.

The centerfolds refer to both the printed page and the cinema—two constant inspirations for Sherman. The size of the prints, with their allusion to the Cinemascope format, allows for a more physical viewing experience than that offered by the "Untitled Film Stills," and a sense that the viewer is entering into (or being surrounded by) a fictive space. Originally commissioned by Ingrid Sischy, then editor of *Artforum*, these send-ups of men's erotic magazine centerfolds were ultimately not published because Sischy was concerned that they might be misunderstood. It recalls the debates triggered by Lynda Benglis's infamous self-produced ad in the November 1974 issue of *Artforum* (fig. 23), wherein she posed nude for the camera wearing nothing but sunglasses and holding a dildo, prompting a group of *Artforum* editors to protest the ad's "vulgarity."[40] Sherman acknowledged the influence of Benglis's ad,

and similarly provocative ads by Robert Morris and Eleanor Antin, "where they used themselves in a kind of joke about advertising."[41]

Sherman's centerfolds depict a variety of young women, mostly in supine positions, photographed close up and cropped so that they seem compressed into the frame and the photographic space is flattened. In many of these pictures, the women are in a state of reverie or daydreaming, seemingly unaware of the camera and staring outside of the picture frame. The characters are in extreme emotional states, ranging from terrified (Untitled #92; plate 96) to heartbroken (Untitled #90; plate 97) to melancholic (Untitled #88; plate 93). The suggestion of interiority is a shift from the surface masquerades and blank stares of the "Untitled Film Stills" and earlier work. The saturated palette contributes to both the intensity and the alienation of the women, heightening the drama of each picture. Sherman uses color to great expressive effect, as in Untitled #96 (plate 90), where the warm glow of the orange sweater of the girl lying on the floor, clutching a lonely-hearts ad, contributes

to her seemingly dreamy state. In Untitled #92, the cool blue tones of the picture enhance the girl's terror-stricken expression. The photographs are at once seductive and anxious-making. It's as if we're witnessing a private moment unfolding, which leads to a number of readings about the status of the viewer as a voyeur in the work. Sherman plays into the male conditioning of looking at photographs of exposed women, but she takes on the roles of both (assumed) male photographer and female pinup. The use of a horizontal format makes the reference to magazine centerfolds unmistakable, forcing us to reflect on this photographic cliché. Sherman's photographs are the antithesis of what a viewer expects to see in a centerfold. Like the "Film Stills," they foreground the way pictures affect us, making us aware of the act of photographing and looking.

The centerfolds provoked debate about the victimization of women because in many of the pictures viewers look down at the model, a vantage point that evokes a male point of view and suggests the woman's passivity and vulnerability. Laura Mulvey saw the photographs as a comment

on women as an erotic construction and fetish of the male gaze: "[The centerfolds] announce themselves as photographs and, as in a pinup, the model's eroticism, and her pose, are directed towards the camera, and ultimately towards the spectator."[42] Untitled #93 (plate 92) was a particular lightning rod for debate, as some interpreted the puffy-faced girl clutching at her bedsheets as a victim of sexual assault. Critic Roberta Smith wrote in 1981: "Some [of the women] seem slightly retarded or dazed, others are fearful—they seem to have been or are about to be victimized."[43] Sherman imagined another scenario entirely: "To me, the whole inspiration for the picture was somebody who'd been up all night drinking and partying and had just gone to sleep five minutes before the sun rose and woke her up. So it bothered me at first when people criticized the picture, seeing the side that I hadn't intended. I finally decided it was something I had to accept."[44] She later commented: "I was definitely trying to provoke in those pictures. But it was more about provoking men into reassessing their assumptions when they look at pictures of women. I was thinking about vulnerability

in a way that would make a male viewer feel uncomfortable—like seeing your daughter in a vulnerable state."[45]

This is typical of the debates that have surrounded Sherman and her work: the artist's accounts of her own intentions often conflict with the scholarly debates about feminism and the role of women in her pictures. The controversy and discussion around the centerfolds, and Untitled #93 in particular, are emblematic of the competing readings of her work. Like the "Untitled Film Stills," the impact of the individual center-folds was generally overlooked in service of the theories about the work. While certainly those readings shed light on the photo-graphs, they didn't acknowledge how all-encompassing Sherman's pictorial worlds are—so persuasive, in fact, that critics were up in arms about the depiction of violence, terror, and fear in her characters.

The centerfolds' references to the printed page and the feminine stereotypes formed and perpetuated by men's magazines were further developed by Sherman in works made for, by, and about fashion. It seems only natural that she would take up the subject of fashion itself

at various points throughout her career, as fashion has been a constant source of inspiration for Sherman and often a leading ingredient in the creation of her characters. After all, fashion is a masquerade that women engage in on a daily basis, in hopes of attaining a more beautiful, sexy, and polished version of themselves. It is an aspirational medium sold via magazines, advertisements, billboards, television, and the Internet with a rich visual language that communicates aspects of culture, gender, and class. Sherman's interest in the construction of femininity and mass circulation of images informs much of the work that takes fashion as its subject, illustrating not only a fascination with fashion images but also a critical stance against what they represent.

Sherman's first fashion commission, in 1983, was from the New York boutique owner Dianne Benson, who also hired Robert Mapplethorpe, Laurie Simmons, and Peter Hujar to produce photographs for advertisements. Sherman's advertisements (fig. 24) ran in the March, April, and June 1983 issues of Interview magazine. With an element of slapstick humor and theatri-

cality, these parodies of fashion photo-graphy were never meant to stand in for traditional fashion shots. Rather than projecting glamour, sex, or wealth, they feature characters that are far from desirable—goofy, hysterical, angry, and slightly mad—challenging conventional notions of beauty and grace. The traditionally acquiescent fashion model is replaced here with powerful and strong women, whose diverse behavior ranges from temper tantrum (Untitled #122; plate 84) to delirious outburst (Untitled #119; plate 83) to prudish giggling (Untitled #131; plate 89). The characters have an eccentric, almost gothic quality. Some critics have noted that it was in these works that Sherman's preoccupation with the grotesque began, seen here in the use of melodrama, violence, and mutilation and eventually expressed through bulbous prostheses and hybrid species in later series such as the fairy tales and sex pictures.[46] In an interview in 1986, Sherman commented on her growing fascination with darker subject matter that consciously worked against fashion's norms: "I'm disgusted with how people get themselves to look

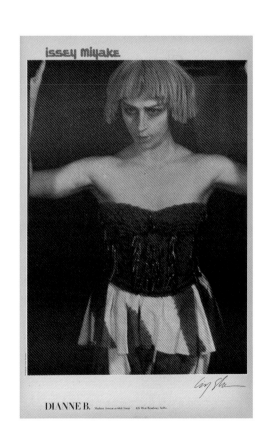

beautiful; I'm much more fascinated with the other side. . . . I was trying to make fun of fashion."[47]

In 1984, the French fashion company Dorothée Bis commissioned Sherman to make photographs for *Vogue Paris*. More extreme than the Benson pictures made a year earlier, they feature ugly characters with bloodshot eyes, bruises, and unflatter-ing pancake makeup. Sherman said about this series: "'This is going to be in French *Vogue*. I've really got to do something to rip open the French fashion world.' So I wanted to make really ugly pictures. The first couple of pictures I shot and sent to Dorothée Bis they didn't like at all. . . . That inspired even more depressing, bloody, ugly characters."[48] The fashion in the pictures is layered, oversized, not at all body conscious or sexy. In Untitled #133 and #137 (plate 87), the women are wrapped in heavy winter coats and sweaters and have a sullen look, disheveled hair, and bruised faces. These characters are beaten down and leaden, in stark opposition to the gazelles typically found bounding across the pages of fashion magazines. On close inspection, though, the clothes are luxurious and expensive

(by designers Comme des Garçons and Issey Miyake) and point to how wealth and class play into conventions of beauty and aging, topics that become more acute in later bodies of Sherman's work from 2000 on. Violence and power are also at play here—an uneasy cruelty, perhaps a suggestion of the implicit violence found just beneath the surface of many fashion pictures.

A decade later, in 1993, *Harper's Bazaar* commissioned Sherman to make editorial pictures for a feature that included clothes by Christian Dior, Jean-Paul Gaultier, John Galliano, Dolce & Gabbana, Calvin Klein, and Vivienne Westwood. In these pictures, clothes are utilized like costumes to create bizarre characters, such as a coy court jester (Untitled #277), a puckered-up Cinderella (Untitled #279), and a hung-over geisha (Untitled #278). Similarly, Sherman's 1994 commission from Comme des Garçons for an advertising mailer includes peculiar characters like a Kabuki-esque mime (Untitled #296; plate 143) and a tattooed truck-stop diva (Untitled #299; plate 85). By hiring Sherman, *Harper's Bazaar* and Comme des Garçons embraced the artist's

Fig. 25

Juergen Teller and Cindy Sherman.
Untitled. 2004. Photograph for
Marc Jacobs Spring/Summer 2005
campaign

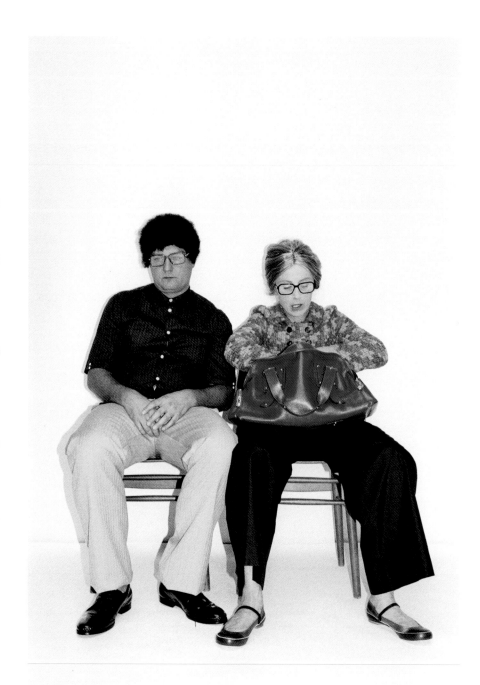

challenge to the conventions of high fashion
and beauty and acknowledged that their
own clothes and media influence were
complicit in the masquerade of fashion. With
these pictures, the circle was completed, as
the ideas of the postmodernists were now
co-opted by the very media they were
commenting on. This strategy was reprised
in the 2004 collaboration between Sherman
and German photographer Juergen Teller
for anti-fashion fashion ads for Marc
Jacobs, which featured both artists dressed
and posing in character for the camera,
looking sometimes like a flamboyant couple
groping each other and other times like
frumpy siblings (fig. 25).

The exaggerated characters in
Sherman's fashion pictures turned to osten-
tatious heights in 2007–08 with a series of
over-the-top fashion victims dressed in
head-to-toe Balenciaga clothes commis-
sioned by *Vogue Paris* for their August 2007
issue (see plates 86, 105, and 164). The
larger-than-life characters resemble steely
fashion editors, PR mavens, assistant
buyers, and wannabe fashionistas trying to
look sexy for the camera. With their telltale
signs of plastic surgery, gaudy dress, and

high-society aspirations, the characters are reminiscent of women in party pictures in fashion magazines or the *Real Housewives* reality show franchise. In an industry obsessed with image and status, these pictures are far from flattering, but as with her collaboration with Teller for Marc Jacobs, they were embraced by Balenciaga and the editors of *Vogue Paris* as a way to align themselves with the cutting edge. Thus the pictures operate on several levels: the photographs are at the center of a rejection of fashion's desire machine, yet they participate in it at the highest echelon.

Sherman's early fashion work marks the beginning of her exploration of the ugly, macabre, and grotesque and a trajectory of the physical disintegration of the body, which she explored to their fullest potential with several series in the 1980s and 1990s, including the fairy tales (1985), disasters (1986–89), civil war (1991), sex pictures (1992), horror and surrealist pictures (1994–96), masks (1995–96), and her 1997 film *Office Killer*. While she did create other series during this period, such as the 1990 history portraits (discussed later in this essay), the grotesque and abject—explored in various forms—were consistent preoccupations throughout these bodies of work.

This subject matter begins to manifest itself with the 1985 fairy tales series, larger-than-life photographs in jewel-toned colors that menace viewers with their dark visions. Although the pictures do not correspond to any specific fairy tales (just as the "Untitled Film Stills" do not refer to specific films), the macabre, gothic, deranged, and monstrous images evoke the narratives of the Brothers Grimm, Teutonic myths, folk legends, and oriental fables.[49] Originally commissioned by *Vanity Fair* but never published (like the *Artforum* centerfolds), the pictures are theatrical and revel in their own artificiality. In these fantastical mise-en-scènes, elements of metamorphosis are rampant, with animal/human hybrids (such as the snout-nosed face in Untitled #140 [plate 110]) and figures that appear neither male nor female, and barely human (see plate 147). The series encompasses a nightmarish perspective on the world that becomes increasingly pronounced in Sherman's work in the years to follow.

With the fairy tales, Sherman introduced prosthetic parts as a stand-in for the human body, a practice that would soon replace the figure altogether. Even when Sherman is in the photographs, she appears doll-like and artificial, as in Untitled #153 (plate 2). Reminiscent of a crime scene photo, the picture shows a dead woman lying on the ground and covered in dirt, her glassy eyes opened wide, as if shocked by her own violent demise. Unlike a police photograph, however, this larger-than-life glossy picture is full of seductive detail, with rich descriptions of the colors and textures of the gravel background, the woman's mussed hair, and her waxy face. With this picture, the suspense and suggestion of violence lurking in the "Untitled Film Stills" and centerfolds is amplified and articulated.

In the series referred to as the disasters (1986–89), Sherman continued the theatrical devices, themes, and motifs explored in the fairy tales. The figure disappears (or is only nominally present) in favor of outlandish and revolting scenes that explore the psychic terrain of the abject. The pictures feature mutilated body parts, blow-up dolls (Untitled #188), rotting food, and substances that look like vomit (Untitled #182; plate 111), feces, and blood,

and recall female bodily functions such as menstruation and giving birth, as well as bulimia, an illness associated with women (see Untitled #175 [plate 116]). Despite their gruesome qualities, the pictures are not without humor, as seen in the reflection of a screaming face in a pair of glasses in Untitled #175. These landscapes of decay are visually rich and painterly in texture and color. Sherman said of these pictures that she "wanted something visually offensive but seductive, beautiful, and textural as well, to suck you in and then repulse you."[50] While some of the photographs do have shock value, that is not their primary intent; rather, the carefully arranged tableaus are surrogates for larger narratives of violence, decomposition, and death.

These grotesque bodies of work marked a turn away from the representation of women, perhaps reflecting Sherman's response to the feminist critical discourse surrounding the "Film Stills" and center-folds. Although debates about feminism and the issue of pornography certainly continued with the sex pictures, the disasters and the subsequent horror and surreal series engendered new ways of framing her work in terms of the psycho-analytic, grotesque, and abject, as articulated by art historians such as Amada Cruz, Hal Foster, and Norman Bryson, among others.[51] The lack of the figure was read by Cruz as a rejection of the "socialized body that we encounter daily in the media"[52] and by Foster (who read Sherman's pictures through Julia Kristeva's construct of abjection) as proof of the "body turned inside out, of the subject literally abjected, thrown out."[53] However, Sherman's shift was motivated at least in part by practicality; she was getting increasingly tired of using herself as a model and had become interested in the theatrical narratives made possible by using dolls, prosthetic body parts, and props. She also made these pictures in response to her increased popularity in the art world. Without the artist in the picture, the work was no longer a recognizable "Sherman." She explained: "I'm pretty disgusted, I guess, with the art world in general. The boy artists, the boy painters, the collectors, the crawl, and climb, and stabbing each other to the top sort of competition. I don't know why that work would come out from those feelings, but I think I wanted to make something that I couldn't imagine anybody buying. 'I dare you to like *this*.'"[54]

Violated and hybrid bodies found their full expression in Sherman's 1992 sex pictures. Sherman wanted to make explicit pictures but was not interested in photographing herself nude, so she used dolls bought from medical supply catalogues, arranged them to simulate sex acts and mimic hard-core pornography, and photographed them, sometimes in extreme and disorienting close-up. She used a cache of body parts, creating her own hybrids at will—a mix of male and female that evoked the crossbreeds from the fairy tales. Sherman added makeup and pubic hair to the plasticized, hairless medical dolls to make them more diverse and lifelike. Mannequins and sex dolls are usually idealized versions of women's bodies with unrealistic proportions, and Sherman's use of medical dolls with gaping orifices and her mix of male and female parts (see Untitled #263; plate 109) challenge fetishized female sexuality. She forces viewers to confront their own preconceived ideas about sex, pornography, and erotic images: "[T]hey were

Fig. 26

Jeff Koons. *Ponies*. 1991. Oil inks
silkscreened on canvas, 90 x 60"
(228.6 x 152.4 cm)

a refusal to make a sexy image about sex," she said. "I've never wanted to do that. . . . Nudity can be a cop out. That is why I use fake tits and asses, to avoid sensationalisms, which I wanted to subvert."[55] Suggested in her combination of bodies and parts is dismemberment and violence, as well as allusions to sadomasochism (seen in Untitled #264 [plate 3]). Her fascination with and repulsion by grotesquely engineered bodies is reprised in later pictures, from 2000 on, that address the manipulation of the body through cosmetic enhancement and plastic surgery.

The sex pictures are distinctly unerotic. While the scenarios are pornographic, the bodies themselves are sterile and medical, and they simply mimic erotic poses and acts (both gay and straight). Their manufactured quality enhances the allusion to pornographic photographs and videos, forcing viewers to become self-conscious about watching themselves watching, keenly aware of the cycle of fetishism and voyeurism on which pornography thrives. Sherman commented on people's reactions to viewing the work: "I got the feeling at the opening and at the other times I would walk into the gallery that people would look around and quickly leave. I think someone told me that they couldn't stay in the gallery very long. . . . I think the show made people very uncomfortable."[56] Although the scenarios were obviously fake, they nonetheless succeeded in making the viewers feel complicit in the act of looking and photographing.

On one level, the sex pictures were Sherman's response to Jeff Koons's bombastic paintings of himself having sex with his wife, Ilona Staller, a former porn star also known as Cicciolina (fig. 26). But they were also made against the politically charged backdrop of debates about censorship and federal funding of the arts after a public outcry against government sponsorship of a Robert Mapplethorpe exhibition. Sherman said: "The censorship issue is important. . . . I felt that my previous show. . . was so commercially successful that it made sense to go out on a limb in these difficult times. Since I really don't expect people to buy my art anyway, and because I don't have to worry about funding or being censored at this point, I thought I might as well really try to pull out all the

Fig. 27

Spread from *Minotaure*, December 1934, showing eighteen photographs of Hans Bellmer's *Poupées*. The Museum of Modern Art Library, New York

stops and just make something that directly deals with sexuality and censorship without compromising my values."[57] The sex pictures also operated under the specter of AIDS, during a period when the body and its surrogate took on new meanings in the context of images of wasted AIDS victims. Devoid of pleasure and intimacy, Sherman's sex pictures reflect a fear of the body and suggest the degeneration and dehumanization of sexual desire. In opposition to the use of the body as a direct instrument of action in art of the 1960s and early 1970s, the bodies in Sherman's sex pictures are empty receptacles that function as signifiers for death, power, and aggression.

The relationship of the sex pictures to Hans Bellmer's experiments with dolls (fig. 27) has been discussed numerous times in the literature on Sherman.[58] Bellmer's *Poupées*, which he constructed and photographed in the 1930s, are surrogates for his fantasies and imagination and comprise terrifying images of women. As a female author of her works, however, Sherman creates photographs that suggest a critique of the fetishes of male artists such as Bellmer and other Surrealists who engaged

Fig. 28

Robert Gober. *Untitled Leg*. 1989–90.
Beeswax, cotton, wood, leather, and
human hair, 11⅜ x 7¾ x 20" (28.9 x 19.7 x
50.8 cm). The Museum of Modern
Art, New York. Gift of the Dannheisser
Foundation

in similar fantastical dismemberments of
the female body. While Bellmer's *Poupées*
are a key precedent, perhaps a more fruitful
and revealing comparison is with Sherman's
contemporary Charles Ray, in particular his
sculpture *Oh! Charley, Charley, Charley . . .*
(fig. 29), a life-scale depiction of the artist
engaged in an orgy with himself, made
in the same year as Sherman's sex pictures.
While Sherman's pictures are artificial and
de-individualized and Ray's sculpture is
realistic, they share an oddly asexual quality
in their examination of how the body
functions in a masturbatory image culture
that seems to endlessly multiply on itself.
Robert Gober also explored the fragmented
body in his sculptural works, which reso-
nate with many of the themes found in
Sherman's sex pictures. Like her pictures,
Gober's dismembered and damaged
bodies (fig. 28) were a response to AIDS
and political art under fire, as well as an
exploration of the language of identity
politics. Both artists paint a bleak picture of
the cultural and political landscape of the
early 1990s.

The artificial tableaus of body parts
and grotesque subjects appeared again in

Fig. 29

Charles Ray. *Oh! Charley, Charley,
Charley. . . .* 1992. Eight painted cast
fiberglass mannequins with wigs, 6 x
15 x 15' (182.9 x 457.2 x 457.2 cm) overall.
Rubell Family Collection, Miami

Fig. 30

Cindy Sherman. *Office Killer*. 1997. Film, 35mm, color, 82 minutes

Sherman's 1997 feature film, *Office Killer* (fig. 30), starring Carol Kane, Molly Ringwald, and Jeanne Tripplehorn.[59] Set in the generic offices of a *Consumer Reports*–type magazine, *Office Killer* follows Dorine (played by Kane), a mousy copy editor whose acci- dental murder of a coworker precipitates a killing spree, after which she hides the bodies in her basement to play house with them. The film resonates with much of the photographic work Sherman was making at the time—especially the colorful tableaus of vomit, body parts, and excrement—and her love of horror films is seen in the movie's campy melodrama (an underappreciated aspect of the work). In the film, the office is dominated by female characters wearing power suits and gaudy jewelry, smacking gum, and being catty. Ringwald's character, Kim Poole, an ambitious young office worker, is remini- scent of the office girls in the "Untitled Film Stills" (such as #21 [plate 35]) or Untitled #74 (plate 108) from the rear screen projection series that followed in 1980. The film's self- awareness and referentiality (to her own work and to B horror movies) echo the strategies of Sherman's photographic work.

It seems inevitable that Sherman would turn to the subject of art itself at some point in her career. The body of work known as the history portraits (also referred to as old masters) was first exhibited in 1990 at Metro Pictures to great acclaim. A critic noted in his review that the gallery "resembled the Impressionist wing of the Met on a busy Sunday" and that the extensive press coverage of the exhibition accorded the works "the kind of cultural legitimation usually reserved for traditional Masterpieces."[60] The series began in 1988, when Artes Magnus, a producer of limited- edition tableware made by artists, invited Sherman to create a dinnerware and tea service with the French porcelain house Limoges, which houses the original molds for the eighteenth-century designs made for Madame de Pompadour, mistress of King Louis XV. Sherman's porcelain objects (fig. 31) are adorned with images of herself as Pompadour, and later that year, for a group exhibition at Metro Pictures, Sherman produced a photograph based on the character (Untitled #183; plate 128). The next year, on the occasion of the bicentennial of the French Revolution,

Fig. 31

Cindy Sherman. *Madame de Pompadour
(née Poisson)*. 1990. Porcelain with
painted and silkscreened decoration,
tureen with cover: 10¼ x 14⅝ x 9¼"
(26 x 37.2 x 23.5 cm), under plate: 2½ x
22⅛ x 17⅛" (6.4 x 56.2 x 43.5 cm)

Sherman produced a group of pictures for a
show at Chantal Crousel gallery in Paris
inspired by that event (Untitled #193–201;
see, for example, plates 119, 120, 122, 125,
and 139). As the series continued to take
shape, she made a second group of pictures
during a two-month stay in Rome in late
1989, and then produced the last group
in the series when she returned to New York.

 These classically composed portraits,
presented in ornate and gilded frames,
refer to Old Master paintings in their format
and size. The subjects, who include
aristocrats, Madonna and child, clergymen,
women of leisure, and milkmaids, pose with
props, costumes, and prostheses. The
portraits borrow from a number of art
historical periods—Renaissance, Baroque,
Rococo, Neoclassical—and make allusions
to Raphael, Caravaggio, Fragonard, and
Ingres. (Of course, all the Old Master
painters were men.) This free-association
sampling creates an illusion of familiarity,
but not to specific eras or styles (just as the
"Untitled Film Stills" evoke generic types,
not particular films). With the exception of a
few works that were inspired by specific
paintings, most of Sherman's subjects are

Fig. 32 (left)

Raffaello Sanzio da Urbino (Raphael). *La Fornarina*. c. 1518. Oil on wood, 34¼ x 24¹³⁄₁₆" (87 x 63 cm). Galleria Nazionale d'Arte Antica, Rome

Fig. 33 (center)

Jean Fouquet. *Virgin of Melun*. c. 1452. Oil on panel, 37¼ x 33¾" (94.5 x 85.5 cm). Koninklijk Museum voor Schone Kunsten, Antwerp

Fig. 34 (right)

Oscar Gustave Rejlander. *Untitled (The Virgin in Prayer)*. c. 1857. Albumen silver print, 8 x 6" (20.3 x 15.2 cm). National Gallery of Victoria, Melbourne. Purchased 2002

anonymous, although their status, roles, and class are denoted through clothing, props, backgrounds, and set dressing. The obvious use of prostheses builds on the theatricality of the fairy tale and disaster series, and the large noses, bulging bellies, squirting breasts, warts, and unibrows that populate these pictures make for less-than-graceful portraits of nobility; one critic described them as "butt-ugly aristocrats."[61] The history portraits toe the line between humorous parody and grotesque, as in Untitled #216 (plate 10), which pokes fun at the Renaissance treatment of female anatomy by featuring an obviously artificial, impossibly globular breast.

For the first time in Sherman's work, men played a big role in the series—nearly half the portraits are of men. Where some of Sherman's previous masquerades as male characters veered toward campy drag, the men in the history portraits blend in seamlessly with the female characters. Their overly bushy eyebrows and ill-fitting wigs are just as artificial as the women's witchy noses and heaving bosoms. All the portraits are treated with a similar mocking questioning of the nature of representation in art

history and the relationship between painter and model.

At first glance, the set dressing and costumes, made from fabrics such as brocade, silk, damask, lace, and velvet, look sumptuous and evoke a general "Old Master" era. However, like elements of a film set, they are required to look convincing only through the camera lens, and in fact most of them are cheap retrofits of contemporary fabrics made to look "period"—a facade that alludes to a historical context. Some contemporary details also appear in the history portraits, such as in Untitled #204 (plate 127), where a shred of contemporary graph paper with illegible notes is wedged in the corner of a mirror in the background. The illusion collapses, as it inevitably does in all of Sherman's photographs, leaving the process of disguise in plain sight as part of the meaning of the work. In creating these pictures, Sherman generally used as her inspiration reproductions in books, further emphasizing her reassessment of and allusion to a representational model: "Even when I was doing those history pictures, I was living in Rome but never went to the churches and

Fig. 35

Michelangelo Merisi da Caravaggio.
Sick Bacchus. c. 1593. Oil on canvas,
26⅜ x 21" (67 x 53.3 cm). Galleria
Borghese, Rome

museums there. I worked out of books, with reproductions. It's an aspect of photography I appreciate, conceptually: the idea that images can be reproduced and seen anytime, anywhere, by anyone."[62] These representational systems are part of our cultural history, familiar to us through generic coffee table art books and vaguely recalled childhood museum visits.

There are a handful of works inspired by actual paintings: Untitled #224 (plate 136) is based on Caravaggio's *Sick Bacchus* (c. 1593); Untitled #205 (plate 134), on Raphael's *La Fornarina*, a portrait of his mistress (c. 1518; fig. 32); and Untitled #216, on Jean Fouquet's *Virgin of Melun* (c. 1452; fig. 33). Untitled #228 (plate 140) refers to the biblical story of Judith beheading Holoferenes, illustrated by numerous painters, including Caravaggio, Donatello, and Botticelli. In Sherman's depiction, Judith seems unmoved, and her apparent lack of emotion as she holds the head of Holoferenes contributes to the sense of fiction and remove from the violent action.

The practice of photographing scenes inspired by paintings was common among Victorian photographers in the nineteenth century, such as Oscar Gustave Rejlander, whose photograph *Untitled (The Virgin in Prayer* (c. 1857; fig. 34) was taken after the seventeenth-century painting *The Virgin in Prayer* by the Italian artist Sassoferrato. Rejlander's carefully staged picture recalls the tradition of copying great works as a pedagogical tool for art students. But whereas Rejlander restaged the Old Masters in photography to prove that the status of the medium was equal to that of drawing and painting, Sherman undermines the historical tradition by combining a variety of styles and references.

Of the history portraits inspired by specific paintings, Untitled #224 is the least caricature-like, but even here Sherman effects a transformation of the original source. In her interpretation of Caravaggio's work (fig. 35), commonly believed to be a self-portrait of the artist as Bacchus, there are numerous layers of representation — a female artist impersonating a male artist impersonating a pagan divinity — creating a sense of pastiche and criticality in her version. Herein lies the brilliance of the history portraits: even where her pictures offer a gleam of art historical recognition,

Sherman has inserted her own interpretation of these ossified paintings, turning them into contemporary artifacts of a bygone era.

Sherman continued to test the boundaries of portraiture, photography, and, perhaps most importantly, identity with a series of head shots executed in 2000–2002 and referred to as Hollywood/ Hamptons or West Coast/East Coast. The format recalls ID pictures, head shots, or vanity portraits made in garden-variety portrait studios by professional photographers (who are fast becoming obsolete in the digital era). In her role as both sitter and photographer, Sherman has disrupted the usual power dynamic between model and artist and created new avenues through which to explore the very apparatus of portrait photography itself. Shown at Gagosian Gallery's Beverly Hills location in 2000 around the time of the Oscars, the first eleven photographs in the series explore the cycle of desire and failed ambition that permeates Hollywood. Sherman conceived a cast of characters who were, in her words, "would-be or has-been actors (in reality secretaries, housewives, or gardeners) posing for headshots to get an acting job.

These people are trying to sell themselves with all their might; they're just begging the viewer: don't you want to hire me?"[63] Later Sherman added eleven "East Coast" types (hence the reference to the Hamptons, the exclusive beach enclave sometimes referred to as East Hollywood) for her show at Metro Pictures in 2001. Whichever part of the country they're from, we've seen these women before—on reality TV, in soap operas, or at the PTA meeting.

The series marked a return to a more intimate scale and the figure after Sherman had been working for almost a decade with dolls and props. The series also recalls early works, such as Untitled A–E, where the focus was on the transformative qualities of makeup, hair, expression, and pose, and the recognition of certain stereotypes as powerful transmitters of cultural clichés. Here Sherman utilizes makeup, clothes, and styling to project well-drawn personas: the enormous pouting lips of the woman in Untitled #360 (plate 158) suggest a yearning for youth, while the glittery makeup and purple iridescent dress worn by the character in Untitled #400 (plate 149) indicate an aspiration to reach a certain social status.

The women in this series covet youth and glamour, sometimes at a level bordering on desperation—just one of the elements that make the series so powerful.

The head-shot series continued Sherman's close engagement with screen sirens, celebrity, and Hollywood, but it would be limiting to read these pictures only in relation to such references. Whereas Hollywood was once the main generator and disseminator of feminine types and role models (the currency of the "Untitled Film Stills"), now magazines, tabloids, the Internet, and reality TV are all progenitors of female stereotypes, and Sherman's work increasingly references these sources. The pictures speak to the pervasive youth-obsessed culture of the twenty-first century and expertly capture the slippage between the artificial face of our personas—the photo-op-ready glamazons—and the insecure individuals underneath the garish makeup and silicone implants. Sherman has explored the theme of failure in several of her series, played out to a certain extent in some of the protagonists of the "Film Stills" and to a gorier end with works she created in the mid-1990s. With this series, however,

44

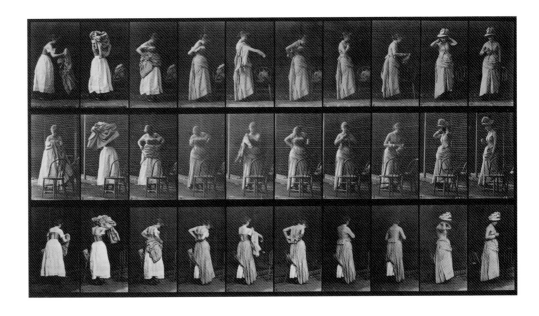

the desperation of the characters is palpable. While there is an element of satire, there are equal, if not greater, parts of compassion for, and affinity with, these women.

The uneasy relationship between artificial surface appearance and inner psychology in portraiture is explored in a series of pictures of clowns Sherman made a few years later, in 2002–04. This series builds on the exploration of the conventions of portraiture seen in the history portraits and head shots, but it is also an extension of Sherman's interest in fairy tales, black humor, and masks. The clowns evoke circus posters in their style but represent a range of emotions and states, from hysterical passion to tragedy. Rather than simply impersonate the clichéd clown, Sherman created a cast of players who are cruel, wicked, disturbed, even lustful—in her words, "intense, with a nasty side or an ugly side, but also with a real pathos."[64]

Clowns wear masks and are predominantly men, and for these portraits Sherman adopted a variety of male characters as well as ambiguously gendered ones, recalling the hybrids of the fairy tales and sex pictures. She was interested in moving beyond the strict set of defined roles and codified types generally assigned to clowns (like the happy or sad clown) to reveal the persona underneath, who might be "an alcoholic, or even a child-molester."[65] (For instance, in Untitled #411 [plate 146] the clown inexplicably wears a neck brace, suggesting violence or an accident.) This opens the door to multiple layers of meaning and narrative: the surface facade denoted by makeup and clothes, as well as the underlayer expressed by Sherman through gesture, pose, and styling.

There is a deeply unsettling quality that permeates the clowns, underscored by the aggressive makeup and garish Day-Glo backdrops. Sherman shot the characters on slide film and made all the backgrounds digitally, allowing her to incorporate multiple figures, which she had wanted to do for many years but had found technically challenging. (She had experimented with digital backgrounds with a few of the head-shot pictures, such as Untitled #408 [plate 103] and #409, and would shoot her first complete series digitally with the Balenciaga pictures in 2007–08.) The new digital techniques she employed in the series recall her college experiments with cutouts of multiple figures, such as *Doll Clothes*, her 1975 stop-motion animated 16mm film,[66] and the 1976 collages Untitled #488 and #489 (plates 166 and 165), which evoke the early experiments in motion photography by Étienne-Jules Marey and Eadweard Muybridge (fig. 36). Where these early works chart the movements and gestures of a character that is replicated and multiplied, the multiple figures in Untitled #425 (plate 161) interact with one another to create a tableau; they also allow for a variation in scale that leads to a nightmarish effect in which clowns seem to encroach on the viewer's physical space.

The clown can be seen as a stand-in for the artist, who is often expected to entertain in the contemporary circus of society and is encouraged to act outside of codified norms. Perhaps the sad clown in Untitled #413 (plate 1), donning a silk jacket embroidered with "Cindy" on the chest, is an acknowledgment of the demands made on the artist to embody such a manufactured persona. Contemporary artists such as Paul McCarthy, Bruce Nauman, Roni Horn, and Ugo Rondinone have also

examined the pathos of the clown; several works by Nauman feature clowns in hysterically extreme states, most memorably in his 1987 video installation *Clown Torture* (fig. 37), a disturbing spectacle of noise exploring themes of surveillance, torture, and madness. Like Nauman, Sherman uses the guise of the clown to explore uncanny and monstrous impulses that have a complex hold on the public imagination.

The larger-than-life clowns made way for the 2008 series of society portraits, an even larger set of pictures (some tower over eight feet tall). They are a continuation of themes explored in the head shots and the series of Balenciaga pictures made in 2007–08 for *Vogue Paris*. The 2008 society portraits feature women "of a certain age" from the top echelons of polite society: politicians' wives, old-money blue bloods, and the nouveau riche. While the characters are not based on actual women, Sherman makes these stereotypes look entirely familiar. Presented in opulent gilded frames, presumably to be installed in the foyers and grand rooms of their mansions, the characters are both vulgar and tragic. "I started to think about some of the

Fig. 37

Bruce Nauman. *Clown Torture*. 1987. Four-channel video, sound (two projections, four monitors), 60-minute loop. The Art Institute of Chicago. Watson F. Blair Prize, Wilson L. Mead and Twentieth-Century Purchase funds; through prior gift of Joseph Winterbotham; gift of Lannan Foundation

46

characters—how they're older women and if they are successful, maybe they're not really that happy," Sherman said. "Maybe they've been divorced, or they're in an unhappy marriage, but because of the money, they're not going to get out. That's what I was thinking—that there's something more below the surface that you can't really see."[67] The characters are set against the backdrop of opulent palazzos, lush gardens, and elegant drawing rooms, holding lap dogs or wearing ball gowns—all familiar signifiers of money and status. To create the portraits, Sherman photographed herself against a green screen and later inserted digital backdrops that she shot herself, in Central Park (Untitled #465; plate 170), the Cloisters (Untitled #466; plate 9), and the National Arts Club in Gramercy Park (Untitled #474; plate 169), among other locations.

The bejeweled and begloved women in these pictures struggle with the impossible standards of beauty that prevail in our youth- and status-obsessed culture, and more than a few of them show the telltale signs of cosmetic alteration. The large scale of the pictures allows viewers to see certain key details very clearly: papery skin around the eyes and lips, the turkey neck that is the bane of older women everywhere, impossibly smooth foreheads thanks to Botox, and arm fat that won't dissipate despite a daily Pilates regimen. The psychological weight of these pictures comes through the unrelenting honesty of the description of aging and the small details that belie the attempt to project a certain appearance. In Untitled #476 (plate 168), a woman sits on a sofa with her Schnauzer, but the dog is fake. In Untitled #466, a grand dame wears an opulent caftan, but her feet are stuffed into pink plastic slippers from a dollar store and she's wearing the kind of thick stockings that reduce varicose veins. Upon careful viewing, these pictures reveal a darker reality lurking beneath the glossy surface of perfection. In a world where nobody knows who has had work done or what is fake, the series confounds viewers, leaving them unsure of what is artificial and what is real.

It would be easy to dismiss the pictures as callous parodies, but Sherman's attention to the details (aging hands, just the right earrings, perfect hair) reveals her intense fascination with, and empathy for, the women she portrays. A sense of personal connection with her characters seems stronger here than in any other body of work: "To me, it's a little scary when I see myself. And it's especially scary when I see myself in these older women."[68] Sherman has always included older characters in her work, but, as Abigail Solomon-Godeau pointed out in her 1991 essay "Suitable for Framing: The Critical Recasting of Cindy Sherman": "that such types [have] become critically invisible grimly parallels their invisibility in real life."[69] Here, women "of a certain age" loom large, unmistakably visible.

With this series, Sherman doesn't critique just ideas of glamour and standards of beauty; she also takes on issues of class. Although the artist did not conceive of these characters as art patrons,[70] Sherman herself has attained celebrity status within the art world, and these are among the types of women she now mingles with. Sherman takes on a subject that challenges her collectors, and one of the many paradoxes of this series is how the patron class is both the champion and the subject of it. As with much of her work, Sherman has a

Fig. 38

Installation view of *Cindy Sherman*,
Sprüth Magers, London, January 12–
February 19, 2011

remarkable capacity to channel the zeitgeist.
These well-heeled divas presage the end of
an era of opulence with the financial
collapse in 2008. The size of the photo-
graphs alone seems a commentary on an
age of excess and the overcompensation of
wealth and status. At this scale the charac-
ters' facades are on full view, making it
easier to decipher the vulnerability behind
the makeup, jewelry, and fabulous settings.
The pictures represent a synthesis of the
opposing compulsions that plague women:
bodily self-loathing and the quest for
youth and status. In the infinite possibilities
of the mutability of identity and gender,
these pictures, like other of Sherman's best
work, stand out for their ability to be at
once provocative, disparaging, empathetic,
and mysterious.

The grandeur of Sherman's society
portraits morphed to an architectural scale
with the photographic murals she began
working on in 2010. Like wallpaper, the
murals cover the gallery from floor to ceiling,
wrapping around multiple walls to create an
immersive fictive environment. They are
Sherman's first foray into transforming
space and represent a huge artistic step,

illustrating her continuing experimental
vigor. The characters are no longer frozen in
their frames; they float in space and
surround and tower over the viewer (fig. 38).
In an echo of her removal of herself in the
1990s in favor of unseemly landscapes of
vomit, body parts, and bodily fluids, the
murals similarly challenge the commodified
photograph, as they are essentially images
that you can't take with you.

The characters are set against a black
and white background reminiscent of
toile wallpaper, a nod to a vaguely rococo
decorative environment. The pastoral
backgrounds were all shot by Sherman, then
mirrored and manipulated in Photoshop to
look more "drawn." The figures—in color—
sport an odd mix of costumes: a feathered
leotard (plate 174), a homemade juggler's
outfit (plate 173), and the shawl and
matronly dress of a babushka (plate 178).
Sherman described the statuesque figures,
which were inspired by a trip she took to
Mexico, as akin to the monumental objects
that often protect or block the entrance
to a shrine, sacred site, or landscape.[71]
Instead of using makeup or prostheses, she
transformed her face via digital means,

exaggerating her features through Photoshop by elongating her nose, narrowing her eyes, or creating smaller lips. The effect is of a natural face, but one that looks oddly off.

The characters seem sad, depleted, and somewhat on the margins. One woman in a tight-fitting body suit might be a batty crystal-loving cat lady; a young boy (or androgynous girl) seems obsessed with gaming, Dungeons and Dragons, and Renaissance reenactments (plate 177); a blonde proudly wears a county-fair medal and cradles leeks (plate 174). These characters are taken from daily life, slightly odd eccentrics that Sherman has elevated to larger-than-life status. Set against the decorative toile background, they seem like protagonists from their own carnivalesque worlds, where fantasy and reality merge. The characters don't fit into a pat category, as the characters of many of her other series do; instead, they hint at the multiple and varied roles demanded of contemporary women.

In a recent series of photographs (see Untitled #512 [plate 176] and Untitled #513 [plate 175])—the result of a commission for a special insert of POP magazine's autumn/winter 2010 issue—Sherman used the same digital methods as the murals. The artist photographed herself against a green screen in head-to-toe Chanel, then digitally inserted herself into photographs she took of the Icelandic landscape, which looks grand and mythic, evoking the folklore and fairy tales of previous series. As in the murals, some characters seem frumpy and others just plain wacky, and she also used Photoshop to alter her features. Because they are bare-faced, wearing no makeup, it seems inevitable that these characters will be seen as a comment on age and the possibilities of digital and surgical enhancements. Ironically, the works where Sherman wears the least makeup are the most opaque. The characters in her murals and Icelandic photographs are mysterious and raise the question as to why they are gathered together. They are emblematic of Sherman's entire practice, which samples at will from all echelons of culture to create a hybrid set of references that inform our own understanding of the world.

THROUGHOUT HER CAREER, SHERMAN HAS broken down stereotypes while also enforcing them. There is no real sex in the sex pictures, no real movies in the "Untitled Film Stills," no nudity in the centerfolds, and little beauty in the fashion pictures. Yet the photographs are persuasive, their fictions all-encompassing. Since she was barely out of college, Sherman's work has been received with enthusiasm, accolades, and unprecedented critical success. Students and professors alike have filled volumes about her pictures, and her work is equally popular with museums, galleries, and collectors. Why is it that Sherman has struck such a vital nerve in our contemporary culture? Sherman has never announced the intentions of her work vis-à-vis theory, nor has she denied or managed any of the myriad of readings. In fact, her silence seems to fan the flames of the historians and critics who write about her work, and in many ways her rejection of any theoretical framework makes her work more available to the many discourses that claim it as their own. In trying to understand the magnetism and enormous influence of Sherman's work, one sees that its power lies in its mutability. More important

than any one reading of Sherman's work is its ability to reflect the ideas of culture at large and its continuing capacity to resonate enormously with multiple audiences.

Sherman's pictures also tell us something about photography: its ability to lie, mask, and seduce. Photography is particularly suited to the synthesis of the real and the imagined, and she has brilliantly exploited the medium's plasticity and narrative capacity. Her work signaled the arrival of photography on art's main stage, and she has been a key player in changing our understanding of it. In the early 1980s she was one of the main agents challenging traditional ideologies of art, and her work represents the fundamental sea change that occurred during that era. Sherman's career matured during the debates about modes of representation in different fields (from academia to Madison Avenue to Hollywood). In a society thoroughly saturated with images, the work of this relentlessly adventurous artist speaks to how we understand the proliferation of cultural myths, icons, and narratives through the prism of photography, and how images participate in the construction of culture, consumption, and ideology.

Let's return to the question I pose in the title of this essay—"Will the Real Cindy Sherman Please Stand Up?"—based on the phrase popularized by *To Tell the Truth*, a game show from the 1950s, wherein celebrity panelists tried to guess the real identity of a described contestant among impersonators. Just like the show, Sherman's photographs afford a glimpse into a character, one that seems real and rooted in life. But the more questions we ask and the closer we look, the more the fiction unravels. There is no *real* Cindy Sherman, only infinite characters who reflect the countless mediated images that bombard us daily. Her work speaks to the conspiratorial role that images play in society's self-visualization and reinforces the artificial nature of these images. Her pictures remind us about our own complicated relationship to identity and representation, and how the archive of images we carry in our collective imagination informs our vision of the world and, ultimately, our view of ourselves. Sherman's photographs speak not only to our desire to transform and be transformed, but also to our desire for art to transform us.

Notes

1 See, for example, critic Peter Schjeldahl's assessment of the 1982 series known as pink robes: "These, I believe, are as close as we will ever get to a glimpse of 'the real Cindy.'" Schjeldahl, "Introduction: The Oracle of Images," in Schjeldahl and I. Michael Danoff, *Cindy Sherman* (New York: Pantheon Books, 1984), 10. Curator Els Barents described the centerfolds: "Dressed in today's clothes, and free of references to archetypes, the portraits seem more refined, natural and closer to Cindy Sherman herself." Els Barents, "Introduction," in *Cindy Sherman* (Amsterdam: The Stedelijk Museum, 1982), 10.

2 Interview with Paul Taylor, *Flash Art* 124 (October/ November 1985): 79.

3 Gail Stavitsky, *The Unseen Cindy Sherman: Early Transformations, 1975/1976* (Montclair, N.J.: Montclair Art Museum, 2004), 5–6.

4 Interview with Noriko Fuku, in Chika Mori et al., eds., *Cindy Sherman* (Shiga, Japan: Asahi Shimbun, 1996), 161.

5 Cindy Sherman, *Cindy Sherman: The Complete Untitled Film Stills* (New York: The Museum of Modern Art, 2003), 5.

6 Interview with Fuku, 161.

7 The building was owned by the charitable organization Ashford Hollow Foundation, which was run by the local sculptor Larry Griffis, who sponsored the building's initial conversion to live/work lofts in 1966–67.

8 CEPA (The Center for Exploratory and Perceptual Arts), founded in 1974 by Robert Muffoletto, a graduate of the Visual Studies Workshop in Rochester, became a sisterlike institution to Hallwalls. Sherman was given early exposure there in a 1975 group show of photographs by five women artists.
The Albright-Knox Art Gallery had recently hired Linda Cathcart as a curator. She became friendly with the artists at Hallwalls and included Sherman's work in a juried exhibition at the gallery in 1975 that also included works by Longo and Clough. Cathcart later organized Sherman's first solo museum exhibition, in 1980, at the Contemporary Arts Museum, Houston.

9 Stavitsky, *The Unseen Cindy Sherman*, 14.

10 Gerald Marzorati, "Imitation of Life," *Art News* 82, no. 7 (September 1983): 85.

11 Excerpt from an interview with Anthony Bannon, in Ronald Ehmke and Elizabeth Licata, eds., *Consider the Alternatives: 20 Years of Contemporary Art at Hallwalls* (Buffalo: Hallwalls, 1996), 32.

12 Sandy Nairne, Geoff Dunlop, and John Wyver, *State of the Art: Ideas & Images in the 1980s* (London: Chatto and Windus, 1987), 132.

13 The "Untitled Film Stills" exist in several sizes, primarily eight by ten inches (approximating publicity stills), but also thirty by forty inches (approximating movie posters). In their first showing, in 1977, at Hallwalls, the "Stills" were presented as eight-by-ten-inch prints; in a 1978 group exhibition at Artists Space (their New York debut), they were thirty by forty inches. A small number of "Stills" were printed at sixteen by twenty inches for *Re:Figuration*, a group exhibition at Max Protetch gallery in 1979–80 before the size of the photographs and the number of editions were established, and Sherman later determined that three sizes were too many. There are very few sixteen-by-twenty-inch prints for most of the "Film Stills." I am grateful to Sarah Evans for the exhaustive exhibition history of the "Film Stills" in her dissertation, *Situating Cindy Sherman: Artistic Communities, Critical Agendas and Cultural Allegiances, 1975–1984* (PhD diss., University of California, Berkeley, 2004), 116.

14 Lisbet Nilson, "Q & A: Cindy Sherman," *American Photographer* 11, no. 3 (September 1983): 77. This presumption is repeated in Rosalind Krauss's essay "Cindy Sherman: Untitled," in Krauss, *Cindy Sherman: 1975–1993* (New York: Rizzoli, 1993), 17, in an anecdote about a lecture given by a critic on Sherman's work comparing the "Stills" to actual films.

15 Marzorati, "Imitation of Life," 85.

16 Phoebe Hoban, "30 Years, 30 Voices; Cindy Sherman: Moving Pictures," *New York*, April 6, 1998, 178.

17 The series comprised sixty-nine photographs until the occasion of the 2003 MoMA publication of the complete "Untitled Film Stills," when a long-lost original contact sheet turned up a "Film Still" Sherman had meant to add (now #62). During the first decade after shooting the "Stills," Sherman would occasionally add and subtract pictures, which accounts for gaps in the numbering, where some seemingly congruent images are separated and others seem to have been added after subsequent series. The seventieth image was placed in one of those gaps.

18 Thom Thompson, "A Conversation with Cindy Sherman," in *Cindy Sherman* (Stony Brook, N.Y.: State University of New York; Middletown, Conn.: Wesleyan University, 1983), n.p.

19 Other photographs in the series were taken by Helene Winer, Diane Bertolo, and Sherman's niece, Barbara Foster.

20 Calvin Tomkins, "Her Secret Identities," *New Yorker*, May 15, 2000, 78.

21 See Evans, *Situating Cindy Sherman*, 132–35; Jeanne Siegel, "Cindy Sherman," in *Art Talk: The Early 80s* (New York: Da Capo Press, 1988), 270; Stavitsky, *The Unseen Cindy Sherman*, 12; and Catherine Morris, "The Education of Cindy Sherman," in Paul Ha, *Cindy Sherman: Working Girl* (Saint Louis: Contemporary Art Museum St. Louis, 2005), 10.

22 For more on Sherman and Cahun, see Katy Kline, "In or Out of the Picture: Claude Cahun and Cindy Sherman," in Whitney Chadwick, ed., *Mirror Images: Women, Surrealism, and Self-Representation* (Cambridge, Mass.: MIT Press, 1998), 66–81; Shelley Rice, ed., *Inverted Odysseys: Claude Cahun, Maya Deren, Cindy Sherman* (Cambridge, Mass.: MIT Press, 1999); and Amelia Jones, "Tracing the Subject with Cindy Sherman," in Amada Cruz, Elizabeth A. T. Smith, and Amelia Jones, *Cindy Sherman: Retrospective* (Chicago: Museum of Contemporary Art; Los Angeles: The Museum of Contemporary Art, 1997), 33–53.

23 Marzorati, "Imitation of Life," 81.

24 Sherman said, "What I didn't want were pictures showing strong emotion . . . what I was interested in was when they were almost expressionless. Which was rare to see; in film stills there's a lot of overacting because they're trying to

sell the movie." Sherman, *Cindy Sherman: The Complete Untitled Film Stills*, 8.

25 Craig Owens, "The Allegorical Impulse: Toward a Theory of Postmodernism, Part 2," *October* 13 (Summer 1980): 77.

26 Arthur C. Danto, *Cindy Sherman: Untitled Film Stills* (New York: Rizzoli, 1990), 14.

27 See Laura Mulvey, "Visual Pleasure and Narrative Cinema," *Screen* 16, no. 3 (1975): 6–18.

28 Krauss, "Cindy Sherman: Untitled," 17.

29 See Douglas Crimp, "Pictures," *October* 8 (Spring 1979): 75–88; Douglas Crimp, "The Photographic Activity of Postmodernism," *October* 15 (Winter 1980): 91–101; and Craig Owens, "The Allegorical Impulse."

30 Thomas Lawson, "Last Exit: Painting," *Artforum* 20, no. 2 (October 1981): 45.

31 Crimp, "Pictures." Crimp also published the essay "About Pictures" in *Flash Art* 88/89 (March/April 1979): 34–36.

32 See Abigail Solomon-Godeau, "Photography after Art Photography," in *Photography at the Dock: Essays on Photographic History, Institutions, and Practices* (Minneapolis: University of Minnesota Press, 1991), 103–23; Thomas Lawson, "The Uses of Representation: Making Some Distinctions," *Flash Art* 88/89 (March/April 1979): 37–39; and Andy Grundberg, *Crisis of the Real: Writings on Photography, 1974–1989* (New York: Aperture, 1990).

33 David Frankel, "Cindy Sherman Talks to David Frankel," *Artforum* 41, no. 7 (March 2003): 54.

34 In her essay "Photography after Art Photography," Abigail Solomon-Godeau argues that Sherman is a crucial figure because she was *using* photography. For more on this distinction (and the question of artist versus photographer), see Solomon-Godeau, "Photography after Art Photography," 113–14.

35 See Judith Williamson, "Images of 'Woman': Judith Williamson Introduces the Photography of Cindy Sherman," *Screen* 24, no. 6 (November/December 1983): 102–16; Laura

Mulvey, "A Phantasmagoria of the Female Body: The Work of Cindy Sherman," *New Left Review* 188 (July/August 1991): 137–50; Mulvey, "Visual Pleasure and Narrative Cinema"; and Abigail Solomon-Godeau, "Suitable for Framing: The Critical Recasting of Cindy Sherman," *Parkett* 29 (1991): 112–15. For many critics feminism was collapsed into the larger postmodern critique of representation, which Amelia Jones questions in her essay "Postfeminism, Feminist Pleasures and Embodied Theories of Art," in the anthology *New Feminist Criticism: Art, Identity, Action*, eds. Joanna Frueh, Cassandra L. Langer, and Arlene Raven (New York: Icon Editions, 1993), 16–41. The above essays point to a new discourse quite apart from postmodernism.

36 Williamson, "Images of 'Woman,'" 102.

37 Sherman, *Cindy Sherman: The Complete Untitled Film Stills*, 9.

38 While much of the critical discourse on the centerfolds addressed feminist issues, it was not the only reading of the work. For example, Rosalind Krauss focused on the pictures' horizontality as the most significant aspect of the work. She argued that the horizontal format challenged the formal categories associated with the vertical plane. She likened this overturning of the vertical axis of high art to the activities of Jackson Pollock, Andy Warhol, and Robert Morris, who worked from a low vantage point: the floor. These artists challenged the vertical plane associated with fetishized fine art, and Krauss placed Sherman's centerfolds within this tradition of resistance. See Krauss, "Cindy Sherman: Untitled," 96 (and see Krauss's footnote in this discussion: "For the argument about Warhol's and Morris's reading of the horizontality of Pollock's mark, see my *The Optical Unconscious*" [Cambridge, Mass.: MIT Press, 1993]).

39 Peter Schjeldahl, "Valley of the Dolls: Cindy Sherman's Return to Form," *New Yorker*, June 7, 1999, 95.

40 In a letter to the editor in the next issue of the magazine, they wrote: "In the specific context of this journal, it exists as an object of extreme vulgarity. Although we realize that it is by no means the first instance of vulgarity to appear in the magazine, it represents a qualitative leap in that genre, brutalizing ourselves and, we think, our readers." Lawrence Alloway, Max Kozloff, Rosalind Krauss, Joseph Mascheck, and

Annette Michelson, "Letters," *Artforum* 13, no. 4 (December 1974): 9.

41 Andy Grundberg, "The '80s Seen Through a Postmodern Lens," *New York Times*, July 5, 1987, 29.

42 Mulvey, "A Phantasmagoria of the Female Body," 143.

43 Roberta Smith, "Spacewalk," *Village Voice*, November 18–24, 1981, 98.

44 Interview with Fuku, 165.

45 Tomkins, "Her Secret Identities," 79.

46 For example, Laura Mulvey wrote of the fashion pictures, "the 'something' that had seemed to be lurking in the phantasmatic topography of femininity, begins, as it were, to congeal." In "A Phantasmagoria of the Female Body," 144.

47 Larry Frascella, "Cindy Sherman's Tales of Terror," *Aperture* 103 (Summer 1986): 49.

48 Interview with Fuku, 164.

49 Later, in 1992, Rizzoli published the book *Fitcher's Bird*, a fairy tale based on a story by the Brothers Grimm and illustrated with Sherman's photographs.

50 Tomkins, "Her Secret Identities," 81.

51 See Amada Cruz, "Movies, Monstrosities, and Masks: Twenty Years of Cindy Sherman," and Elizabeth A. T. Smith, "The Sleep of Reason Produces Monsters," in Cruz, Smith, and Jones, *Cindy Sherman: Retrospective*, 1–17 and 19–31, respectively; Hal Foster, "Obscene, Abject, Traumatic," *October* 78 (Fall 1996): 106–24; Norman Bryson, "House of Wax," in Krauss, *Cindy Sherman*, 216–23; Norman Bryson, "The Ideal and the Abject: Cindy Sherman's Historical Portraits," *Parkett* 29 (1991): 91–93; Simon Taylor, "The Phobic Object: Abjection in Contemporary Art," in Jack Ben-Levi et al., eds., *Abject Art: Repulsion and Desire in American Art* (New York: Whitney Museum of American Art, 1993), 59–83.

52 Cruz, "Movies, Monstrosities, and Masks," 10.

53 Foster, "Obscene, Abject, Traumatic," 112.

54 Gary Indiana, "Untitled (Cindy Sherman Confidential)," *Village Voice*, June 2, 1987, 87.

55 Ingvild Goetz and Christiane Meyer-Stoll, *Jürgen Klauke/Cindy Sherman* (Munich: Sammlung Goetz, 1994), 69.

56 Therese Lichtenstein, "Cindy Sherman," *Journal of Contemporary Art* 5, no. 2 (1992): 81.

57 Ibid., 82.

58 See Krauss, "Cindy Sherman: Untitled"; Foster, "Obscene, Abject, Traumatic"; and Johanna Burton, "A Body Slate: Cindy Sherman," in Burton, ed., *Cindy Sherman*, October Files (Cambridge, Mass.: MIT Press, 2006), 193–215.

59 Todd Haynes, Elise MacAdam, and Tom Kalin developed the *Office Killer* screenplay based on Sherman's idea, and Evan Lurie from the Lounge Lizards scored the music.

60 David Rimanelli, "Cindy Sherman: Metro Pictures," *Artforum* 28, no. 9 (May 1990): 187.

61 Foster, "Obscene, Abject, Traumatic," 111.

62 Michael Kimmelman, "At the Met With: Cindy Sherman; Portraitist in the Halls of Her Artistic Ancestors," *New York Times*, May 19, 1995, C1.

63 Maik Schlüter and Isabelle Graw, *Cindy Sherman: Clowns* (Munich: Schirmer/Mosel, 2004), 58.

64 Betsy Berne, "Studio: Cindy Sherman," *Tate Arts and Culture* 5 (May/June 2003): 38.

65 Jo Craven, "What Lies Beneath," *Vogue* (London), June 2003, 186.

66 Due to the fragility of the original material, *Doll Clothes* was transferred to DVD in 2006, and is now exhibited from DVD. The film was not viewed between 1975 and 2006, when it was shown at Metro Pictures gallery for the first time since the year it was made.

67 David Hershkovits, "In Your Face?," *Paper*, November 2008, 54.

68 Ibid.

69 Solomon-Godeau, "Suitable for Framing," 114.

70 Conversation with the author, June 6, 2010.

71 Ibid.

Cindy Sherman:
Abstraction and Empathy[1]

Johanna Burton

Fig. 1

Cindy Sherman. Untitled #253. 1992.
Chromogenic color print, 6' 3" x 50"
(190.5 x 127 cm)

I. Empathy

EMPATHY—THE WORD CROPS UP FREQUENTLY,
if rather sneakily, too, in discussions
surrounding Cindy Sherman's work made
during the past decade or so. I first noticed
it in the lengthy profile penned by Calvin
Tomkins for the *New Yorker* in 2000.[2] In that
piece, the author makes it his priority to
establish Sherman's benevolence as a
person; indeed, his very first sentence (and,
in fact, much of the subsequent account)
addresses the regularity with which people
are surprised, given the artist's fame and
the often dark underbelly of her pictures, by
how "nice" Sherman is—"niceness"
seemingly gauged by a relatively easygoing
nature, a lack of overt aggression, and what
Tomkins portrays as a slightly introverted
demeanor. Strangely enough, there is one
moment in Tomkins's depiction (relayed but
then left mostly unplumbed) that casts
some doubt on his otherwise seamless
characterization. Accompanying Sherman in
2000 to an opening of an exhibition at the
Gagosian Gallery in Los Angeles of what
would come to be unofficially dubbed as
her Hollywood/Hamptons photographs, the
writer details an encounter with an
anonymous female viewer who clearly

bears a shade too much resemblance to the cast of Sherman's "characters" lining the gallery's walls. After asking Tomkins what he thinks of the images on view (and receiving an apparently murmured, noncommittal answer), the woman—described only as "in a fur stole"—expresses her own opinion quite forcefully, and the ensuing dialogue is relayed by Tomkins as follows: "'I've been looking at her work for a long time,' the woman said, in a firm and measured tone, 'and these are the most disturbing things I've seen yet. There is no empathy in them, none at all. Every woman I've talked to here feels the same way.' I asked if she meant that the pictures were cruel, and she said yes, emphatically. I could see her point."[3]

The point that Tomkins could see was apparently this: Sherman's most recent work at the time comprised a suite of pictures that emanated, to Tomkins's mind anyway, "a kind of desperation that went beyond parody."[4] Whether this was what the woman in the fur stole also meant by "cruel" isn't totally clear, since the catalyst for her discomfort is, in this regard, more or less left to assumption. But what is obvious is that the ruthless frontality he attributes to Sherman's presentation of this "type" of woman ("you couldn't help seeing how hard they worked to hang on to things—youth, glamour, hope," he writes) was, in Tomkins's view, neither something willfully created by the artist nor mean-spiritedly magnified by her; the pitiless nature is, instead, somehow understood to be inherent to the images themselves (or perhaps, rather, to Sherman's imagistic *embodiments*). For as soon as the tale of his encounter with the woman in the gallery is wrapped up, Tomkins's emphasis on Sherman's clean character is rigorously restored. She is a good storyteller, he concludes, a master at giving over "gripping" and "merciless" tales, while presumably all the while remaining at some kind of neutral or, perhaps more to the point, ambiguous remove from the cultural reserve and those cultural mores upon which she necessarily draws to create her work. In other words, we are to understand that if, in fact, there is no empathy to be found in Sherman's "portraits" of these various *fictional* (yet nonetheless referential to ostensibly "real") women, this ought not to be seen as an effect of the artist's intention but rather as something natural to, which is to say already deeply present *within*, the subject matter at hand.

That subject matter is harder to classify than it might first seem. The images that comprise the so-called Hollywood/ Hamptons series (I've also heard them referred to as West Coast/East Coast or, simply, as head shots) are, as with all of Sherman's work, avowedly *not* descriptively labeled by the artist; like the rest of her photographs, these are untitled and each assigned a number by Sherman's gallery for identification purposes.[5] But, like previous series, such as the sex pictures (fig. 1), the fairy tale images, and the history portraits, these, too, were quickly, via what feels like a kind of anonymous consensus, granted a broad contextual classification, almost as though inadvertently operating to congeal and offer up the most immediate and culturally pervasive meanings possible via language. It's hard to pinpoint just how each series has attained its informal designation, but the shorthand around any given body quickly (and most often firmly) sticks, and it becomes difficult, one finds, not to use such notations since they feel more or less

accurate anyway—succinct enough in their broad sweeps and legible to virtually any viewer or reader in both their generic arcs and vague specificities.[6] And while Sherman herself would aim—in maintaining a system of bare-bones banal numbering only—to keep such classification at bay, the compulsion to identify the logic of what is *pictured*, or what is *invoked*, is nonetheless a pervasive and continual aspect of the artist's work as it has been received and discussed over time. This said, there is inevitably something that exceeds those categories whose baseline values are so obviously met, that stretches the boundaries of the very types, genres, and visual quotations that Sherman's work would seem so inarguably to offer. And that is where, for instance, the Hollywood/Hamptons photographs demand further interrogation, particularly in light of the fact that the presence or absence of "empathy" finds itself under debate in the literal face of these images.

Here, then, it would seem are so many portraits, if by "portrait" one reverts firmly to the etymological dimension of "depiction," which grants no expectation to fidelity of any sort. But this is where the trouble begins when it comes to Sherman, percolating now some three and a half decades since the beginning of her career. While they are not portraits *of* the artist, the artist *is*, after all, pictured in each one. (We can think of her body as some kind of miraculous blank slate, or as a host open for viral visual infection, but even should we choose to take the corpus as medium this way, Sherman herself—as a presence— accretes over time and across images, and while she may patently avoid being the subject of her own work, it would be impossible to ignore that she, at the very least, has been haunting it for a very long time.) But, setting aside for the moment the question of how to quantify, or even qualify, Sherman's strange persistence in these pictures, just what do we see? Again, so many portraits, taken at midrange, on relatively blank backgrounds: of women who are "of a certain age," of a certain demographic, of a certain bearing, of a certain moment. They surely seem to hold in common; in fact, they are usually described in a single gloss, as in one review written immediately after their exhibition at Metro Pictures gallery in New York:

"women who, you might say, used to be somebody, maybe: sad sacks, bit players in Hollywood movies or tabloid flashes in the pan. They are neighbors of people who know people who once met a real star, characters on the margins of show biz and success."[7] Yet they also differ radically in kind, to say nothing of the variations in terms of their emotional countenance and affective impact. Untitled #355 (plate 151) stares confidently, almost defiantly, at the camera, her long dark hair pulled back by sunglasses that have been upended as if to accommodate the wearer coming momentarily inside. A skimpy tank top bares tattoos; the woman's nails are long. Her posture is slouchy: either truly casual or a concerted effort at being casual. Untitled #358 (fig. 2) gazes into the camera as well, but hers is the carefully choreographed countenance of contentment and inner peace—thick dark hair; completely white, flowy clothes; and an assortment of recognizably handmade jewelry (to say nothing of a single stone placed prominently on her forehead) all point to her status as a spiritual practitioner—and her demeanor of unruffled calm appears

Fig. 2 (top)

Cindy Sherman. Untitled #358. 2000.
Chromogenic color print, 30 x 20"
(76.2 x 50.8 cm)

Fig. 3 (bottom)

Cindy Sherman. Untitled #403. 2000.
Chromogenic color print, 22 x 15"
(55.9 x 38.1 cm)

part of a concentrated effort to keep the "good" energy flowing. Untitled #400 (plate 149) wears a severe coif and a purple, one-shouldered evening dress, tan lines exposed, too much corrective concealer below her eyes and around her mouth. Untitled #403 (fig. 3) is less overtly theatrical if no less done-up: photographed on a dark back-ground, she has severely bleach-blond hair cut into a "smart" bob, and while her makeup and fake tan are—like those on many of the other women pictured—over the top, too much, we've nevertheless encountered them as such in the world. Posing rather staidly, with just the glimmer of a smile on her lips, the sitter wears a beaded necklace that hits just at the top of her cleavage, which is accentuated by the collision of a too-low tank top and too-high bra cup. Untitled #402 (plate 155) reminds me very much of someone in my immediate family, so much so that I have a hard time looking at the image, though I find myself doing so compulsively. The sitter wears shoulder-length frizzy hair, a straw hat, and an American flag–inspired blouse (stars and stripes), yet for all her outfit's flamboy-ance, she is tucked into herself, her smile pinched and shy, her hands wrapped tightly around her own elbows in a protective self-embrace.

When I first encountered these images, on the occasion of their showing in New York, I found myself floating quickly past some and stopping for long periods in front of others. I saw these images less as a cohesive series detailing the varied genus of overly aspirational, washed-up ladies from the two coasts than as individual assemblages of overtly staged accoutrements, accents, and attitudes, which from time to time allowed something of what Roland Barthes has called "the reality effect" to flicker through.[8] If it is no coincidence that Untitled #402—the image that calls to mind for me, rather disturbingly, one of my own family members—is the picture that *holds* me, it is because there is in that image something that I can't escape. In its details (again, to quote Barthes, what he would call its "narrative luxury"[9]), there is a bait uniquely, for a moment anyway, mine, placed by the artist but nonetheless activated outside of her purview. Indeed, what is important about thinking of each image separately in this series is simply this: *you* will walk right

past Untitled #402, only to stop in front of another image, one I will find less magnetic, more conjured, if only because I do not find some element of my own immediate life in it, for better or for worse.

To return to empathy, then: I have just made the undoubtedly problematic argument that the images comprising Cindy Sherman's Hollywood/Hamptons series succeed or fail (or, better, have a particular kind of *effect*) based on who is viewing them and what kinds of identification each viewer has (or doesn't have) with the characters pictured. It is an argument that broadens the investigation of where empathy, if it exists in relation to Sherman's work, can be said to be located: should we be looking for it in the artist's intent or in the images themselves, or should we instead be searching for it in each particular viewer? Thus, in using Untitled #402 as an example, what I am hoping to get at is simply that the images that allow me to glide past them remain, for me, somewhat on the level of caricature, the various elements of hair, makeup, expression, etc., amounting somehow to costume, whereas the image that stops me has a corollary in

the world as I have experienced it. What complicates the investigation further is that the image that stops me does not produce an empathetic impulse, or at least not simply an empathetic impulse. If I am honest about it, it's nothing less than deep ambivalence, a rush of conflicted emotion, in the face of this image that calls-up-without-being someone I know well.

Unalloyed empathy—as opposed to what I describe above—implies an identificatory process by which one person not only understands or feels for another person but, rather, experiences *with* them, nearly *as* them. Without going overly far down the path of that operation (or plumbing the question of how often it really occurs), it is compelling to raise the question of just when and why concerns around empathy arise when it comes to Sherman's recent work. Indeed, it is worth revisiting the assertion made by the unnamed female viewer of the Hollywood/Hamptons series in L.A.: "there is no empathy" in Sherman's images. It is a curious construction and would seem to locate the place, if not the actuality, for empathy within the images themselves.

Likewise, the critic Jerry Saltz would seem to locate empathy within Sherman's work, too, but unlike the anonymous gallery visitor in L.A., he would seem to find it. In writing about the society portraits, works Sherman made in 2008 that picture upper-class, art-world-patron types, Saltz offhandedly notes that, in giving over images of women who "show their years," Sherman necessarily enters something of "the real world" and affords her characters "psychological weight and empathetic power."[10] Talking about these same images, whose details conjure as much about class and social stature as they do about age, Sherman herself refers to empathy, if not necessarily her own: "With the Hollywood/Hamptons ladies I was criticized for making fun of these characters, they were sweet and more innocent, but here I think there is more of an empathetic thing going on: these ladies aren't so innocent—not that they are actually guilty of anything . . ."[11] This is somewhat baffling; one wonders just what the artist means here by "an empathetic thing," especially in light of the fact that one would expect that more empathy would be directed toward the "sweet and

58

more innocent." But perhaps this is the point: if empathy in Sherman's work can't be precisely located, and even if in some cases it is only discussed anxiously and by way of its potential absence, it certainly flags a particular precariousness, one that strangely parallels the problem of how to situate Sherman herself.

II. Abstraction

"THEY'RE CURIOUS ABOUT WHAT I LOOK LIKE. I'm aware of this built-in curiosity about the 'real me,' which other artists wouldn't necessarily have to contend with."[12] For as long as Sherman has been written about, the question of where to find her—body, intention, signature, etc.—in her work has been raised. Indeed, only a figure such as Warhol would appear to have garnered as much critical speculation around an artist's persona; yet, while Warhol has largely been attributed a kind of machinelike, affectless, pure drive (arguably, his very person endlessly produced and evacuated as a key part of the art he made), Sherman is quite oppositely pried out of her practice by those who write about her, portrayed as an almost accidently brilliant performer, able to take on abject and seedy roles without absorbing any of their residues. Tendencies of the kind of journalistic profile with which I began this essay—inclined toward portraying Sherman as benign and agreeable—seep into some of the most ostensibly theoretical writing, and this, in part, occurs because Sherman has largely managed to dodge giving firm accounts of how she positions herself in relation to

the work she makes (the most famous example being the still-unresolved-for-some wrangle over whether or not she can be seen as participating overtly in debates around feminism and representation). And while I bring up the pervasive compulsion to focus on Sherman qua Sherman here, even magnifying it in the first half of my essay, I do so in order to draw attention to a particular shift that has occurred in Sherman's more recent work as well as in the critical response it evokes. In one sense, it's the most obvious observation one can make: Sherman's turn toward images that might be seen to take as their subject women who are often described politely as "past their prime" coincides precisely with changes in her own body (at the time of this writing, she is fifty-seven years old). And while one might argue that the artist has—since the time of the "Untitled Film Stills," in which Sherman could be said to approximate (more or less well) variations on cinematic styles—long played chameleon with visual tropes of the female body, the conditions have indubitably changed. No one worried much about whether or how the early images are vested with

Fig. 4

Cindy Sherman. Untitled #67. 1980.
Chromogenic color print, 20 x 24"
(50.8 x 61 cm)

empathy—rather, the terms of engagement were parlayed fiercely around deconstruction (with theorists such as Craig Owens discussing Sherman's ability to play with the very "activity of reference" in her work) and, relatedly, feminism (Laura Mulvey and others, for instance, focusing on the female body as always already *imaged* and, thus, fetishized, to be wrested from the all-pervasive male gaze).[13] In other words, empathy as such only becomes a pressing issue many decades later, with the appearance of the Hollywood/Hamptons series and subsequent images of women who read more overtly *aged* and *classed*. In Untitled #474 (plate 169), a tastefully anointed lady stands in what appears to be her study, one hand balanced on a desk chair, the other lightly to thigh, her hair and makeup stiff but not ostentatious, the backdrop of the whole comprised of a salon-style hanging of what look to be charcoal drawings, similarly staid and respectable. Like many of the "Untitled Film Stills," this is an image that could almost pass for what it mimics, as would Untitled #475 (plate 163), a portrait of a woman and, perhaps, her sister that comes undone a

beat late, since it takes a moment to realize that both are portrayed by Sherman—so what in them would seem to call for, or need to be produced via, empathy?

In his 1993 "House of Wax," an essay on Sherman that positions her both in terms of historical shifts in representation and, more pointedly, with regard to postmodern ideas of "the real," Norman Bryson describes the arc of the artist's career, to that point, as proceeding in "a single sweep": "the movement from the ideal to the abject."[14] Bryson's specific aim in his text is to give a reading of how the human body fares in a culture increasingly dictated by representation (its excesses cleansed and sublimated, only to surface "on the fringes" as extremes of pain and pleasure). The trajectory of Sherman's practice at that time offered a near-perfect account of such a shift. Her "Untitled Film Stills," in retrospect for Bryson, already bore the traces of dread and danger at the edges. Though seemingly images aspiring to cinematic glamour, he argues, here are, in fact, so many "symptomatic" screens: the famous "hitchhiker" (Untitled Film Still #48; plate 62), for instance, not innocent at all but rather the

Fig. 5

Cindy Sherman. Untitled #312. 1994.
Chromogenic color print, 61 x 41½"
(154.9 x 105.4 cm)

focus of a dread that itself cannot be shown but only felt, densely and darkly, by the viewer. That dark density had fully taken over the logic of Sherman's work by the early 1990s, in images from those series known now as the fairy tales, the horror and surrealist pictures, and the disasters—images that, as Bryson points out, come to fully subsume or absorb Sherman's body, and thus claim it for the "drives and pulsions" that have overtaken its recognizable contours.

And it is true that, between 1990 and 2000, we didn't see much of "The Girl" that so many critics had celebrated in Sherman's work, as she appeared in the "Untitled Film Stills," rear screen projections (fig. 4), or centerfolds, among other series.[15] The artist herself has described her move into more and more aggressively unpleasant terrain as staging a kind of resistance to what she saw had come to be a relatively easy consumption of her photographs, and her desire was to disrupt that process (she has remarked on more than one occasion of her impulse to produce the horror and surrealist pictures that they served as a kind of dare to collectors, acting as an overt attack on

refined aesthetic taste). Yet, the search for traces of her persisted. In Untitled #175 (plate 116), much is made of her reflection in the lens of a pair of discarded sunglasses; there is endless speculation about whether she can be seen behind the S&M mask of Untitled #264 (plate 3), a splayed-open mannequin with plastic breasts. Even in uncanny images like Untitled #312 (fig. 5), one can find commentary that asserts there is the gleam of a human eye at play, animating what would otherwise be only an assembly of stand-ins. (Sherman asserts that many of the images in which people "find her" do *not*, in fact, include her visage or body at all.)[16] So, the fact that Sherman, in a sense, "disappeared" from her work for a decade is notable, but perhaps just as notable is the fact that her presence was still assumed or, more precisely, fervently desired.[17] More important still is this: it is only after Sherman has now "reappeared," after having passed on through to the other side of "abjection," that her work has become a magnet to that seemingly very different term, *empathy*.

Such a change in the terms of reception points, I think, to a fundamental

shift within Sherman's practice, one that opens onto larger questions than whether the artist herself can be found in the images. (And, as we shall see, to look for Sherman is to look past one's own responses to her work—and, even, to overlook her work's real content.) Throughout her career, Sherman has always taken up a kind of abstraction, as much as any figuration, in her work, and it is along this particular axis that crucial distinctions regarding her practice can be made. In her earliest series, including the "Untitled Film Stills," Sherman made repeated reference to abstract codes of representation, underscoring the ways in which identity is produced and conveyed within culture. Audiences would, for example, seem to "know" every scene and every character Sherman created, but this illusion of familiarity was based on conventions put forward by the mass media—or, to use the parlance of art during the late 1970s, "structures of signification." Sherman's most recent work, by contrast, does not refer so much to images of the mass media (e.g., film stills) and, moreover, does not refer to any kind of stable codes. Instead, if structures of signification exist

here, they are, in a sense, socialized: the identity of the figure cannot be found simply by referring to conventions, whether in the mass media or in culture more broadly, but rather demands some consideration of identification itself as a relational phenomenon. What is conveyed by any person, picture, or image cannot be considered apart from *how* it is perceived and *by whom*.

Of course, this postulation owes a significant debt to earlier considerations of the artist. In a text from 1993, titled "Cindy Sherman's Gravity: A Critical Fable,"[18] Rosalind Krauss points somewhat differently to the problem I've been advancing here: as she relates, critics discussing Sherman's work from a variety of perspectives nevertheless tended to share a desire to map Sherman—her ability to "perform," her intentions with regard to her subject matter, the scope of her imagination—onto the "characters" she presented in her photographs. Krauss's dissatisfaction with this tack links critics from opposing camps (which she names "humanist" and "feminist" in this case) in their urge both to "read" the narratives of what the artist presents and to

acknowledge Sherman's obvious abilities to bring such stories (whether novelistic or deconstructive) to light. Instead, Krauss advises, we must see Sherman's works as exercises in experimenting with the relations between signifier and signified; more simply put, she argues that Sherman is systematically working through the ways in which meaning is made and giving viewers case studies in how "controlled differences in camera angle, framing, depth of field, lighting, etc., produce a wholly different cinematic style each time, one that, in turn, produces a different 'character.'" Indeed, Krauss goes so far as to say that "Sherman herself is not acting. 'She' has no relation to the purported role. The role is instead a *function* of the cinematic signifiers."[19] Similar in ways to Bryson's analysis, Krauss's argument extends well beyond the "Untitled Film Stills" (where one can easily see how the various manipulations of frames, lighting, camera angle, and melodramatic poses can produce radically different effects), proceeding through the centerfolds to the horror and surrealist pictures and the history portraits in order to show how the

Fig. 6

Installation view of Untitled in *Sexuality and Transcendence*, Pinchuk Art Centre, Kiev, April 24–September 19, 2010

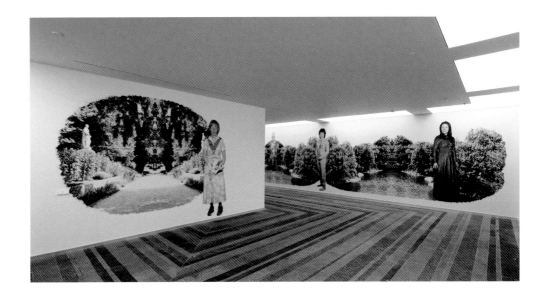

literal undoing of verticality (the centerfolds necessarily horizontal in format, the horror and surrealist images taking up the sprawl of the formless, and the history portraits comprised of so many sagging prostheses, literally bearing the weight of gravity) could undo something of the logic and coherency of representation. By unsettling the conventions through which imagery within these various genres operates— making the seams visible and, on occasion, the boundaries utterly porous—Sherman prompts viewers to recognize both the codes by which identity is constructed and conveyed, and the artifice (mediated, social, psychological) underpinning such cultural norms.

Reading Krauss's argument in the mid-1990s, I was fully convinced both of Sherman's work as performing an ongoing analysis—unveiling the vicissitudes of signification—and the necessity of removing Sherman entirely from the expected role of *expressive* "actress" or "performer" in those scenes she produced. Yet, nearly twenty years later, and with works such as the Hollywood/Hamptons series in mind (as well as the attending questions of empathy

the works provoke), I find myself wanting to complicate some aspects of these terms. Indeed, if Sherman's "abject" period ushered in the very elements that might be said to trouble representation (the "traumatic" and the "real," for instance),[20] her seeming return now to head-on portraits might suggestively reinstitute representation where it commonly ceases to accommodate and in ways that point to its aporias and antagonisms, at least when considered strictly using the terms of Krauss's reading. Thus, one might argue that Sherman's "return" to her own work over the last decade enacts a kind of revenge on a culture that wills women to slowly disappear as they age, or to render them desexualized but campy, comic-relief characters. But such a reading would merely replace the problematic figure of "The Girl" with that of "The Crone" and reinscribe the telos such images might otherwise displace. Yet, to oppositely claim that these are pictures that somehow celebrate women, or in and of themselves undo certain codes and conventions, would also enact another kind of bad faith, projecting a gentleness and generosity—that all-too-easily imagined

empathy—onto images that do not possess or produce either.

The limitations of adhering solely to Krauss's point of view become perhaps even more apparent when we consider work that Sherman has been producing over the last two years and continues to work on now (fig. 6). As murals rather than autonomous photographic works, the artist's latest pieces are conceived to hew to the architecture they hang in. They stretch over lengths of wall like wallpaper and portray weirdly flattened and redoubled backgrounds (schematic foliage and buildings that duplicate, Rorschach-like), while various human creatures (Sherman all, often simultaneously on a single plane) take up odd poses and are dressed in an assortment of strange clothes at once absurd and clinical (for instance: a "nude" suit, made like a child's Halloween costume, with puffy, doughnutlike breasts and a triangle of schematic pubic hair [fig. 7]). In these works, there is something of the regressive: the horror, comedy, and pathos of seeing a mature woman in a state of uncomfortably ambiguous play. But there is something of the abstract here as well, and

in a sense slightly altered from the abstraction entailed by those earlier structures of signification: as though loosened from their usual signifying functions, various human traits proceed in a hyperbolized, even formalized fashion. Indeed, if Sherman is no less—and no more—recognizable as "herself," the compositions of which she is a part provide little in the way of an establishing frame. Without clear contextual markers, the task of deconstruction is rendered somewhat moot, or at the very least asked to perform very differently. Whereas Sherman's earlier work engaged abstraction by uncovering the operations of signifiers— how codes create and possess specific meaning in media and culture—this later work considers, and prompts an awareness of, abstraction of another order: a slippery negotiation among signifiers, produced and navigated via encounters that acknowledge, if don't account for, the affective and psychological nature of information.

For all their clarity as images, and for the ostensible straightforwardness with which they would appear to labor, like the "Untitled Film Stills," under the strictures of representation as such, I would argue that

Sherman's Hollywood/Hamptons series as well as the society portraits can be read analogously to her most recent mural works. These photographs no longer point to any fixed, abstract codes in media or culture by which identity or its representation might be measured or assigned. Their mode of address is, subsequently, more ambiguous, and it is more unsettling among viewers, for whom an awareness of their participation in the creation and maintenance of such codes is being brought more directly to bear on their experience. Tropes of representation might well be present, but only while a sense of personhood—or, better, subjectivity— entwined with such abstraction is palpable as well. Similarly, while Sherman is, herself, not any of the women, states, emotions, or roles she portrays, her body nonetheless finds itself bending both toward and away from that which it facilitates. That such bending becomes clearer as certain limits are reached is of utmost importance. Indeed, that Sherman in her twenties inhabited a repertoire of images differently than she does now is crucial to the artist's ongoing plumbing of the operation of

images—and has ramifications on levels beyond the coolly ideological.

This is demonstrated by the fact that Sherman's more recent work is capable, for some viewers at least, of summoning a multitude of undeniable (if also uncertain) emotional responses, as is evidenced by the desire of journalists and art critics (and that woman in the fur stole) to understand where Sherman herself is coming from. But that line of inquiry, as I have already suggested, quickly runs into a kind of dead end. Instead, I would borrow from the theorist Eve Kosofsky Sedgwick and suggest that Sherman's work from the last ten years or so might be regarded as imparting something of a "threshold." When Sedgwick introduced the term "threshold effect" in 1995, she was writing in particular about the identity and perception of gender.[21] She argued that although certain individual traits that we associate with gender expression are often discussed as either biologically innate or socially constructed, they are, in fact, produced relationally: exhibited, acquired, acknowledged, and fed back to subjects as they move and interact in the world. More

Fig. 7

Cindy Sherman. Detail of Untitled. 2010.
Pigment print on PhotoTex adhesive
fabric, dimensions variable

simply said: the message I think I'm sending
might not be the one you receive. To be
sure, Sherman's work traffics in questions
that go beyond gender representation, but
Sedgwick's concept can be read as
malleable and multivalent. Thus, in this
regard, the threshold is the place where we
begin to grapple with how our own mutable
perceptions (of gender, yes, but also of
class, race, age, etc.) are mediated by our
own individual cultural context. If the
nameless women "of a certain age" who
populate Sherman's later series of portraits
and who exhibit certain vague references to
class distinction are not Sherman herself,
neither are they the same woman to any
two viewers who encounter them.

And here is, I think, a crucial turn in
Sherman's photographs to date. In
relinquishing a desire to find "empathy" in
Sherman's work (or person), but also
recognizing that the strategically
deconstructive dismisses a whole affective
and relational register, I find myself coming
back again and again to the "threshold
effect." For if Untitled #402 holds me
because it *reminds* me of someone I know,
it also recalls me to the particular relational

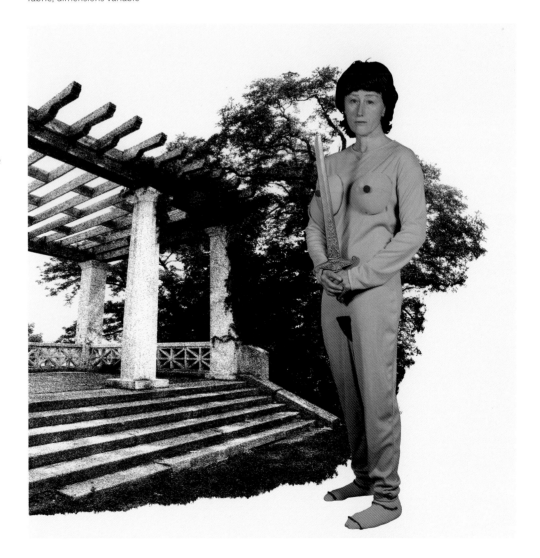

thread we negotiate every time we see each other. Sherman's work gives tangible form to the ambivalent process of meaning making with its many coauthored subject positions. Looking again at the Hollywood/ Hamptons and society women, they can only be adjectively abundant: gender-y, class-y, sex-y, race-y (these all very different animals from their sound-same counterparts), and, of course, age-y. Bearing Sedgwick's analysis in mind, then, perhaps we can step away from the vexed search for signs of "empathy"—both within Sherman's recent pictures and the ambiguous pangs they inspire in viewers— and recognize our own part in creating the individuals before us.

Notes

1 I borrow the title "Abstraction and Empathy" from Wilhelm Worringer, whose book of that name was published in 1908. There, taking up wholly other content, the author explores empathy as a mode of engaging with representational art (Renaissance, in his example) at moments when both objects and self feel relatively stable; abstraction (such as primitivism and modernist expression), on the other hand, surfaces as a primary mode of art making when historical contexts feel less secure. While I will not take up these ideas explicitly in this essay, the very notion of unstable images is key to my exploration of Sherman. See Worringer, *Abstraction and Empathy*, trans. Michael Bullock (Chicago: Elephant Paperbacks, 1997).

2 Calvin Tomkins, "Her Secret Identities," *New Yorker*, May 15, 2000, 74–83.

3 Ibid., 76

4 Ibid. Sherman's exhibition at Gagosian included only the "Hollywood" types; their East Coast counterparts (the "Hamptons" types) were conceived and produced slightly later, but the two are generally understood as in dialogue and making up a cohesive series. Since Tomkins's piece was published in May 2000, and the associated works were made during 2000–2002, the *New Yorker* profile necessarily discusses only the "Hollywood" images.

5 Such a deliberate move away from descriptive naming is one that Sherman herself has discussed as necessary for her working method, for while flirting (sometimes dangerously) with clichés throughout her various series, her aim is less to inhabit than to exceed or baffle their contours. In an interview with Noriko Fuku, Sherman explicitly discusses her decision to limit an audience's access to what her own interpretations of a photograph might be. "I want all the clues to what's going on in the pictures to be visual. I thought if I titled them, people would start to see what I was seeing in the picture. I like the idea that different people can see different things in the same image, even if that's not what I would want them to see." Cindy Sherman in conversation with Noriko Fuku, "A Woman of Parts," *Art in America* 85, no. 6 (June 1997): 125.

6 In the case of the "Untitled Film Stills" (1977–80), of course, the title did include some description, but after concluding that series, Sherman's works progressed via numbers alone. She is, herself, often partially responsible for providing language as to the content—with the Hollywood/ Hamptons images, for instance, she states in an interview with Isabelle Graw that these are women "posing for headshots." Yet, her decision to keep the images unfettered with titles remains bound to a commitment for them to be read in multiple ways. See Isabelle Graw, "No Make-Up" (interview with Cindy Sherman), in *Cindy Sherman: Clowns* (Munich: Schirmer/Mosel, 2004), 58.

7 Michael Kimmelman, "Art in Review: Cindy Sherman," *New York Times*, November 24, 2000, E36.

8 See Roland Barthes, "The Reality Effect," in *The Rustle of Language*, trans. Richard Howard (Berkeley: University of California Press, 1989).

9 Ibid., 141.

10 Jerry Saltz, "Sherman's March of Time: The Original Chameleon Shows Her Characters' Aging—And Is Reborn," *New York*, December 1, 2008, 76–77.

11 Louisa Buck, "Cindy Sherman," *Ponystep*, May 13, 2009. Accessed June 1, 2011: http://www.Ponystep.com/art/article/CindySherman_319.aspx.

12 Fuku, "A Woman of Parts," 79.

13 See Craig Owens, "The Allegorical Impulse: Toward a Theory of Postmodernism, Part 2," *October* 13 (Summer 1980): 80; and Laura Mulvey, "A Phantasmagoria of the Female Body: The Work of Cindy Sherman," *New Left Review* 188 (July/August 1991): 137–50. There is one notable exception to my argument: while not turning to the concept of empathy per se, Kaja Silverman's "How To Face the Gaze" argues that the "Untitled Film Stills" are themselves rife with productive flaws—Sherman, rather than approximate ideals of femininity, as is often argued, produces "good enough" images that open generously (and counterintuitively) toward viewers, making a new kind of pleasure, "one made possible by a more improvisatory relation to the ideal," available. See Silverman, "How To Face the Gaze," in *Cindy Sherman*, ed. Johanna Burton (Cambridge, Mass.: MIT Press, October Files, 2006), 143–70.

14 Norman Bryson, "House of Wax," in Rosalind Krauss, *Cindy Sherman: 1975–1993* (New York: Rizzoli, 1993), 223.

15 "The Girl" was a term coined by Arthur Danto in his discussion of Sherman's "Untitled Film Stills" and, as pointed out by a number of critics before me, it served to underline and revitalize the very clichés that Sherman's work potentially undid. As Abigail Solomon-Godeau points out, for instance, the "Untitled Film Stills" themselves hardly show one kind of "girl," and if one is looking closely, it is possible to find women of all ages and backgrounds—hardly all glamorous. But the popular *idea* attending Sherman's early work (even still) often makes looking beside the point, which is only to say that if one assumes the glamour in something called a "film still," one is able to find it, even at the expense of what is actually there. See Danto, *Cindy Sherman: Untitled Film Stills* (New York: Rizzoli, 1990); and Solomon-Godeau, "Suitable for Framing: The Critical Recasting of Cindy Sherman," *Parkett* 29 (1991): 112–15.

16 Relatedly, even when only medical dolls and obviously prosthetic parts were used in her constructions, the sex pictures were regarded in some instances as potential targets for censorship. (I experienced this firsthand when editing an anthology of critical writing on the artist—we had to print the book outside the United States after opting to include the more "graphic" of the sex pictures, despite their actual still-life status.) Says Sherman, "It still surprises me to hear the work talked about as pornographic, because there's nothing really going on in any of them, even any erection. But I know that our culture is very repressed. I'm a product of it, and I'm aware of my repression. I don't want to be nude in any of the pictures, because my work is not about revealing me on any level. Why would I want to show my real breasts? It's much more interesting to show a fake body and a fake face." In Fuku, "A Woman of Parts," 125.

17 A group of photos Sherman made in 1999 in which pint-size dolls (Barbie and its ilk) were mutilated and staged in various configurations was the only series where it was utterly clear that the artist could not be lurking in the shadows—and it was also the one series to receive roundly negative reviews. Mentioning it in passing, and pointing to it somewhat less dismissively as a kind of turning point, Michael

Kimmelman called those pictures either "peak, or nadir," noting that the work would either take a turn for the better or the artist would "go . . . into therapy." See Kimmelman, "Art in Review: Cindy Sherman," E36.

18 I assume the text was named after Amy Lowell's anonymously penned work, "A Critical Fable," from 1921, in which the poet took a number of her contemporaries to task.

19 Rosalind Krauss, "Cindy Sherman's Gravity: A Critical Fable," *Artforum* 32, no. 1 (September 1993): 64. In a much longer essay, "Cindy Sherman: Untitled," in her book *Cindy Sherman: 1975–1993*, Krauss expands on the premise of this essay and details each of her series to that point utilizing Roland Barthes's concept of "myth," which she also sketches out in the shorter article.

20 For the best account of artistic practices that courted these elements, see Hal Foster's "Obscene, Abject, Traumatic," in *October* 78 (Fall 1996): 106–24.

21 Eve Kosofsky Sedgwick, "'Gosh, Boy George, You Must Be Awfully Secure In Your Masculinity,'" in *Constructing Masculinity*, eds. Maurice Berger, Brian Wallis, and Simon Watson (New York: Routledge, 1995), 11–20. To extend this thought, the "reality," if we can call it that, of just how "feminine," say, someone is has probably less to do with their self-fashioning than with some kind of affective force. As Sedgwick points out, some people are simply more "gender-y" than others (and this can mean more feminine, more masculine, a lot of both, deeply effeminate, highly butch, etc.). Efforts to corral or magnify one's abundance or lack of "gender-yness"—through behavior, self-presentation, etc.— amount to meeting standards for a certain kind of cultural consistency around codes but are more often than not cover-ups rather than substantive correctives.

Cindy Sherman and John Waters: A Conversation

Fig. 1

Cindy Sherman. Untitled (Lucy). 1975.
Gelatin silver print (printed 2001), 10¼ x
8¼" (26 x 21 cm)

*This conversation between Cindy Sherman
and John Waters took place in February 2011
at the artist's studio in New York City.
It was transcribed and edited for length and
clarity.*

JOHN WATERS—One of the most basic
questions about your work is why,
from the very beginning, you've chosen
to use yourself as the model for your
own photographs. Maybe the key
is that you used yourself because you
didn't want to have to pay a model.

CINDY SHERMAN—No, because I tried that.
Not in the very beginning, but in the
mid-eighties, I hired a model and I tried
using friends and family. This was after
having worked by myself for about ten years.
But in the very beginning I thought, if this
doesn't work out, I don't have to show
it to anybody; I can just do what I want.

JW—You mean, when you started
doing the work, before anyone saw it?

CS—Before I ever photographed it, I
was playing around in costumes and dressing
up as characters in my room.

JW—So you were doing it, secretly, not

even for art. That's great. Did you tell your friends?

cs—When I was living with Robert Longo, he would witness it and say, "You know, you really should do something with this."

JW—Or else it's just going to be thought of as pathological.

cs—I don't know if it was therapeutic, out of boredom, or my own fascination with thinking about makeup in the mid-seventies, when women weren't supposed to like makeup. I had this desire to transform myself. I would just play around and turn into a character in my bedroom [fig. 1].

Later, after I had just moved to New York, I did a few "performances"—I'm not sure that's the right term—in public. When I worked at Artists Space, I arrived in character a couple of times [see page 18]. Some mornings at home, I'd play around and become a character. One day I was doing this and realized, it's time to go to work—I guess I'll just go as is. Everyone loved it. I only did it three or four times, and occasionally at parties, but after that it was too weird. I felt like I was just another crazy person out there.

JW—Are you constantly shopping for characters when you're out? Are you a voyeur? You *have* to be, in a way.

cs—It's not like I'm conscious of it. I think it's just natural for me.

JW—But whatever you see, you can't have a bad day out.

cs—Especially in this city.

JW—You are a female female impersonator in your work, but you're not at all in your real life.

cs—But I wish I was more like that in public. I wish I could treat every day as Halloween, and get dressed up and go out into the world as some eccentric character.

JW—But if you did that, you wouldn't have the art career. You'd have to reverse it, where you dressed as you for your art career. This weird, eccentric artist, who goes to galleries . . .

cs— . . . in character—aren't there some artists who already do that?

JW—Do you look back and wonder why some of your works have been remembered more than others? Does

it make sense to you?

cs—Sure, it makes sense. The "Untitled Film Stills" started my career, like you with *Pink Flamingos*. I think the first thing that anybody is known for is always going to be the most popular. And then there are certain things I did that I knew at the time would never be embraced.

JW—And did you sometimes do them on purpose?

cs—Yeah, sure.

JW—Do you ever get mad when your things are *so* loved and accepted?

cs—I don't get so much mad as nervous. I definitely felt that in the eighties. Right after I shot the centerfolds, and they were in Documenta and the Venice Biennale, I started doing some of the more disgusting pictures.

JW—Is that because you almost felt guilty for being accepted so quickly?

cs—Yes.

JW—Can you say why some works were more successful than others in terms of how they were received

critically and how they were received by collectors?

cs — I feel like I've been very lucky with both responses. Other than the fact that collectors mostly prefer works that I'm in, there hasn't been that much disparity between how things are critically received and what's collected. The reaction to the history portraits, however, really scared me, even though I knew they'd be popular. I think that's why right after that I did the sex pictures.

JW — You can see why the history portraits were popular. But were there outtakes?

cs — Well, the outtakes were mostly just earlier versions of the pictures before it all sort of came together.

JW — When did you change to digital?

cs — I was shooting the clowns with film, but I did the backgrounds digitally, and they were printed digitally. But it wasn't until the Balenciaga pieces that I shot digitally.

JW — You still use no crew at all? No assistants?

cs — Not in my studio, no.

JW — So when you're in that room, there's still no "hair and makeup." You're the entire film crew. Wouldn't it be easier to have someone help you? Or is it too private?

cs — I don't think I could do what I do. I think I would be too self-conscious . . .

JW — . . . if someone was watching.

cs — It's weird to be in character around other people. Occasionally, if someone happened to see me, I felt like it became a game, even though I was taking it seriously. I'd be working and suddenly, "Oh, look at you; you're so funny, so weird."

JW — You've also gone on location, for example, for the "Untitled Film Stills." Are those the only works shot on location?

cs — Obviously, some of the "Film Stills" were shot on location, but that's it. The ones set in Flagstaff were taken by my dad while we were on a family vacation. I'd carry around a little suitcase full of wigs and costumes. I did it in New York too: planning the characters in advance, going behind a Dumpster to change, then yelling to Helene

[Winer] or Robert to start shooting. I would just do a few poses.

JW — And then you would go to another location in the city and get in another outfit. It wasn't like you came home, got ready, and went there. So it was hit and run, like guerrilla filmmaking. Did you have permission?

cs — No, and I always tried to do it where there were no people, because I did not want other people in my pictures.

JW — You've been called a practical joker by the press. Do you agree with that?

cs — No, I don't think so. That sort of implies that I'm making fun.

JW — Do you read your reviews?

cs — Most of the time.

JW — And are you touchy? In the beginning, I was just glad they noticed. But as I get older, I'm touchier.

cs — If anything, when I've read something that was negative, it helped me with the next series.

JW — You've done great commercial

work. No one ever gave you grief about doing that, maybe because your work in the commercial line was so opposite of what a real commercial might look like. It was so like your other work—you couldn't tell the difference, really. Did you ever hesitate about doing commercial work?

cs—No. There were things I turned down, but not because they seemed too commercial. I usually accept things when I don't have anything else on the horizon and I'm looking for inspiration. I make it a condition, not only with whoever I'm working with, but also with myself, to make sure that I'm going to get something out of it that I like, that isn't just to please them.

JW—In the early 1975 work that's in the show [Untitled A–E; plates 4–8], you posed as a boy. Was that the only time?

cs—I did some asexual types early on, and in the history pictures I did men. In really early work I did more male characters too. In one series between the rear screen projections and the centerfolds, there were a few characters that were boyish [fig. 2]. I want to do a whole series of men someday.

JW—As you mentioned, you're going to be known forever for the "Untitled Film Stills." I've always said that people don't remember movies; they remember the stills. And I think you really captured that quality. But why do you think they're so iconic?

cs—I think it probably had something to do with the crossover of photography into fine art at that moment, and more artists using cameras and photography as a tool to make art.

JW—But why did a few of them—like the one where you're hitchhiking [#48; plate 62]—stand out so much?

cs—I don't know; maybe what's so "iconic" is that you don't even see the girl's face. She's got her back to the camera, so it's like anybody can imagine who she is.

JW—A lot of people think they're stills from a movie, but none of them are references to specific directors, are they?

cs—No, no, no, no, no.

JW—This is why I think they're so brilliant. They weren't done with one director in mind, but you saw all of

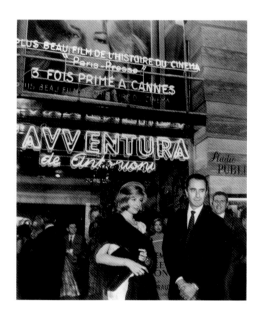

Fig. 3

Monica Vitti with Michelangelo
Antonioni in Paris at the premiere of
L'Avventura, 1960

those directors' movies—so they were
in you.

cs—Right.

jw—Look at this picture of Antonioni
with Monica Vitti [fig. 3]. It looks like
you. I think it's you when I see it. It's a
great picture. A lot of times people
associate your film stills with Antonioni,
or certainly foreign films.

cs—Or Hitchcock.

jw—Hitchcock, of course, is important
for your rear screen projection series.
Were your photographs ever done with
a real rear projection, with a movie
playing behind them?

cs—No. In fact, I didn't even own a slide
projector; I think I rented it. It was really so
low-tech that I had to balance out the light I
was shining on myself, and figure out the
distances so as not to wash out the screen.
I had to do this depth-of-field thing where I
put the focal length between me and the
screen. So that's why, in a lot of those pictures,
I'm actually as out of focus as the background.

jw—But before digital, how did you
do this—trial and error? You had to go

get the film developed and printed and
come back.

cs—Yes. I was running back and forth to the
lab. Actually, in those days, I was developing
it myself, so I could stay in character and in
half an hour could see the results.

jw—Could you do Polaroids?

cs—Yes, but I was doing Polaroid contact
prints that were the size of 35mm film—
tiny, so I would only get a general sense. I
couldn't be sure how the focus was, and the
color was completely different. But then in
the mid-nineties I started to take the film to
a lab. So then I had to get out of character,
go to the lab, wait two or three hours, come
back, and then . . .

jw—Get back in drag.

cs— . . . realize I had to do it all over again.

jw—And it was just you. Nobody was
even running to the lab.

cs—No, but in a way, it was okay. I love
shooting digitally and would never go back to
film. But I feel like I get so much more
obsessed with working now, because when
I'm working I can just keep going. At least

72

when I had those two or three hours while the film was being developed, I could run errands.

JW—I'm curious about the centerfolds, which were originally commissioned by *Artforum*. Why didn't they run them? Because they were the opposite of *Playboy*?

CS—Well, they weren't titillating enough to mimic a real centerfold, but they were too disturbing otherwise.

JW—They weren't very "feminist" either. A lovesick or sad or longing woman didn't fit the "feminist correctness" of the period, which is why they're so great. And you certainly *are* a feminist, and I think always were.

CS—But it wasn't "in your face." I think there was a subtlety in them that Ingrid [Sischy] was a little nervous about, given the high-brow audience.

JW—So where were they first shown?

CS—At Metro Pictures. That was one of the last times I ever did any public speaking. I think it was at SVA [School of Visual Arts, New York], and those kids were just raking me over the coals: "This looks like something out of *True Detective* magazine."

JW—I think that's a compliment.

CS—They thought I was being antifeminist and should add wall text to "explain" the pictures to viewers.

JW—But was that series reflecting any particular sadness in your personal life at the time?

CS—No, it was more about the format. I wanted to fill this centerfold format, and the reclining figure allows you to do that. I also wanted to comment on the nature of centerfolds, where you see a woman lying there, and then you look at it closer and suddenly realize, Oops, I didn't mean to invade this private moment. I wanted to make people feel uncomfortable. But then, years later, I'd hear, "I have that centerfold hanging over my bed. It's so sexy."

JW—The opposite of what it was supposed to be.

CS—But I've even heard that about some of the sex pictures.

JW—Do you ever look at a picture and think, I look awful there? Do you ever edit one out because you personally look bad?

CS—I take it out if it looks too much like me. Generally I feel somehow removed from the characters, but sometimes they do sort of hit too close to home, where it just seems like me on a bad day.

JW—So, in other words, you didn't fully become the character.

CS—Right.

JW—And people can tell that's Cindy Sherman.

CS—Or *I* can. Sometimes I also kill things that just seem like a variation on a character I did five years ago. I feel I should try to push it a little more.

JW—Do you feel you lose your vanity when you become a character?

CS—Yes, I like experimenting with being as ugly as I can possibly be. But I guess that's because I don't think of it as me.

JW—Do other photographers inspire you? I've read that in the beginning

Fig. 4

Diane Arbus. *Puerto Rican Woman with Beauty Mark, New York City*. 1965. Gelatin silver print (printed by Neil Selkirk), 14¹¹⁄₁₆ x 14⅝" (37.3 x 37.2 cm). The Museum of Modern Art, New York. Purchase

Fig. 4

Diane Arbus. *Puerto Rican Woman with Beauty Mark, New York City*. 1965. Gelatin silver print (printed by Neil Selkirk), 14¹¹⁄₁₆ x 14⅝" (37.3 x 37.2 cm). The Museum of Modern Art, New York. Purchase

Diane Arbus was a very important influence on you [fig. 4]. On me, too. In addition to Arbus, was Warhol an influence?

cs—Definitely Warhol, early on.

jw—I think the one mistake Andy made was his drag pictures. I think he looks ridiculous, though many people would argue with me. And you might argue, because that's the only time he ever did something kind of like what you do.

cs—I hadn't thought about that. I was disappointed when I met him. I felt dismissed, because I was a woman, basically. I think both times I met him he was surrounded by a bunch of young guys. And I went over to say I'm a big fan, or something like that.

jw—Did he know your work then?

cs—I don't remember. I'm sure by the second time he did. But definitely he was a big influence.

jw—The fairy tales seem to me to be less known than some of your other work. Can you talk a little about them?

cs—They began as illustrated fairy tales for a magazine, but again, none of them are referencing any particular fairy tale.

jw—So it's like the movie stills. It's the overall world of fairy tales, without saying, "This is 'Hansel and Gretel.'"

cs—Right. I was reading tons of stories, and I was looking for my favorite. Years after I did that series somebody commissioned me to do a children's fairy tale book, and I chose "Fitcher's Bird."

jw—Did you do the gory disaster pictures when you were tired of everybody liking your work?

cs—Yes, for sure. I said, "Hang this vomit above your couch." [laughing]

jw—Are you in all of these pictures?

cs—There were two phases. I was in the first phase, where I'm a reflection or a blurry figure in the top, the background, or the shadows somewhere. And then there's another phase where I was really completely out of them.

jw—So you broke up with yourself, kind of?

cs — Or, as some reviews said, I was totally deconstructing myself, chopping myself up by getting smaller and smaller, and then finally disappearing. But the way I saw it was that I was nervous that I was too dependent on myself, so I wanted to see if I could tell a story or make an image without including myself. And that's when I started using the mannequins, masks, and things like that.

JW — Did AIDS have anything to do with that series? It was the late eighties, and many of our friends were dying.

cs — I wasn't thinking about disease while I was making the pictures, but there were a few that were definitely related to AIDS, especially once I started doing the sex pictures.

JW — I'm amazed that the history portraits weren't more complicated to do than the other ones.

cs — They were so easy because I'd just come out of working on the disaster landscapes, which were torturous. What was so hard and complicated about those pictures, where I was using mannequins, was that I was setting up a still life, so I really had to decide in advance, what is this picture

about? What is going on? In the past, when I was posing in the picture, by moving around, I could discover something; the serendipity of happening to blink suddenly became the perfect shot. And yet I wouldn't know it until I looked at the slides. So when I finished those disaster pictures and went back to the history pictures using myself, it was such a relief. I could just hang up some fabric in the background and make it look like a curtain, put an old candle on an old table.

JW — But it's not so easy. It seems to me like those pictures were the most like a movie project, having to go out and do every job there is in a movie.

cs — I would go to a Salvation Army and look for certain kinds of costume-y things. But so much of it was junky stuff. I would rip up a pair of pants and use the legs as sleeves for some other kind of garment that looked like brocade from the seventeenth century. But it was just some cut-up pieces of fabric.

JW — New York must be the worst city to go thrift shopping in, because everybody knows everything, even at the Goodwill. Do you have secret places where you find stuff?

cs — Online, actually. I got some of the clown stuff on eBay, but it wasn't real clown stuff — it was for square dancing.

JW — When you travel, do you go to thrift shops?

cs — Not so much anymore.

JW — Do you go to costume-rental places?

cs — No, I've never done that.

JW — Never? Every one of those historical costumes you found in thrift shops?

cs — About a third of that series was shot when I was in Rome. The woman who owned the studio was related to the Borghese family, and one or two of the outfits were from her family. There's a Madonna holding a child; that dress was from her family, so that's the most "real" costume. But they had good flea markets in Rome where I got a bunch of old religious things.

JW — Now, the sex pictures. I remember once I gave you a copy of *Adult Video News*, and you were poring over it. That magazine is shocking; it has stuff

that is jaw-dropping. But you read every word of it. Did you ever go in sex shops when you were doing all of this?

cs—No, it never even occurred to me. Years later, somebody pointed out that there were no hard cocks in that series. And I thought, why didn't I ever think of getting a dildo? Instead my inspiration was a medical supply catalogue, and I ordered from that. You could get male and female hip sections that looked like they were cast from real bodies—you could see all the wrinkles—except for the actual genitals, which you could tell were molded from clay because you could see fingerprints. Those were for practicing catheterization. And then the testicles, which I put makeup on so they looked more fleshy—they're for feeling tumors.

JW—What about erotic photography, like Athletic Model Guild, Bettie Page, or that kind of stuff?

cs—Sure, Bettie Page [fig. 5]. Right before I was working on the cut-up doll series, I got the magazine *Physique Pictorial*.

JW—Those pictures are amazing; they're iconic. Yet in your own photographs, you've never been nude.

cs—Except really early on, in college, before I even did makeup, before I took pictures of my face. There was this class that was famous for its spring break romp through the waterfalls—"Let's all get naked and take photographs of each other!"—and it terrified me. One of the early projects was to confront something that was difficult. So I did all of these really boring, analytical pictures of myself without any clothes on.

JW—Since the work is about sex parts and all that, were you ever turned on by being one of these characters?

cs—No. There have been times when I've looked in the mirror and I've felt so completely like I was looking at another person that I'd spontaneously start acting—not in an eroticized way, but I'd start imagining, what if I were filming this? And so I think that is a turn-on, just because I do not recognize myself at all. It's so bizarre. Weirdly, what happens more frequently, now that I'm getting older, is doing characters that suddenly look like a character I was doing twenty or thirty years ago, when I was trying

to look older. Only now there's less makeup and it happens a lot more easily.

JW—So you're never going to get a facelift, because you've already given yourself reverse facelifts.

cs—But with Photoshop.

JW—Let's talk about *Office Killer* [fig. 6]. I love that movie, and I want you to make another one. But it's hard to cross into the film world from the art world. Do you still want to make another film?

cs—Yes. It took me about five years to recover from *Office Killer*, to feel like I could think about doing a movie again. But for years I've been saying I want to do another one; it's just a question of starting some-how. And since I don't work narratively, for a long time that was the problem, because I didn't really know what kind of a story I'd *want* to tell. And then I kept saying I should put a camera in my studio, and when I'm working, just turn on the video.

JW—But that's different; that's an art video.

cs—That's what I decided I should start with. I heard David Lynch speak when his

Fig. 5 (top)
Pinup model Bettie Page, 1950s

Fig. 6 (bottom)
Publicity poster for Cindy Sherman's
Office Killer, 1997

Inland Empire was at the film festival here. He said the way he made it was he called some friends, and they shot one little scene. A few months later, he shot another scene. He was never thinking of how they would go together. And in a way, the movie feels like that, but in a great way. So I thought, that's the way I want to do this.

JW—But as a genre? Because your first movie was a genre; it was a horror film.

CS—Right. I'm thinking I just need to get started doing it and to feel comfortable with it.

JW—You had actors in *Office Killer*. Are you talking about having actors again?

CS—No, I would try the way I'm used to working, just to begin. Because thinking in terms of movement is rare for me—both the figures' movement and the camera's move-ment. I think I have to sort of throw myself into all those things right now, and not worry.

JW—Was that hard for you, the real thing? You've got to yell, "Action!" You've got to have shot lists and a crew and all that. That must be the opposite of how you usually work.

CS—Yes, it is so much the opposite. I had

no idea what to expect. I was lucky that everybody working on it was really nice and helpful. I don't think we had the ending when we started. I started storyboarding, but got maybe just one scene into it. I was so inexperienced that for the beginning scene I had about twenty different angles, which is just ridiculous for low-budget. I learned so many lessons that I thought, I should do this again. It was really interesting and a great challenge.

JW—You say that you don't work narratively, but every one of the "Film Stills" tells a story. You do work in a narrative way, more than you think.

CS—Right, but there's no dialogue.

JW—So the horror and surrealist pictures, they came after *Office Killer*? Were they related?

CS—I don't think so, no. I think I was still working with mannequins; I wasn't using myself. And yet, I wanted to try to bring back this idea of serendipity. I was moving the camera, so some of the pictures are blurry or double exposures, and also cross-processing the film, so the colors are weird.

Fig. 7

Cindy Sherman. Untitled #317. 1996.
Chromogenic color print, 57⅞ x 39¼"
(147 x 99.7 cm)

I could feel a sense of discovery when I was looking at the slides.

JW—The masks are probably your scariest work, in a way [fig. 7]. Do you like being scared? Do you seek out scary things?

CS—Scary movies.

JW—When you were a kid, did you torture your dolls? I used to torture my sister's dolls, give them bad hairdos and put them back in the box. And then my sister would be outraged when she would find them.

CS—That's hysterical.

JW—I don't want to ask you a Barbie question, but I have to. Did you hate Barbie?

CS—No, I didn't. I had Barbies, but I also had a whole family of troll dolls, and I made little houses out of shoeboxes and decorated them and made the furniture. I also made their clothes; they had outfits.

JW—The head shots [2000–2002] are my second favorite body of work you've done. When I walked into the

gallery the first time, I felt like I knew those people. But it's the same as the movie stills—it's not a specific person, but the aura of the person that is so strong. Are these pictures cruel?

CS—I don't think so. They were criticized as if I was making fun of these people. But I empathize with these characters. Some of the most pitiful little characters in that series, my heart goes out to them. I just adore them.

JW—Did collectors ever get mad, thinking the pictures were of them?

CS—No, although I definitely had people come up to me and say, "I know you did me in here somewhere. I'm not sure which one, but I'm in here."

JW—Well, that's because it isn't a particular one, it's the feeling of all of them mixed in. So how did you approach the clowns?

CS—That was hard because there was a real art to learning about clown makeup. At first I would put on what I thought looked like a clown face, and it just didn't work. So when I researched it online, I saw all of these pictures of people trying to promote

themselves for children's parties. With some of them you're thinking, this one's an alcoholic, that one's a child molester, that one feels pathetic because no one loves him—so they all want to make kids laugh. I started thinking about it in terms of the character underneath the makeup, which helped me think about the clown as a whole. That was really fun, once I got to that point.

JW—And your last show [2008]: I think it's the best work you've ever done. That show was so spectacular and so many-leveled. Talk about narrative! You could see where those characters lived. Was that technically complicated? It certainly doesn't look low-tech.

CS—Thank you. The shooting was very basic; I just shot it here on a green screen. It was the first time I used a green screen. What was more complicated was thinking of the backgrounds, then thinking of how to integrate these characters into the backgrounds.

I was downloading stuff from the Internet about society portraits, but not photography. Some seemed like quasi-royalty. Sometimes they'd be posing with their plaid, or they'd have their dog with them. A lot of

them don't have backgrounds, which gave me the idea for the floating figures.

JW—Were any of your backgrounds appropriated?

CS—No, I shot them all. A lot of them were in Central Park; some were in Spain, shot on a vacation.

JW—Tell us a little about the new work, the murals.

CS—I started doing some stuff lately where the background is even more abstracted. I didn't use any makeup, because I thought these were more like studies. But then I started changing the faces digitally to slightly alter them, so it's kind of like using Photoshop instead of makeup.

JW—So you *are* giving facelifts.

CS—Yes, and just tweaking. For example, the eyes may be closer together, or higher up, or smaller. Or I'll flesh out the cheeks more. I see them all as related, but they have different wigs and these weird costumes.

JW—But it's all one piece, one mural?

CS—When I showed it in Kiev, it was floor to ceiling, about eight feet high. It's great

paper—super-high-quality photographic contact paper that sticks right to the wall.

JW—It looks like something nobody has seen before. I think it will be a great final addition to your show.

PLATE 1. Untitled #413. 2003

83

PLATE 2. Untitled #153. 1985

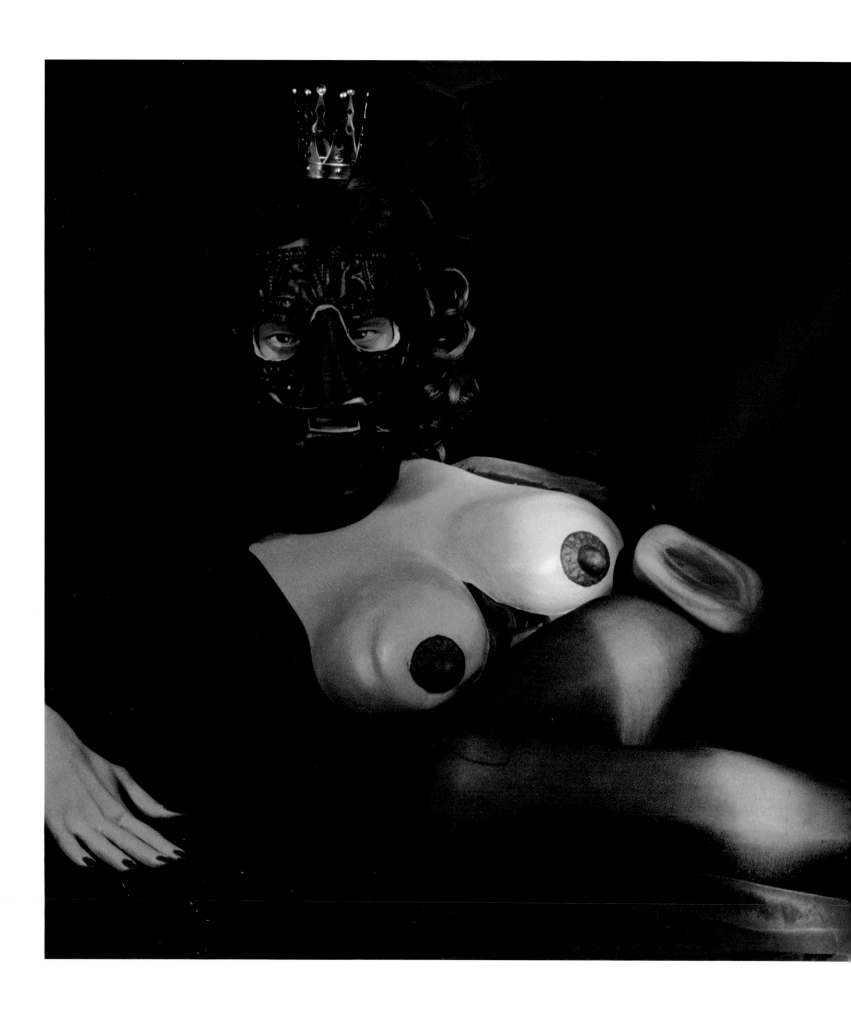

PLATE 3. Untitled #264. 1992 84

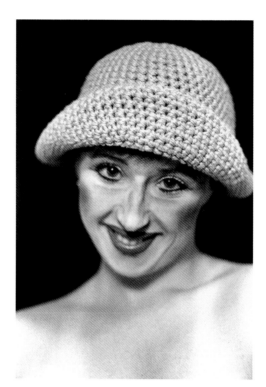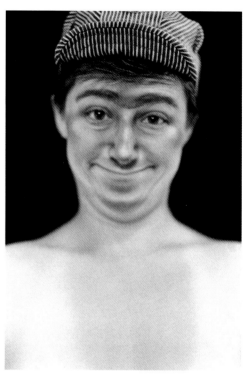

PLATES 4–8. Untitled A–E. 1975

PLATE 9. Untitled #466. 2008

PLATE 10. Untitled #216. 1989

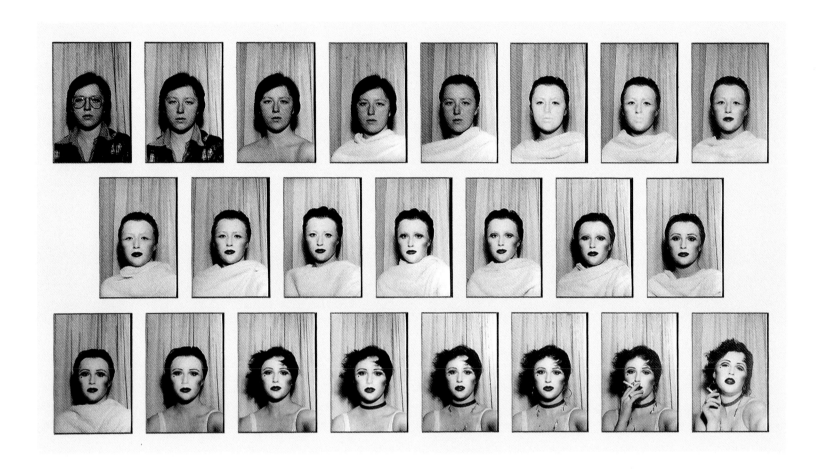

 PLATE 11. Untitled #479. 1975

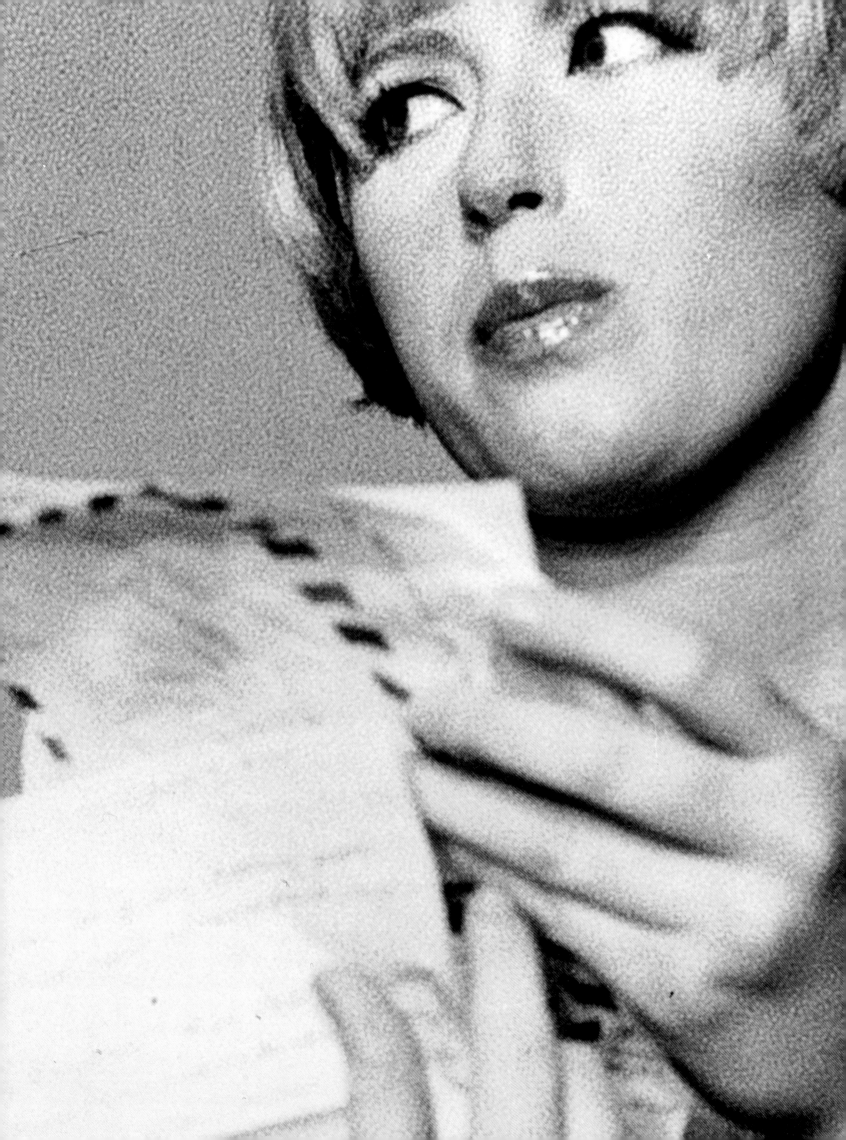

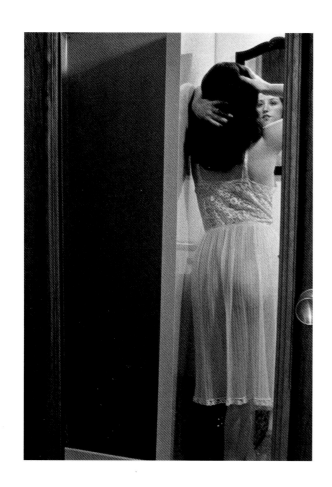

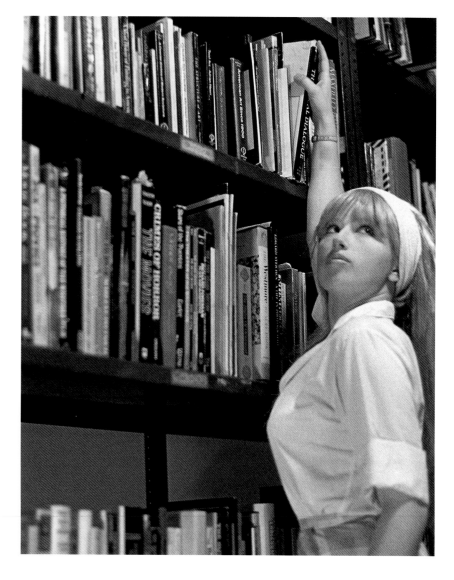

(top) PLATE 12. Untitled Film Still #81. 1980

(bottom) PLATE 13. Untitled Film Still #13. 1978

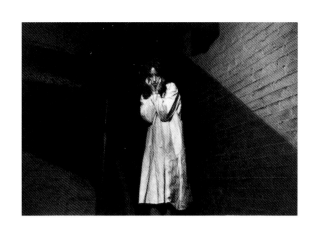

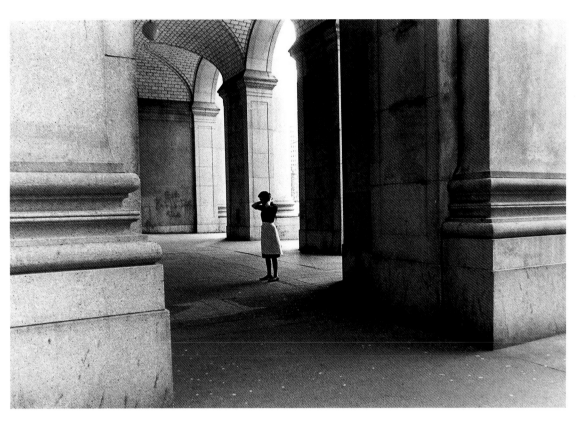

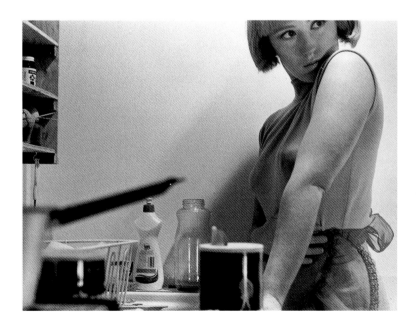

95

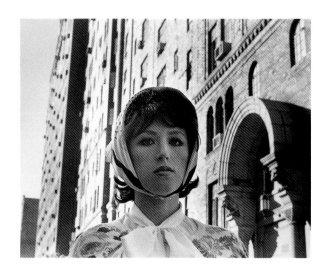

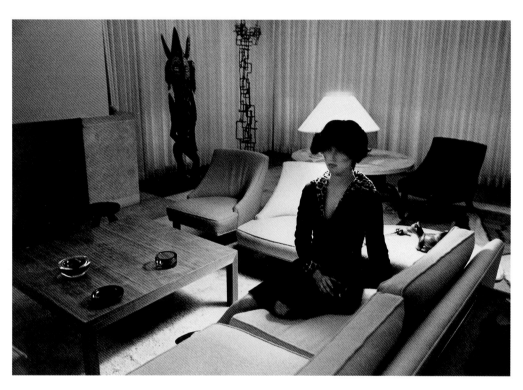

(top) PLATE 17. Untitled Film Still #17. 1978

(center) PLATE 18. Untitled Film Still #50. 1979

(bottom) PLATE 19. Untitled Film Still #59. 1980

96

(top) PLATE 20. Untitled Film Still #34. 1979

(bottom) PLATE 21. Untitled Film Still #8. 1978

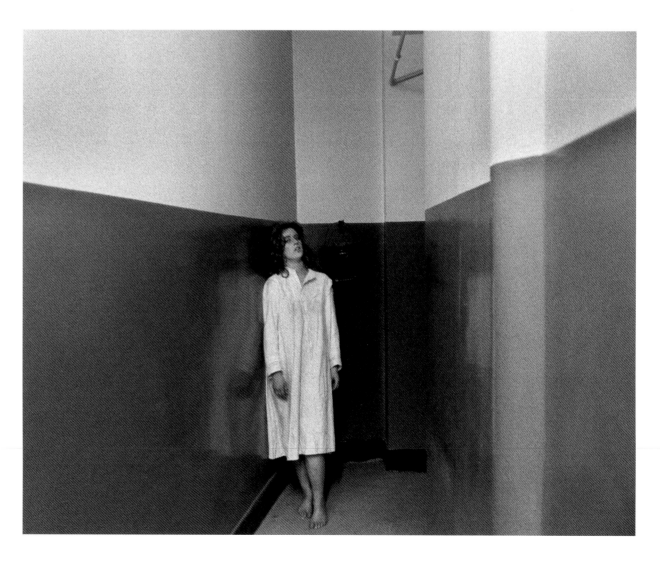

(top) PLATE 22. Untitled Film Still #47. 1979

(bottom) PLATE 23. Untitled Film Still #27b. 1979

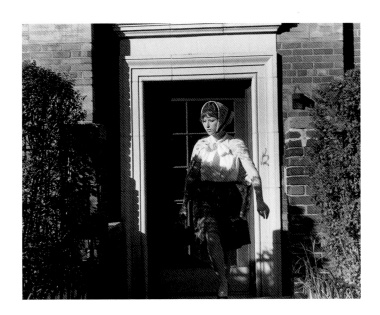

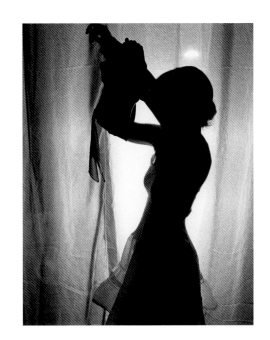

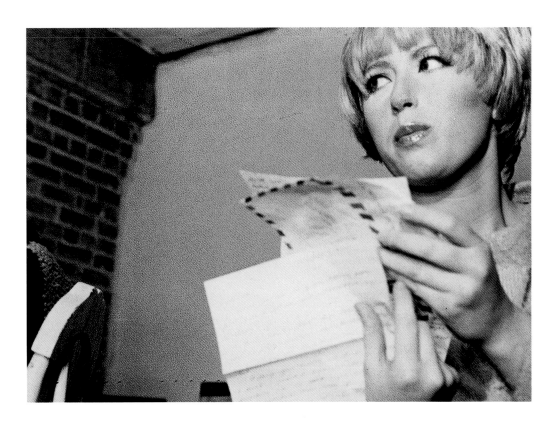

(top) PLATE 24. Untitled Film Still #36. 1979

(center) PLATE 25. Untitled Film Still #20. 1978

(bottom) PLATE 26. Untitled Film Still #5. 1977

(top) PLATE 27. Untitled Film Still #22. 1978

(bottom) PLATE 28. Untitled Film Still #42. 1979

101

(top) PLATE 32. Untitled Film Still #7. 1978

(center) PLATE 33. Untitled Film Still #1. 1977

(bottom) PLATE 34. Untitled Film Still #46. 1979

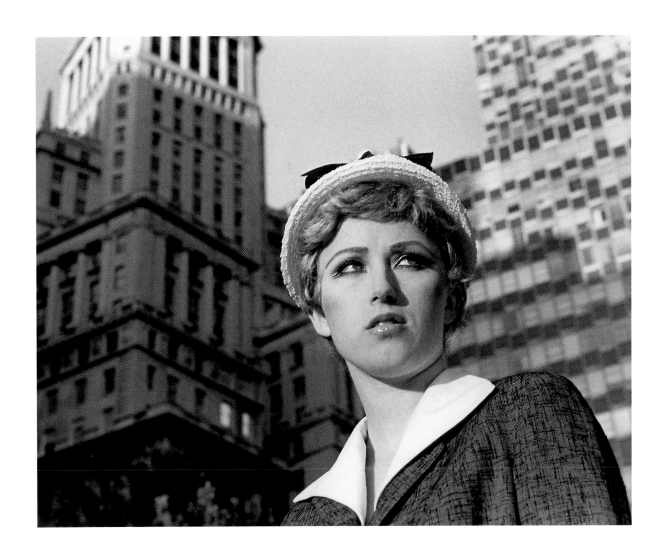

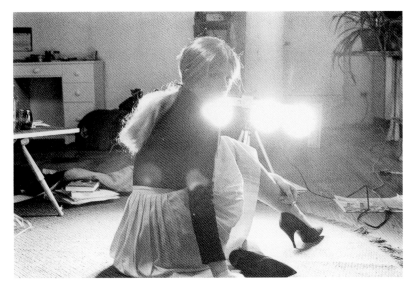

(top) PLATE 35. Untitled Film Still #21. 1978

(bottom) PLATE 36. Untitled Film Still #62. 1977

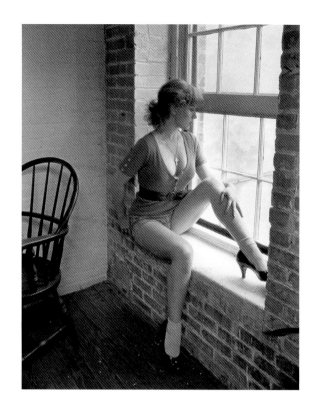

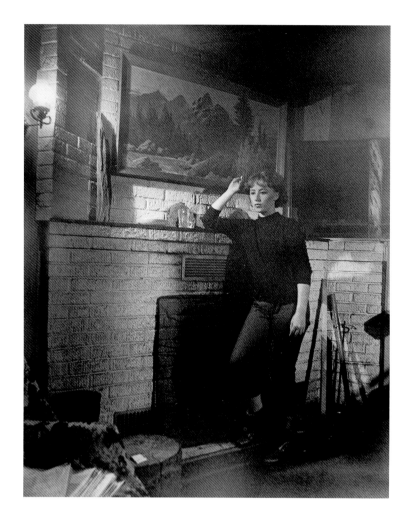

(top) PLATE 37. Untitled Film Still #15. 1978

(center) PLATE 38. Untitled Film Still #37. 1979

(bottom) PLATE 39. Untitled Film Still #19. 1978

104

(top) PLATE 40. Untitled Film Still #24. 1978

(bottom) PLATE 41. Untitled Film Still #54. 1980

(top) PLATE 42. Untitled Film Still #43. 1979

(bottom) PLATE 43. Untitled Film Still #32. 1979

106

(top) PLATE 44. Untitled Film Still #14. 1978

(center) PLATE 45. Untitled Film Still #28. 1979

(bottom) PLATE 46. Untitled Film Still #53. 1980

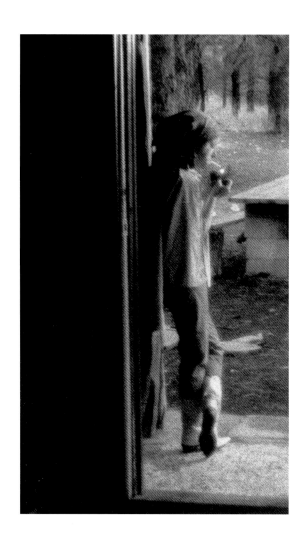

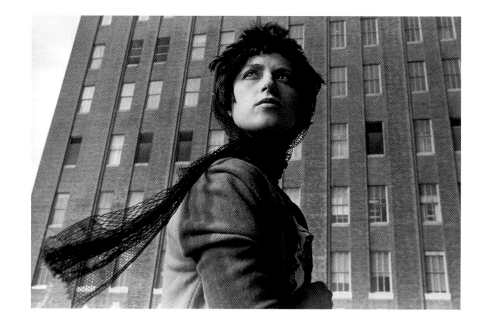

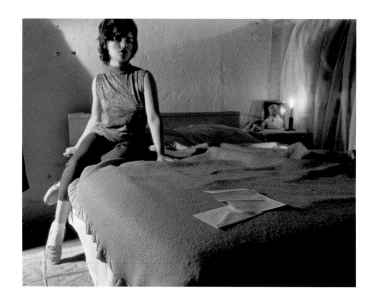

(top) PLATE 47. Untitled Film Still #61. 1979

(center) PLATE 48. Untitled Film Still #58. 1980

(bottom) PLATE 49. Untitled Film Still #33. 1979

108

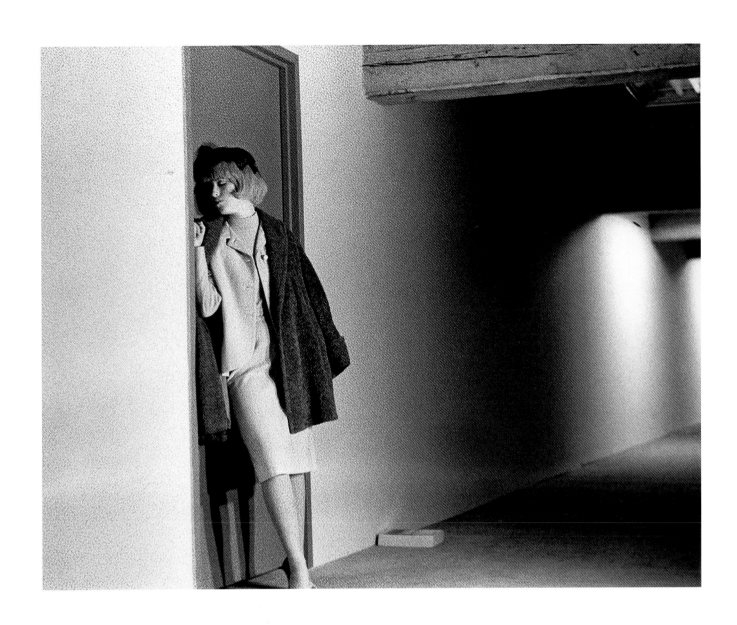

(top) PLATE 50. Untitled Film Still #4. 1977

(bottom) PLATE 51. Untitled Film Still #18. 1978

(top) PLATE 52. Untitled Film Still #49. 1979

(bottom) PLATE 53. Untitled Film Still #44. 1979

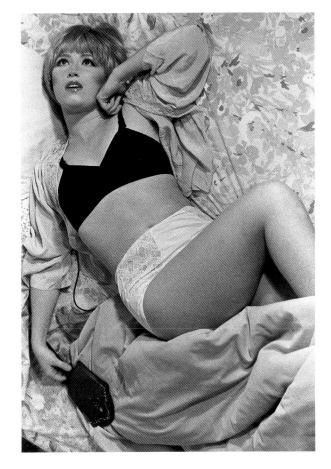

111

(top) PLATE 57. Untitled Film Still #63. 1980

(bottom) PLATE 58. Untitled Film Still #25. 1978

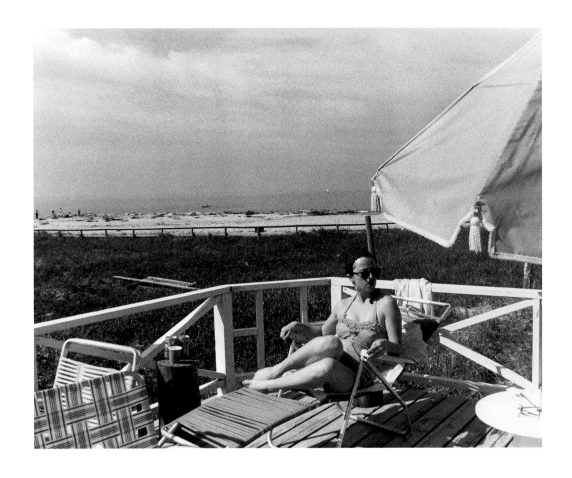

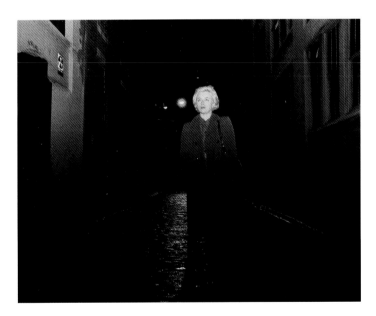

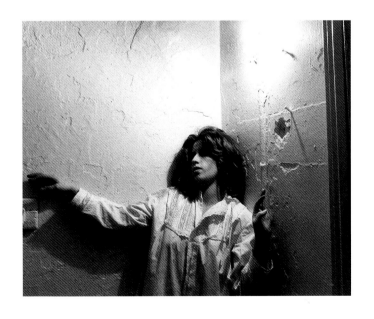

(top) PLATE 59. Untitled Film Still #9. 1978

(center) PLATE 60. Untitled Film Still #55. 1980

(bottom) PLATE 61. Untitled Film Still #29. 1979

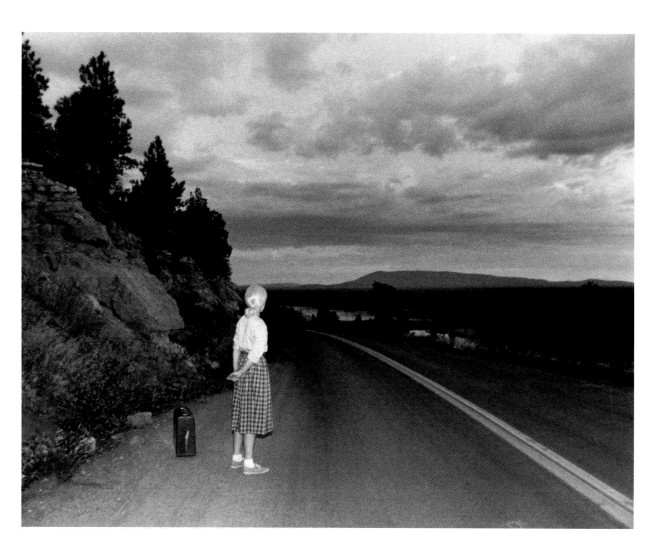

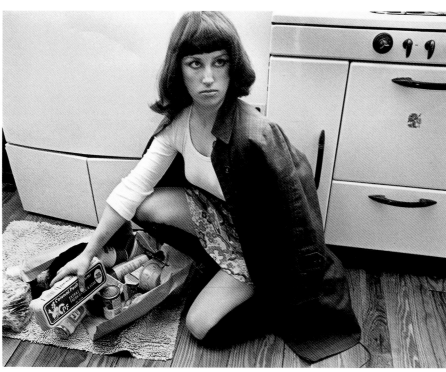

(top) PLATE 62. Untitled Film Still #48. 1979

(bottom) PLATE 63. Untitled Film Still #10. 1978

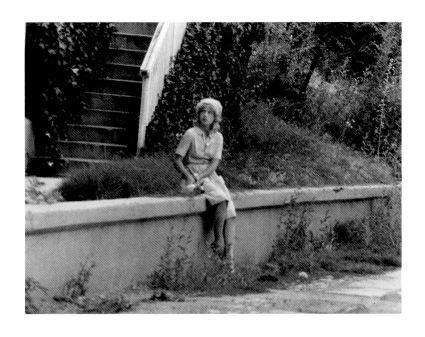

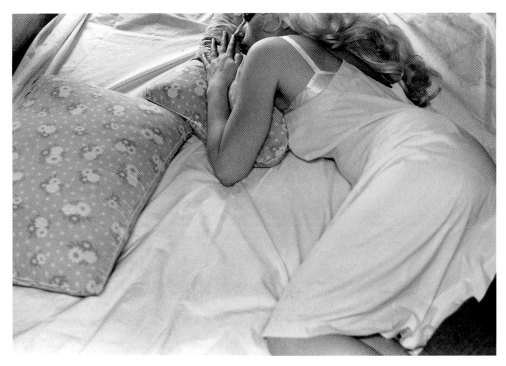

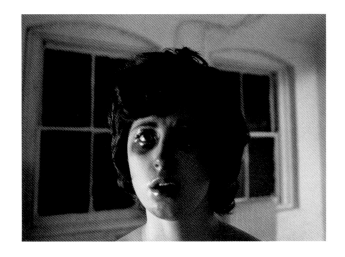

(top) PLATE 64. Untitled Film Still #40. 1979

(center) PLATE 65. Untitled Film Still #52. 1979

(bottom) PLATE 66. Untitled Film Still #30. 1979

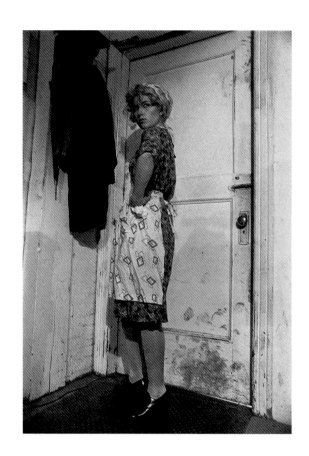

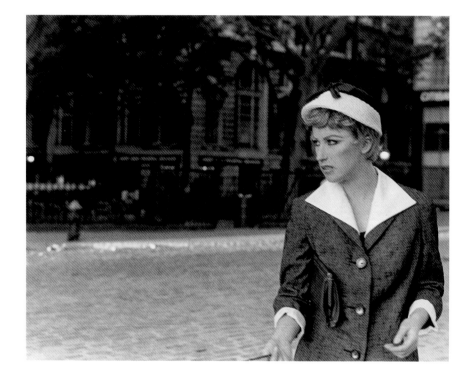

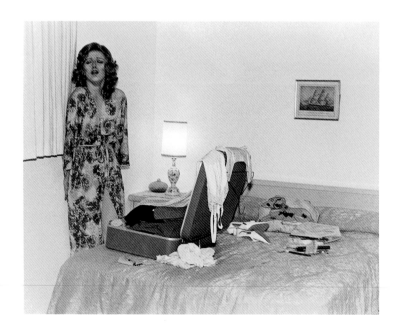

(top) PLATE 67. Untitled Film Still #35. 1979

(center) PLATE 68. Untitled Film Still #23. 1978

(bottom) PLATE 69. Untitled Film Still #12. 1978

116

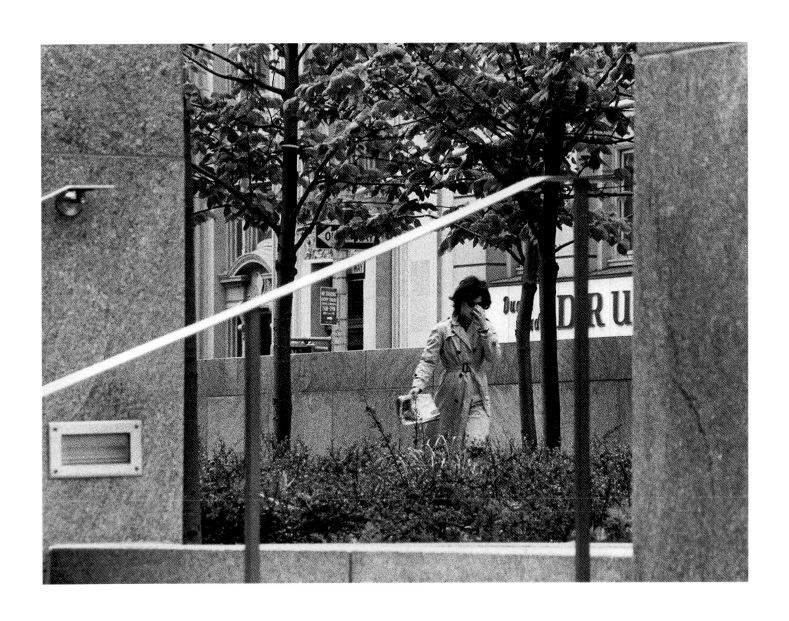

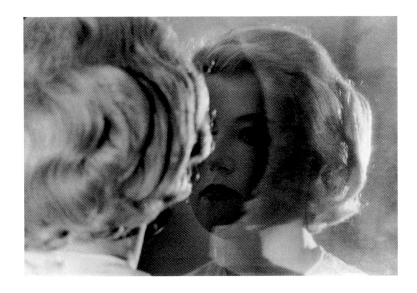

117

(top) PLATE 72. Untitled Film Still #31. 1979

(bottom) PLATE 73. Untitled Film Still #84. 1978

118

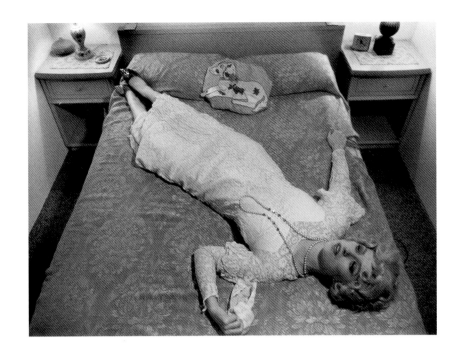

(top) PLATE 74. Untitled Film Still #11. 1978

(center) PLATE 75. Untitled Film Still #60. 1980

(bottom) PLATE 76. Untitled Film Still #2. 1977

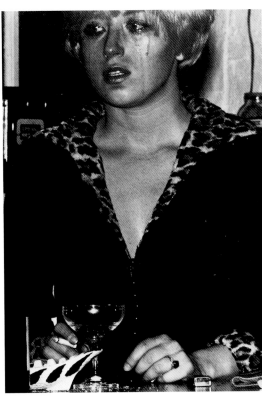

(top) PLATE 77. Untitled Film Still #45. 1979

(center) PLATE 78. Untitled Film Still #27. 1979

(bottom) PLATE 79. Untitled Film Still #82. 1980

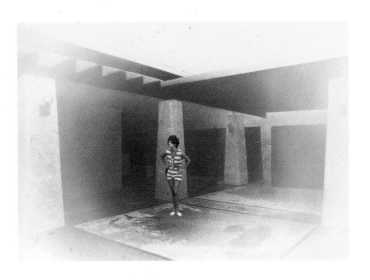

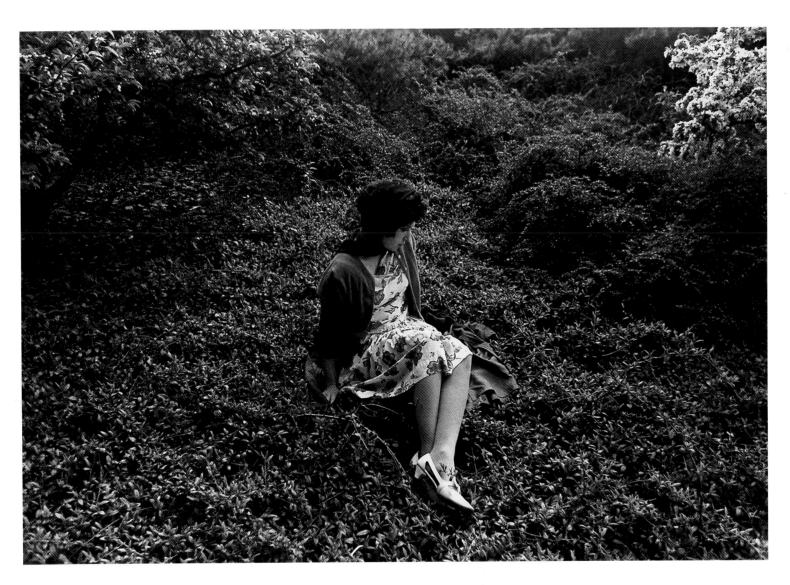

(top) PLATE 80. Untitled Film Still #41. 1979

(bottom) PLATE 81. Untitled Film Still #57. 1980

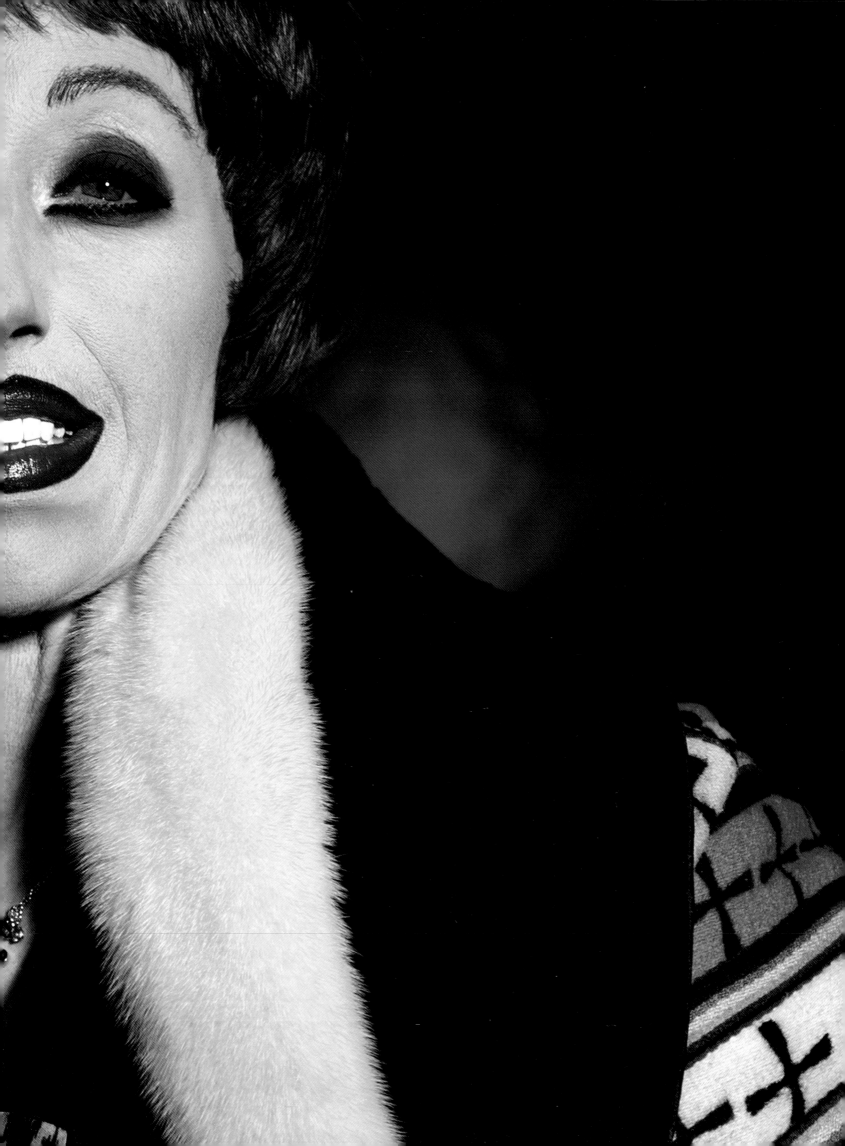

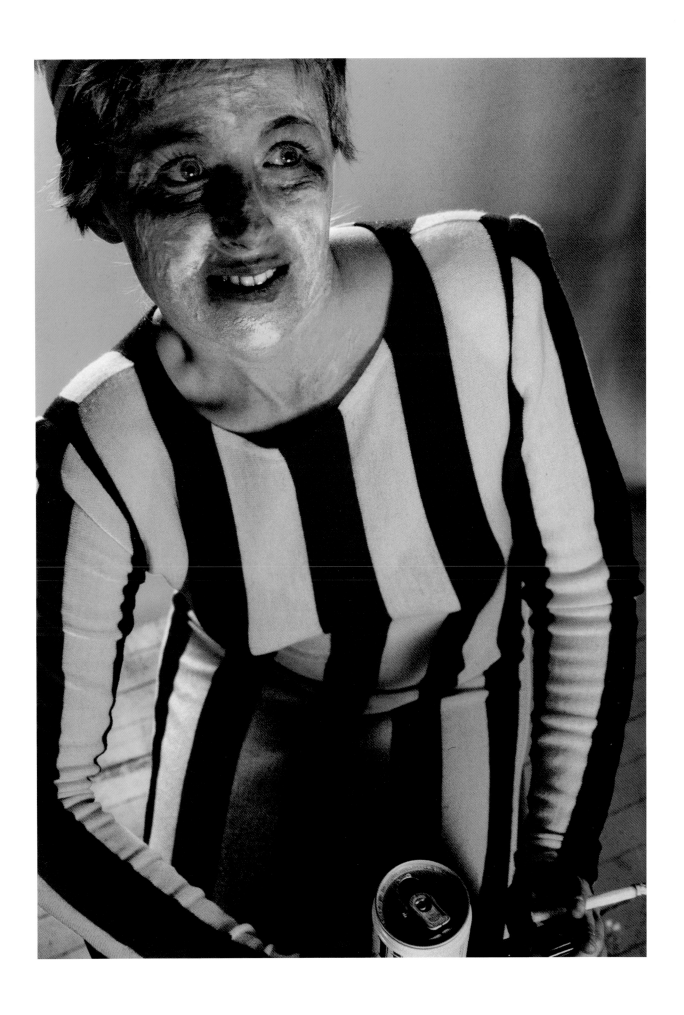

PLATE 82. Untitled #132. 1984

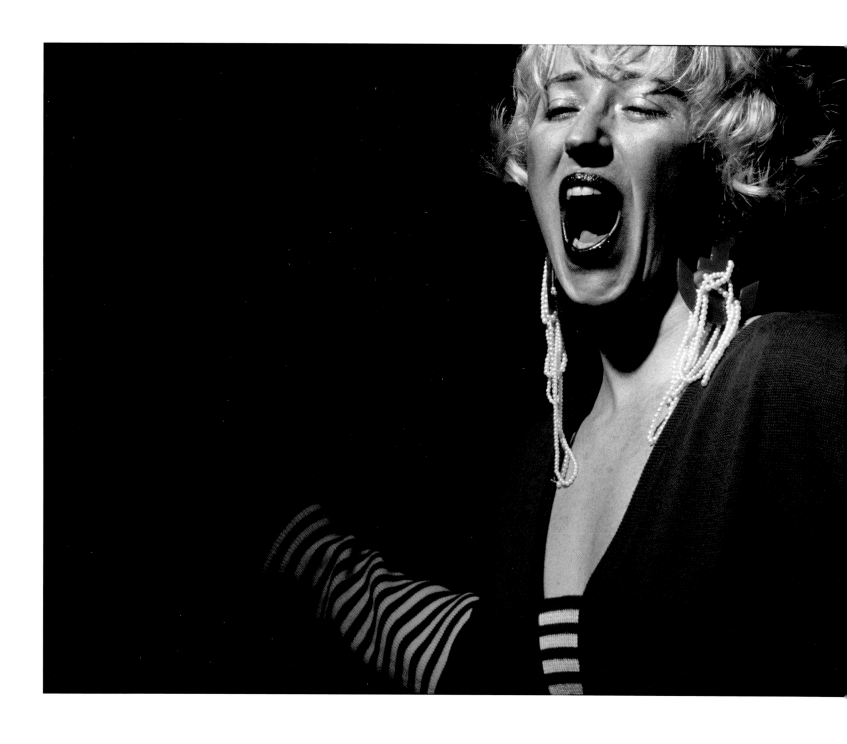

PLATE 83. Untitled #119. 1983 126

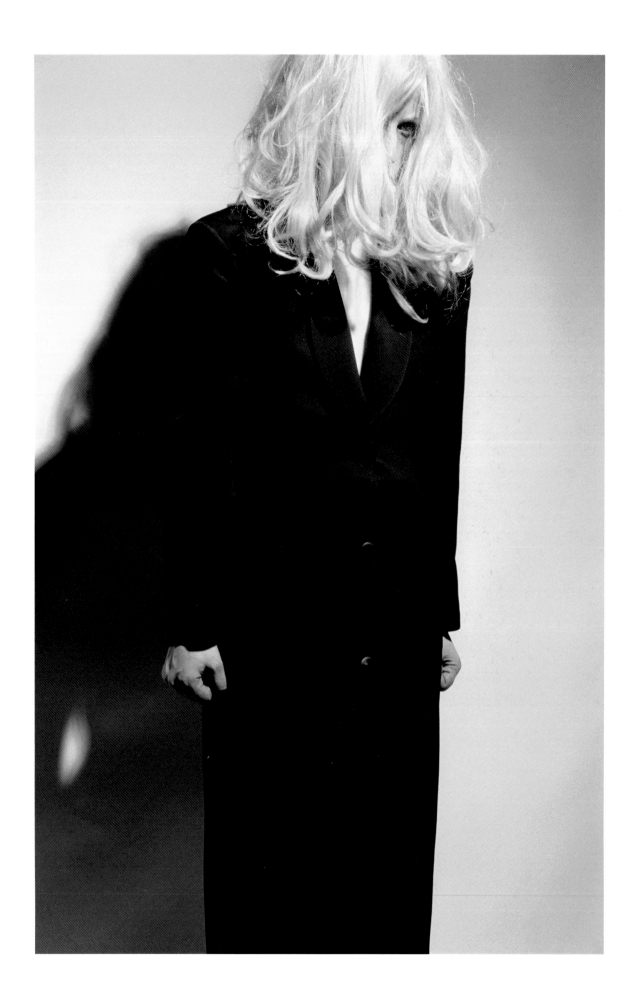

PLATE 84. Untitled #122. 1983 128

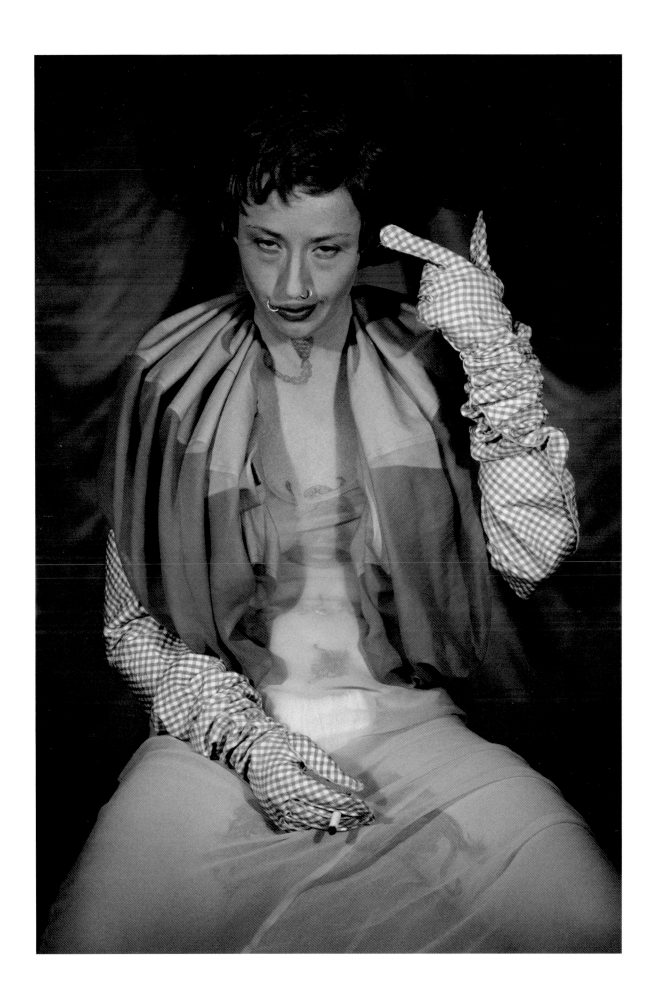

PLATE 85. Untitled #299. 1994

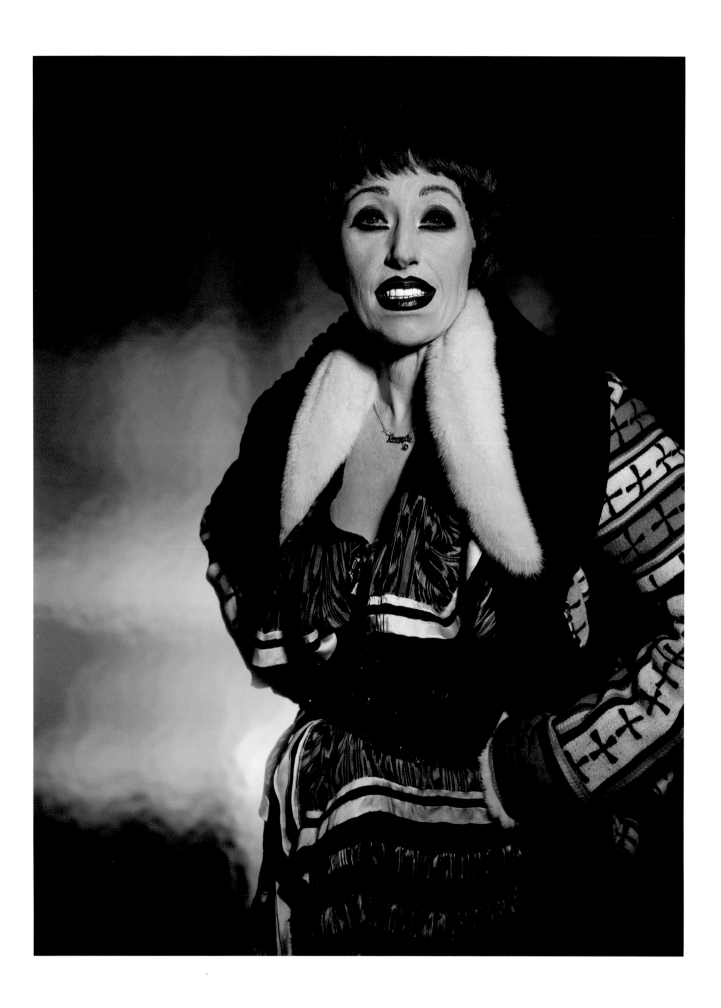

PLATE 86. Untitled #458. 2007–08 130

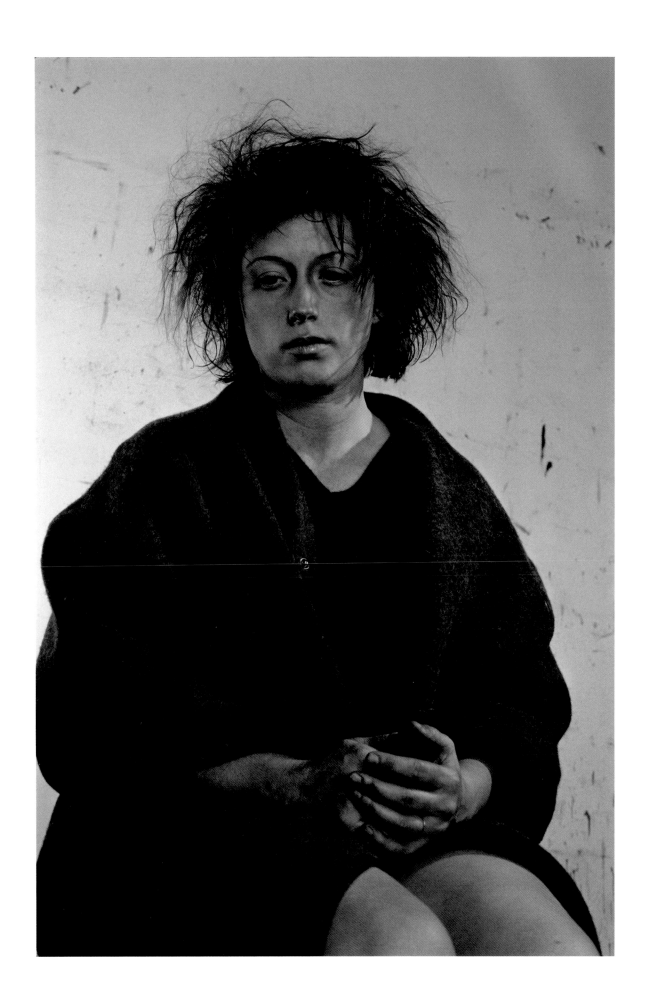

PLATE 87. Untitled #137. 1984

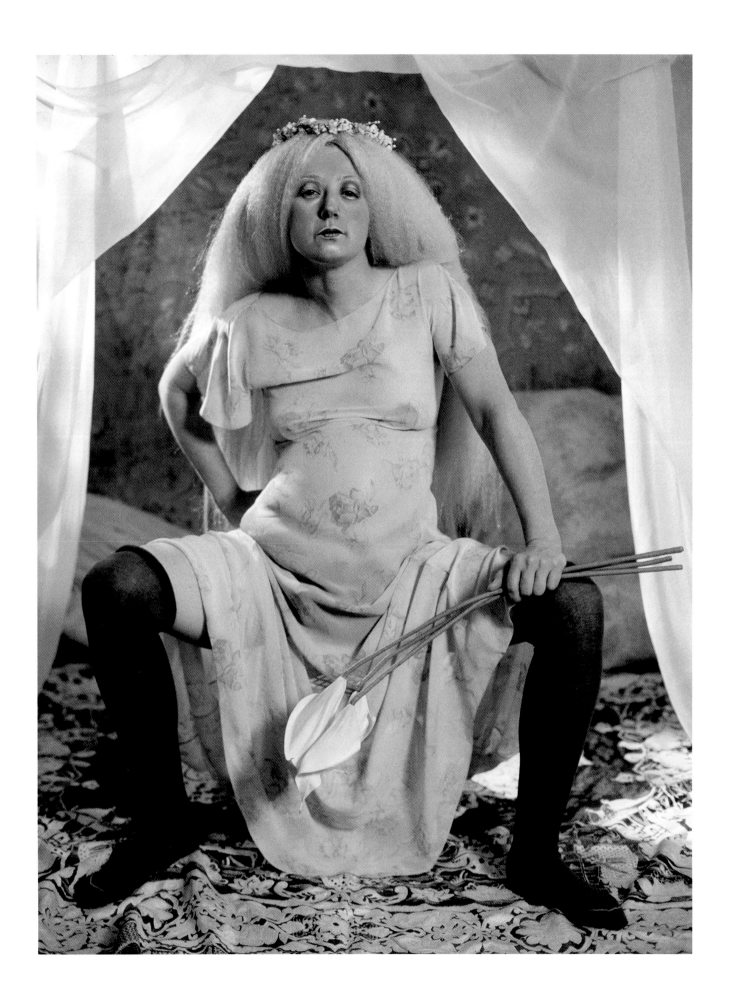

PLATE 88. Untitled #276. 1993 132

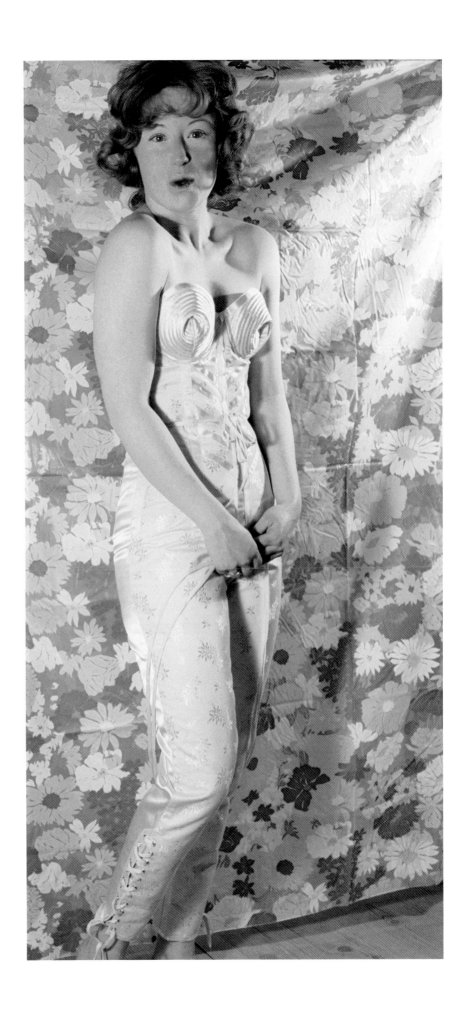

PLATE 89. Untitled #131. 1983

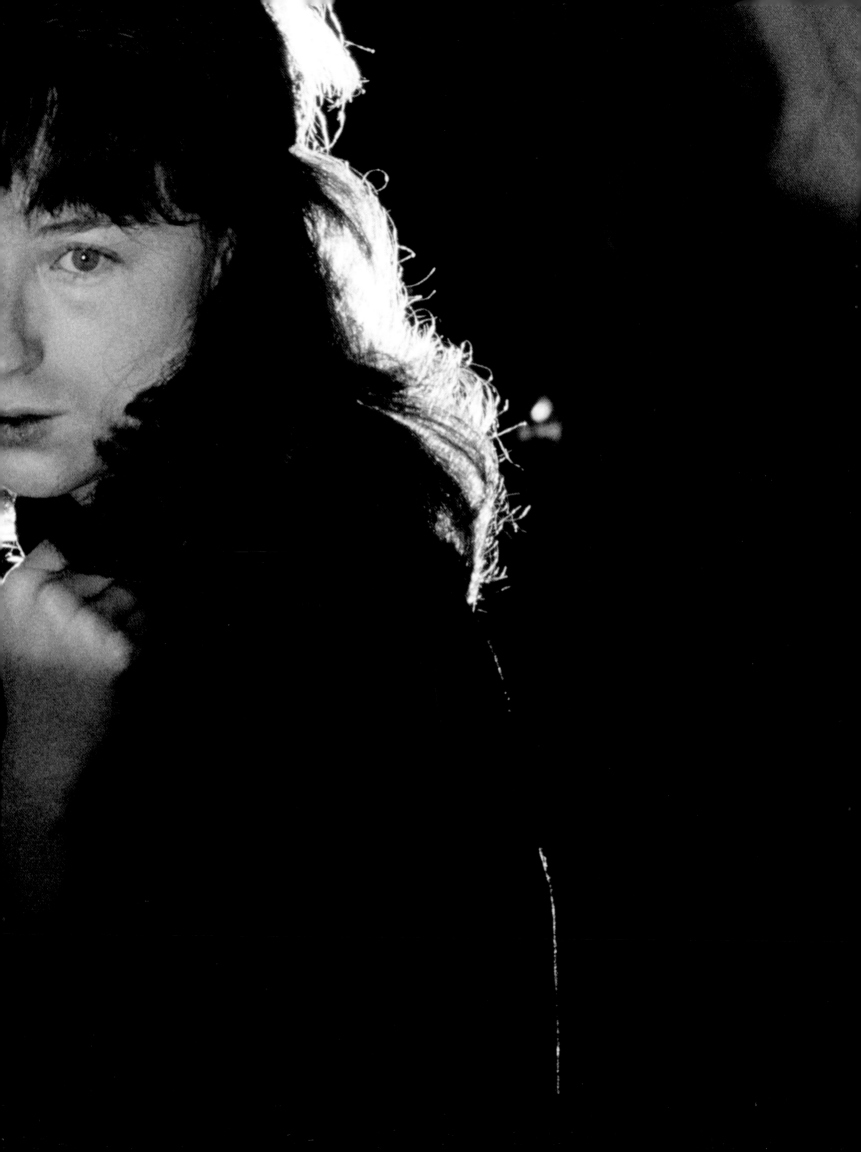

PLATE 90. Untitled #96. 1981

139

PLATE 92. Untitled #93. 1981

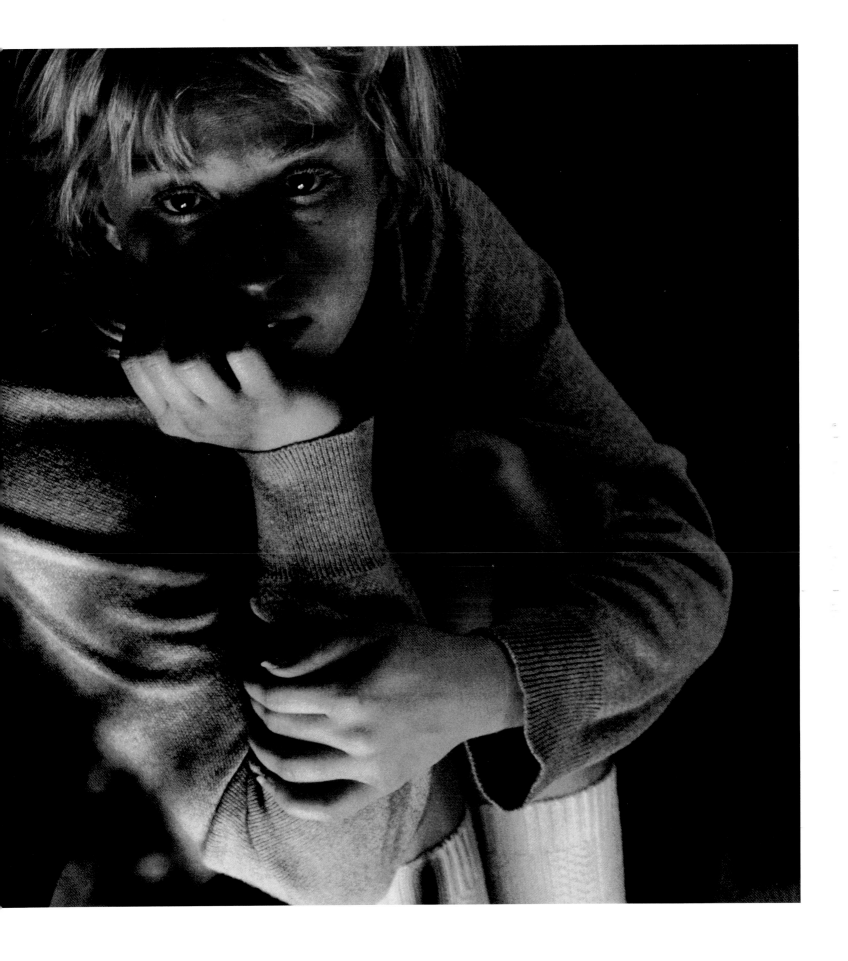

PLATE 93. Untitled #88. 1981

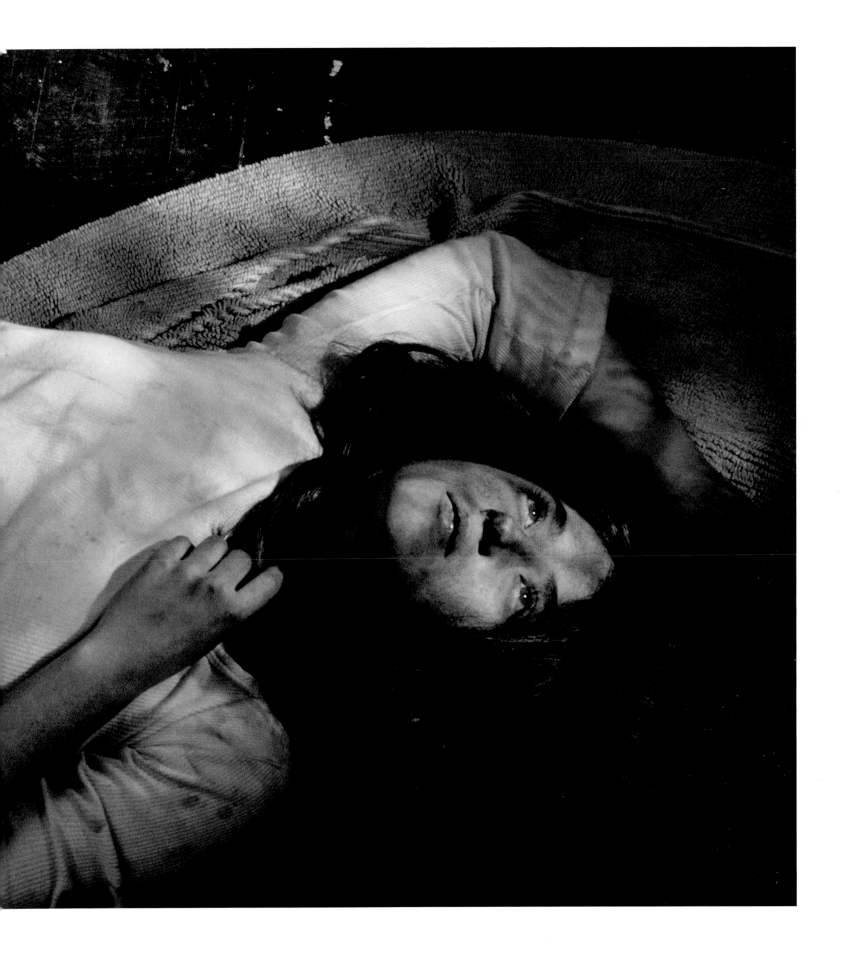

PLATE 94. Untitled #91. 1981

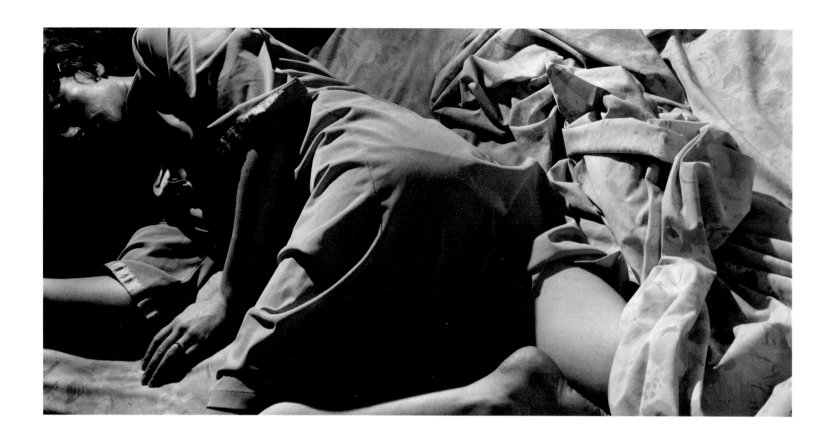

PLATE 95. Untitled #89. 1981 144

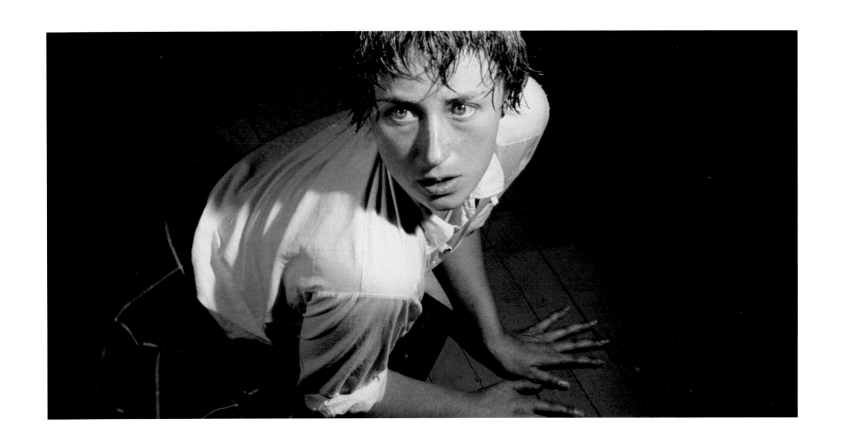

PLATE 96. Untitled #92. 1981

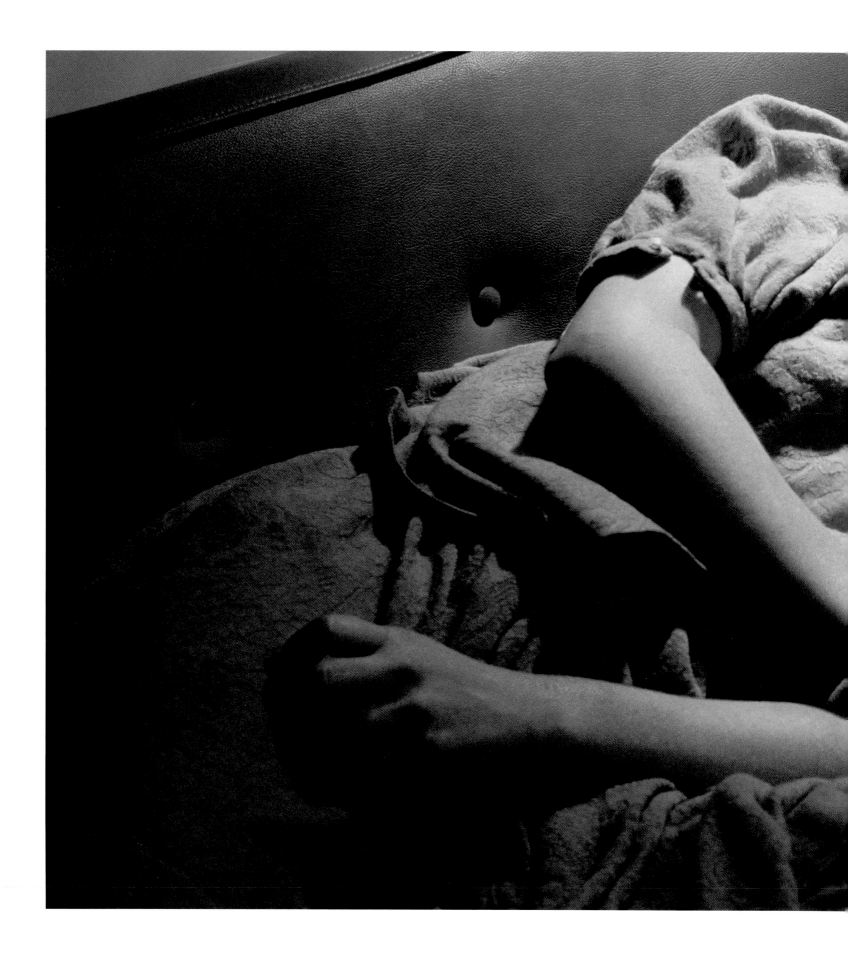

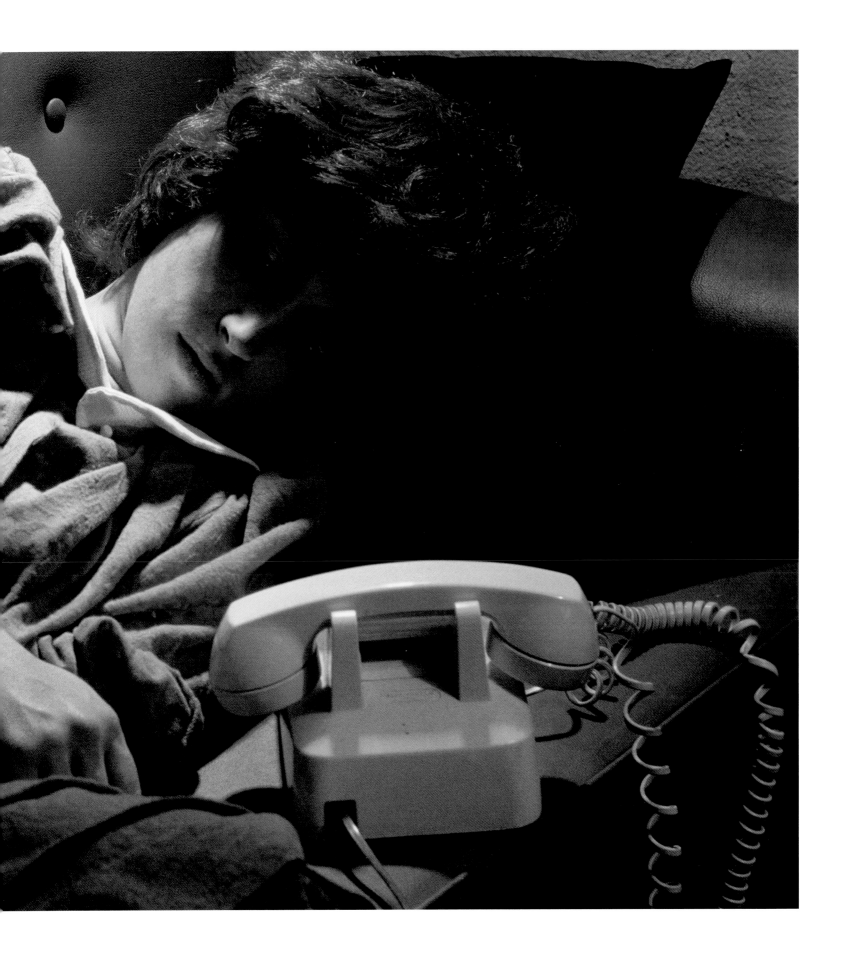

PLATE 97. Untitled #90. 1981

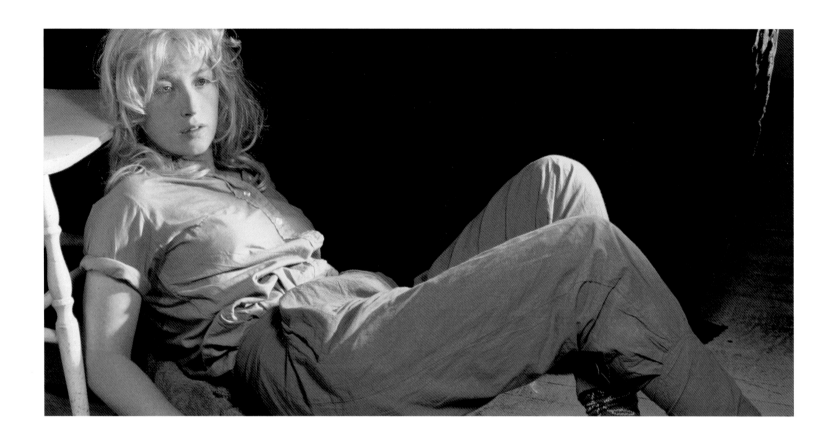

PLATE 98. Untitled #94. 1981 148

PLATE 99. Untitled #85. 1981

PLATE 100. Untitled #87. 1981 150

151 PLATE 101. Untitled #95. 1981

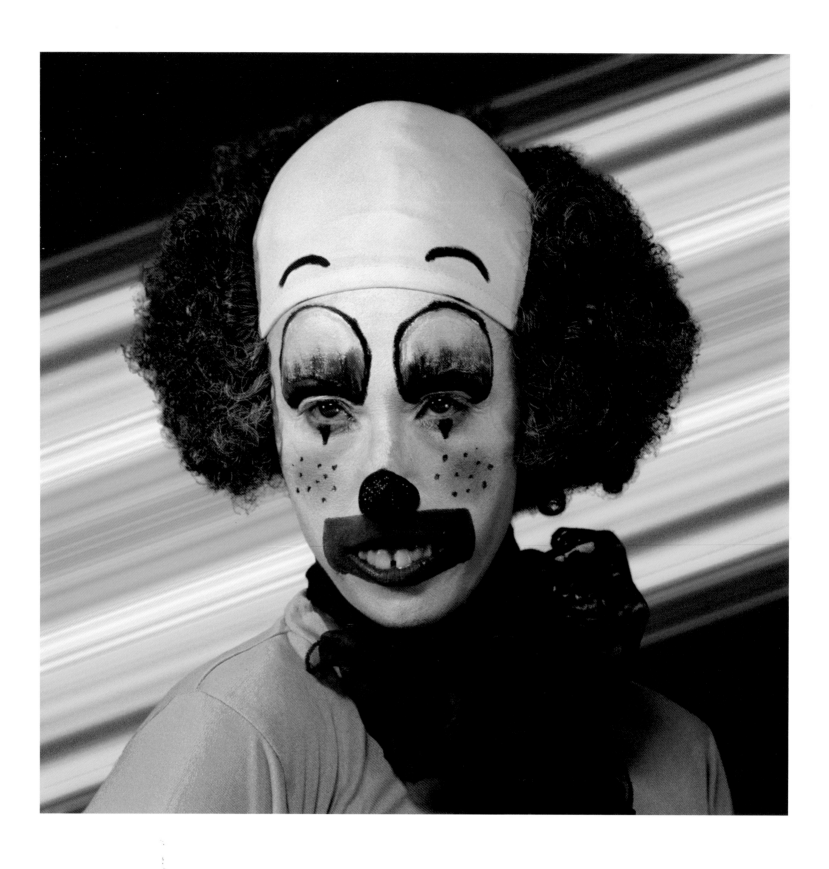

PLATE 102. Untitled #424. 2004

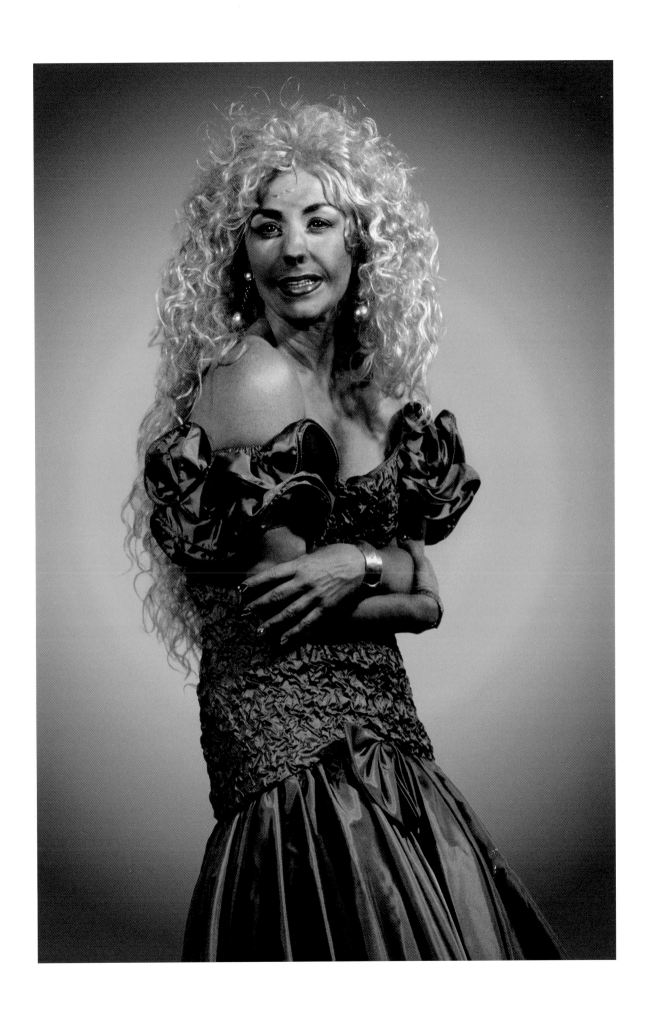

PLATE 103. Untitled #408. 2002

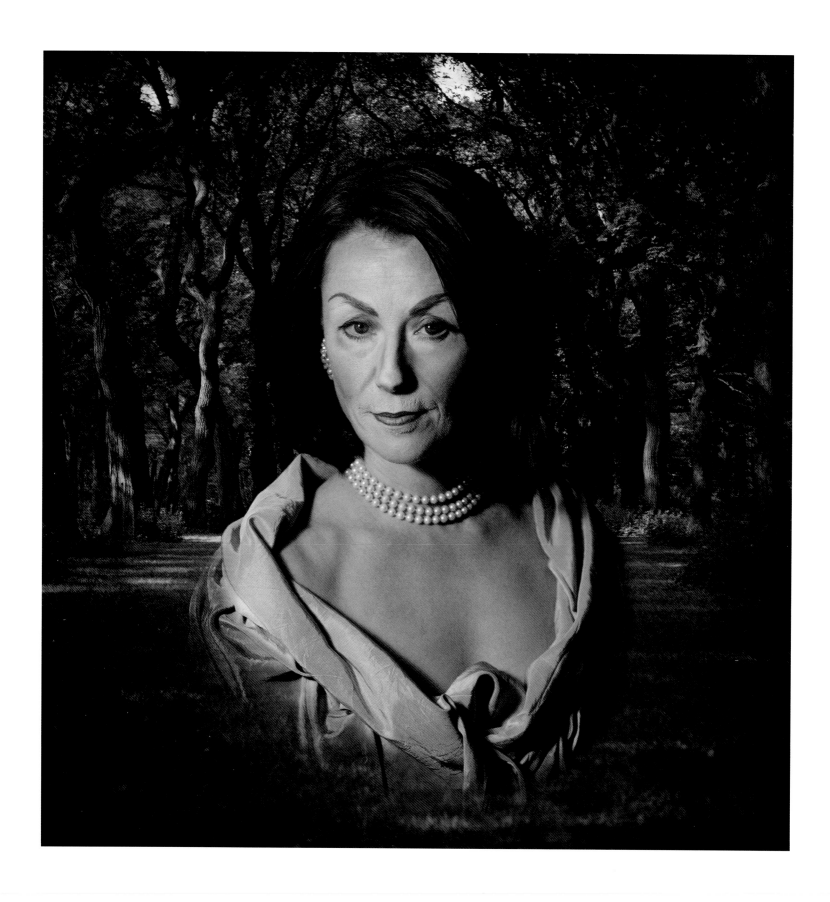

PLATE 104. Untitled #469. 2008

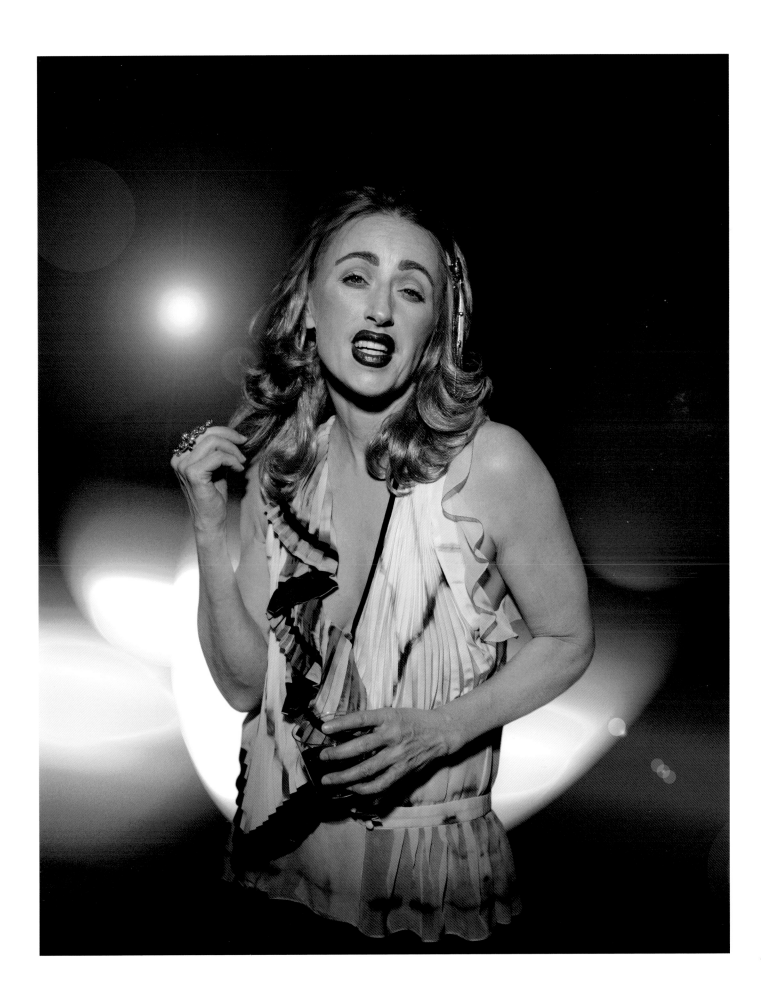

157

PLATE 105. Untitled #461. 2007–08

(top) PLATE 106. Untitled #70. 1980

(bottom) PLATE 107. Untitled #66. 1980

PLATE 108. Untitled #74. 1980

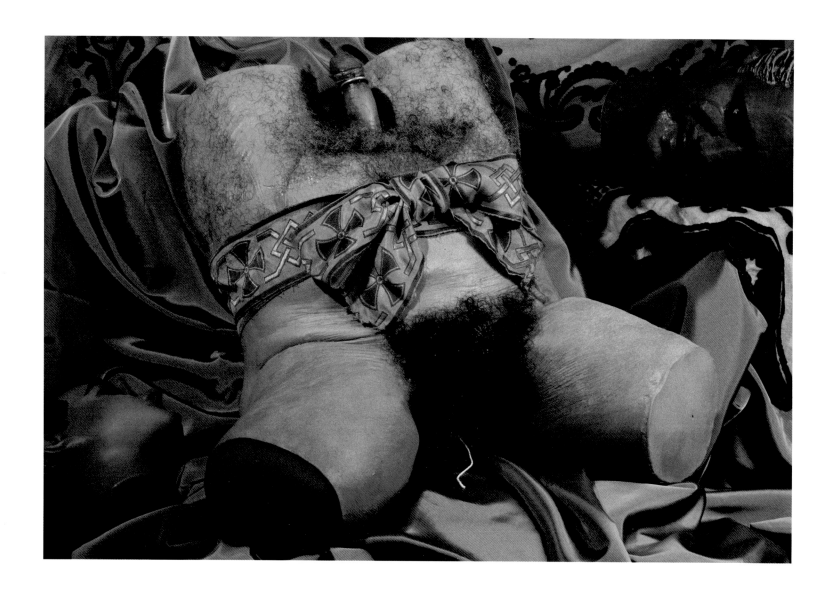

PLATE 109. Untitled #263. 1992

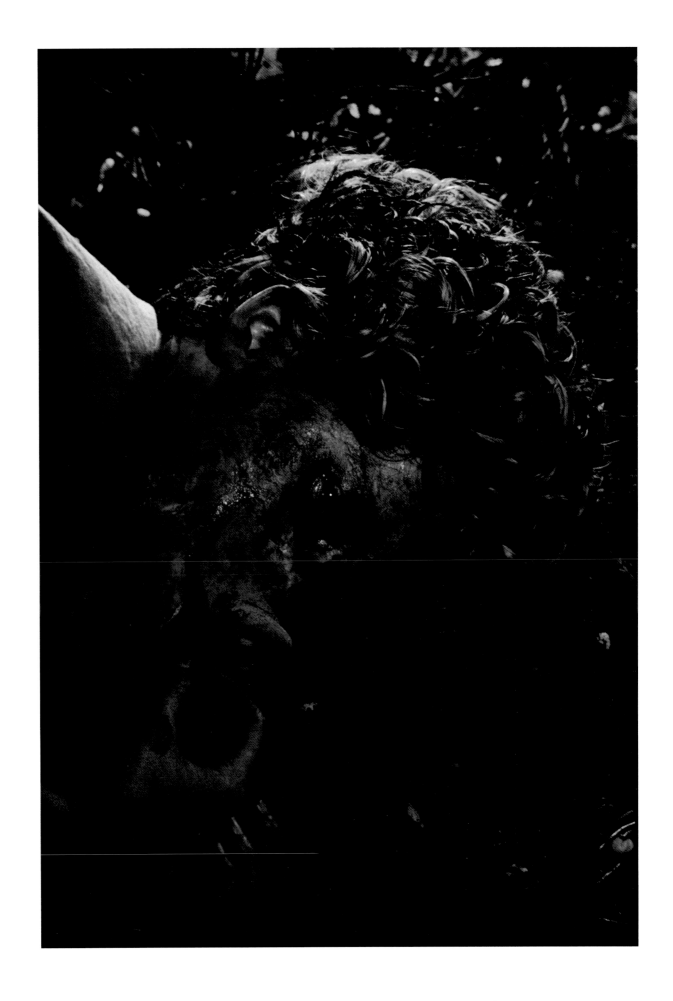

PLATE 110. Untitled #140. 1985

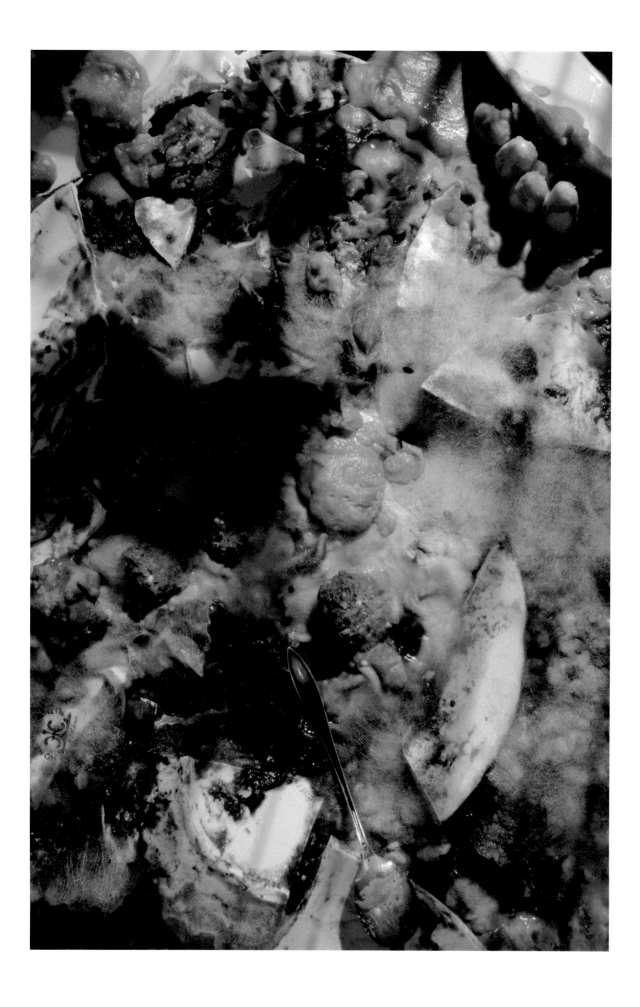

PLATE 111. Untitled #182. 1987 164

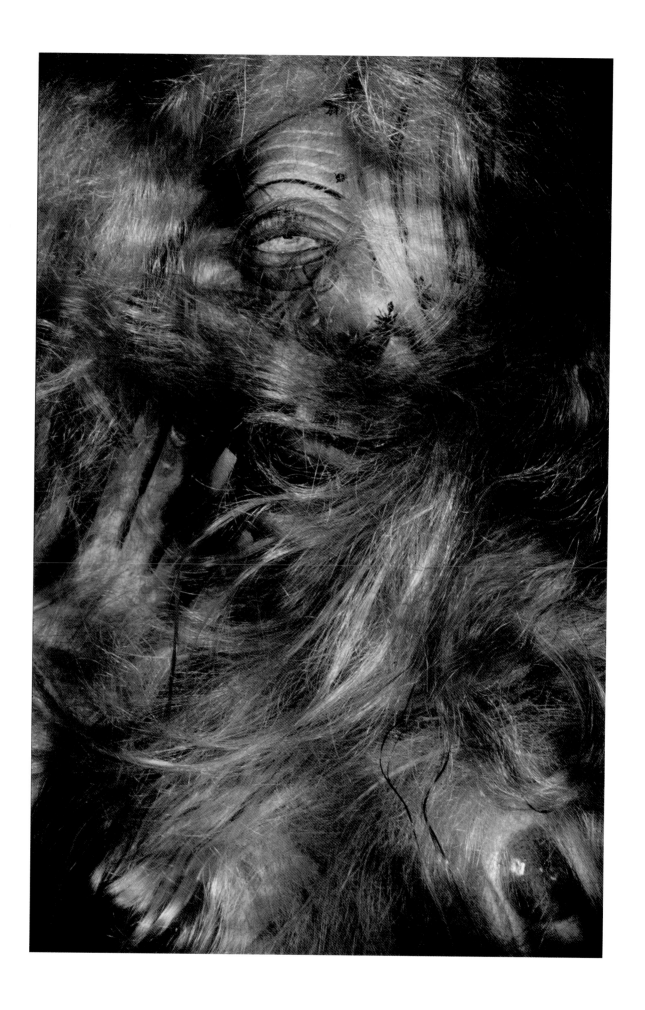

PLATE 112. Untitled #191. 1989

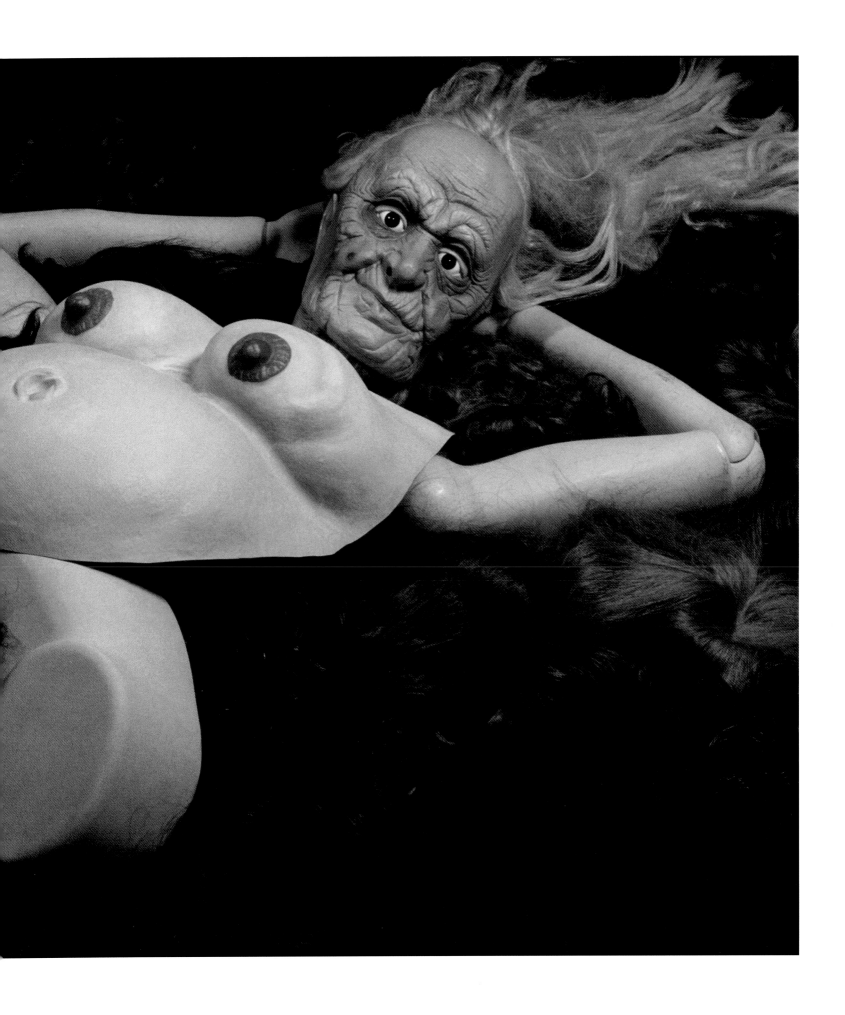

PLATE 113. Untitled #250. 1992

PLATE 114. Untitled #190. 1989 168

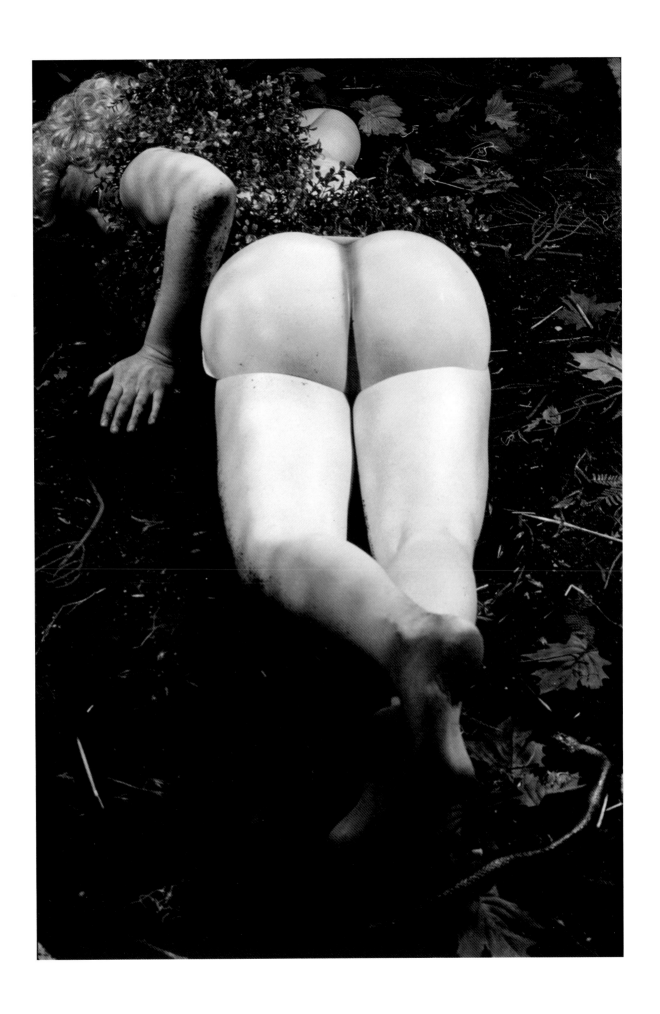

PLATE 115. Untitled #155. 1985

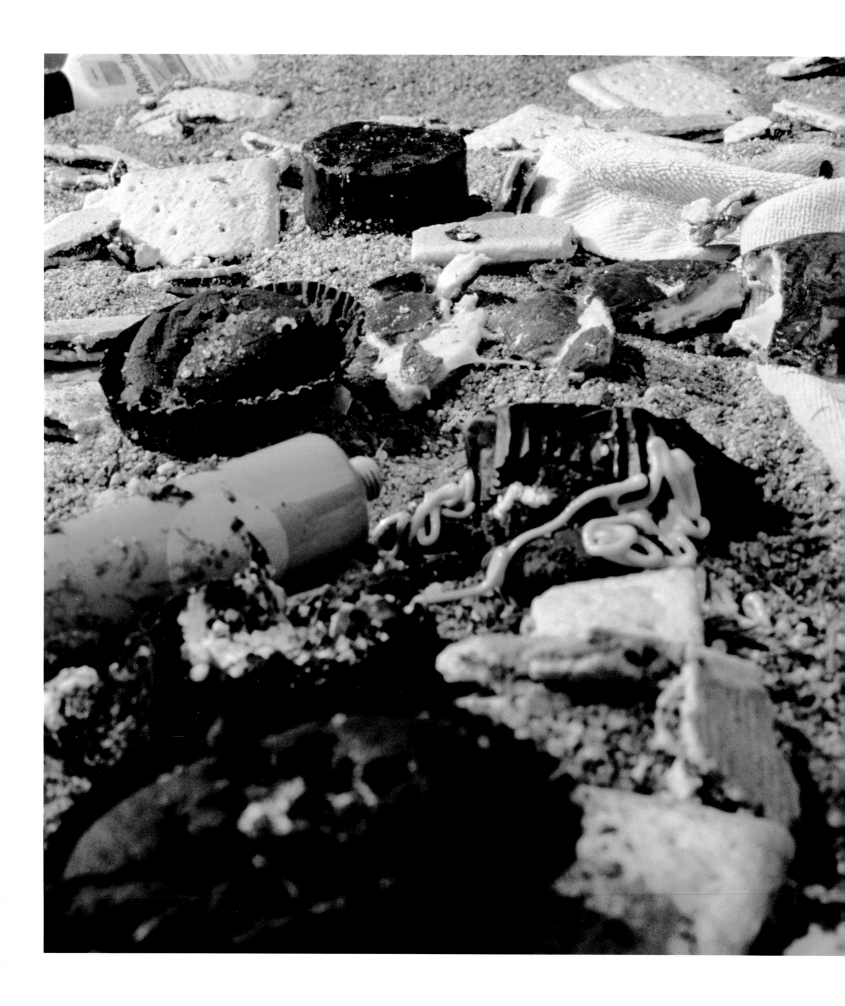

PLATE 116. Untitled #175. 1987

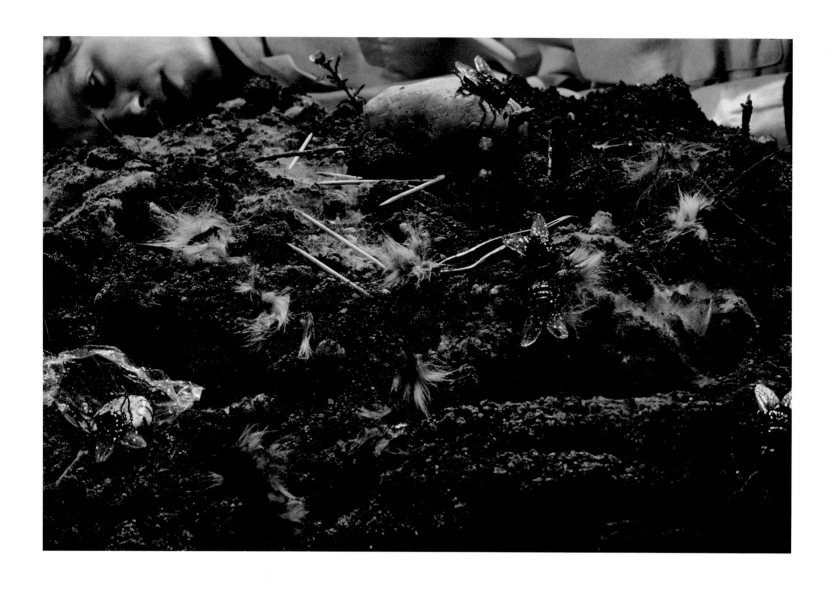

PLATE 117. Untitled #173. 1986

172

PLATE 118. Untitled #177. 1987

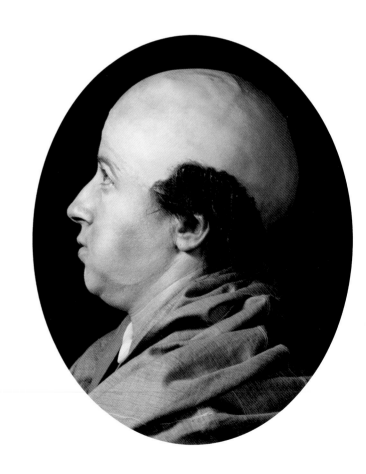

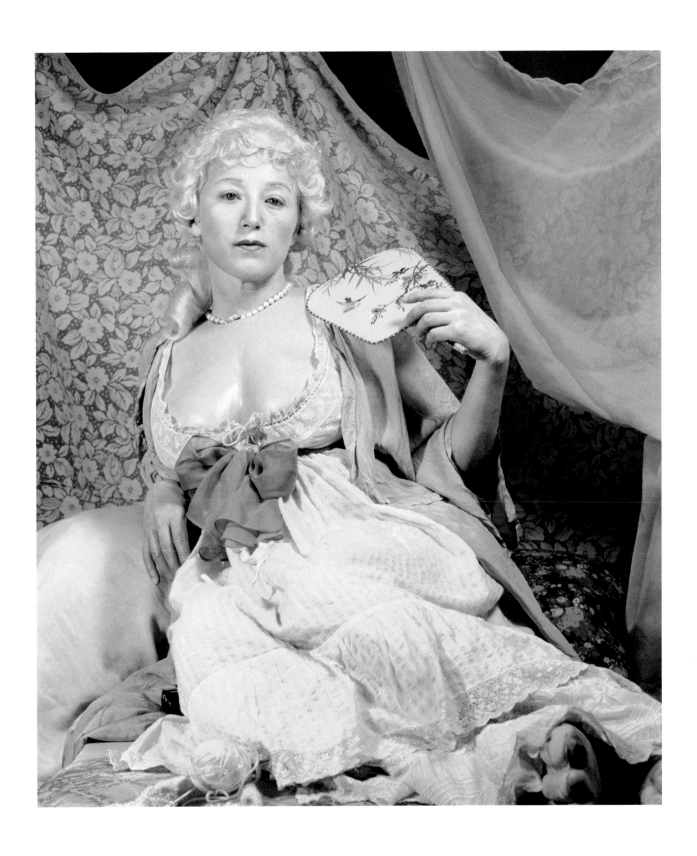

PLATE 122. Untitled #193. 1989

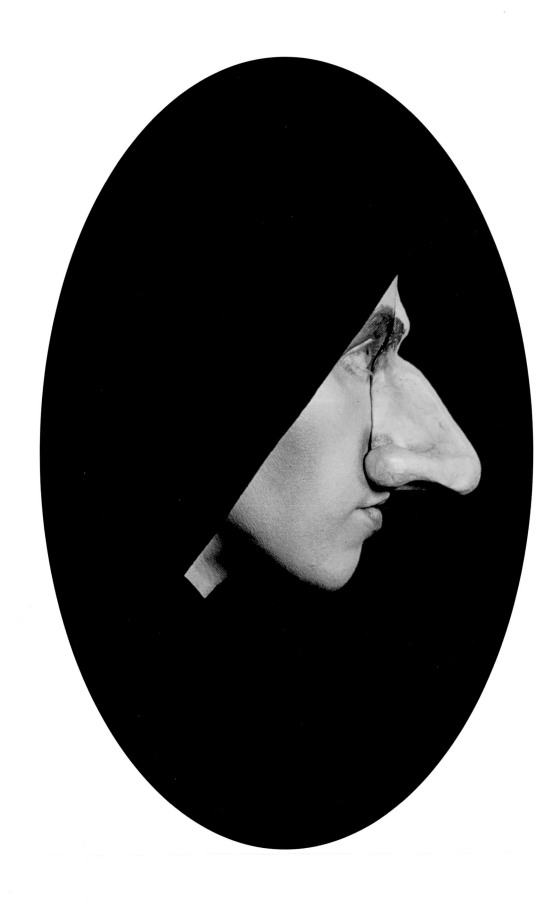

PLATE 123. Untitled #219. 1990

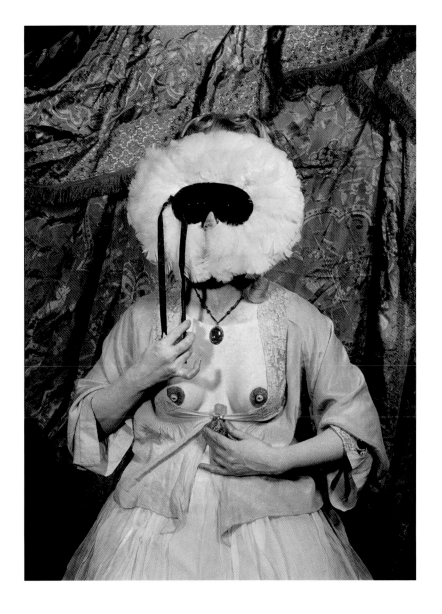

179

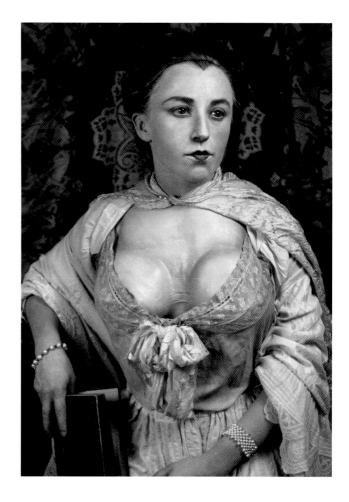

(top) PLATE 127. Untitled #204. 1989

(center) PLATE 128. Untitled #183. 1988

(bottom) PLATE 129. Untitled #215. 1989

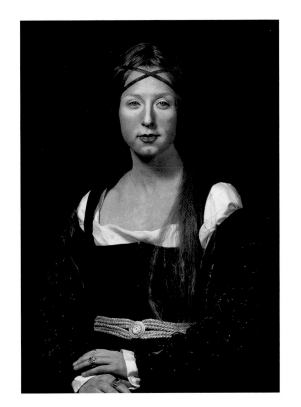

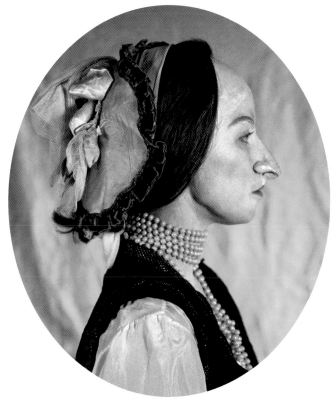

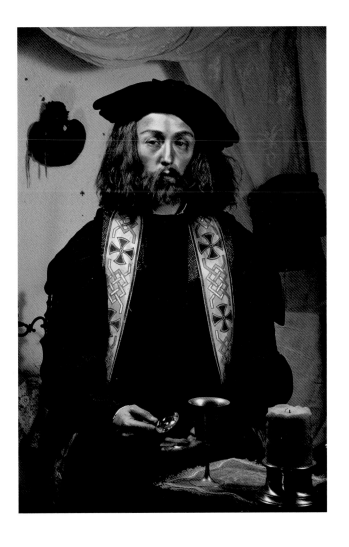

181

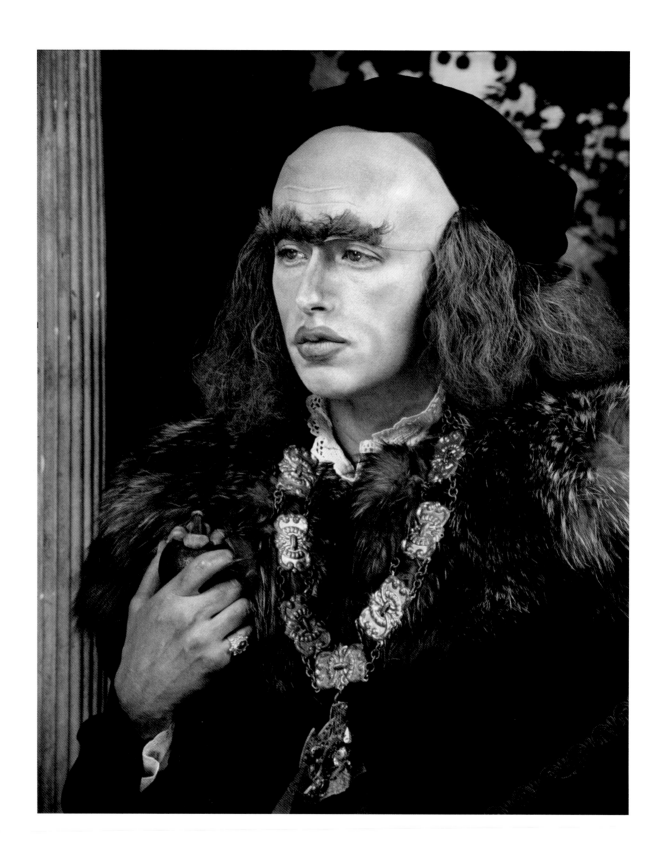

PLATE 133. Untitled #213. 1989 182

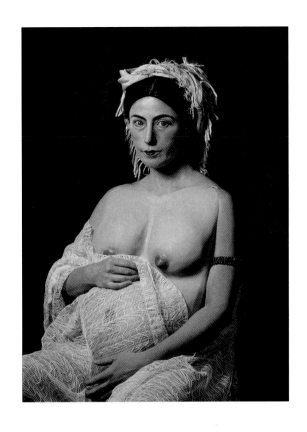

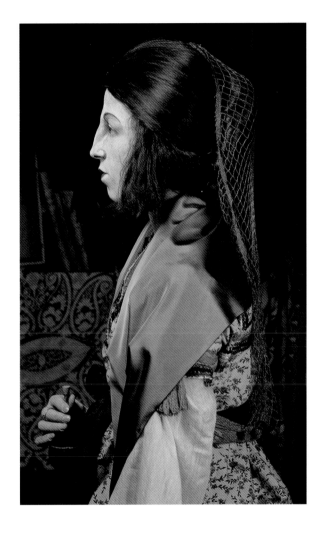

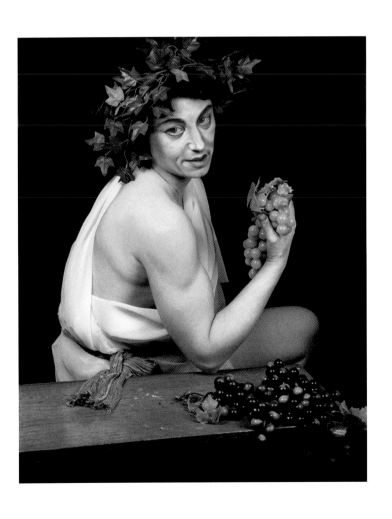

183

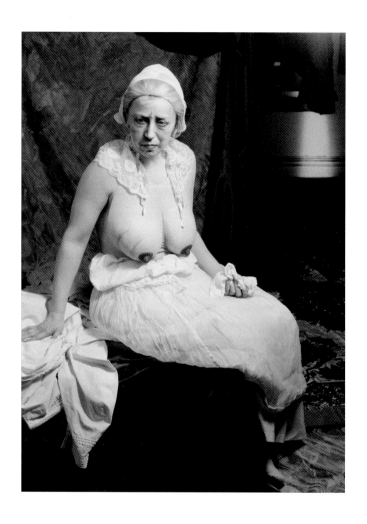

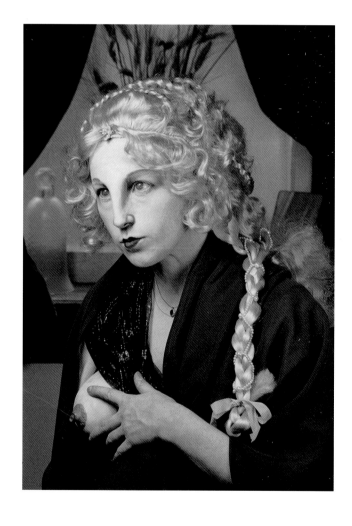

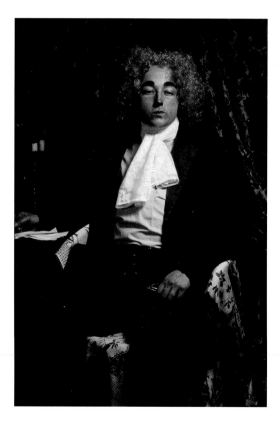

(top) PLATE 137. Untitled #222. 1990

(center) PLATE 138. Untitled #225. 1990

(bottom) PLATE 139. Untitled #201. 1989

184

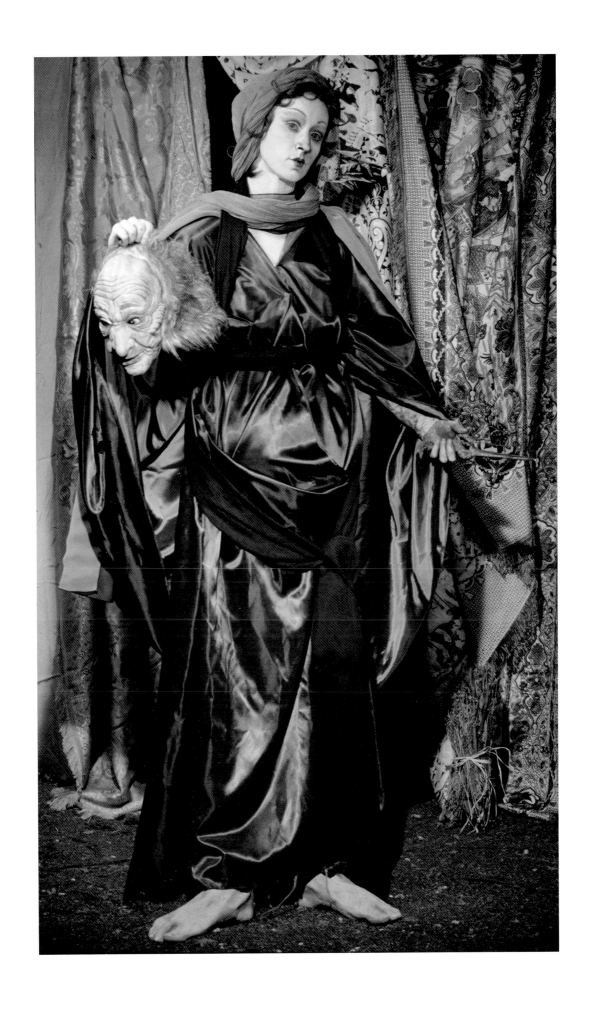

PLATE 140. Untitled #228. 1990

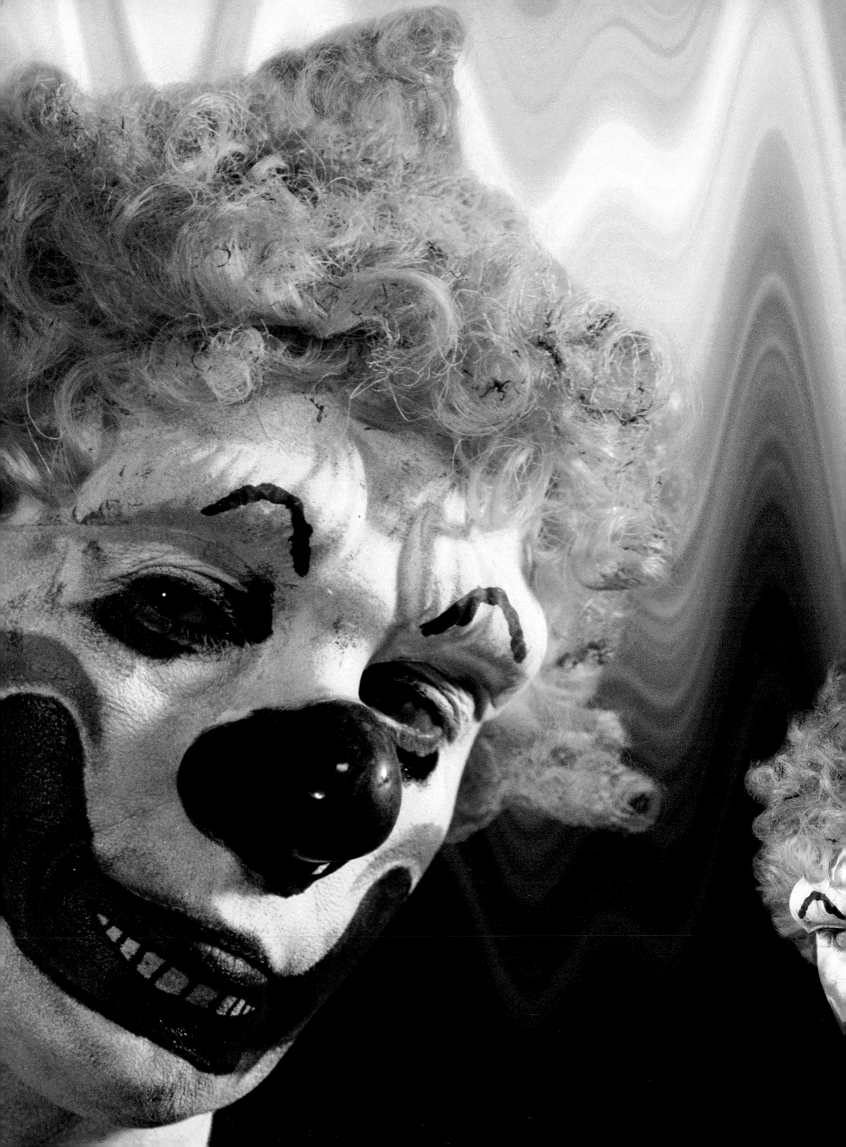

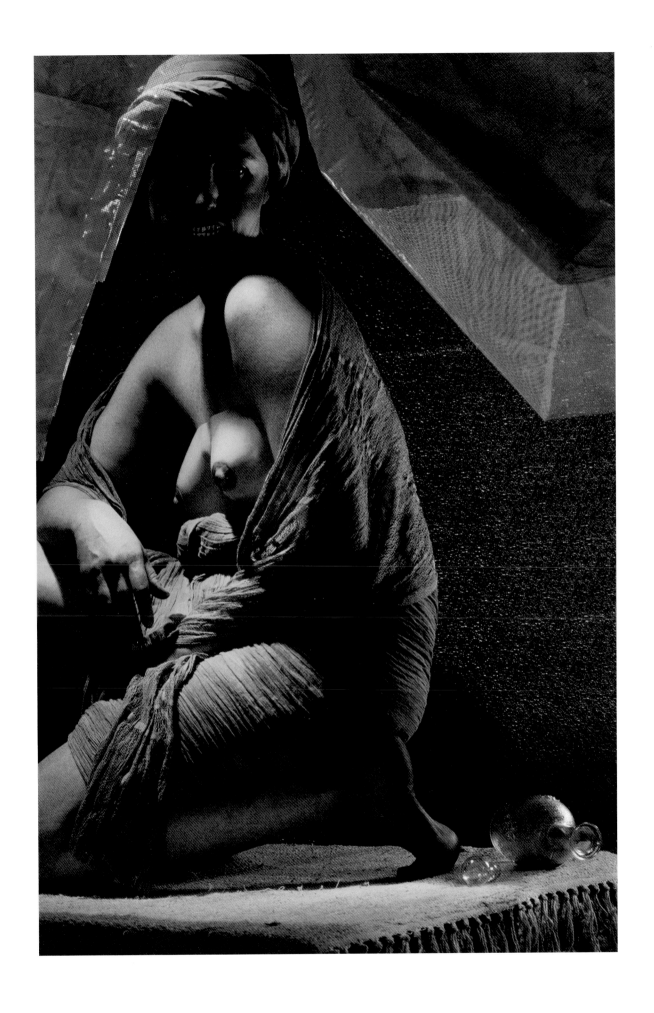

PLATE 141. Untitled #146. 1985

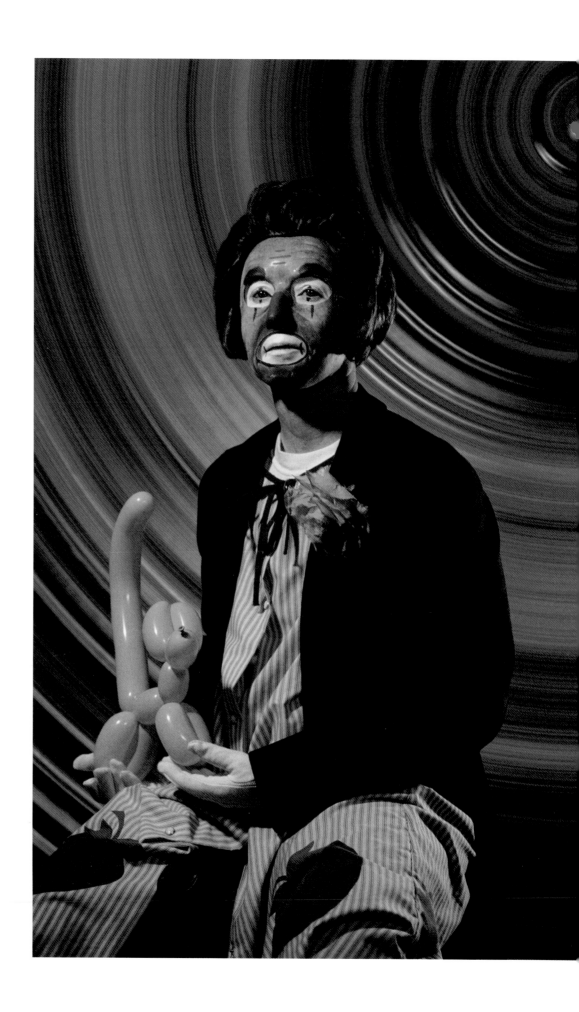

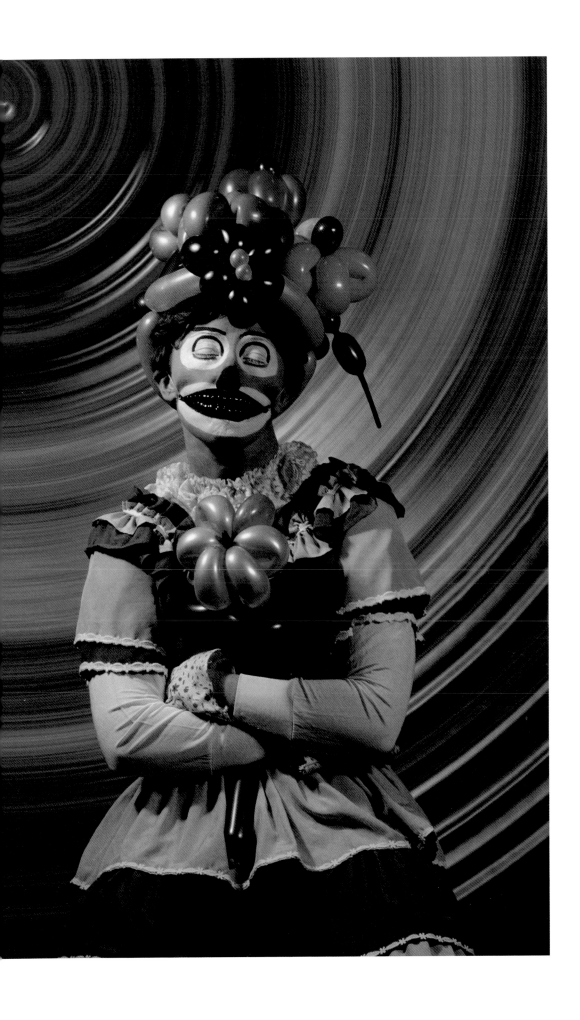

PLATE 142. Untitled #420. 2004

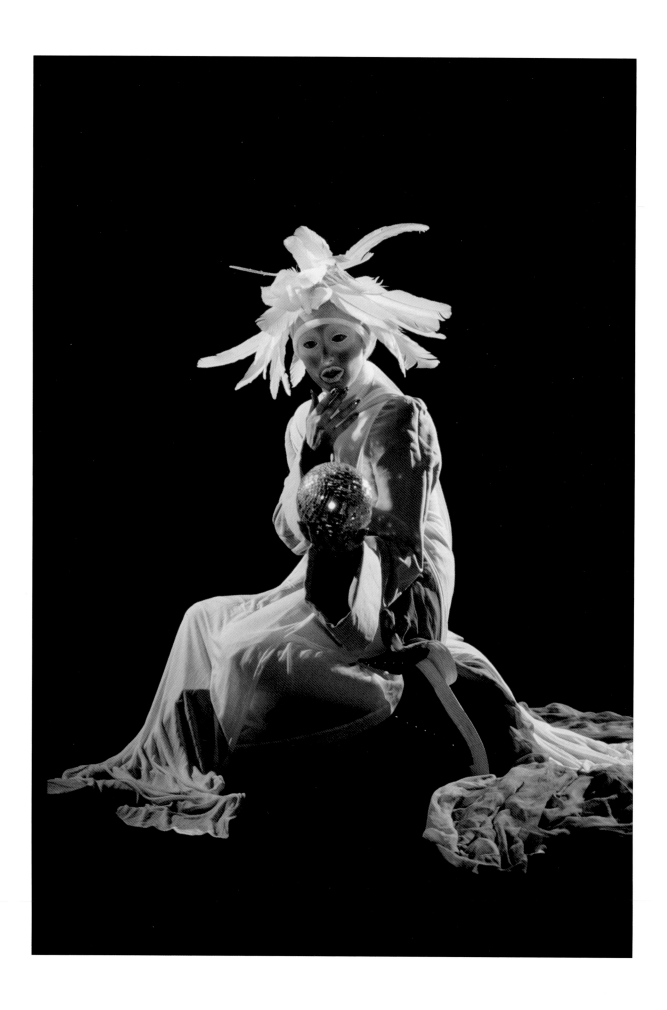

PLATE 143. Untitled #296. 1994

192

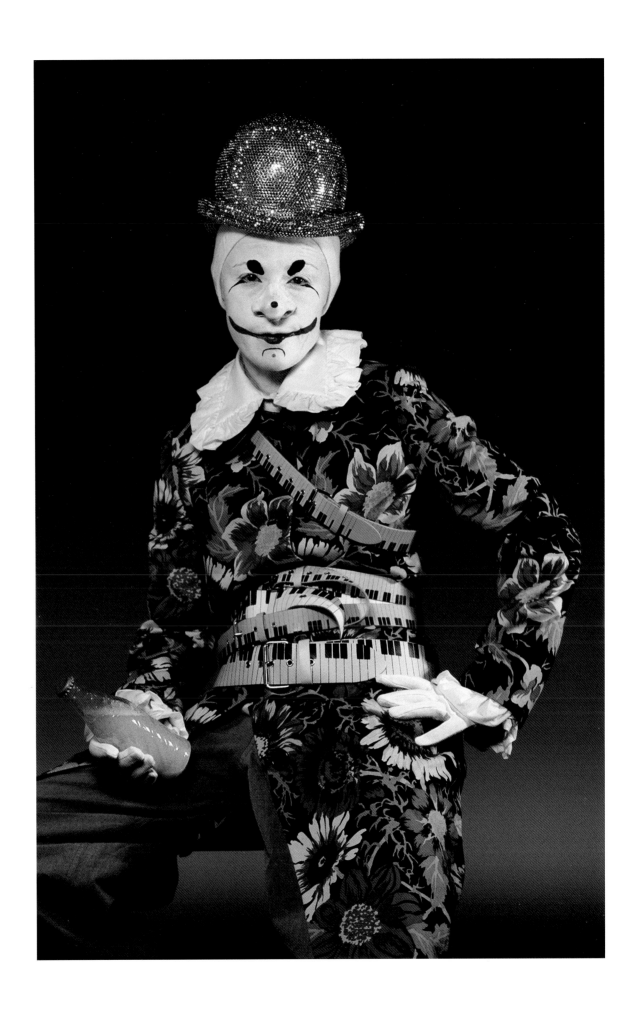

PLATE 144. Untitled #415. 2004

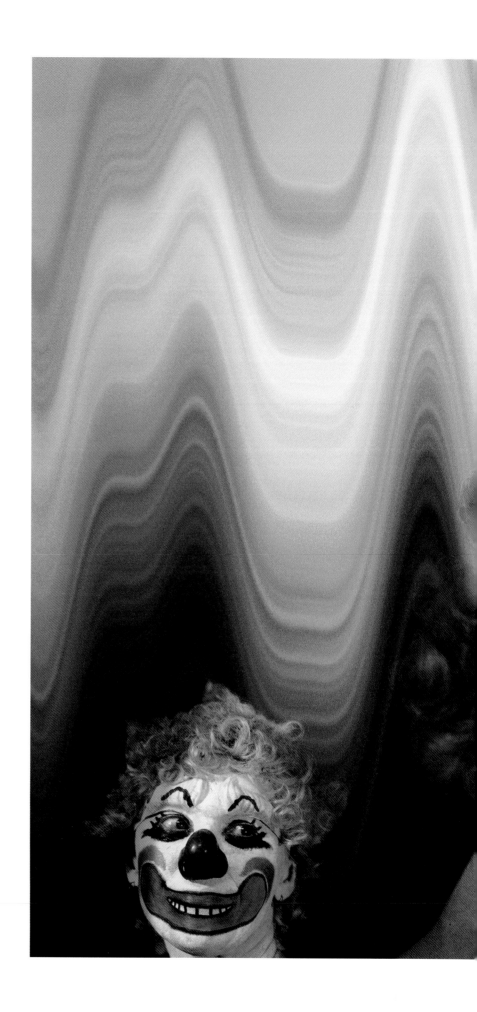

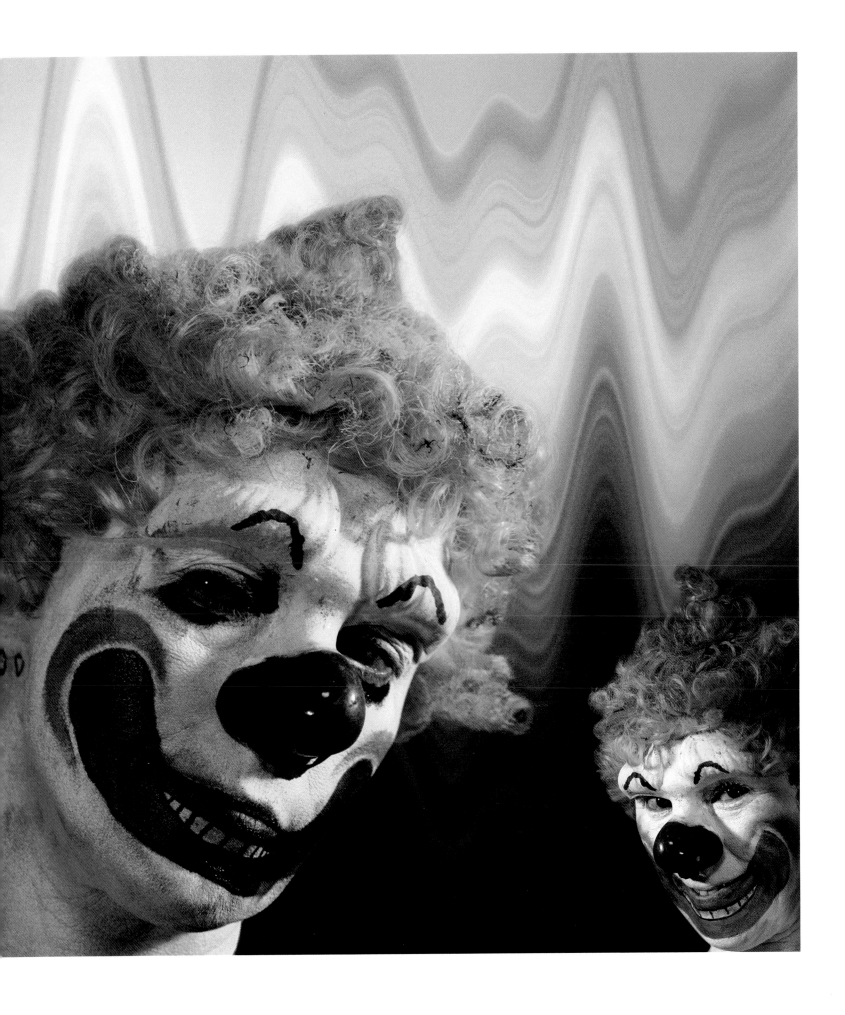

PLATE 145. Untitled #417. 2004

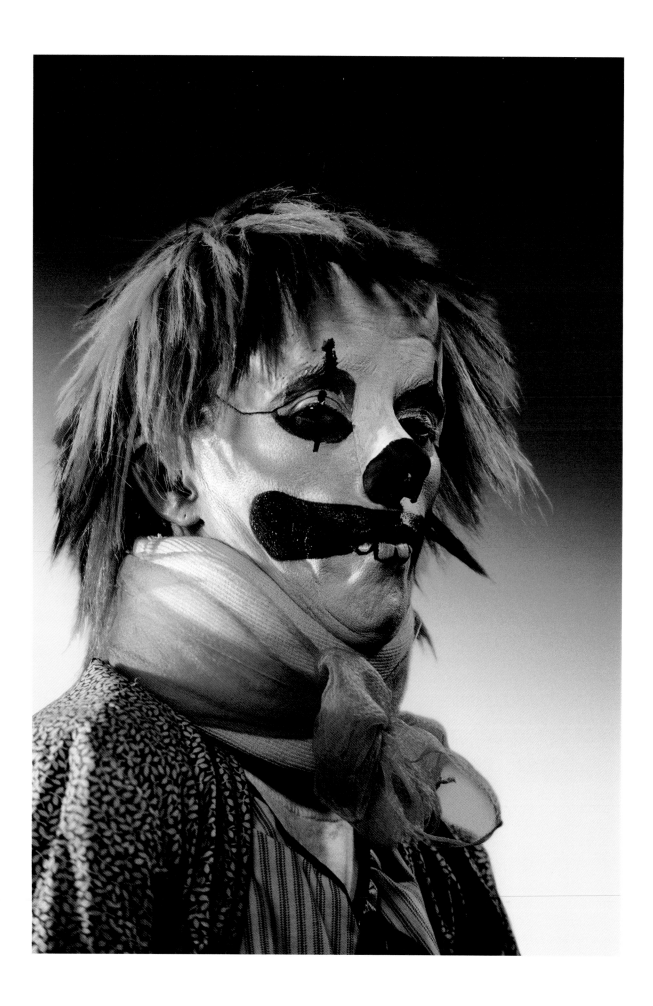

PLATE 146. Untitled #411. 2003 196

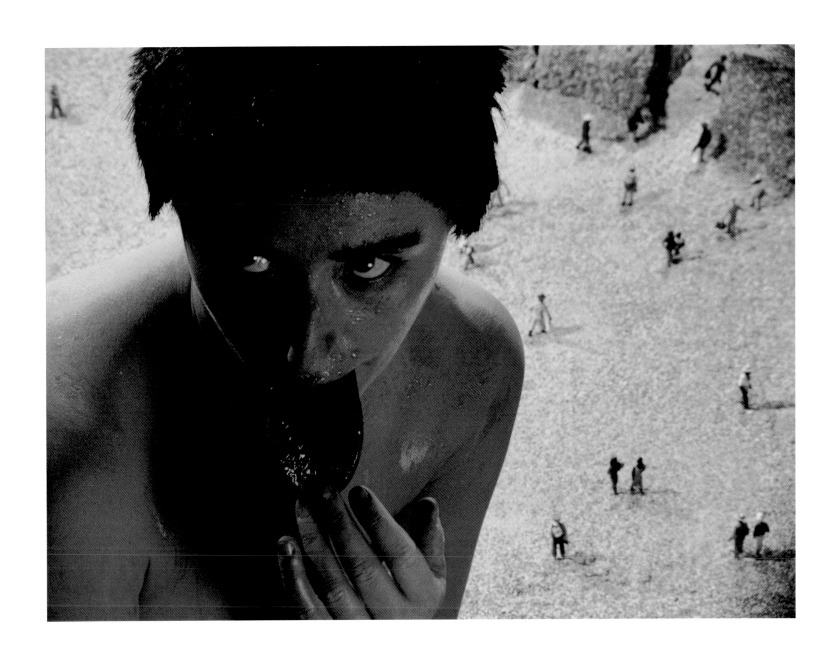

PLATE 147. Untitled #150. 1985

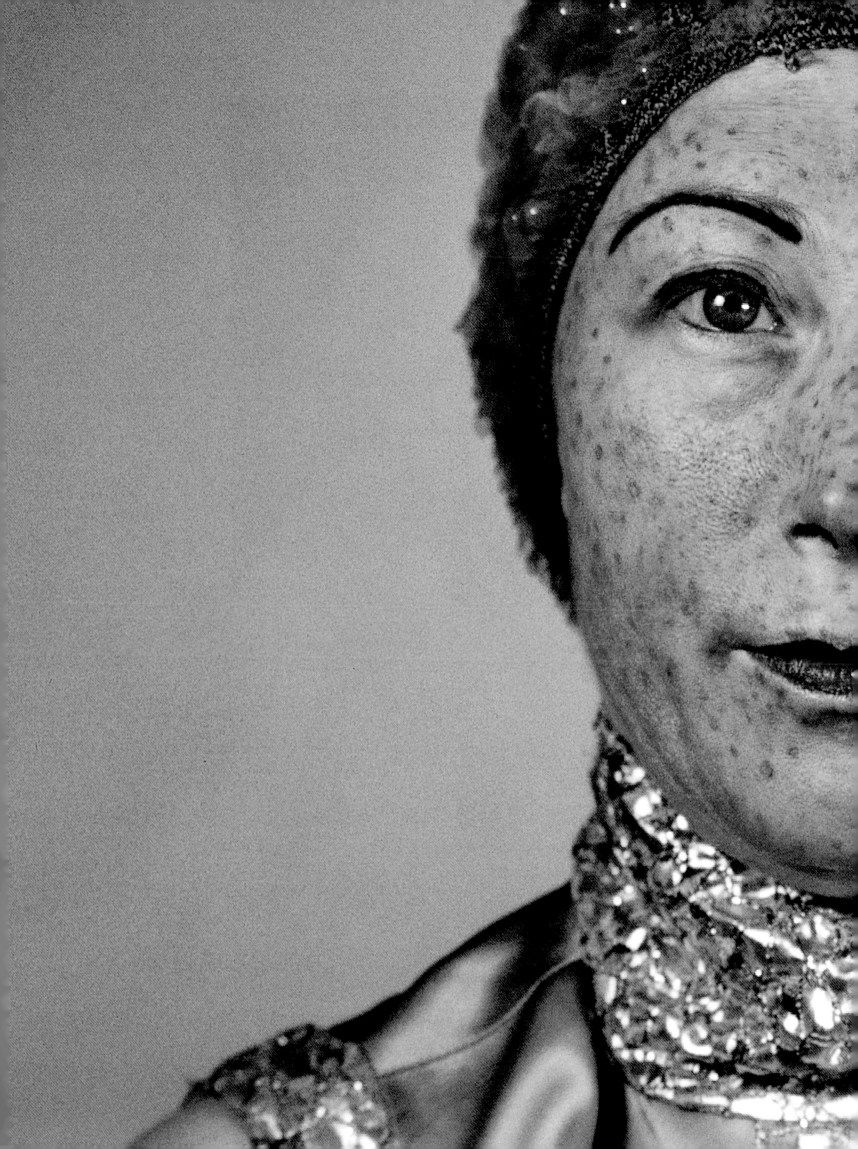

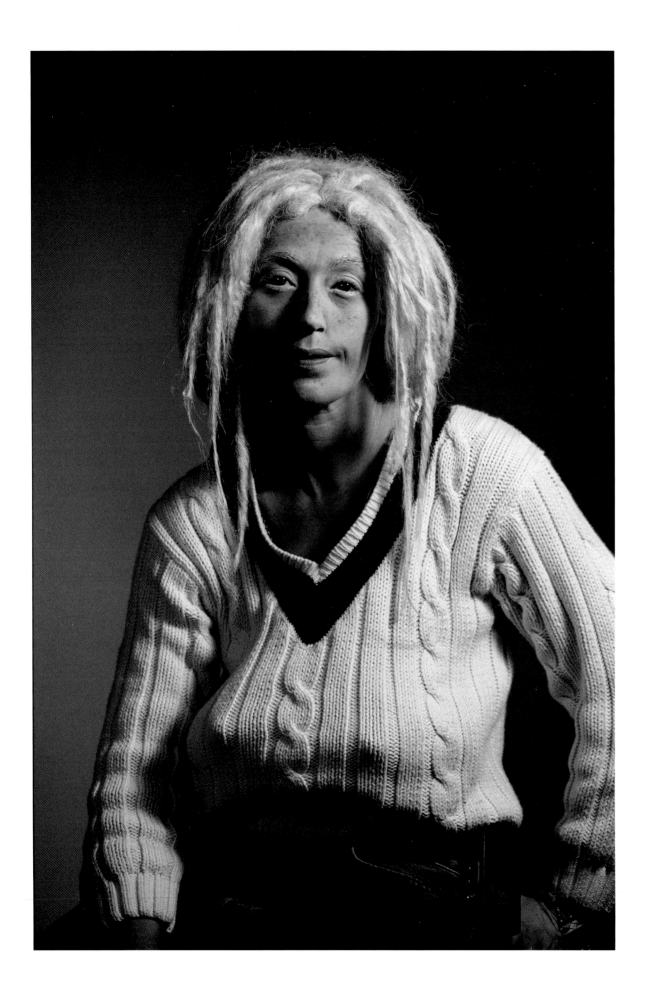

PLATE 148. Untitled #399. 2000

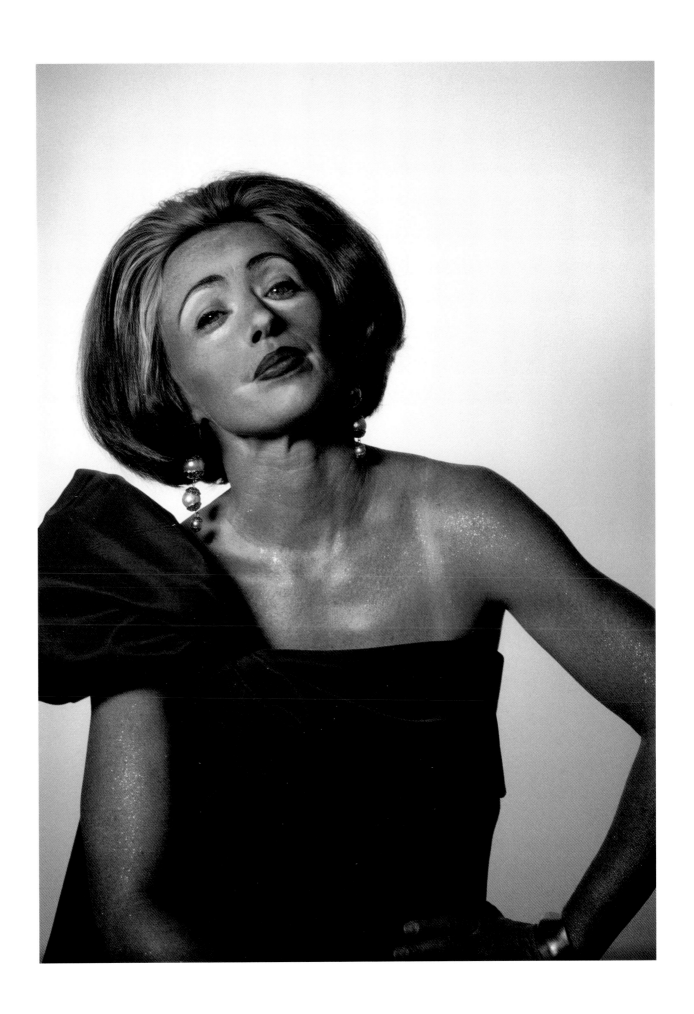

PLATE 149. Untitled #400. 2000

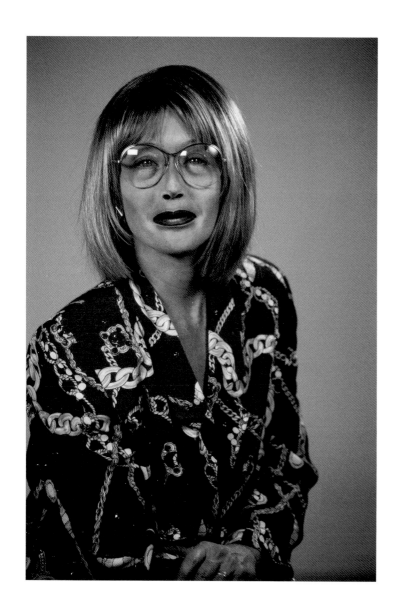

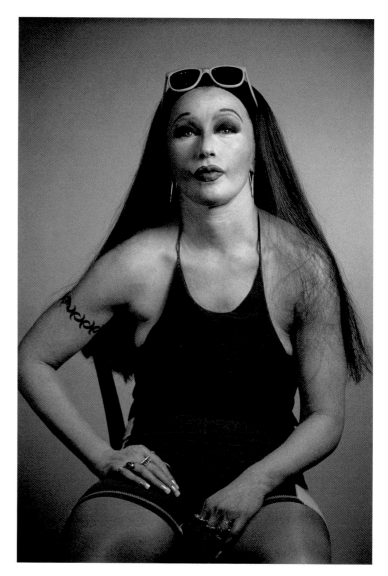

(left) PLATE 150. Untitled #405. 2000

(right) PLATE 151. Untitled #355. 2000

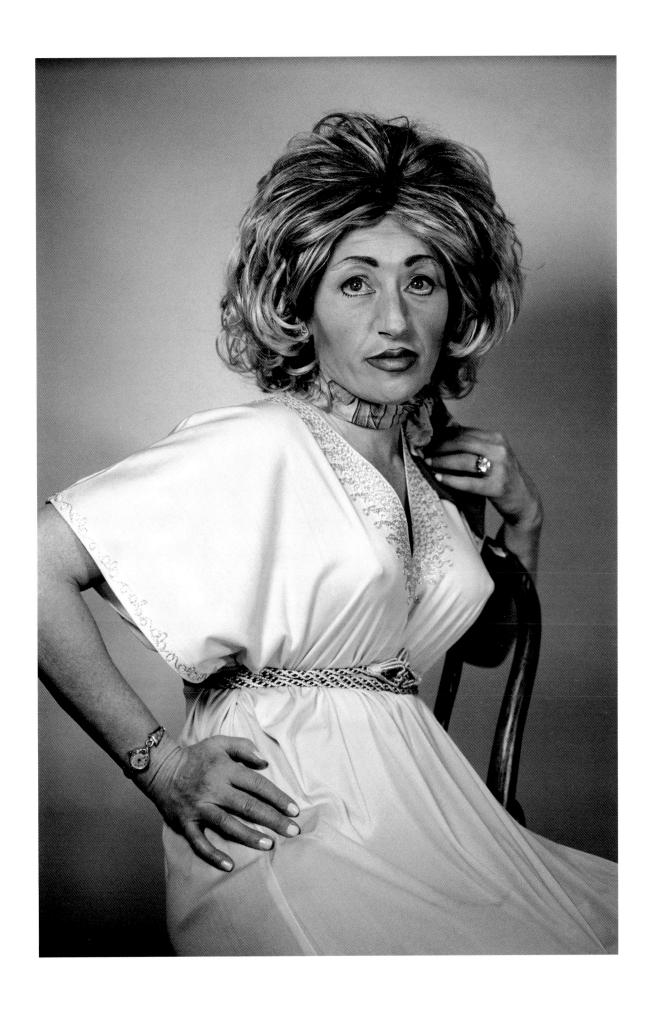

PLATE 152. Untitled #353. 2000

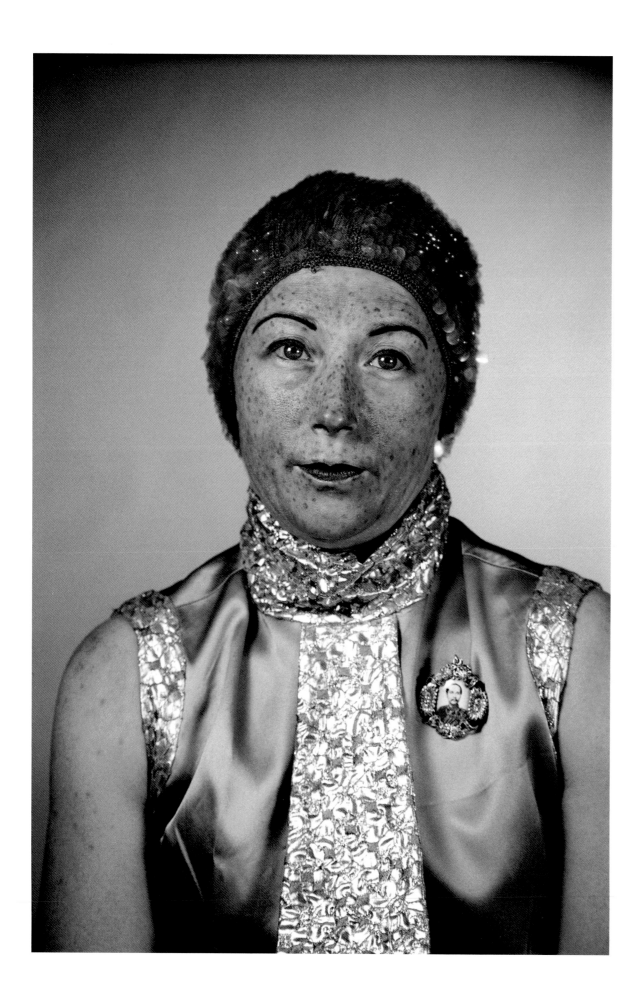

PLATE 153. Untitled #351. 2000

204

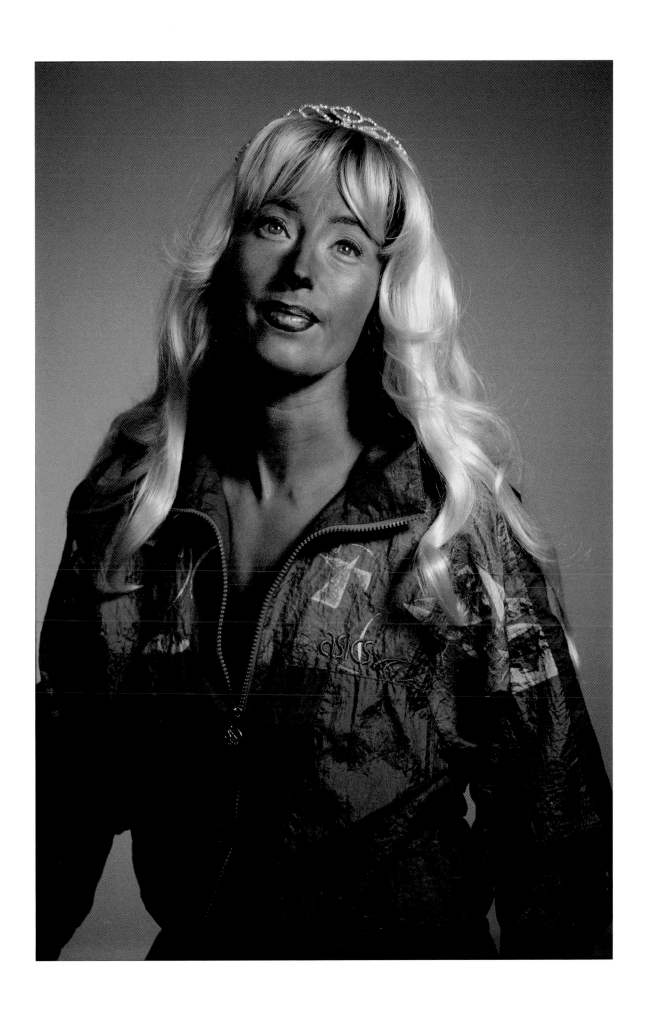

PLATE 154. Untitled #397. 2000

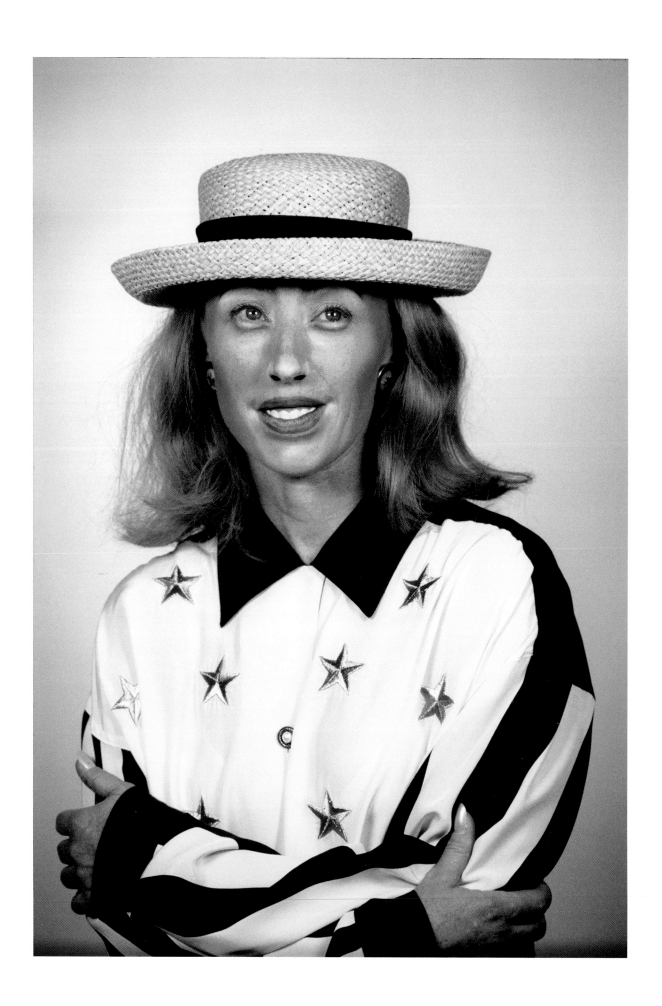

PLATE 155. Untitled #402. 2000 206

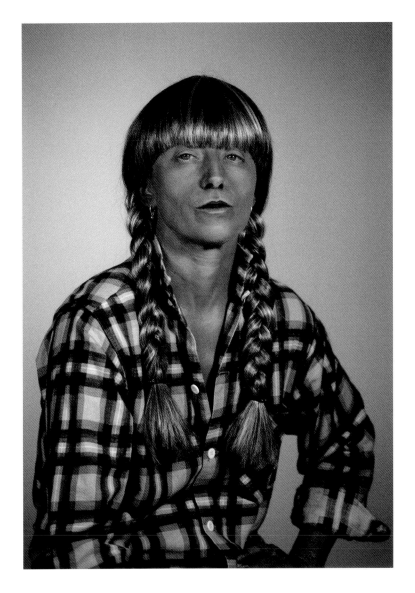

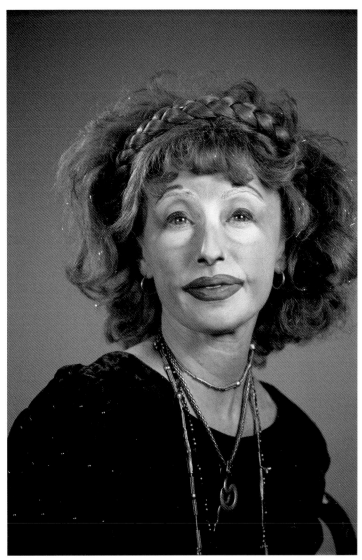

207

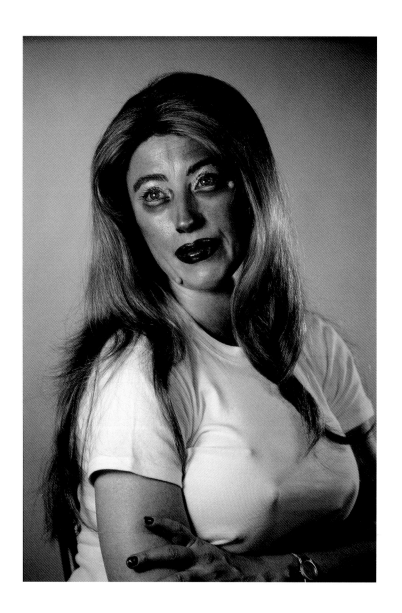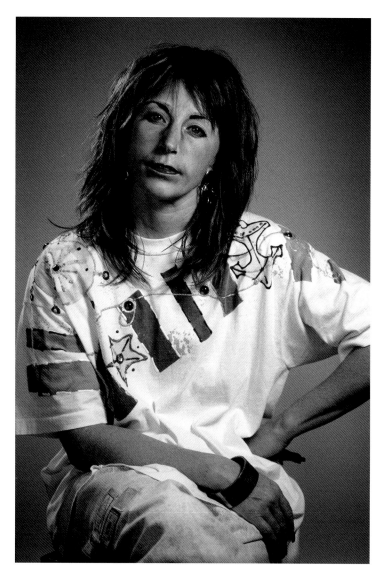

(left) PLATE 158. Untitled #360. 2000

(right) PLATE 159. Untitled #396. 2000

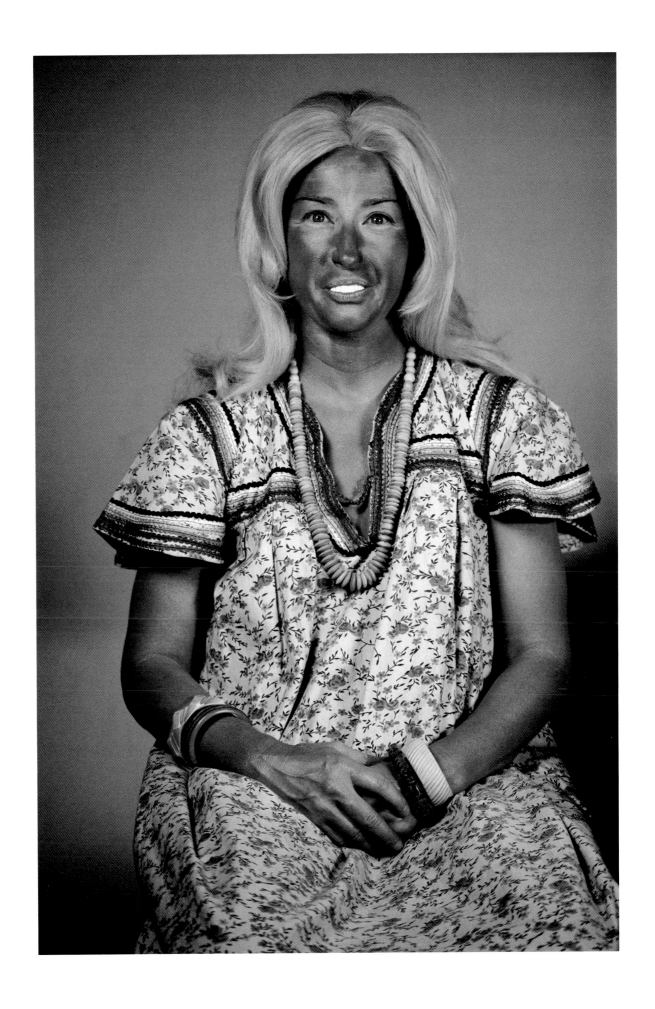

PLATE 160. Untitled #354. 2000

PLATE 161. Untitled #425. 2004

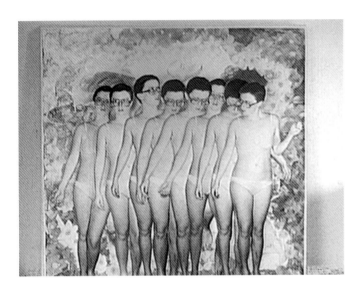

PLATE 162. Stills from *Doll Clothes*. 1975

PLATE 163. Untitled #475. 2008

PLATE 164. Untitled #463. 2007–08

(top) PLATE 165. Untitled #489. 1976

(bottom) PLATE 166. Untitled #488. 1976

PLATE 167. Untitled #470. 2008

222

PLATE 168. Untitled #476. 2008

PLATE 169. Untitled #474. 2008

PLATE 170. Untitled #465. 2008

PLATE 171. Untitled #467. 2008

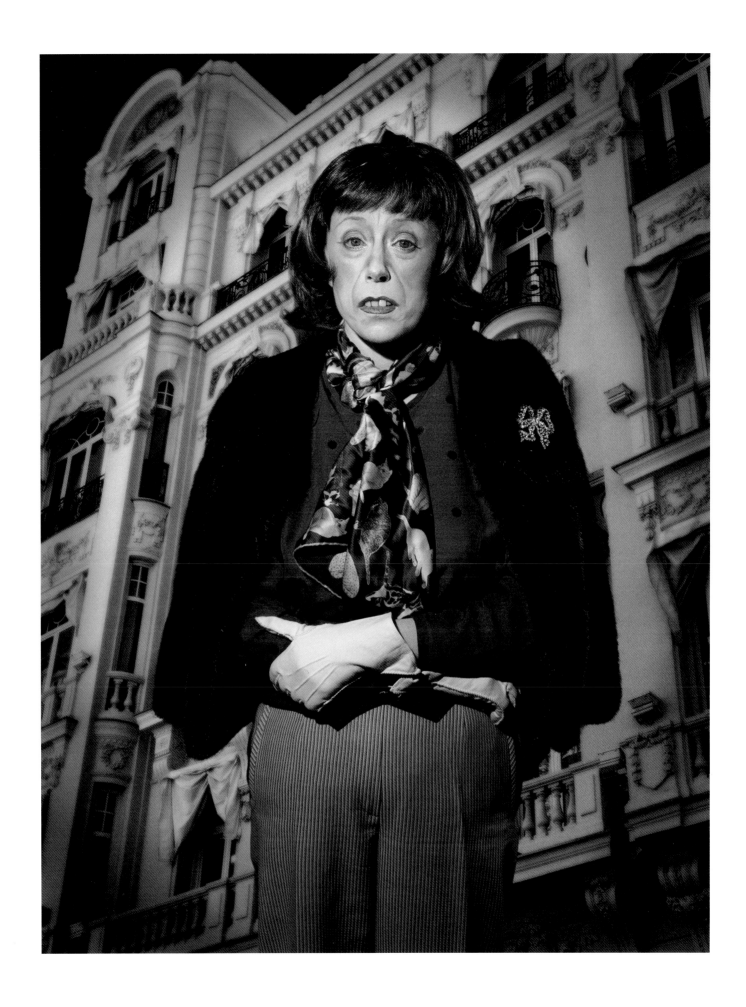

PLATE 172. Untitled #468. 2008

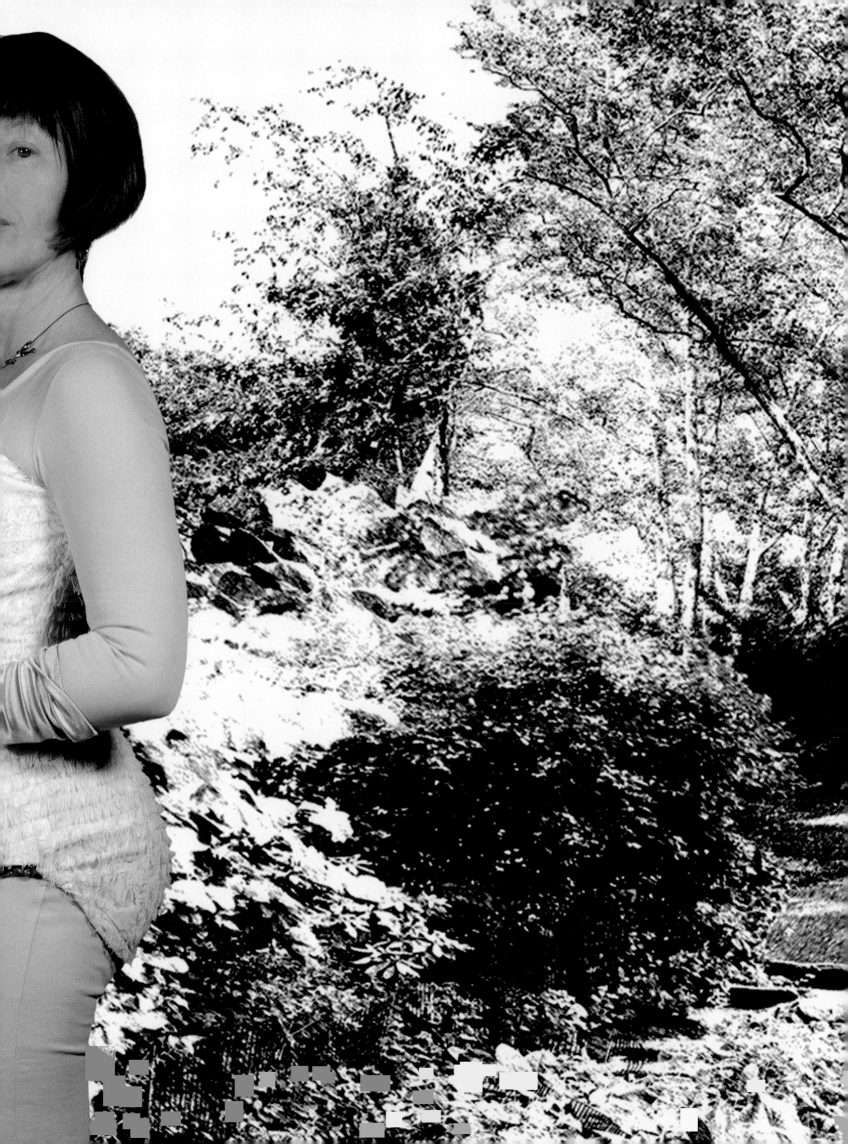

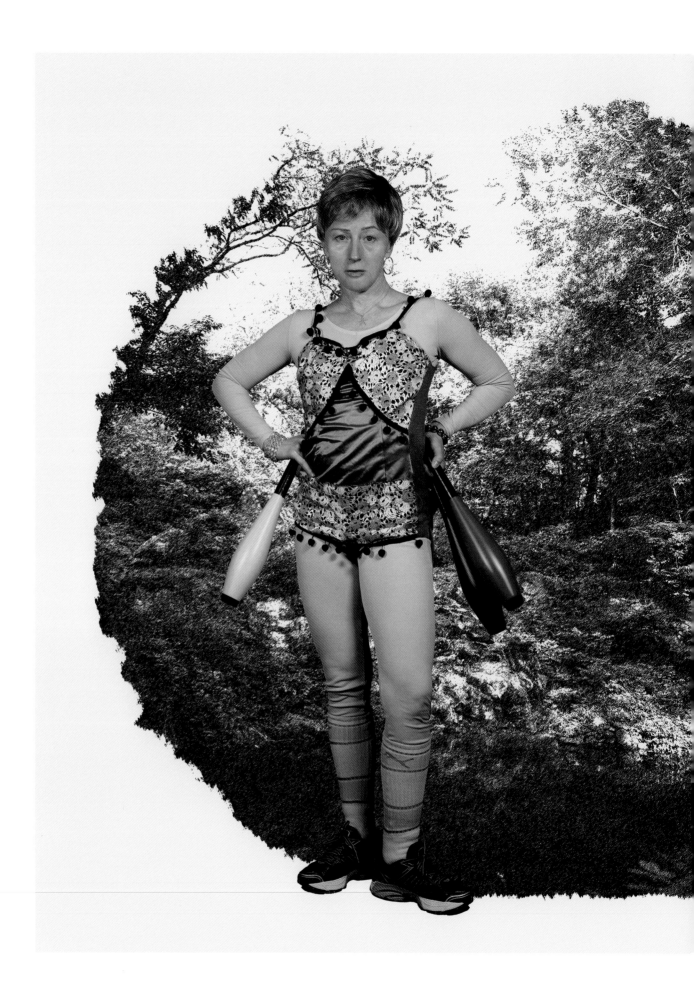

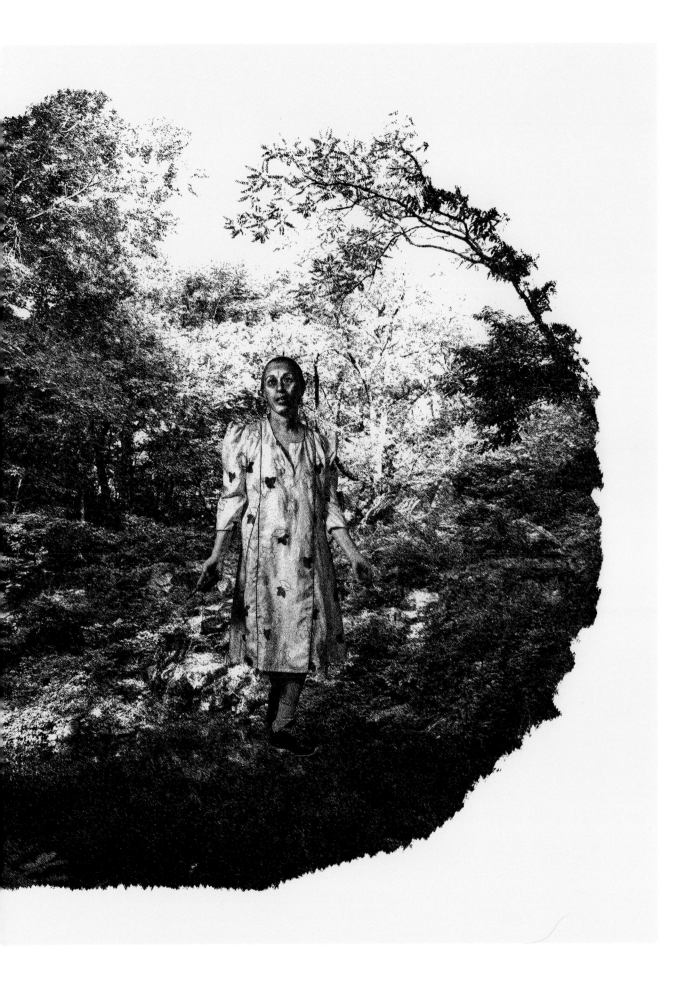

PLATE 173. Untitled. 2010

(following pages) PLATE 174. Untitled. 2010

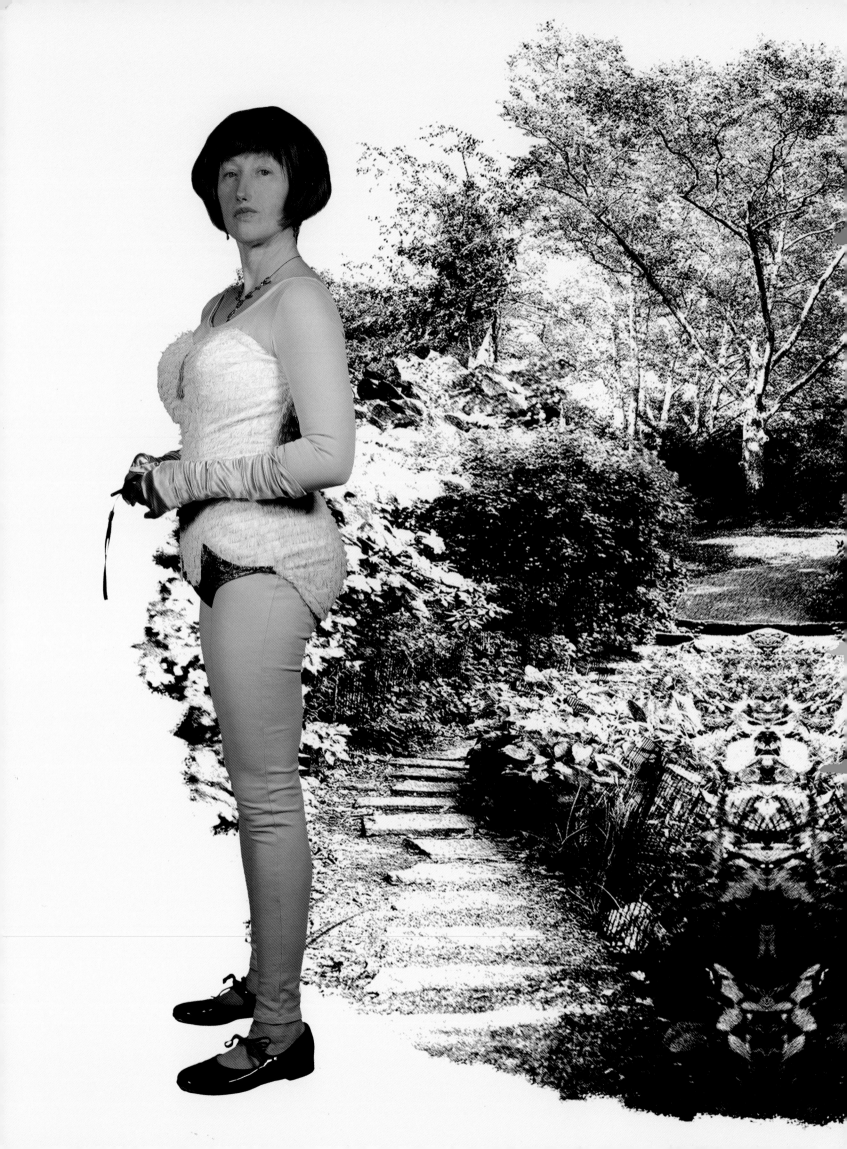

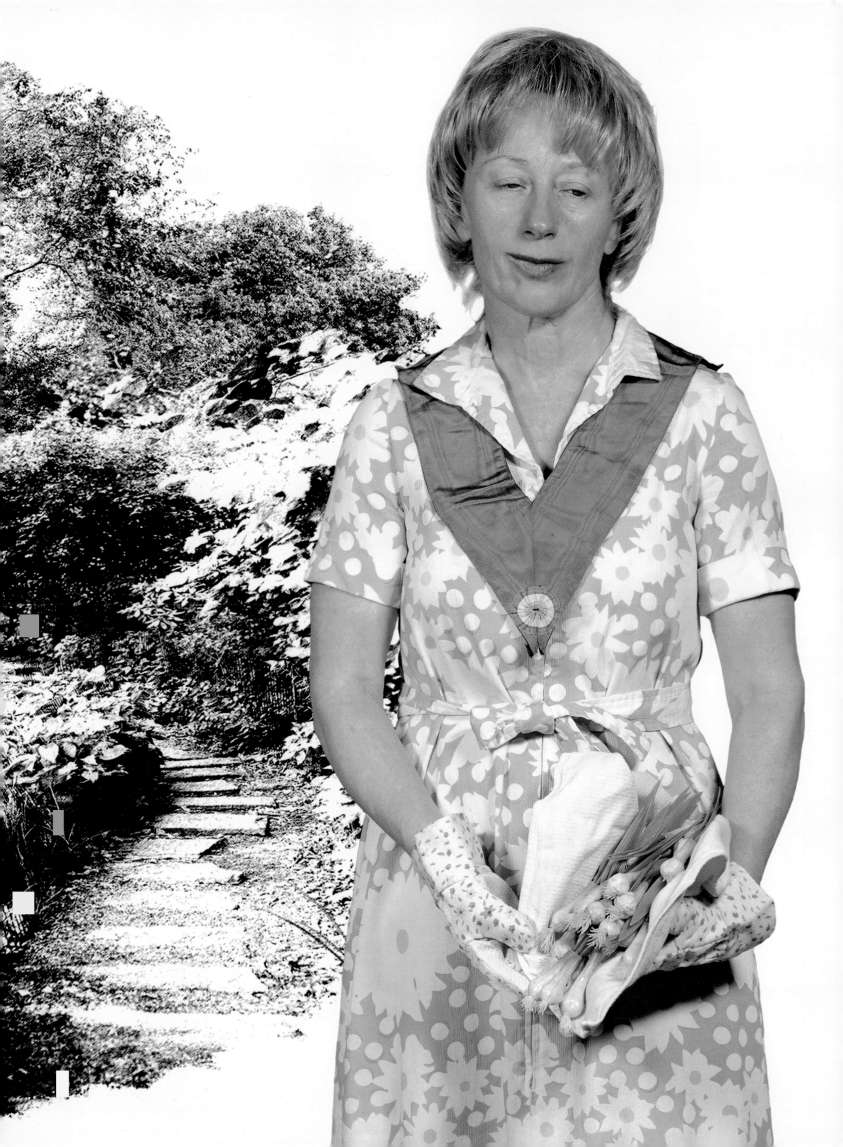

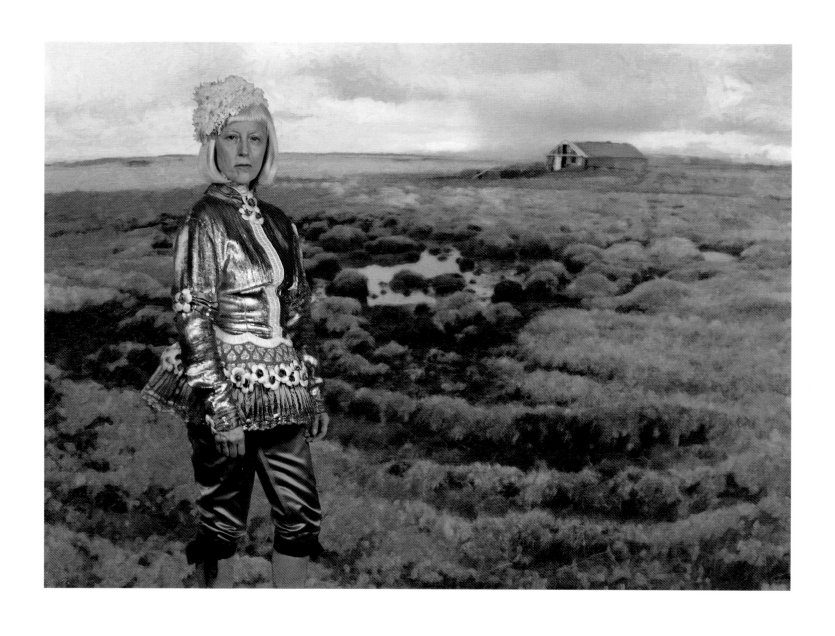

PLATE 175. Untitled #513. 2011 234

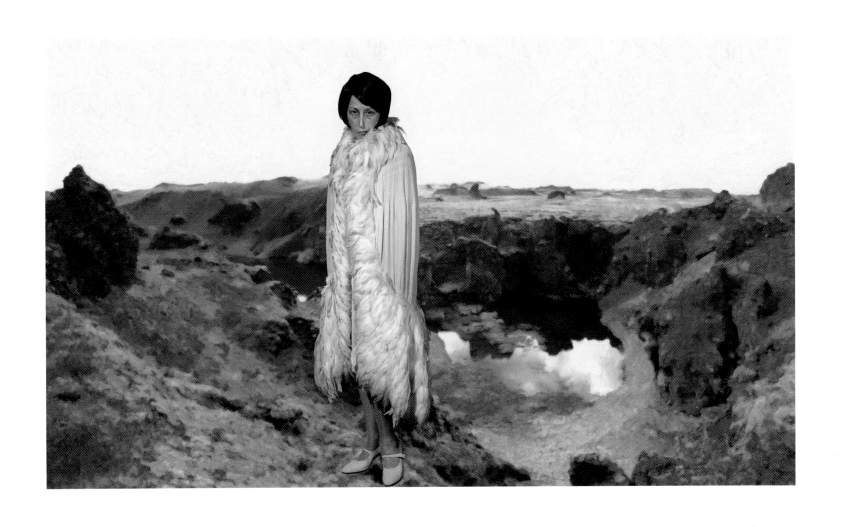

PLATE 176. Untitled #512. 2011

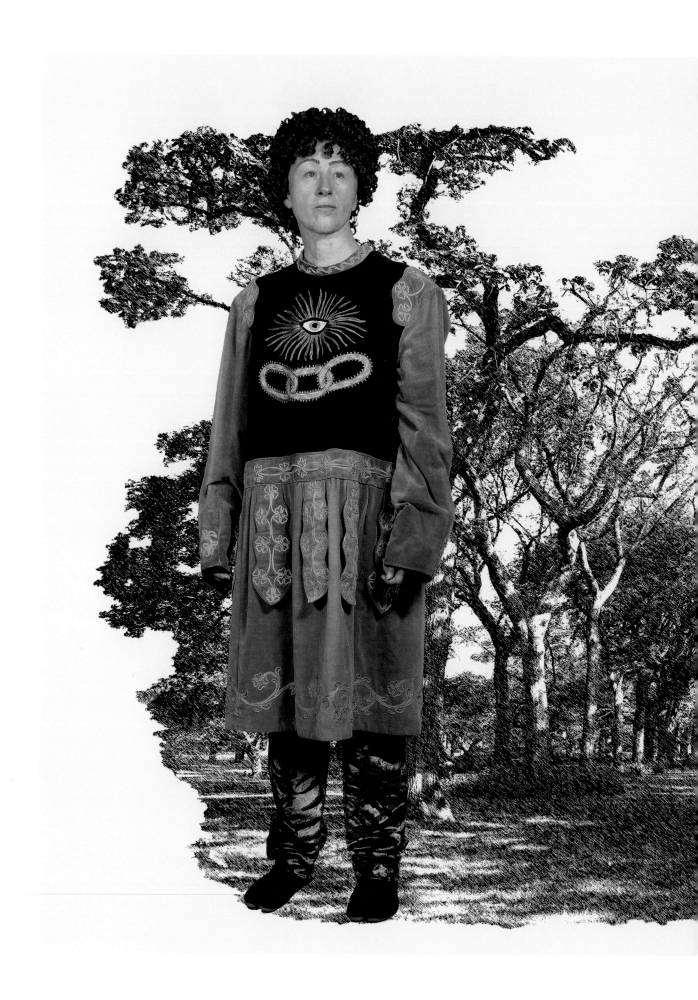

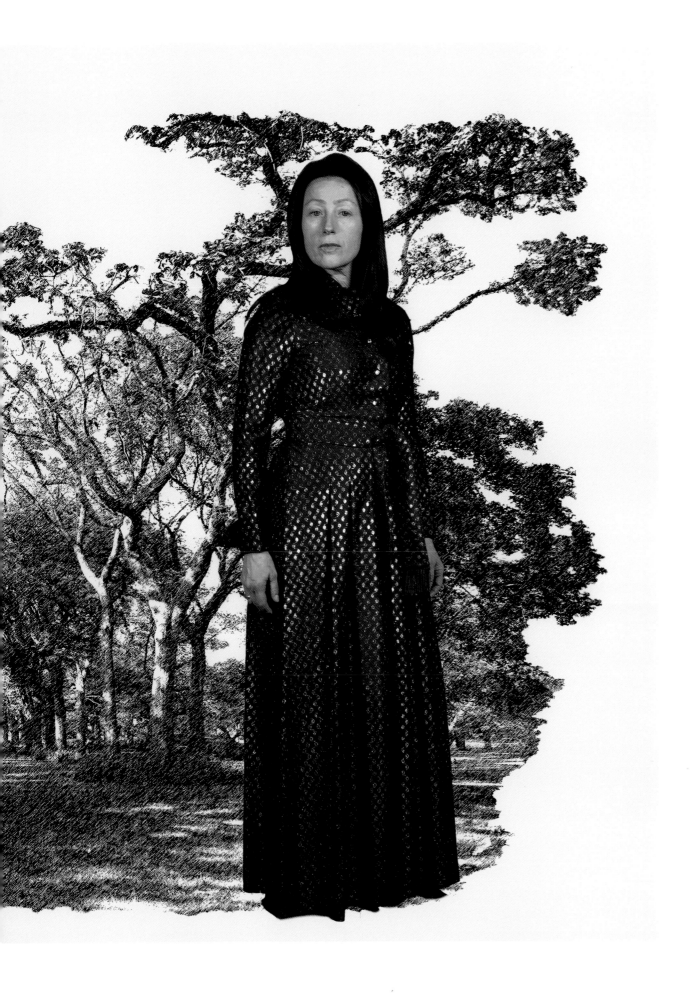

PLATE 177. Untitled. 2010

(following pages) PLATE 178. Untitled. 2010

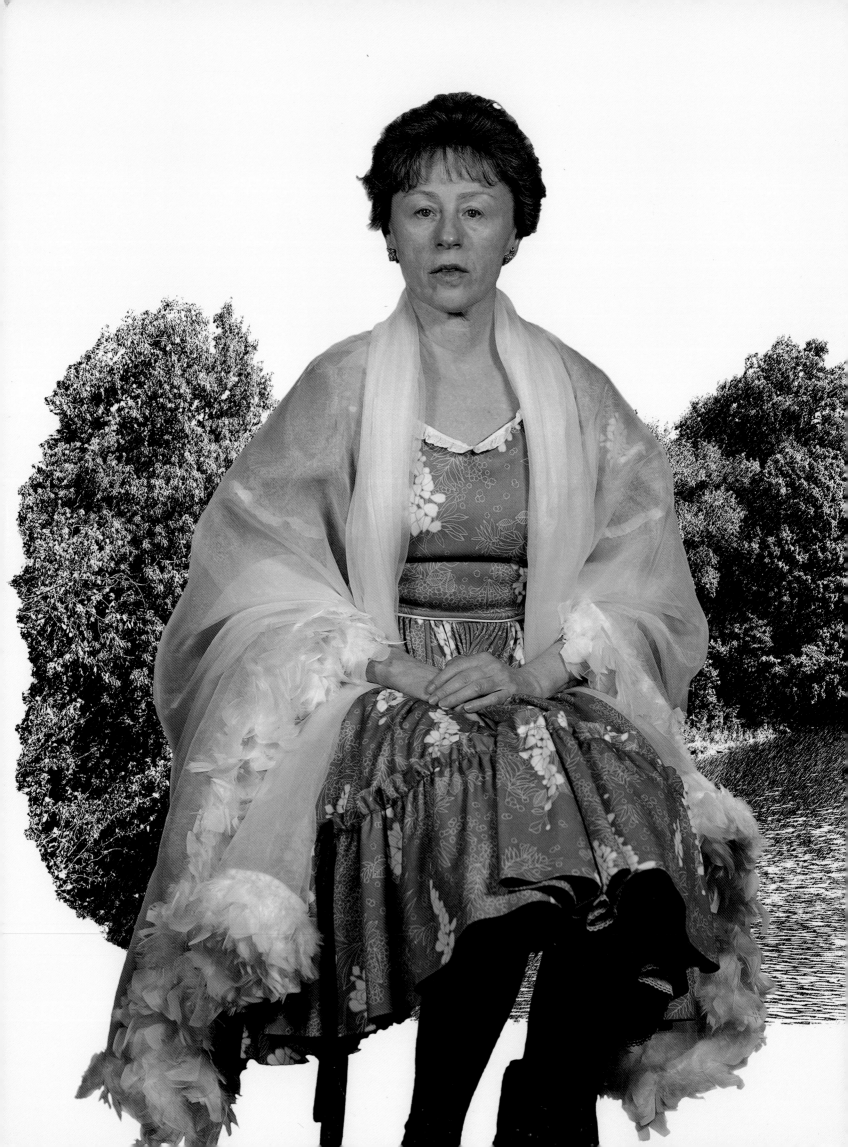

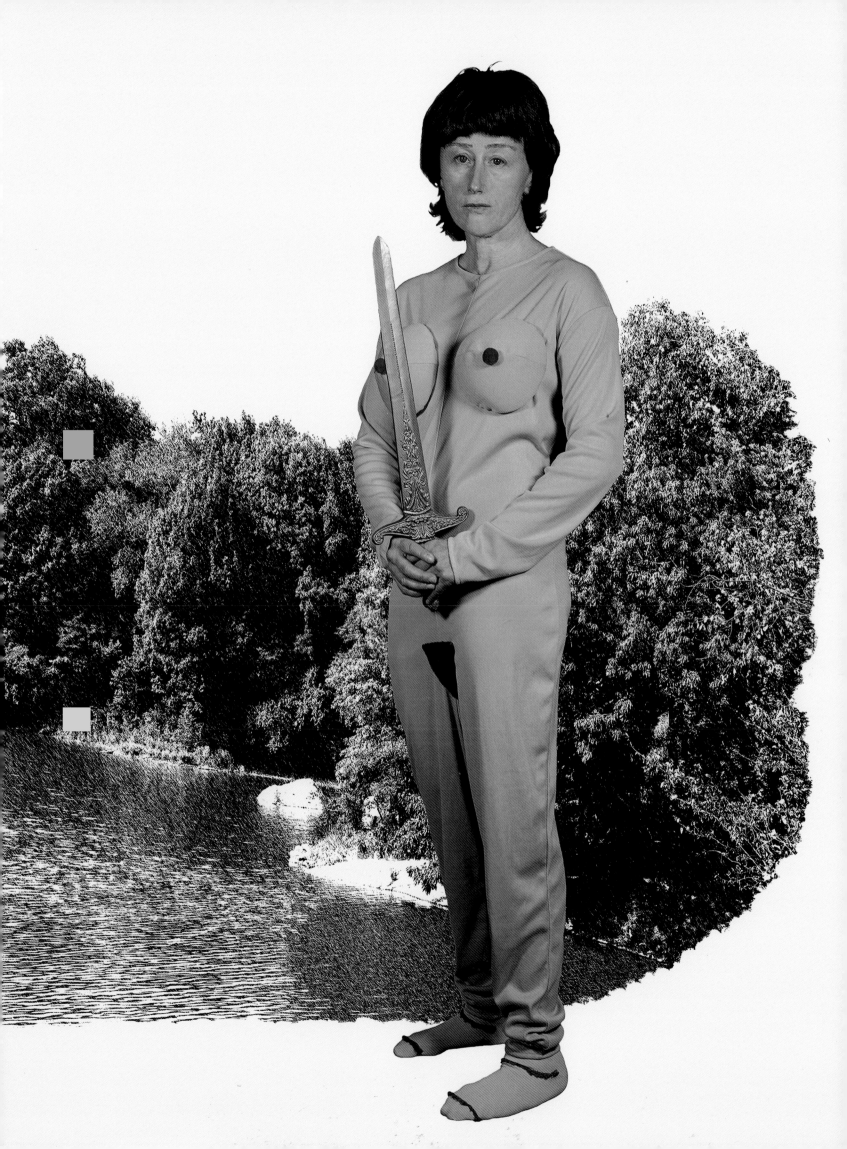

List of Plates

The only body of work that Cindy Sherman has titled is the "Untitled Film Stills." The rest of her series are untitled, although many of them have been published extensively with series titles. These titles are referred to in the essays for clarity, but they are not proper titles. Sherman has also not numbered her photographs. The numbers that appear after "untitled" are inventory numbers assigned by her gallery, Metro Pictures. Since the numbered titles have been widely published, we have chosen to include the numbers in this book and exhibition for consistency.

The works are arranged here in chronological order, and then in numerical order within each year, except for a few of the "Untitled Film Stills." For information about the numbering of the "Film Stills," see note 17 on page 51.

Dimensions are in inches and centimeters; height precedes width.

Doll Clothes
1975
16mm film transferred to DVD
2 minutes, 22 seconds
Courtesy the artist and
Metro Pictures, New York
PLATE 162

Untitled #479
1975
Twenty-three hand-colored
gelatin silver prints
20½ x 33½" (52.1 x 85.1 cm)
overall
Dorothy and Peter Waldt
PLATE 11

Untitled A–E
1975
Five gelatin silver prints
16⅜ x 11¹⁄₁₆" (41.6 x 28.1 cm)
each
Collection Museum of
Contemporary Art, Chicago.
Gift of Lannan Foundation
PLATES 4–8

Untitled #488
1976
Black-and-white cut-
out photographs mounted
on paper
16¼ x 39¼" (41.3 x 99.7 cm)
Glenstone
PLATE 166

Untitled #489
1976
Black-and-white cut-
out photographs mounted
on paper
15³⁄₁₆ x 50¹¹⁄₁₆" (38.6 x 128.8 cm)
Solomon R. Guggenheim
Museum, New York.
Purchased with funds contri-
buted by the International
Director's Council and
Executive Committee
Members: Eli Broad, Elaine
Terner Cooper, Ronnie
Heyman, J. Tomilson Hill,
Dakis Joannou, Barbara Lane,
Robert Mnuchin, Peter
Norton, Thomas Walther,
and Ginny Williams, 1997
PLATE 165

Untitled Film Still #1
1977
Gelatin silver print
9⁷⁄₁₆ x 7⁹⁄₁₆" (24 x 19.2 cm)
The Museum of Modern Art,
New York. Grace M. Mayer
Fund
PLATE 33

Untitled Film Still #2
1977
Gelatin silver print
9½ x 7⁹⁄₁₆" (24.1 x 19.2 cm)
The Museum of Modern Art,
New York. Horace W.
Goldsmith Fund through
Robert B. Menschel
PLATE 76

Untitled Film Still #3
1977
Gelatin silver print
7¹⁄₁₆ x 9⁷⁄₁₆" (18 x 24 cm)
The Museum of Modern Art,
New York. Acquired through
the generosity of Peter Norton
PLATE 16

Untitled Film Still #4
1977
Gelatin silver print
7⁹⁄₁₆ x 9⁷⁄₁₆" (19.2 x 24 cm)
The Museum of Modern Art,
New York. Grace M. Mayer
Fund
PLATE 50

Untitled Film Still #5
1977
Gelatin silver print
6¾ x 9⁷⁄₁₆" (17.2 x 24 cm)
The Museum of Modern Art,
New York. Horace W.
Goldsmith Fund through
Robert B. Menschel
PLATE 26

Untitled Film Still #6
1977
Gelatin silver print
9⁷⁄₁₆ x 6½" (24 x 16.5 cm)
The Museum of Modern Art,
New York. Acquired through
the generosity of Jo Carole
and Ronald S. Lauder
in memory of Eugene M.
Schwartz
PLATE 55

Untitled Film Still #62
1977
Gelatin silver print
6¼ x 9⁵⁄₁₆" (15.9 x 23.6 cm)
The Museum of Modern Art,
New York. Gift of the
photographer
PLATE 36

Untitled Film Still #7
1978
Gelatin silver print
9½ x 7⁹⁄₁₆" (24.1 x 19.2 cm)
The Museum of Modern Art,
New York. Acquired through
the generosity of Sid R. Bass
PLATE 32

Untitled Film Still #8
1978
Gelatin silver print
7⁹⁄₁₆ x 9½" (19.2 x 24.1 cm)
The Museum of Modern Art,
New York. Grace M. Mayer
Fund
PLATE 21

Untitled Film Still #9
1978
Gelatin silver print
7⁹⁄₁₆ x 9⁷⁄₁₆" (19.2 x 24 cm)
The Museum of Modern Art,
New York. Purchase
PLATE 59

Untitled Film Still #10
1978
Gelatin silver print
7⁵⁄₁₆ x 9⁷⁄₁₆" (18.6 x 24 cm)
The Museum of Modern Art,
New York. Acquired through
the generosity of Jo Carole
and Ronald S. Lauder
PLATE 63

Untitled Film Still #11
1978
Gelatin silver print
7¹⁄₁₆ x 9⁷⁄₁₆" (17.9 x 24 cm)
The Museum of Modern Art,
New York. Acquired through
the generosity of Sid R. Bass
PLATE 74

Untitled Film Still #12
1978
Gelatin silver print
7½ x 9⁷⁄₁₆" (19.1 x 24 cm)
The Museum of Modern Art,
New York. Grace M. Mayer
Fund
PLATE 69

Untitled Film Still #13
1978
Gelatin silver print
9⁷⁄₁₆ x 7½" (24 x 19.1 cm)
The Museum of Modern Art,
New York. Acquired through
the generosity of Jo Carole
and Ronald S. Lauder
in memory of Eugene M.
Schwartz
PLATE 13

Untitled Film Still #14
1978
Gelatin silver print
9⁷⁄₁₆ x 7½" (24 x 19.1 cm)
The Museum of Modern Art,
New York. Acquired through
the generosity of Peter Norton
PLATE 44

Untitled Film Still #15
1978
Gelatin silver print
9⁷⁄₁₆ x 7½" (24 x 19.1 cm)
The Museum of Modern Art,
New York. Acquired through
the generosity of Barbara
and Eugene Schwartz in
honor of Jo Carole and Ronald
S. Lauder
PLATE 37

Untitled Film Still #16
1978
Gelatin silver print
9⁷⁄₁₆ x 7⁹⁄₁₆" (24 x 19.2 cm)
The Museum of Modern Art,
New York. Acquired through
the generosity of Jo Carole and
Ronald S. Lauder in memory of
Eugene M. Schwartz
PLATE 29

Untitled Film Still #17
1978
Gelatin silver print
7½ x 9⁷⁄₁₆" (19.1 x 24 cm)
The Museum of Modern Art,
New York. Grace M. Mayer
Fund
PLATE 17

Untitled Film Still #18
1978
Gelatin silver print
7⁹⁄₁₆ x 9½" (19.2 x 24.1 cm)
The Museum of Modern Art,
New York. Purchase
PLATE 51

Untitled Film Still #19
1978
Gelatin silver print
7½ x 9⁷⁄₁₆" (19.1 x 24 cm)
The Museum of Modern Art,
New York. Purchase
PLATE 39

Untitled Film Still #20
1978
Gelatin silver print
7½ x 9⁷⁄₁₆" (19.1 x 24 cm)
The Museum of Modern Art,
New York. Purchase
PLATE 25

Untitled Film Still #21
1978
Gelatin silver print
7½ x 9½" (19.1 x 24.1 cm)
The Museum of Modern Art,
New York. Horace W.
Goldsmith Fund through
Robert B. Menschel
PLATE 35

Untitled Film Still #22
1978
Gelatin silver print
7⁹⁄₁₆ x 9⁷⁄₁₆" (19.2 x 24 cm)
The Museum of Modern Art,
New York. Purchase
PLATE 27

Untitled Film Still #23
1978
Gelatin silver print
7½ x 9⁷⁄₁₆" (19.1 x 24 cm)
The Museum of Modern Art,
New York. Purchase
PLATE 68

Untitled Film Still #24
1978
Gelatin silver print
6⁷⁄₁₆ x 9⁷⁄₁₆" (16.4 x 24 cm)
The Museum of Modern Art,
New York. Purchase
PLATE 40

Untitled Film Still #25
1978
Gelatin silver print
7⁹⁄₁₆ x 9⁷⁄₁₆" (19.2 x 24 cm)
The Museum of Modern Art,
New York. Horace W.
Goldsmith Fund through
Robert B. Menschel
PLATE 58

Untitled Film Still #84
1978
Gelatin silver print
7½ x 9⁷⁄₁₆" (19.1 x 24 cm)
The Museum of Modern Art,
New York. Purchase
PLATE 73

Untitled Film Still #26
1979
Gelatin silver print
6³⁄₈ x 9⁷⁄₁₆" (16.2 x 24 cm)
The Museum of Modern Art,
New York. Purchase
PLATE 14

Untitled Film Still #27
1979
Gelatin silver print
9⁷⁄₁₆ x 6¹¹⁄₁₆" (24 x 17 cm)
The Museum of Modern Art,
New York. Acquired through
the generosity of Peter Norton
PLATE 78

Untitled Film Still #27b
1979
Gelatin silver print
7⁹⁄₁₆ x 9⁷⁄₁₆" (19.2 x 24 cm)
The Museum of Modern Art,
New York. Grace M. Mayer
Fund
PLATE 23

Untitled Film Still #28
1979
Gelatin silver print
7½ x 9⁷⁄₁₆" (19.1 x 24 cm)
The Museum of Modern Art,
New York. Purchase
PLATE 45

Untitled Film Still #29
1979
Gelatin silver print
7⁹⁄₁₆ x 9⁷⁄₁₆" (19.2 x 24 cm)
The Museum of Modern Art,
New York. Purchase
PLATE 61

Untitled Film Still #30
1979
Gelatin silver print
6¹³⁄₁₆ x 9½" (17.3 x 24.1 cm)
The Museum of Modern Art,
New York. Purchase
PLATE 66

Untitled Film Still #31
1979
Gelatin silver print
7⁹⁄₁₆ x 9⁷⁄₁₆" (19.2 x 24 cm)
The Museum of Modern Art,
New York. Purchase
PLATE 72

Untitled Film Still #32
1979
Gelatin silver print
7½ x 9⁷⁄₁₆" (19.1 x 24 cm)
The Museum of Modern Art,
New York. Acquired through
the generosity of Sid R. Bass
PLATE 43

Untitled Film Still #33
1979
Gelatin silver print
7¼ x 9⁷⁄₁₆" (18.4 x 24 cm)
The Museum of Modern Art,
New York. Purchase
PLATE 49

Untitled Film Still #34
1979
Gelatin silver print
9⁷⁄₁₆ x 7⁹⁄₁₆" (24 x 19.2 cm)
The Museum of Modern Art,
New York. Horace W.
Goldsmith Fund through
Robert B. Menschel
PLATE 20

Untitled Film Still #35
1979
Gelatin silver print
9⁷⁄₁₆ x 6⁹⁄₁₆" (24 x 16.7 cm)
The Museum of Modern Art,
New York. Horace W.
Goldsmith Fund through
Robert B. Menschel
PLATE 67

Untitled Film Still #36
1979
Gelatin silver print
9⁷⁄₁₆ x 7⁹⁄₁₆" (24 x 19.2 cm)
The Museum of Modern Art,
New York. Grace M. Mayer
Fund
PLATE 24

Untitled Film Still #37
1979
Gelatin silver print
9⁷⁄₁₆ x 7⁹⁄₁₆" (24 x 19.2 cm)
The Museum of Modern Art,
New York. Purchase
PLATE 38

Untitled Film Still #38
1979
Gelatin silver print
9⁷⁄₁₆ x 7³⁄₁₆" (24 x 18.3 cm)
The Museum of Modern Art,
New York. Grace M. Mayer
Fund
PLATE 30

Untitled Film Still #39
1979
Gelatin silver print
9⁷⁄₁₆ x 6¹⁄₁₆" (24 x 15.4 cm)
The Museum of Modern Art,
New York. Purchase
PLATE 54

Untitled Film Still #40
1979
Gelatin silver print
7¹⁄₁₆ x 9⁷⁄₁₆" (17.9 x 24 cm)
The Museum of Modern Art,
New York. Purchase
PLATE 64

Untitled Film Still #41
1979
Gelatin silver print
6⁹⁄₁₆ x 8⁷⁄₁₆" (16.7 x 21.4 cm)
The Museum of Modern Art,
New York. Purchase
PLATE 80

Untitled Film Still #42
1979
Gelatin silver print
7½ x 8¹¹⁄₁₆" (19.1 x 22.1 cm)
The Museum of Modern Art,
New York. Grace M. Mayer
Fund
PLATE 28

Untitled Film Still #43
1979
Gelatin silver print
7⁹⁄₁₆ x 9⁷⁄₁₆" (19.2 x 24 cm)
The Museum of Modern Art,
New York. Acquired through
the generosity of Sid R. Bass
PLATE 42

Untitled Film Still #44
1979
Gelatin silver print
7⁹⁄₁₆ x 9⁷⁄₁₆" (19.2 x 24 cm)
The Museum of Modern Art,
New York. Purchase
PLATE 53

Untitled Film Still #45
1979
Gelatin silver print
6¹³⁄₁₆ x 9⁷⁄₁₆" (17.3 x 24 cm)
The Museum of Modern Art,
New York. Purchase
PLATE 77

Untitled Film Still #46
1979
Gelatin silver print
7⁹⁄₁₆ x 9⁷⁄₁₆" (19.2 x 24 cm)
The Museum of Modern Art,
New York. Horace W.
Goldsmith Fund through
Robert B. Menschel
PLATE 34

Untitled Film Still #47
1979
Gelatin silver print
7⁹⁄₁₆ x 9⁷⁄₁₆" (19.2 x 24 cm)
The Museum of Modern Art,
New York. Grace M. Mayer
Fund
PLATE 22

Untitled Film Still #48
1979
Gelatin silver print
7⁷⁄₁₆ x 9⁷⁄₁₆" (18.9 x 24 cm)
The Museum of Modern Art,
New York. Acquired through
the generosity of Jo Carole
and Ronald S. Lauder
in memory of Eugene M.
Schwartz
PLATE 62

Untitled Film Still #49
1979
Gelatin silver print
6¹³⁄₁₆ x 9⁷⁄₁₆" (17.3 x 24 cm)
The Museum of Modern Art,
New York. Purchase
PLATE 52

Untitled Film Still #50
1979
Gelatin silver print
6⁹⁄₁₆ x 9⁷⁄₁₆" (16.7 x 24 cm)
The Museum of Modern Art,
New York. Horace W.
Goldsmith Fund through
Robert B. Menschel
PLATE 18

Untitled Film Still #51
1979
Gelatin silver print
9⁷⁄₁₆ x 7⁹⁄₁₆" (24 x 19.2 cm)
The Museum of Modern Art,
New York. Purchase
PLATE 56

Untitled Film Still #52
1979
Gelatin silver print
6½ x 9⁷⁄₁₆" (16.5 x 24 cm)
The Museum of Modern Art,
New York. Purchase
PLATE 65

Untitled Film Still #61
1979
Gelatin silver print
9¼ x 6⅜" (23.5 x 16.2 cm)
The Museum of Modern Art,
New York. Purchase
PLATE 47

Untitled Film Still #53
1980
Gelatin silver print
6⅜ x 9⁷⁄₁₆" (16.2 x 24 cm)
The Museum of Modern Art,
New York. Grace M. Mayer
Fund
PLATE 46

Untitled Film Still #54
1980
Gelatin silver print
6¹³⁄₁₆ x 9⁷⁄₁₆" (17.3 x 24 cm)
The Museum of Modern Art,
New York. Acquired through
the generosity of Peter Norton
PLATE 41

Untitled Film Still #55
1980
Gelatin silver print
7⁹⁄₁₆ x 9⁷⁄₁₆" (19.2 x 24 cm)
The Museum of Modern Art,
New York. Purchase
PLATE 60

Untitled Film Still #56
1980
Gelatin silver print
6⅜ x 9⁷⁄₁₆" (16.2 x 24 cm)
The Museum of Modern Art,
New York. Acquired
through the generosity of
Jo Carole and Ronald S.
Lauder in memory of
Mrs. John D. Rockefeller 3rd
PLATE 71

Untitled Film Still #57
1980
Gelatin silver print
6⁹⁄₁₆ x 9⁷⁄₁₆" (16.7 x 24 cm)
The Museum of Modern Art,
New York. Purchase
PLATE 81

Untitled Film Still #58
1980
Gelatin silver print
6⁵⁄₁₆ x 9⁷⁄₁₆" (16 x 24 cm)
The Museum of Modern Art,
New York. Grace M. Mayer
Fund
PLATE 48

Untitled Film Still #59
1980
Gelatin silver print
6¾ x 9½" (17.2 x 24.1 cm)
The Museum of Modern Art,
New York. Purchase
PLATE 19

Untitled Film Still #60
1980
Gelatin silver print
9⁷⁄₁₆ x 7½" (24 x 19.1 cm)
The Museum of Modern Art,
New York. Purchase
PLATE 75

Untitled Film Still #63
1980
Gelatin silver print
7⁹⁄₁₆ x 9⁷⁄₁₆" (19.2 x 24 cm)
The Museum of Modern Art,
New York. Purchase
PLATE 57

Untitled Film Still #64
1980
Gelatin silver print
6⁷⁄₁₆ x 9⁷⁄₁₆" (16.4 x 24 cm)
The Museum of Modern Art,
New York. Purchase
PLATE 15

Untitled Film Still #65
1980
Gelatin silver print
9⁷⁄₁₆ x 6¾" (24 x 17.2 cm)
The Museum of Modern Art,
New York. Purchase
PLATE 31

Untitled Film Still #81
1980
Gelatin silver print
9⁷⁄₁₆ x 6⁹⁄₁₆" (24 x 16.7 cm)
The Museum of Modern Art,
New York. Grace M. Mayer
Fund
PLATE 12

Untitled Film Still #82
1980
Gelatin silver print
9⁷⁄₁₆ x 6⁹⁄₁₆" (24 x 16.7 cm)
The Museum of Modern Art,
New York. Purchase
PLATE 79

Untitled Film Still #83
1980
Gelatin silver print
7¹⁄₁₆ x 9⁷⁄₁₆" (17.9 x 24 cm)
The Museum of Modern Art,
New York. Purchase
PLATE 70

Untitled #66
1980
Chromogenic color print
15⁵⁄₁₆ x 23⁷⁄₁₆" (38.9 x 59.5 cm)
Whitney Museum of American
Art, New York. Gift of Barbara
and Eugene Schwartz
PLATE 107

Untitled #70
1980
Chromogenic color print
16 x 23¹⁵⁄₁₆" (40.7 x 60.8 cm)
The Museum of Modern Art,
New York. Acquired through
the generosity of Janelle
Reiring and Helene Winer,
by exchange
PLATE 106

Untitled #74
1980
Chromogenic color print
16 x 24" (40.6 x 61 cm)
Barbara and Richard S. Lane
PLATE 108

Untitled #85
1981
Chromogenic color print
24 x 48" (61 x 121.9 cm)
Collection of Jean Pigozzi,
Geneva
PLATE 99

Untitled #86
1981
Chromogenic color print
24 x 48" (61 x 121.9 cm)
Eric Fischl and April Gornik
PLATE 91

Untitled #87
1981
Chromogenic color print
24 x 48" (61 x 121.9 cm)
Collection Per Skarstedt
PLATE 100

Untitled #88
1981
Chromogenic color print
24 x 48" (61 x 121.9 cm)
Sender Collection, New York
PLATE 93

Untitled #89
1981
Chromogenic color print
24 x 48" (61 x 121.9 cm)
Dallas Museum of Art.
General Acquisitions Fund
PLATE 95

Untitled #90
1981
Chromogenic color print
24 x 48" (61 x 121.9 cm)
Des Moines Art Center
Permanent Collections. Gift of
Joan Simon
PLATE 97

Untitled #91
1981
Chromogenic color print
24 x 48" (61 x 121.9 cm)
Neda Young, New York
PLATE 94

Untitled #92
1981
Chromogenic color print
24 x 48" (61 x 121.9 cm)
The Museum of Modern Art,
New York. The Fellows of
Photography Fund
PLATE 96

Untitled #93
1981
Chromogenic color print
24 x 48" (61 x 121.9 cm)
Marieluise Hessel Collection,
Hessel Museum of Art, Center
for Curatorial Studies, Bard
College, Annandale-on-
Hudson, New York
PLATE 92

Untitled #94
1981
Chromogenic color print
24 x 48" (61 x 121.9 cm)
The Broad Art Foundation,
Santa Monica
PLATE 98

Untitled #95
1981
Chromogenic color print
24 x 48" (61 x 121.9 cm)
Collection of Ninah and
Michael Lynne
PLATE 101

Untitled #96
1981
Chromogenic color print
24 x 48" (61 x 121.9 cm)
The Museum of Modern Art,
New York. Gift of Carl D. Lobell
PLATE 90

Untitled #119
1983
Chromogenic color print
48½ x 94" (123.2 x 238.8 cm)
Courtesy the artist and
Metro Pictures, New York
PLATE 83

Untitled #122
1983
Chromogenic color print
75¾ x 45¾" (192.4 x 116.2 cm)
Courtesy the artist and
Metro Pictures, New York
PLATE 84

Untitled #131
1983
Chromogenic color print
94¾ x 45¼" (240.7 x 114.9 cm)
Courtesy the artist and
Metro Pictures, New York
PLATE 89

Untitled #132
1984
Chromogenic color print
67 x 47" (170.2 x 119.4 cm)
Collection of John Cheim
PLATE 82

Untitled #137
1984
Chromogenic color print
70½ x 47¾" (179.1 x 121.3 cm)
Philadelphia Museum of Art.
Purchased with the Alice
Newton Osborn Fund, 1985
PLATE 87

Untitled #140
1985
Chromogenic color print
72½ x 48⅜" (184.2 x 122.9 cm)
Sender Collection, New York
PLATE 110

Untitled #146
1985
Chromogenic color print
71⁹⁄₁₆ x 48⅛" (181.8 x 122.2 cm)
Collection Per Skarstedt
PLATE 141

Untitled #150
1985
Chromogenic color print
49½ x 66¾" (125.7 x 169.5 cm)
Private collection, New York
PLATE 147

Untitled #153
1985
Chromogenic color print
67¼ x 49½" (170.8 x 125.7 cm)
The Museum of Modern Art,
New York. Joel and
Anne Ehrenkranz Fund
PLATE 2

Untitled #155
1985
Chromogenic color print
6' ½" x 49¼" (184.2 x 125.1 cm)
Courtesy the artist and
Metro Pictures, New York
PLATE 115

Untitled #173
1986
Chromogenic color print
60" x 7' 6" (152.4 x 228.6 cm)
Collection Per Skarstedt
PLATE 117

Untitled #175
1987
Chromogenic color print
46⅞" x 71½" (119.1 x 181.6 cm)
Whitney Museum of American
Art, New York. Gift of
The Foundation To-Life, Inc.
in memory of Eugene M.
Schwartz
PLATE 116

Untitled #177
1987
Chromogenic color print
43⁵⁄₁₆" x 6' 1¼" (110 x 186.1 cm)
Collection of Mike Kelley
PLATE 118

Untitled #182
1987
Chromogenic color print
7' 5½" x 59½" (227.3 x 151.1 cm)
Courtesy the artist and
Metro Pictures, New York
PLATE 111

Untitled #183
1988
Chromogenic color print
38 x 22¾" (96.5 x 57.8 cm)
The Art Institute of Chicago.
Gift of Boardroom, Inc.
PLATE 128

Untitled #190
1989
Two chromogenic color prints
48¼" x 6' 1" (122.6 x 185.4 cm)
each
The Broad Art Foundation,
Santa Monica
PLATE 114

Untitled #191
1989
Chromogenic color print
7' 6" x 60" (228.6 x 152.4 cm)
Courtesy the artist and
Metro Pictures, New York
PLATE 112

Untitled #193
1989
Chromogenic color print
48⅞ x 41¹⁵⁄₁₆" (124.1 x 106.5 cm)
The Doris and Donald Fisher
Collection
PLATE 122

Untitled #197
1989
Chromogenic color print
31⁵⁄₁₆ x 20⅞" (79.6 x 53.1 cm)
The Museum of Modern Art,
New York. The Family of
Man Fund
PLATE 119

Untitled #198
1989
Chromogenic color print
38⅞ x 27⅞" (98.7 x 70.8 cm)
The Broad Art Foundation,
Santa Monica
PLATE 125

Untitled #199
1989
Chromogenic color print
24¹⁵⁄₁₆ x 18" (63.3 x 45.7 cm)
Barbara and Richard S. Lane
PLATE 120

Untitled #201
1989
Chromogenic color print
52⅞ x 35⅞" (134.3 x 91.1 cm)
Private collection, New York
PLATE 139

Untitled #204
1989
Chromogenic color print
60 x 44" (152.4 x 111.8 cm)
Jane and Leonard Korman
PLATE 127

Untitled #205
1989
Chromogenic color print
53½ x 40¼" (135.9 x 102.2 cm)
Carol and David Appel
PLATE 134

Untitled #209
1989
Chromogenic color print
57 x 41" (144.8 x 104.1 cm)
Private collection
PLATE 130

Untitled #210
1989
Chromogenic color print
66 x 44" (167.6 x 111.8 cm)
Virginia and Bagley Wright
Collection. Promised gift
to the Seattle Art Museum in
honor of the 75th Anniversary
PLATE 132

Untitled #211
1989
Chromogenic color print
37 x 31" (94 x 78.7 cm)
Neda Young, New York
PLATE 131

Untitled #212
1989
Chromogenic color print
33 x 24" (83.8 x 61 cm)
Collection of Carla Emil and
Rich Silverstein. Fractional
and promised gift to the
San Francisco Museum of
Modern Art
PLATE 126

Untitled #213
1989
Chromogenic color print
41½ x 33" (105.4 x 83.8 cm)
Collection of Carla Emil and
Rich Silverstein. Fractional
and promised gift to the
San Francisco Museum of
Modern Art
PLATE 133

Untitled #214
1989
Chromogenic color print
29½ x 24" (74.9 x 61 cm)
Private collection
PLATE 121

Untitled #215
1989
Chromogenic color print
6' 2¼" x 51" (188.6 x 129.5 cm)
The Eli and Edythe L. Broad
Collection, Los Angeles
PLATE 129

Untitled #216
1989
Chromogenic color print
7' 3⅛" x 56⅛" (221.3 x
142.5 cm)
The Museum of Modern Art,
New York. Gift of Werner and
Elaine Dannheisser
PLATE 10

Untitled #219
1990
Chromogenic color print
65 x 40" (165.1 x 101.6 cm)
Collection of Larry Sanitsky,
Beverly Hills
PLATE 123

Untitled #222
1990
Chromogenic color print
60 x 44" (152.4 x 111.8 cm)
Collection Art Gallery of
Ontario, Toronto. Gift of Carol
and David Appel, 2000
PLATE 137

Untitled #223
1990
Chromogenic color print
58 x 42" (147.3 x 106.7 cm)
Neda Young, New York
PLATE 124

Untitled #224
1990
Chromogenic color print
48 x 38" (121.9 x 96.5 cm)
Collection of Linda and
Jerry Janger, Los Angeles
PLATE 136

Untitled #225
1990
Chromogenic color print
48 x 33" (121.9 x 83.8 cm)
Collection of Nina and Frank
Moore
PLATE 138

Untitled #226
1990
Chromogenic color print
47¼ x 29½" (120 x 74.9 cm)
Courtesy the artist and
Metro Pictures, New York
PLATE 135

Untitled #228
1990
Chromogenic color print
6' 10⅟₁₆" x 48" (208.4 x 122 cm)
The Museum of Modern Art,
New York. Acquired through
the generosity of Eileen
and Peter Norton
PLATE 140

Untitled #250
1992
Chromogenic color print
49⅜" x 6' 2½" (125.5 x
189.2 cm)
The Museum of Modern Art,
New York. Gift of the
Dannheisser Foundation
PLATE 113

Untitled #263
1992
Chromogenic color print
40 x 60" (101.6 x 152.4 cm)
The Museum of Modern Art,
New York. The Family of
Man Fund
PLATE 109

Untitled #264
1992
Chromogenic color print
50 x 6' 3" (127 x 190.5 cm)
Solomon R. Guggenheim
Museum, New York.
Purchased with funds contri-
buted by the International
Director's Council and
Executive Committee
Members: Edythe Broad,
Elaine Terner Cooper, Dimitris
Daskalopoulos, Harry David,
Gail Mary Engelberg, Nicki
Harris, Ronnie Heyman,
Dakis Joannou, Barbara Lane,
Sondra Mack, Linda Macklowe,
Peter Norton, Willem Peppler,
Pepler, Tonino Perna,
Elizabeth Richebourg Rea,
Simonetta Seragnoli, David
Teiger, and Elliot K. Wolk, 2002
PLATE 3

Untitled #276
1993
Chromogenic color print
6' 8½" x 61" (204.5 x 154.9 cm)
Private collection, New York
PLATE 88

Untitled #296
1994
Chromogenic color print
69 x 44½" (175.3 x 113 cm)
Collection Glenn and Amanda
Fuhrman, New York. Courtesy
The FLAG Art Foundation
PLATE 143

Untitled #299
1994
Chromogenic color print
48⅞ x 32¹⁵⁄₁₆" (124.1 x 83.7 cm)
Sibley Family
PLATE 85

Untitled #351
2000
Chromogenic color print
30 x 20" (76.2 x 50.8 cm)
Sandra and Stephen
Abramson
PLATE 153

Untitled #353
2000
Chromogenic color print
36 x 24" (91.4 x 61 cm)
Courtesy the artist and
Metro Pictures, New York
PLATE 152

Untitled #354
2000
Chromogenic color print
36 x 24" (91.4 x 61 cm)
Collection of Ninah and
Michael Lynne
PLATE 160

Untitled #355
2000
Chromogenic color print
36 x 24" (91.4 x 61 cm)
Collection Metro Pictures,
New York
PLATE 151

Untitled #359
2000
Chromogenic color print
30 x 20" (76.2 x 50.8 cm)
Collection Metro Pictures,
New York
PLATE 157

Untitled #360
2000
Chromogenic color print
30 x 20" (76.2 x 50.8 cm)
Stefan T. Edlis Collection
PLATE 158

Untitled #396
2000
Chromogenic color print
36 x 24" (91.4 x 61 cm)
Collection Norman and Norah
Stone, San Francisco
PLATE 159

Untitled #397
2000
Chromogenic color print
36 x 24" (91.4 x 61 cm)
Rubell Family Collection, Miami
PLATE 154

Untitled #398
2000
Chromogenic color print
34¼ x 24" (87 x 61 cm)
Ellen and Richard Levine
PLATE 156

Untitled #399
2000
Chromogenic color print
39 x 26" (99.1 x 66 cm)
Collection of Carla Emil and
Rich Silverstein. Fractional
and promised gift to the
San Francisco Museum of
Modern Art
PLATE 148

Untitled #400
2000
Chromogenic color print
36 x 24" (91.4 x 61 cm)
Collection Albright-Knox Art
Gallery, Buffalo. Sarah Norton
Goodyear Fund, 2000
PLATE 149

Untitled #402
2000
Chromogenic color print
36 x 24" (91.4 x 61 cm)
Ann and Mel Schaffer Family
Collection
PLATE 155

Untitled #405
2000
Chromogenic color print
33 x 22" (83.8 x 55.9 cm)
Collection of Mandy and Cliff
Einstein
PLATE 150

Untitled #408
2002
Chromogenic color print
54 x 36" (137.2 x 91.4 cm)
Collection of Melva
Bucksbaum and Raymond J.
Learsy
PLATE 103

Untitled #411
2003
Chromogenic color print
45¼ x 31⅛" (114.9 x 79.1 cm)
Collection Philippe Segalot,
New York
PLATE 146

Untitled #413
2003
Chromogenic color print
46 x 31⅛" (116.8 x 79.1 cm)
Glenstone
PLATE 1

Untitled #415
2004
Chromogenic color print
68 x 44½" (172.7 x 113 cm)
Michael Young, New York
PLATE 144

Untitled #417
2004
Chromogenic color print
59¹³⁄₁₆" x 7' 5⅝" (151.9 x 227.6 cm)
Collection Martin Z. Margulies
PLATE 145

Untitled #420
2004
Two chromogenic color prints
71¹³⁄₁₆ x 45⅝" (182.4 x 115.8 cm)
each
Collection of Ninah and
Michael Lynne
PLATE 142

Untitled #424
2004
Chromogenic color print
53¾ x 54¾" (136.5 x 139.1 cm)
Holzer Family Collection
PLATE 102

Untitled #425
2004
Chromogenic color print
70¾" x 7' 5¾" (179.7 x 228 cm)
Collection of Jennifer and
David Stockman
PLATE 161

Untitled #458
2007–08
Chromogenic color print
6' 5⅜" x 58¼" (196.5 x 148 cm)
Glenstone
PLATE 86

Untitled #461
2007–08
Chromogenic color print
60½ x 48" (153.7 x 121.9 cm)
The Broad Art Foundation,
Santa Monica
PLATE 105

Untitled #463
2007–08
Chromogenic color print
68⅝ x 72" (174.2 x 182.9 cm)
John and Amy Phelan
PLATE 164

Untitled #465
2008
Chromogenic color print
63¾ x 57¼" (161.9 x 145.4 cm)
Whitney Museum of American
Art, New York. Purchase, with
funds from the Painting
and Sculpture Committee and
the Photography Committee
PLATE 170

Untitled #466
2008
Chromogenic color print
8' 6" x 70" (259.1 x 177.8 cm)
The Museum of Modern Art,
New York. Acquired through
the generosity of Robert B.
Menschel in honor of
Jerry I. Speyer
PLATE 9

Untitled #467
2008
Chromogenic color print
7' 6" x 60" (228.6 x 152.4 cm)
Allison and Warren Kanders
PLATE 171

Untitled #468
2008
Chromogenic color print
70¼ x 54" (178.4 x 137.2 cm)
The Broad Art Foundation,
Santa Monica
PLATE 172

Untitled #469
2008
Chromogenic color print
61⅝ x 60" (156.5 x 152.4 cm)
Meredith and Bryan Verona
PLATE 104

Untitled #470
2008
Chromogenic color print
7' 1¼" x 58" (216.5 x 147.3 cm)
Private collection, courtesy of
The Heller Group
PLATE 167

Untitled #474
2008
Chromogenic color print
7' 6¾" x 60" (230.5 x 152.4 cm)
The Museum of Modern Art,
New York. Acquired through
the generosity of an
anonymous donor, Michael
Lynne, Charles Heilbronn, and
the Carol and David Appel
Family Fund
PLATE 169

Untitled #475
2008
Chromogenic color print
7' 2⅜" x 71½" (219.4 x 181.6 cm)
The Broad Art Foundation,
Santa Monica
PLATE 163

Untitled #476
2008
Chromogenic color print
7' ½" x 68" (214.6 x 172.7 cm)
Collection of Pamela and
Arthur Sanders
PLATE 168

Untitled
2010
Pigment print on PhotoTex
adhesive fabric
Dimensions variable
Courtesy the artist and
Metro Pictures, New York
PLATES 173, 174, 177, AND 178

Untitled #512
2011
Chromogenic color print
Dimensions to be determined
Courtesy the artist and
Metro Pictures, New York
PLATE 176

Untitled #513
2011
Chromogenic color print
Dimensions to be determined
Courtesy the artist and
Metro Pictures, New York
PLATE 175

Selected Exhibition History

Compiled by Lucy Gallun

Solo Exhibitions

1979

Hallwalls, Buffalo. *Cindy Sherman*. March 2–25.

1980

Contemporary Arts Museum, Houston. *Cindy Sherman: Photographs*. February 2–March 23 (brochure).

The Kitchen, New York. *Cindy Sherman: Untitled Film Stills*. March 18–29.

Metro Pictures, New York. *Cindy Sherman*. December 6, 1980–January 7, 1981.

1981

Metro Pictures, New York. *Cindy Sherman*. November 7–28.

Young Hoffman Gallery, Chicago. *Cindy Sherman: New Color Photographs*. November 20, 1981–January 5, 1982.

1982

Galerie Chantal Crousel, Paris. *Cindy Sherman*. September 18–October 23.

Carl Solway Gallery, Cincinnati. *Cindy Sherman: Photographs, 1978–1982*. September 23–November 8.

Larry Gagosian Gallery, Los Angeles. *Cindy Sherman: Portraits*. September 29–October 23.

Metro Pictures, New York. *Cindy Sherman*. October 16–November 13.

Galerie Déjà vu, Dijon, France. *Cindy Sherman*. October 25–November 13 (brochure).

Stedelijk Museum, Amsterdam. *Cindy Sherman*. December 23, 1982–February 6, 1983 (catalogue). Traveled to Vereniging Actuele Kunst, Gewad, Ghent,

Belgium, April 2–30, 1983; Watershed Gallery, Bristol, United Kingdom, May 4–28, 1983; John Hansard Gallery, University of Southampton, United Kingdom, June 13–July 16, 1983; Palais Stutterheim, Erlangen, West Germany, August 12–September 7, 1983; Haus am Waldsee, West Berlin, September 10–October 9, 1983; Centre d'Art Contemporain, Geneva, October 13–November 16, 1983; Sonja Henie–Niels Onstad Foundation, Høvikodden, Norway, November 24, 1983–January 15, 1984; Louisiana Museum of Modern Art, Humlebaek, Denmark, January 21–April 4, 1984.

1983

Fay Gold Gallery, Atlanta. *Cindy Sherman: New Color Photographs*. February 18–March 16.

Saint Louis Art Museum. *Currents 20: Cindy Sherman*. March 1–April 10 (brochure).

Galerie Schellmann & Klüser, Munich. *Cindy Sherman*. March 3–31.

Art Gallery, Fine Arts Center, State University of New York, Stony Brook. *Cindy Sherman*. October 1–November 2 (brochure). Traveled to Zilkha Gallery, Center for the Arts, Wesleyan University, Middletown, Conn., November 9–December 16.

Metro Pictures, New York. *Cindy Sherman*. October 29–November 26.

Musée d'Art et d'Industrie de Saint-Étienne, France. *Cindy Sherman*. December 1983–January 1984 (catalogue).

1984

Seibu Contemporary Art Gallery, Tokyo. *Cindy Sherman*. February 17–29 (brochure).

Laforet Museum, Tokyo. *Cindy Sherman*. April 23–May 4 (catalogue).

Akron Art Museum, Ohio. *Cindy Sherman*. June 23–September 2 (brochure). Traveled to Institute of Contemporary Art, Philadelphia, December 13, 1984–January 27, 1985; Museum of Art, Carnegie Institute, Pittsburgh, February 9–April 7, 1985; Des Moines Art Center, Iowa, September 13–November 17, 1985; The Baltimore Museum of Art, June 3–August 3, 1986.

Monika Sprüth Galerie, Cologne. *Cindy Sherman: Neue Arbeiten*. September 7–25.

Galerie Grita Insam, Vienna. *Cindy Sherman: Neue Fotoarbeiten*. September 20–October 27.

1985

Metro Pictures, New York. *Cindy Sherman*. October 5–26.

Westfälischer Kunstverein, Münster, West Germany. *Cindy Sherman, Photographien*. December 7, 1985–January 7, 1986 (catalogue).

1986

The Wadsworth Atheneum, Hartford, Conn. *Cindy Sherman: MATRIX 88*. January 18–March 9 (brochure).

Portland Art Museum, Ore. *Perspectives 4: Cindy Sherman*. February 5–April 6 (brochure).

Galerie Crousel-Hussenot, Paris. *Cindy Sherman*. October 18–November 15.

1987

Metro Pictures, New York. *Cindy Sherman*. May 2–30.

Hoffman/Borman Gallery, Santa Monica, Calif. *Cindy Sherman: New Work*. June 27–July 25.

Whitney Museum of American Art, New York. *Cindy Sherman*. July 9–October 4 (catalogue). Traveled to Institute of Contemporary Art, Boston, November 19,

1987–January 17, 1988; Dallas Museum of Art, March 6–April 24, 1988.

Provinciaal Museum, Hasselt, Belgium. *Cindy Sherman.* December 12, 1987–January 31, 1988.

1988

Monika Sprüth Galerie, Cologne. *Cindy Sherman: Neue Arbeiten.* April 29–May 28.

1989

Metro Pictures, New York. *Cindy Sherman.* March 25–April 22.

National Art Gallery, Wellington, New Zealand. *Cindy Sherman.* June 17–August 13 (brochure). Traveled to Waikato Museum of Art and History, New Zealand, August 27–October 7.

1990

Metro Pictures, New York. *Cindy Sherman.* January 6–27.

Linda Cathcart Gallery, Santa Monica, Calif. *Cindy Sherman.* May 31–June 23.

University Art Museum, University of California, Berkeley. *MATRIX 138: Cindy Sherman.* September 1–October 20.

Monika Sprüth Galerie, Cologne. *Cindy Sherman.* September 21–November 3.

Padiglione d'arte Contemporanea, Milan. *Cindy Sherman.* October 4–November 4 (catalogue).

1991

The Saatchi Collection, London. *Cindy Sherman.* January 11–July 28.

Milwaukee Art Museum. *Currents 18: Cindy Sherman.* January 25–March 17 (brochure). Traveled to Center for the Fine Arts, Miami, May 23–July 14; Walker Art Center, Minneapolis, August 31–October 27.

Kunsthalle Basel. *Cindy Sherman.* March 28–May 20 (catalogue). Traveled to Staatsgalerie Moderner Kunst, Munich, June 21–July 24; Whitechapel Gallery, London, August 2–September 22.

1992

Metro Pictures, New York. *Cindy Sherman.* April 11–May 9.

Linda Carthcart Gallery, Santa Monica, Calif. *Cindy Sherman.* May 23–June 27.

Monika Sprüth Galerie, Cologne. *Cindy Sherman.* September 25–October 21.

1993

Texas Gallery, Houston. *Cindy Sherman: The Civil War Series.* June 15–July 24.

Tel Aviv Museum of Art. *Cindy Sherman.* June 15–August 29.

1994

ACC Galerie Weimar, Germany. *Cindy Sherman: New York Photographien.* July 9–August 21 (catalogue).

Manchester Art Gallery, United Kingdom. *Cindy Sherman: Possession.* September 17–October 30.

Irish Museum of Modern Art, Dublin. *From Beyond the Pale: Cindy Sherman.* November 17, 1994–February 12, 1995 (catalogue).

1995

Metro Pictures, New York. *Cindy Sherman.* January 14–February 18.

Hirshhorn Museum and Sculpture Garden, Smithsonian Institution, Washington, D.C. *Directions: Cindy Sherman, Film Stills.* March 15–June 25 (brochure).

Monika Sprüth Galerie, Cologne. *Cindy Sherman.* May 5–July 29.

Deichtorhallen Hamburg. *Cindy Sherman Photographien 1975–1995.* May 25–July 30 (catalogue). Traveled to Malmö Konsthall, Sweden, August 26–October 22; Kunstmuseum Luzern, Switzerland, December 8, 1995–February 11, 1996.

Museu de Arte Moderna de São Paulo. *Cindy Sherman: The Self Which Is Not One.* June 27–July 30 (catalogue).

1996

Museum Boijmans Van Beuningen, Rotterdam. *Cindy Sherman.* March 10–May 19 (catalogue). Traveled to Museo Nacional Centro de Arte Reina Sofía, Madrid, July 8–September 22; Sala de Exposiciones Rekalde, Bilbao, Spain, October 15–December 1; Staatliche Kunsthalle, Baden-Baden, Germany, January 19–March 23, 1997.

Museum of Modern Art, Shiga, Japan. *Cindy Sherman.* July 6–August 18 (catalogue). Traveled to Marugame Genichiro–Inokuma Museum of Contemporary Art, Marugame, Japan, September 8–October 13; Museum of Contemporary Art, Tokyo, October 26–December 15.

The Cleveland Museum of Art. *Metamorphosis: Cindy Sherman Photographs.* September 10–November 3.

Metro Pictures, New York. *Cindy Sherman.* October 26–November 23.

1997

Museo de Bellas Artes, Caracas. *Cindy Sherman: una selección de las colecciones de la Eli Broad Family Foundation.* May 25–July 20 (catalogue).

The Museum of Modern Art, New York. *Cindy Sherman: The Complete Untitled Film Stills.* June 26–September 2.

The Museum of Contemporary Art, Los Angeles. *Cindy Sherman: Retrospective.* November 2, 1997–February 1, 1998 (catalogue). Traveled to Museum of Contemporary Art, Chicago, February 28–May 31, 1998; Galerie

Rudolfinum, Prague, June 25–August 13, 1998; Barbican Art Gallery, London, September 10–December 13, 1998; CAPC Musée d'Art Contemporain, Bordeaux, France, February 6–April 25, 1999; Museum of Contemporary Art, Sydney, June 4–August 29, 1999; Art Gallery of Ontario, Toronto, October 1, 1999–January 2, 2000.

Museum Ludwig, Cologne. *Cindy Sherman.* November 7, 1997–February 1, 1998.

1998

Metro Pictures, New York. *Cindy Sherman.* April 18–May 16.

1999

Metro Pictures, New York. *Cindy Sherman.* May 15–June 26.

Monika Sprüth Galerie, Cologne. *Cindy Sherman: Neue Arbeiten.* November 5, 1999–February 12, 2000.

2000

Hasselblad Center, Gothenburg, Sweden. *Cindy Sherman: The Hasselblad Award 1999.* March 4–April 24 (catalogue).

Gagosian Gallery, Beverly Hills. *Cindy Sherman.* March 23–April 29.

Skarstedt Fine Art, New York. *Cindy Sherman: Fairy Tales, 1985.* May 2–July 1.

Sprüth Magers, Munich. *Cindy Sherman.* June 29–September 2.

Glenn Horowitz Bookseller, East Hampton, N.Y. *Early Work of Cindy Sherman.* August 18–October 1 (catalogue).

The Museum of Modern Art, New York. *Open Ends: Cindy Sherman, Untitled Film Stills.* September 28, 2000–March 4, 2001.

Metro Pictures, New York. *Cindy Sherman.* November 11, 2000–January 6, 2001.

2001

Kunsthallen Nikolaj, Copenhagen. *Cindy Sherman: Moment of Truth.* June 2–August 12.

2003

Skarstedt Fine Art, New York. *Cindy Sherman: Centerfolds.* May 10–June 14 (catalogue).

Serpentine Gallery, London. *Cindy Sherman.* June 3–August 25 (catalogue). Traveled to Scottish National Gallery of Modern Art, Edinburgh. December 6, 2003–March 7, 2004.

2004

Montclair Art Museum, N.J. *The Unseen Cindy Sherman: Early Transformations, 1975/1976.* March 21–August 1 (catalogue). Traveled to Hallwalls, Buffalo. October 23, 2004–January 9, 2005.

Metro Pictures, New York. *Cindy Sherman*. May 8–June 26.

Kestnergesellschaft, Hanover, Germany. *Cindy Sherman: Clowns*. September 24–November 7 (catalogue).

Sprüth Magers, London. *Cindy Sherman: Clowns*. November 26, 2004–January 15, 2005.

2005

Sprüth Magers, Munich. *Cindy Sherman: Clowns*. January 20–February 26.

Contemporary Art Museum St. Louis. *Cindy Sherman: Working Girl*. September 16–December 31 (catalogue).

2006

Jeu de Paume, Paris. *Cindy Sherman, Retrospective*. May 16–September 3 (catalogue). Traveled to Kunsthaus Bregenz, Austria, December 2, 2006–January 28, 2007; Louisiana Museum of Modern Art, Humlebaek, Denmark, February 16–May 20, 2007; Martin-Gropius-Bau, Berlin, June 15–September 10, 2007.

2007

Sprüth Magers, London. *Cindy Sherman: A Play of Selves*. May 23–June 14 (catalogue).

2008

Sprüth Magers, Berlin. *Cindy Sherman*. February 19–April 18.

Gagosian Gallery, Rome. *Cindy Sherman*. June 7–September 19.

Skarstedt Gallery, New York. *Cindy Sherman: History Portraits*. November 7–December 20.

Metro Pictures, New York. *Cindy Sherman*. November 15–December 23.

2009

Sprüth Magers, London. *Cindy Sherman*. April 16–May 27.

2010

National Gallery of Iceland, Reykjavík. *Cindy Sherman: Untitled Film Stills*. May 15–September 12.

2011

Sprüth Magers, London. *Cindy Sherman*. January 12–February 19.

Bruce Museum, Greenwich, Conn. *Cindy Sherman: Works from Friends of the Bruce Museum*. January 29–April 23 (catalogue).

2012

Sammlung Verbund, Vienna. *That's Me—That's Not Me: Early Works by Cindy Sherman*. January 26–May 16 (catalogue).

Group Exhibitions

1975

Hallwalls, Buffalo. *Buffalo Books: Visual Ideas in Book Form*. June 3–30.

CEPA Gallery, Buffalo. Opened August 1.

1976

Hallwalls, Buffalo. *Noise*. June 4–26.

Hallwalls, Buffalo. *Open Spaces*. August 17–28.

Hallwalls, Buffalo. *ArtpArkArt II*. October 8–27.

1977

Albright-Knox Art Gallery, Buffalo. *Photography '77*. January 13–February 20.

Hallwalls, Buffalo. *Snow Show*. February 10–20.

Albright-Knox Art Gallery, Buffalo. *In Western New York*. March 26–April 17 (catalogue).

Artists Space, New York. *Hallwalls*. November 6–27.

Hallwalls, Buffalo. *WHERENWHEN*. December 3, 1977–January 6, 1978.

1978

N.A.M.E. Gallery, Chicago. *Buffalo Chicago Exchango*. September 15–October 7.

Artists Space, New York. *[No Title]*. September 23–October 28 (catalogue).

1979

Upton Gallery, Buffalo State College. *Hallwalls: 5 Years*. November 5–15 (catalogue, published in 1980). Traveled to A Space, Toronto, February 16–March 8, 1980; New Museum, New York, July 1–31, 1980.

Max Protetch, New York. *Re:Figuration*. December 11, 1979–January 19, 1980.

1980

Castelli Graphics, New York. *Likely Stories*. July 7–September 13.

Metro Pictures, New York. *Opening Group Exhibition*. November 15–December 3.

Musée d'Art Moderne de la Ville de Paris. *Ils se disent peintres, ils se disent photographes*. November 22, 1980–January 4, 1981 (catalogue).

1981

Allen Memorial Art Museum, Oberlin, Ohio. *Young Americans*. April 1–May 3 (catalogue).

Galerie Chantal Crousel, Paris. *Picturealism—New York*. May 23–July 2.

Musée National d'Art Moderne, Centre Georges Pompidou, Paris. *Autoportraits Photographiques 1898–1981*. July 8–September 14 (catalogue).

Hayden Gallery, Massachusetts Institute of Technology,

Cambridge. *Body Language: Figurative Aspects of Recent Art*. October 2–December 24 (catalogue, published in 1982). Traveled to Fort Worth Art Museum, September 11–October 24, 1982; University of South Florida, Tampa, November 12–December 17, 1982; Contemporary Arts Center, Cincinnati, January 13–February 27, 1983.

Vienna Secession. *Erweiterte Fotografie: 5th Vienna International Biennale*. October 22–November 22 (catalogue).

1982

Walker Art Center, Minneapolis. *Eight Artists: The Anxious Edge*. April 25–June 23 (catalogue).

The Renaissance Society at The University of Chicago. *A Fatal Attraction: Art and the Media*. May 2–June 12 (catalogue).

Arte come arte: persistenza dell'opera. La Biennale di Venezia. June 13–September 12 (catalogue).

Documenta 7. Kassel, West Germany. June 19–September 28 (catalogue).

Seibu Museum of Art, Tokyo. *20th Century Photographs from the Museum of Modern Art*. October 2–19 (catalogue).

Institute of Contemporary Arts, London. *Urban Kisses*. October 14–November 21 (catalogue). Traveled to Bluecoat Gallery, Liverpool, December 2, 1982–January 7, 1983.

Milwaukee Art Museum. *New Figuration in America*. December 3, 1982–January 23, 1983 (catalogue).

Institute of Contemporary Art, University of Pennsylvania, Philadelphia. *Image Scavengers: Photography*. December 8, 1982–January 30, 1983 (catalogue).

1983

Hirshhorn Museum and Sculpture Garden, Smithsonian Institution, Washington, D.C. *Directions 1983*. March 10–May 15 (catalogue).

Whitney Museum of American Art, New York. *1983 Biennial Exhibition*. March 15–May 22 (catalogue).

The Museum of Modern Art, New York. *Big Pictures by Contemporary Photographers*. April 14–June 28.

Tate Gallery, London. *New Art at the Tate Gallery*. September 14–October 23 (catalogue).

Kunstmuseum Luzern, Switzerland. *Back to the USA: Amerikanische Kunst der Siebziger und Achtziger Jahre*. May 29–July 24 (catalogue). Traveled to Rheinisches Landesmuseum, Bonn. October 27, 1983–January 15, 1984; Wurttembergischer Kunstverein, Stuttgart, May 5–June 17, 1984.

1984

Art Gallery of New South Wales, Sydney. *The Fifth Biennale of Sydney: Private Symbol, Social Metaphor*. April 11–June 17 (catalogue).

Musée National d'Art Moderne, Centre Georges Pompidou, Paris. *Alibis*. July 5–September 17 (catalogue).

Contemporary Arts Museum, Houston. *The Heroic Figure*. September 15–November 4, 1984 (catalogue). Traveled to Brooks Memorial Art Gallery, Memphis, November 17, 1984–January 6, 1985; Alexandria Museum, La., February 21–March 10, 1985; The Santa Barbara Museum of Art, Calif., April 12–June 9, 1986.

Hirshhorn Museum and Sculpture Garden, Smithsonian Institution, Washington, D.C. *Content: A Contemporary Focus, 1974–1984*. October 4, 1984–January 6, 1985 (catalogue).

1985

Musée cantonal des Beaux-Arts Lausanne. *L'Autoportrait à l'âge de la photographie (Self-Portrait in the Age of Photography)*. January 18–March 24 (catalogue). Traveled to Württembergischer Kunstverein, Stuttgart, April 19–June 9; Akademie der Künste, Berlin, September 1–October 6; Sarah Campbell Blaffer Gallery, Houston, March 2–30, 1986; Travis Park Plaza, San Antonio, April 12–27, 1986.

Whitney Museum of American Art, New York. *1985 Biennial Exhibition*. March 13–June 2 (catalogue).

Barbican Art Gallery, London. *American Images: Photography 1945–1980*. May 10–June 30 (catalogue).

The Museum of Modern Art, New York. *Self-Portrait: The Photographer's Persona, 1840–1985*. November 7, 1985–January 7, 1986.

Carnegie Museum of Art, Pittsburgh. *1985 Carnegie International*. November 9, 1985–January 5, 1986 (catalogue).

1986

Phoenix Art Museum. *Altered Egos: Samaras, Sherman, Wegman*. January 10–February 23 (catalogue).

Seattle Art Museum. *Stills: Cinema and Video Transformed*. January 30–March 16 (catalogue).

Contemporary Arts Center, Cincinnati. *Personae: Jenny Holzer/Cindy Sherman*. February 7–March 22 (catalogue).

Frankfurter Kunstverein. *Prospect 86*. September 9–November 2 (catalogue).

International Center of Photography, New York. *Cindy Sherman, Stephen Frailey, and William Wegman*. September 14–November 9.

National Portrait Gallery, London. *Staging the Self: Self-Portrait Photography 1840s–1980s*. October 3, 1986–January 11, 1987 (catalogue). Traveled to Plymouth Arts Centre, United Kingdom, January 21–February 22, 1987; John Hansard Gallery, University of Southhampton, United Kingdom, March 2–April 11, 1987; Ikon Gallery, Birmingham, United Kingdom, May 1987.

Fundació Caixa de Pensions, Madrid. *Art and Its Double: A New York Perspective*. November 27, 1986–January 11, 1987 (catalogue, published in 1987). Traveled to La Caixa de Pensions, Barcelona. February 6–March 22, 1987.

The Museum of Contemporary Art, Los Angeles. *Individuals: A Selected History of Contemporary Art, 1945–1986*. December 10, 1986–January 10, 1988 (catalogue).

1987

Los Angeles County Museum of Art. *Avant-Garde in the Eighties*. April 25–July 12 (catalogue).

Musée National d'Art Moderne, Centre Georges Pompidou, Paris. *L'époque, la mode, la morale, la passion: aspects de l'art d'aujourd'hui, 1977–1987*. May 21–August 17 (catalogue).

Los Angeles County Museum of Art. *Photography and Art: Interactions Since 1946*. June 4–August 30 (catalogue). Traveled to Museum of Art, Fort Lauderdale, Fla., October 15, 1987–January 24, 1988; Queens Museum of Art, Flushing, N.Y., February 13–April 3, 1988; Des Moines Art Center, Iowa, May 6–June 2, 1988.

Moderna Museet, Stockholm. *Implosion: A Postmodern Perspective*. October 4, 1987–January 10, 1988 (catalogue).

The Clocktower Gallery, Institute for Contemporary Art, Long Island City, N.Y. *Modern Dreams: The Rise and Fall of Pop Art*. October 22, 1987–June 12, 1988 (catalogue, published in 1988).

1988

Milwaukee Art Museum. *1988: The World of Art Today*. May 6–August 28 (catalogue).

The Brooklyn Museum, N.Y. *Appropriation and Syntax: The Uses of Photography in Contemporary Art*. July 6–October 10 (catalogue).

1989

Corcoran Gallery of Art, Washington, D.C. *Surrogate Selves: David Levinthal, Cindy Sherman, Laurie Simmons*. January 24–April 16 (catalogue).

Museum of Fine Arts, Houston. *The Art of Photography: 1839–1989*. February 11–April 30 (catalogue). Traveled to National Gallery of Australia, Canberra, June 17–August 27; Royal Academy of Arts, London, September 23–December 23.

The Museum of Modern Art, New York. *Photography Until Now*. February 14–May 29 (catalogue).

Victoria and Albert Museum, London. *Photography Now*. February 15–April 30 (catalogue).

Cincinnati Art Museum. *Making Their Mark: Women Artists Move into the Mainstream, 1970–85*. February 22–April 2 (catalogue). Traveled to New Orleans Museum of Art, May 6–June 18; Denver Art

Museum, July 22–September 10; Pennsylvania Academy of the Fine Arts, Philadelphia, October 21–December 31.

National Museum of American Art, Smithsonian Institution, Washington, D.C. *The Photography of Invention: American Pictures of the 1980s*. April 28–September 10 (catalogue).

The Museum of Contemporary Art, Los Angeles. *A Forest of Signs: Art in the Crisis of Representation*. May 7–August 13 (catalogue).

The Metropolitan Museum of Art, New York. *Invention and Continuity in Contemporary Photography*. June 13–October 8.

Kunstverein, Munich. *Das konstruierte Bild: Fotografie—arrangiert und inszeniert*. October 28–December 3 (catalogue, published in English in 1995). Traveled to Kunsthalle Nuremberg, Germany, February 23–March 25, 1990; Forum Böttcherstrasse, Bremen, Germany, March 25–June 13, 1990; Badischer Kunstverein, Karlsruhe, Germany, July–August 1990.

Whitney Museum of American Art, New York. *Image World: Art and Media Culture*. November 8, 1989–February 18, 1990 (catalogue).

1990

Hirshhorn Museum and Sculpture Garden, Smithsonian Institution, Washington, D.C. *Culture and Commentary: An Eighties Perspective*. February 8–May 6 (catalogue).

Stedelijk Museum, Amsterdam. *Energieen*. April 8–July 29 (catalogue).

The Readymade Boomerang: Eighth Biennale of Sydney. April 11–June 3 (catalogue).

The Museum of Modern Art, New York. *High and Low: Modern Art and Popular Culture*. October 7, 1990–January 15, 1991 (catalogue).

1991

Whitney Museum of American Art, New York. *1991 Biennial Exhibition*. April 2–June 30 (catalogue).

Martin-Gropius-Bau, Berlin. *Metropolis*. April 20–July 21 (catalogue).

1992

Museo de Monterrey, Mexico. *Becher, Mapplethorpe, Sherman*. April–June 1992 (catalogue).

Musée d'Art Contemporain, Lausanne. *Post Human*. June 4–September 13 (catalogue). Traveled to Castello di Rivoli, Turin, October 1–November 22; Deste Foundation Centre for Contemporary Art, Athens, December 3, 1992–February 14, 1993; Deichtorhallen Hamburg, March 12–May 9, 1993; Israel Museum, Jerusalem, June 23–October 10, 1993.

Whitney Museum of American Art at Equitable Center, New York. *Dirt & Domesticity: Constructions of the Feminine*. June 12–August 14 (catalogue).

1993

Kunstnernes Hus, Oslo. *Louise Lawler, Cindy Sherman, Laurie Simmons*. January 30–March 7 (catalogue). Traveled to Museum of Contemporary Art, Helsinki, March 26–May 9.

Whitney Museum of American Art, New York. *1993 Biennial Exhibition*. February 24–June 20 (catalogue).

Martin-Gropius-Bau, Berlin. *American Art in the 20th Century: Painting and Sculpture 1913–93*. May 8–July 25 (catalogue). Traveled to Royal Academy of Arts, London, September 16–December 12.

Whitney Museum of American Art, New York. *Abject Art: Repulsion and Desire in American Art*. June 23–August 29 (catalogue).

Musée National d'Art Moderne, Centre Georges Pompidou, Paris. *L'envers des choses: Annette Messager, Cindy Sherman, George Kuchar*. September 7–October 11 (catalogue).

1994

Sammlung Goetz, Munich. *Jürgen Klauke/Cindy Sherman*. September 19, 1994–March 17, 1995 (catalogue).

Transformers: The Art of Multiphrenia. Organized by Independent Curators International, New York (catalogue). Traveled to Center for Curatorial Studies, Bard College, Annandale-on-Hudson, N.Y., September 21–November 13; Decker Galleries, Maryland Institute College of Art, Baltimore, November 17–December 17; Herbert F. Johnson Museum of Art, Cornell University, Ithaca, N.Y., January 27–March 26, 1995; Nexus Contemporary Art Center, Atlanta, April 12–June 1, 1995; Art Gallery of Windsor, Ontario, June 21–September 9, 1995; Illingworth Kerr Art Gallery, Alberta College of Art and Design, Calgary, November 4–28, 1995.

Henry Art Gallery, University of Washington, Seattle. *After Art: Rethinking 150 Years of Photography*. December 4, 1994–March 5, 1995 (catalogue). Traveled to The Friends of Photography, Ansel Adams Center, San Francisco, May 17–July 9, 1995; Portland Art Museum, Maine, October 29, 1995–January 14, 1996.

1995

Whitney Museum of American Art, New York. *1995 Biennial Exhibition*. March 23–June 4 (catalogue).

Kunsthaus Zürich. *Zeichen & Wunder*. March 31–June 18 (catalogue). Traveled to Centro Galego de Arte Contemporánea, Santiago de Compostela, Spain, July 20–October 20.

Burchfield Penny Art Center, Buffalo. *Alternatives: 20 Years of Hallwalls Contemporary Arts Center*. April 8–June 18 (catalogue, published in 1996).

Identity and Alterity: Figures of the Body, 1895–1995. La Biennale di Venezia. June 15–November 9 (catalogue).

The Parrish Art Museum, Southampton, N.Y. *Face*

Value: American Portraits. July 16–September 13 (catalogue). Traveled to Wexner Center for the Arts, The Ohio State University, Columbus, February 3–April 21, 1996; Tampa Museum of Art, Fla., July 14–September 8, 1996.

Musée National d'Art Moderne, Centre Georges Pompidou, Paris. *FémininMasculin: le sexe de l'art*. October 24, 1995–February 12, 1996 (catalogue).

Carnegie Museum of Art, Pittsburgh. *Carnegie International 1995*. November 5, 1995–February 18, 1996 (catalogue).

1996

The Museum of Contemporary Art, Los Angeles. *Hall of Mirrors: Art and Film Since 1945*. March 17–July 28 (catalogue). Traveled to Wexner Center for the Arts, The Ohio State University, Columbus, September 9, 1996–January 5, 1997; Palazzo delle Esposizioni, Rome, June 2–September 1, 1997; Museum of Contemporary Art, Chicago, October 11, 1997–January 21, 1998.

Musée National d'Art Moderne, Centre Georges Pompidou, Paris. *L'informe: mode d'emploi*. May 22–August 26 (catalogue).

Neue Galerie am Landesmuseum Joanneum and Künstlerhaus, Graz, Austria. *Radical Images: The 2nd Austrian Triennial of Photography*. June 14–July 28, 1996 (catalogue).

1997

Solomon R. Guggenheim Museum, New York. *Rrose is a Rrose is a Rrose: Gender Performance in Photography*. January 17–May 7 (catalogue).

Making it Real. Organized by Independent Curators International, New York (catalogue). Traveled to The Aldrich Contemporary Art Museum, Ridgefield, Conn., January 19–April 20; Reykjavík Municipal Art Museum, Iceland, October 18–November 23; Portland Museum of Art, Maine, January 22–March 22, 1998; Sandra & David Bakalar Gallery, Massachusetts College of Art, Boston, November 24–December 24, 1998; Emerson Gallery, Hamilton College, Clinton, N.Y., January 18–February 21, 1999; Bayly Art Museum, University of Virginia, Charlottesville, September 18–November 15, 1999.

Saint Louis Art Museum. *Defining Eye: Women Photographers of the 20th Century*. September 23, 1997–January 11, 1998 (catalogue).

The Museum of Modern Art, New York. *On the Edge: Contemporary Art from the Werner and Elaine Dannheisser Collection*. September 30, 1997–January 20, 1998 (catalogue).

1998

MIT List Center, Massachusetts Institute of Technology, Cambridge. *Mirror Images: Women, Surrealism, and Self-Representation*. April 9–June 28 (catalogue). Traveled to Miami Art Museum, September 18–

November 29; San Francisco Museum of Modern Art, January 8–April 20, 1999.

The Power Plant Contemporary Art Gallery at Harbourfront Centre, Toronto. *American Playhouse: The Theatre of Self-Presentation*. September 25–December 20, 1998 (catalogue).

1999

Kunsthalle, Bremen, Germany. *Von Beuys bis Cindy Sherman: Sammlung Lothar Schirmer*. March 6–July 25 (catalogue).

Museum of Modern Art, Oxford. *Notorious: Alfred Hitchcock and Contemporary Art*. July 11–October 3 (catalogue). Traveled to Museum of Contemporary Art, Sydney, December 15, 1999–April 24, 2000.

Kunstmuseum Wolfsburg, Germany. *Gesammelte Werke 1: Zeitgenössische Kunst seit 1968*. July 17–October 3 (catalogue).

Whitney Museum of American Art, New York. *The American Century: Art and Culture 1900–2000, Part II*. September 26, 1999–February 13, 2000 (catalogue).

Hirshhorn Museum and Sculpture Garden, Smithsonian Institution, Washington, D.C. *Regarding Beauty: A View of the Late Twentieth Century*. October 7, 1999–January 17, 2000 (catalogue). Traveled to Haus der Kunst, Munich, February 11–April 30, 2000.

Los Angeles County Museum of Art. *Ghost in the Shell: Photography and the Human Soul, 1850–2000*. October 16, 1999–January 17, 2000 (catalogue).

Grey Art Gallery, New York University. *Inverted Odysseys: Claude Cahun, Maya Deren, Cindy Sherman*. November 16, 1999–January 29, 2000 (catalogue). Traveled to Museum of Contemporary Art, North Miami, March 31–May 28, 2000.

2000

Walker Art Center, Minneapolis. *Let's Entertain: Life's Guilty Pleasures*. February 12–April 30 (catalogue). Traveled to Portland Art Museum, Ore., July 7–September 17; Musée National d'Art Moderne, Centre Georges Pompidou, Paris, November 19, 2000–January 8, 2001; Kunstmuseum Wolfsburg, Germany, March 17–July 15, 2001; Miami Art Museum, September 14–November 18, 2001.

Kunsthaus Zürich. *Hyper Mental: Rampant Reality 1950–2000, from Salvador Dalí to Jeff Koons*. November 17, 2000–January 21, 2001 (catalogue). Traveled to Hamburger Kunsthalle, February 16–May 6, 2001.

2001

Generali Foundation, Vienna. *Double Life: Identität und Transformation in der zeitgenössischen Kunst*. May 11–August 12 (catalogue).

Los Angeles County Museum of Art. *Jasper Johns to Jeff Koons: Four Decades of Art from the Broad Collection*.

October 7, 2001–January 6, 2002 (catalogue). Traveled to Corcoran Gallery of Art, Washington, D.C., March 16–June 3, 2002; Museum of Fine Arts, Boston, July 21–October 20, 2002.

2002

Whitney Museum of American Art, New York. *Visions from America: Photographs from the Whitney Museum of American Art, 1940–2001*. June 27–September 22 (catalogue).

Solomon R. Guggenheim Museum, New York. *Moving Pictures: Contemporary Photography and Video from the Guggenheim Collections*. June 28, 2002–January 12, 2003 (catalogue).

Museum of Contemporary Art, Chicago. *Life, Death, Love, Hate, Pleasure, Pain*. November 16, 2002–April 20, 2003 (catalogue).

Sammlung Goetz, Munich. *Just Love Me, Post/Feminist Positions of the 1990s from the Goetz Collection*. December 2, 2002–March 15, 2003 (catalogue). Traveled to Bergen Art Museum, Norway, August 23–October 26, 2003; Fries Museum Leeuwarden, The Netherlands, April 24–June 21, 2004.

2003

Deste Foundation Centre for Contemporary Art, Athens. *Monument to Now: The Dakis Joannou Collection*. June 22, 2003–December 31, 2004 (catalogue).

Walker Art Center, Minneapolis. *The Last Picture Show: Artists Using Photography, 1960–1982*. October 11, 2003–January 11, 2004 (catalogue). Traveled to Hammer Museum, University of California, Los Angeles, February 8–May 9, 2004; Fotomuseum Winterthur, Switzerland, November 29, 2004–February 20, 2005; Miami Art Central, March 11–June 12, 2005.

2004

Galeries Nationales du Grand Palais, Paris. *The Great Parade: Portrait of the Artist as Clown*. March 11–May 31 (catalogue). Traveled to National Gallery of Canada, Ottawa, June 25–September 19.

The Museum of Modern Art, New York. *Fashioning Fiction in Photography since 1990*. April 16–June 28 (catalogue).

SITE Santa Fe. *Disparities and Deformations: Our Grotesque, Fifth International Biennial Exhibition*. July 18, 2004–January 9, 2005 (catalogue).

Arario Gallery, Chungnam, Korea. *Her Bodies: Cindy Sherman and Vanessa Beecroft*. September 1–November 21 (catalogue).

2005

Kunstmuseum Basel, Museum für Gegenwartskunst. *Flashback: Revisiting the Art of the Eighties*. October 30, 2005–February 12, 2006 (catalogue).

2006

Museum of Contemporary Art, Sydney. *Masquerade: Representation and the Self in Contemporary Art*. March 23–May 21 (catalogue).

P.S.1 Contemporary Art Center, Long Island City, N.Y. *Into Me / Out of Me*. June 25–September 25 (catalogue). Traveled to KW Institute for Contemporary Art, Berlin, November 25, 2006–March 4, 2007; MACRO Museo d'Arte Contemporanea, Rome, April 21–September 30, 2007.

Hessel Museum of Art, Center for Curatorial Studies, Bard College, Annandale-on-Hudson, N.Y. *Wrestle: Marieluise Hessel Collection*. November 12, 2006–May 27, 2007 (catalogue).

2007

The Museum of Contemporary Art, Los Angeles. *WACK! Art and the Feminist Revolution*. March 4–July 16 (catalogue). Traveled to National Museum of Women in the Arts, Washington, D.C., September 21–December 16; P.S.1 Contemporary Art Center, Long Island City, N.Y., February 17– May 12, 2008.

Museum of Applied Arts (MAK), Vienna. *Held Together With Water: Art from the Sammlung Verbund*. May 9–September 16 (catalogue). Traveled to Museum of Modern Art, Istanbul, September 10, 2008–January 11, 2009.

Museu d'Art Contemporani de Barcelona. *A Theater without Theater*. May 25–September 11 (catalogue). Traveled to Museu Colecção Berardo, Lisbon. November 16, 2007–February 17, 2008.

Barbican Art Gallery, London. *Panic Attack! Art in the Punk Years*. June 5–September 9 (catalogue).

2008

Los Angeles County Museum of Art, Los Angeles. *The Broad Contemporary Art Museum at the Los Angeles County Museum of Art: BCAM/LACMA/2008*. March 1–September 20 (catalogue).

Tate Modern, London. *Street & Studio: An Urban History of Photography*. May 22–August 31 (catalogue). Traveled to Museum Folkwang, Essen, Germany, October 11, 2008–January 11, 2009.

2009

The Museum of Modern Art, New York. *Into the Sunset: Photography's Image of the American West*. March 29–June 8 (catalogue).

The Metropolitan Museum of Art, New York. *The Pictures Generation: 1974–1984*. April 21–August 2 (catalogue).

Punta della Dogana, Venice. *Mapping the Studio: Artists from the François Pinault Collection*. June 6, 2009–June 6, 2010 (catalogue).

International Center of Photography, New York. *Dress Codes: The Third ICP Triennial of Photography and Video*. October 2, 2009–January 17, 2010 (catalogue).

2010

Galleria Nazionale d'Arte Moderna, Rome. *Donna: Avanguardia Femminista negli anni '70 dalla Sammlung Verbund di Vienna*. February 19–May 16 (catalogue).

Solomon R. Guggenheim Museum, New York. *Haunted: Contemporary Photography/Video/ Performance*. March 26–September 6 (catalogue). Traveled to Guggenheim Museum Bilbao, Spain, November 9, 2010–March 13, 2011.

Pinchuk Art Centre, Kiev. *Sexuality and Transcendence*. April 24–September 19 (catalogue).

The Museum of Modern Art, New York. *Pictures by Women: A History of Modern Photography*. May 7, 2010–April 4, 2011.

New Museum, New York. *Skin Fruit: Selections from the Dakis Joannou Collection*. June 6–20 (catalogue).

Museo Nacional Centro de Arte Reina Sofía, Madrid. *Mixed Use, Manhattan: Photography and Related Practices, 1970s to the Present*. June 9–September 27 (catalogue).

SITE Santa Fe. *The Dissolve: Eighth International Biennial Exhibition*. June 20, 2010–January 2, 2011 (catalogue).

10,000 Lives: Gwangju Biennale 2010, Korea. September 3–November 7 (catalogue).

2011

Neuberger Museum of Art, Purchase College, State University of New York. *The Deconstructive Impulse: Women Artists Reconfigure the Signs of Power, 1973–1990*. January 15–April 3 (catalogue). Traveled to Nasher Museum of Art at Duke University, Durham, N.C. September 15, 2011–January 8, 2012.

Alcalá 31, Fundación Telefónica, Madrid. *PhotoEspaña 2011: 1000 caras / 0 caras / 1 rostro: Cindy Sherman, Thomas Ruff, Frank Montero*. May 31–July 24 (catalogue).

ILLUMInations: La Biennale di Venezia. June 4–November 27 (catalogue).

Selected Bibliography

Compiled by Lucy Gallun

Solo Exhibition Catalogues and Monographs

1980

Cathcart, Linda. *Cindy Sherman: Photographs.* Brochure. Houston: Contemporary Arts Museum, 1980.

1982

Barents, Els. *Cindy Sherman.* Amsterdam: Stedelijk Museum, 1982.

Bonnotte, Catherine, and Laurence Cyrot. *Cindy Sherman.* Brochure. Dijon, France: Galerie Déjà vu, 1982.

1983

Caujolle, Christian. *Cindy Sherman.* Saint-Étienne, France: Musée d'Art et d'Industrie, 1983.

Cowart, Jack. *Currents 20: Cindy Sherman.* Brochure. Saint Louis: Saint Louis Art Museum, 1983.

Thompson, Thom. *Cindy Sherman.* Brochure. Stony Brook, N.Y.: Art Gallery, Fine Arts Center, State University of New York, 1983.

1984

Cindy Sherman. Brochure. Tokyo: Seibu Contemporary Art Gallery, 1984.

Danoff, I. Michael. *Cindy Sherman.* Brochure. Akron, Ohio: Akron Art Museum, 1984.

Next Wave of American Women, Vol. 2: Cindy Sherman. Tokyo: Laforet Museum Harajuku, 1984.

Schjeldahl, Peter, and I. Michael Danoff. *Cindy Sherman.* New York: Pantheon Books, 1984.

1985

Stockebrand, Marianne. *Cindy Sherman, Photographien.* Münster, West Germany: Westfälischer Kunstverein, 1985.

1986

Cloudman, Ruth. *Perspectives 4: Cindy Sherman.* Brochure. Portland, Ore.: Portland Art Museum, 1986.

Miller-Keller, Andrea. *Cindy Sherman: MATRIX 88.* Brochure. Hartford, Conn.: The Wadsworth Atheneum, 1986.

1987

Barents, Els, and Peter Schjeldahl. *Cindy Sherman.* Munich: Schirmer/Mosel, 1987.

Phillips, Lisa, and Peter Schjeldahl. *Cindy Sherman.* New York: Whitney Museum of American Art, 1987.

Suzuki, Gyoh, and Seiko Uyeda, eds. *Cindy Sherman.* Tokyo: Parco, 1987.

1989

Bieringa, Luit. *Cindy Sherman.* Brochure. Wellington, New Zealand: National Art Gallery, 1989.

1990

Danto, Arthur C. *Cindy Sherman: Untitled Film Stills.* New York: Rizzoli, 1990.

Meneguzzo, Marco. *Cindy Sherman.* Milan: Mazzotta, 1990.

1991

Danto, Arthur C. *Cindy Sherman: History Portraits.* New York: Rizzoli, 1991.

deAk, Edit, ed. *Cindy Sherman: Specimens.* Kyoto: Kyoto Shoin International, 1991.

Kellein, Thomas. *Cindy Sherman.* Basel: Kunsthalle Basel, 1991.

Sobel, Dean. *Currents 18: Cindy Sherman.* Brochure. Milwaukee: Milwaukee Art Museum, 1991.

1992

Sherman, Cindy. *Fitcher's Bird.* New York: Rizzoli, 1992.

1993

Krauss, Rosalind. *Cindy Sherman: 1975–1993.* New York: Rizzoli, 1993.

1994

Nerlich, Klaus. *Cindy Sherman: New York Photographien.* Weimar, Germany: ACC Galerie, 1994.

Tarantino, Michael. *From Beyond the Pale: Julião Sarmento and Cindy Sherman.* Dublin: Irish Museum of Modern Art, 1994.

1995

Basualdo, Carlos. *Cindy Sherman: The Self Which Is Not One.* São Paulo: Museu de Arte Moderna de São Paulo, 1995.

Dickhoff, Wilfried. *Cindy Sherman: Kunst Heute Nr. 14.* Cologne: Kiepenheuer & Witsch, 1995.

Felix, Zdenek, and Martin Schwander, eds. *Cindy Sherman Photographien 1975–1995.* Munich: Schirmer Art Books, 1995.

Rosenzweig, Phyllis D. *Directions: Cindy Sherman, Film Stills.* Brochure. Washington, D.C.: Hirshhorn Museum and Sculpture Garden, Smithsonian Institution, 1995.

Schneider, Christa. *Cindy Sherman: History Portraits.* Munich: Schirmer/Mosel, 1995.

1996

Mori, Chika, et al., eds. *Cindy Sherman.* Shiga, Japan: Asahi Shimbun, 1996.

Schampers, Karel. *Cindy Sherman.* Rotterdam: Museum Boijmans Van Beuningen, 1996.

1997

Cindy Sherman: una selección de las colecciones de la Eli Broad Family Foundation. Caracas: Museo de Bellas Artes, 1997.

Cruz, Amada, Elizabeth A. T. Smith, and Amelia Jones. *Cindy Sherman: Retrospective*. Chicago: Museum of Contemporary Art; Los Angeles: The Museum of Contemporary Art, 1997.

1999

Morris, Catherine. *The Essential Cindy Sherman*. New York: Harry N. Abrams, 1999.

2000

Knape, Gunilla. *Cindy Sherman: The Hasselblad Award 1999*. Gothenburg, Sweden: Hasselblad Center, 2000.

Williams, Edsel. *Early Work of Cindy Sherman*. East Hampton, N.Y.: Glenn Horowitz Bookseller, 2000.

2003

Phillips, Lisa. *Cindy Sherman: Centerfolds*. New York: Skarstedt Fine Art, 2003.

Sherman, Cindy. *Cindy Sherman: The Complete Untitled Film Stills*. New York: The Museum of Modern Art, 2003.

Steiner, Rochelle. *Cindy Sherman*. London: Serpentine Gallery, 2003.

2004

Schlüter, Maik, and Isabelle Graw. *Cindy Sherman: Clowns*. Munich: Schirmer/Mosel, 2004.

Stavitsky, Gail. *The Unseen Cindy Sherman: Early Transformations, 1975/1976*. Montclair, N.J.: Montclair Art Museum, 2004.

2005

Ha, Paul. *Cindy Sherman: Working Girl*. Saint Louis: Contemporary Art Museum St. Louis, 2005.

2006

Burton, Johanna, ed. *Cindy Sherman*. October Files. Cambridge, Mass.: MIT Press, 2006.

Durand, Régis, and Véronique Dabin. *Cindy Sherman*. Paris: Flammarion/Éditions Jeu de Paume, 2006.

2007

Cindy Sherman: A Play of Selves. Ostfildern, Germany: Hatje Cantz, 2007.

Stocchi, Francesco. *Cindy Sherman*. Super Contemporary series. Milan: Electa, 2007.

2011

Silver, Kenneth E., Peter C. Sutton, and Linda Nochlin. *Cindy Sherman: Works from Friends of the Bruce Museum*. Greenwich, Conn.: Bruce Museum, 2011.

2012

Schor, Gabriele. *Cindy Sherman: The Early Works, 1975–1977, Catalogue Raisonné*. Ostfildern, Germany: Hatje Cantz, 2012.

Group Exhibition Catalogues and Books

1977

In Western New York. Buffalo: Albright-Knox Art Gallery, 1977.

1978

Reiring, Janelle. [No Title]. New York: Artists Space, 1978.

1980

Denson, G. Roger, and Linda Cathcart. *Hallwalls: 5 Years*. Buffalo: Hallwalls, 1980.

Nuridsany, Michel. *Ils se disent peintres, ils se disent photographes*. Paris: ARC/Musée d'Art Moderne de la Ville de Paris, 1980.

Olander, William. *Young Americans: Janet Cooling, Hudson, David Salle, Cindy Sherman, David Saunders, and David Wells*. Special issue, *Allen Memorial Art Museum Bulletin* 38, no. 2 (1980–81). Oberlin, Ohio: Allen Memorial Art Museum, 1980.

1981

Roche, Denis. *Autoportraits Photographiques 1898–1981*. Paris: Musée National d'Art Moderne, Centre Georges Pompidou, 1981.

Thomas, Lew, and Peter D'Agostino. *Still Photography: The Problematic Model*. San Francisco: NFS Press, 1981.

Weibel, Peter, and Anna Auer. *Erweiterte Fotografie: 5th Vienna International Biennale*. Vienna: Vienna Secession, 1981.

1982

La Biennale di Venezia. Milan: Electa Editrice; Venice: Edizioni La Biennale di Venezia, 1982.

Foster, Hal. *Urban Kisses*. London: Namara Press, 1982.

Fuchs, Rudi. *Documenta 7: Volume II*. Kassel: D + V Paul Dierichs, 1982.

Goldstein, Rosalie, ed. *New Figuration in America*. Milwaukee: Milwaukee Art Museum, 1982.

Lawson, Thomas. *A Fatal Attraction: Art and the Media*. Chicago: The Renaissance Society at the University of Chicago, 1982.

Lyons, Lisa. *Eight Artists: The Anxious Edge*. Minneapolis: Walker Art Center, 1982.

Marincola, Paula. *Image Scavengers: Photography*. Philadelphia: Institute of Contemporary Art, University of Pennsylvania, 1982.

Smith, Roberta. *Body Language: Figurative Aspects of Recent Art*. Cambridge, Mass.: Hayden Gallery, Massachusetts Institute of Technology, 1982.

Szarkowski, John, and Susan Kismaric. *20th Century Photographs from the Museum of Modern Art*. Tokyo: Seibu Museum of Art, 1982.

1983

Compton, Michael. *New Art at the Tate Gallery*. London: Tate Gallery, 1983.

Harnhardt, John G., et al. *1983 Biennial Exhibition*. New York: Whitney Museum of American Art, 1983.

Honnef, Klaus, and Barbara Kückels, eds. *Back to the USA: Amerikanische Kunst der Siebziger und Achtziger Jahre*. Cologne: Rheinland-Verlag: 1983.

Rosenzweig, Phyllis D. *Directions 1983*. Washington, D.C.: Hirshhorn Museum and Sculpture Garden, Smithsonian Institution, 1983.

1984

Blistène, Bernard, et al. *Alibis*. Paris: Musée National d'Art Moderne, Centre Georges Pompidou, 1984.

Cathcart, Linda L. *The Heroic Figure*. Houston: Contemporary Arts Museum, 1984.

Fox, Howard N., Miranda McClintic, and Phyllis D. Rosenzweig. *Content: A Contemporary Focus, 1974–1984*. Washington, D.C.: Hirshhorn Museum and Sculpture Garden, Smithsonian Institution, 1984.

Paroissien, Leon. *The Fifth Biennale of Sydney: Private Symbol, Social Metaphor*. Sydney: Biennale of Sydney, 1984.

1985

Armstrong, Richard, et al. *1985 Biennial Exhibition*. New York: Whitney Museum of American Art, 1985.

Billeter, Erika. *Self-Portrait in the Age of Photography*. Berlin: Akademie der Künste, 1985.

Lane, John R., Saskia Bos, and John Caldwell. *1985 Carnegie International*. Pittsburgh: Carnegie Museum of Art, 1985.

Turner, Peter. *American Images: Photography 1945–1980*. London: Barbican Art Gallery; New York: Penguin Books, 1985.

1986

Kurtz, Bruce D. *Altered Egos: Samaras, Sherman, Wegman*. Phoenix: Phoenix Art Museum, 1986.

Lingwood, James. *Staging the Self: Self-Portrait Photography 1840s–1980s*. London: National Portrait Gallery, 1986.

Rogers-Lafferty, Sarah. *Personae: Jenny Holzer/ Cindy Sherman*. Cincinnati: Contemporary Arts Center, 1986.

Slemmons, Rod. *Stills: Cinema and Video Transformed*. Seattle: Seattle Art Museum, 1986.

Turrell, Julia Brown. *Individuals: A Selected History of Contemporary Art, 1945–1986*. Los Angeles: The Museum of Contemporary Art, 1986.

Weiermair, Peter. *Prospect 86*. Frankfurt: Frankfurter Kunstverein, 1986.

1987

Blistène, Bernard, Catherine David, and Alfred Pacquement. *L'époque, la mode, la morale, la passion: aspects de l'art d'aujourd'hui , 1977–1987*. Paris: Musée National d'Art Moderne, Centre Georges Pompidou, 1987.

Cameron, Dan. *Art and Its Double: A New York Perspective*. Madrid: Fundació Caixa de Pensions, 1987.

Fox, Howard N. *Avant-Garde in the Eighties*. Los Angeles: Los Angeles County Museum of Art, 1987.

Hoy, Anne H. *Fabrications: Staged, Altered, and Appropriated Photographs*. New York: Abbeville Press, 1987.

Nairne, Sandy, Geoff Dunlop, and John Wyver. *State of the Art: Ideas & Images in the 1980s*. London: Chatto and Windus, 1987.

Nittve, Lars. *Implosion: A Postmodern Perspective*. Stockholm: Moderna Museet, 1987.

1988

Alloway, Lawrence, et al. *Modern Dreams: The Rise and Fall of Pop Art*. Cambridge, Mass.: MIT Press, 1988.

Bowman, Russell. *1988: The World of Art Today*. Milwaukee: Milwaukee Art Museum, 1988.

Celant, Germano. *Unexpressionism: Art Beyond the Contemporary*. New York: Rizzoli, 1988.

Weintraub, Laural. *Appropriation and Syntax: The Uses of Photography in Contemporary Art*. Brooklyn, N.Y.: The Brooklyn Museum, 1988.

1989

Gudis, Catherine, ed. *A Forest of Signs: Art in the Crisis of Representation*. Los Angeles: The Museum of Contemporary Art, 1989.

Haworth-Booth, Mark. *Photography Now*. London: Victoria and Albert Museum, 1989.

Heiferman, Marvin, and Lisa Phillips. *Image World: Art and Media Culture*. New York: Whitney Museum of American Art, 1989.

Rosen, Randy, and Catherine C. Brawer, eds. *Making Their Mark: Women Artists Move into the Mainstream, 1970–85*. New York: Abbeville Press, 1989.

Smith, Joshua P. *The Photography of Invention: American Pictures of the 1980s*. Washington, D.C.: National Museum of American Art, Smithsonian Institution; Cambridge, Mass.: MIT Press, 1989.

Sultan, Terrie. *Surrogate Selves: David Levinthal, Cindy Sherman, Laurie Simmons*. Washington, D.C.: Corcoran Gallery of Art, 1989.

Szarkowski, John. *Photography Until Now*. New York: The Museum of Modern Art, 1989.

Weaver, Mike. *The Art of Photography: 1839–1989*. New Haven, Conn.: Yale University Press, 1989.

1990

Beeren, Wim. *Energieen*. Amsterdam: Stedelijk Museum, 1990.

Halbreich, Kathy. *Culture and Commentary: An Eighties Perspective*. Washington D.C.: Hirshhorn Museum and Sculpture Garden, Smithsonian Institution, 1990.

Kirker, Anne, and Joachim Sartorius. *The Readymade Boomerang: Eighth Biennale of Sydney*. Sydney: Biennale of Sydney, 1990.

Sullivan, Constance, ed. *Women Photographers*. New York: Harry N. Abrams, 1990.

Varnedoe, Kirk, and Adam Gopnik. *High and Low: Modern Art and Popular Culture*. New York: The Museum of Modern Art, 1990.

1991

Armstrong, Richard, et al. *1991 Biennial Exhibition*. New York: Whitney Museum of American Art, 1991.

Rosenthal, Norman, and Christos M. Joachimides, eds. *Metropolis*. New York: Rizzoli, 1991.

1992

Bronfen, Elizabeth. *Over Her Dead Body: Death, Femininity, and the Aesthetic*. New York and London: Routledge, 1992.

Debroise, Olivier. *Becher, Mapplethorpe, Sherman*. Monterrey, Mexico: Museo de Monterrey, 1992.

Deitch, Jeffrey. *Post Human*. New York: DAP/ Distributed Art Publishers; Lausanne: Musée d'Art Contemporain, 1992.

Fuenmayor, Jesús, et al., *Dirt & Domesticity: Constructions of the Feminine*. New York: Whitney Museum of American Art, 1992.

1993

Ben-Levi, Jack, et al., eds., *Abject Art: Repulsion and Desire in American Art*. New York: Whitney Museum of American Art, 1993.

Gibson, Pamela Church, and Roma Gibson. *Dirty Looks: Women, Pornography, Power*. London: BFI Publishing, 1993.

Grenier, Catherine. *L'envers des choses: Annette Messager, Cindy Sherman, George Kuchar*. Paris: Musée Nationale d'Art Moderne, Centre Georges Pompidou, 1993.

Rosenthal, Norman, and Christos M. Joachimides, eds. *American Art in the 20th Century: Painting and Sculpture 1913–93*. Munich: Prestel, 1993.

Sussman, Elisabeth, et al. *1993 Biennial Exhibition*. New York: Whitney Museum of American Art, 1993.

Thorkildsen, Asmund, and Leena-Maija Rossi. *Louise Lawler, Cindy Sherman, Laurie Simmons*. Oslo: Kunstnernes Hus; Helsinki: Museum of Contemporary Art, 1993.

1994

Bruce, Chris. *After Art: Rethinking 150 Years of Photography*. Seattle: Henry Art Gallery, University of Washington, 1994.

Goetz, Ingvild, and Christiane Meyer-Stoll. *Jürgen Klauke/Cindy Sherman*. Munich: Sammlung Goetz, 1994.

Lucie-Smith, Edward. *Race, Sex, and Gender in Contemporary Art*. London: Art Books International, 1994.

Nochlin, Linda. *The Body in Pieces: The Fragment as a Metaphor of Modernity*. New York: Thames and Hudson, 1994.

Rosenblum, Naomi. *A History of Women Photographers*. New York: Abbeville Press, 1994.

Rugoff, Ralph. *Transformers: The Art of Multiphrenia*. New York: Independent Curators International, 1994.

1995

Armstrong, Richard, and Paola Morsiani. *Carnegie International 1995*. Pittsburgh: Carnegie Museum of Art, 1995.

Bernadac, Marie-Lauré, and Bernard Marcadé. *FémininMasculin: le sexe de l'art*. Paris: Gallimard/ Electa and Éditions du Centre Georges Pompidou, 1995.

Brusatin, Manlio, and Jean Clair, eds. *Identity and Alterity: Figures of the Body, 1895–1995. La Biennale di Venezia, 46th Esposizione Internazionale d'Arte*. Venice: La Biennale di Venezia, 1995.

Curiger, Bice, ed. *Zeichen & Wunder*. Küsnacht, Switzerland: Cantz, 1995.

De Salvo, Donna. *Face Value: American Portraits*. Southampton, N.Y.: Parrish Art Museum; Paris: Flammarion, 1995.

Kertess, Klaus. *1995 Biennial Exhibition*. New York: Whitney Museum of American Art and Harry N. Abrams, 1995.

Köhler, Michael, ed. *Constructed Realities: The Art of Staged Photography*. Zurich: Edition Stemmle,

1995. Originally published as *Das konstruierte Bild: Fotografie—arrangiert und inszeniert*, 1989.

Neumaier, Diane, ed. *Reframings: New American Feminist Photographies*. Philadelphia: Temple University Press, 1995.

Pultz, John. *The Body and the Lens: Photography 1839 to the Present*. New York: Harry N. Abrams, 1995.

1996

Betterton, Rosemary. *An Intimate Distance: Women, Artists, and the Body*. New York and London: Routledge, 1996.

Bois, Yve-Alain, and Rosalind Krauss. *L'informe: mode d'emploi*. Paris: Musée National d'Art Moderne, Centre Georges Pompidou, 1996.

Brougher, Kerry. *Hall of Mirrors: Art and Film Since 1945*. Los Angeles: The Museum of Contemporary Art, 1996.

Ehmke, Ronald, and Elizabeth Licata, eds. *Consider the Alternatives: 20 Years of Contemporary Art at Hallwalls*. Buffalo: Hallwalls, 1996.

Fenz, Werner, and Reinhard Braun. *Radical Images*. Graz, Austria: Edition Camera Austria and Neue Galerie, 1996.

Meskimmon, Marsha. *The Art of Reflection: Women Artists' Self-Portraiture in the Twentieth Century*. New York: Columbia University Press, 1996.

1997

Blessing, Jennifer. *Rrose is a Rrose is a Rrose: Gender Performance in Photography*. New York: Harry N. Abrams, 1997.

Lahs-Gonzales, Olivia, and Lucy Lippard. *Defining Eye: Women Photographers of the 20th Century*. Saint Louis: Saint Louis Art Museum, 1997.

Muniz, Vik, and Luc Sante. *Making it Real*. New York: Independent Curators International, 1997.

Storr, Robert. *On the Edge: Contemporary Art from the Werner and Elaine Dannheisser Collection*. New York: The Museum of Modern Art and Harry N. Abrams, 1997.

1998

Gould, Claudia, and Valerie Smith. *5000 Artists Return to Artists Space: 25 Years*. New York: Artists Space, 1998.

Monk, Philip. *American Playhouse: The Theatre of Self-Presentation*. Toronto: The Power Plant Contemporary Art Gallery at Harbourfront Centre, 1998.

1999

Benezra, Neal, and Olga M. Viso. *Regarding Beauty: A View of the Late Twentieth Century*. Washington, D.C.: Hirshhorn Museum and Sculpture Garden, Smithsonian Institution, 1999.

Broeker, Holger. *Gesammelte Werke 1: Zeitgenössische Kunst seit 1968*. Ostfildern, Germany: Hatje Cantz, 1999.

Brougher, Kerry, and Michael Tarantino. *Notorious: Alfred Hitchcock and Contemporary Art*. Oxford: Museum of Modern Art, 1999.

Kemp, Wolfgang. *Von Beuys bis Cindy Sherman: Sammlung Lothar Schirmer*. Munich: Schirmer/Mosel, 1999.

Phillips, Lisa. *The American Century: Art and Culture 1950–2000*. New York: Whitney Museum of American Art and W. W. Norton, 1999.

Rice, Shelley, ed. *Inverted Odysseys: Claude Cahun, Maya Deren, Cindy Sherman*. Cambridge, Mass.: MIT Press, 1999.

Sobieszek, Robert A. *Ghost in the Shell: Photography and the Human Soul, 1850–2000*. Los Angeles: Los Angeles County Museum of Art, 1999.

2000

Curiger, Bice, and Christoph Heinrich. *Hyper Mental: Rampant Reality 1950–2000, from Salvador Dalí to Jeff Koons*. Ostfildern, Germany: Hatje Cantz, 2000.

Vergne, Philippe. *Let's Entertain: Life's Guilty Pleasures*. Minneapolis: Walker Art Center, 2000.

2001

Barron, Stephanie, and Lynn Zelevansky. *Jasper Johns to Jeff Koons: Four Decades of Art from the Broad Collection*. Los Angeles: Los Angeles County Museum of Art, 2001.

Breitwieser, Sabine. *Double Life: Identität und Transformation in der zeitgenössischen Kunst*. Vienna: Generali Foundation, 2001.

Heartney, Eleanor. *Postmodernism*. Cambridge: Cambridge University Press, 2001.

2002

Dennison, Lisa, Nancy Spector, and Joan Young. *Moving Pictures: Contemporary Photography and Video from the Guggenheim Collections*. New York: Solomon R. Guggenheim Museum; London: Thames and Hudson, 2002.

Schumacher, Rainald, and Matthias Winzen, eds. *Just Love Me, Post/Feminist Positions of the 1990s from the Goetz Collection*. Cologne: König, 2003.

Smith, Elizabeth A. T., Alison Pearlman, and Julie Rodrigues Widholm. *Life, Death, Love, Hate, Pleasure, Pain*. Chicago: Museum of Contemporary Art, 2002.

Wolf, Sylvia, and Andy Grundberg. *Visions from America: Photographs from the Whitney Museum of American Art, 1940–2001*. New York: Whitney Museum of American Art, 2002.

2003

Deitch, Jeffrey, ed. *Monument to Now: The Dakis Joannou Collection*. Athens: Deste Foundation Centre for Contemporary Art, 2004.

Fogle, Douglas. *The Last Picture Show: Artists Using Photography, 1960–1982*. Minneapolis: Walker Art Center, 2003.

2004

Clair, Jean, ed. *The Great Parade: Portrait of the Artist as Clown*. New Haven, Conn.: Yale University Press, 2004.

Joo, Yeon-Hwa. *Her Bodies: Cindy Sherman and Vanessa Beecroft*. Chungnam, Korea: Arario Gallery, 2004.

Kismaric, Susan, and Eva Respini. *Fashioning Fiction in Photography since 1990*. New York: The Museum of Modern Art, 2006.

Storr, Robert. *Disparities and Deformations: Our Grotesque, Fifth International Biennial Exhibition*. Santa Fe: SITE Santa Fe, 2004.

2005

Kaiser, Philipp. *Flashback: Revisiting the Art of the Eighties*. Ostfildern, Germany: Hatje Cantz, 2005.

2006

Biesenbach, Klaus, ed. *Into Me / Out of Me*. Ostfildern, Germany: Hatje Cantz, 2006.

Eccles, Tom, and Trevor Smith. *Wrestle: Marieluise Hessel Collection*. Annandale-on-Hudson, N.Y.: Center for Curatorial Studies, Bard College, 2006.

Kent, Rachel. *Masquerade: Representation and the Self in Contemporary Art*. Sydney: Museum of Contemporary Art, 2006.

2007

Borja-Villel, Manuel J., Bernard Blistène, and Yann Chateigné. *A Theater without Theater*. Barcelona: Museu d'Art Contemporani de Barcelona; Lisbon: Museu Colecção Berardo, 2007.

Butler, Cornelia. *WACK! Art and the Feminist Revolution*. Los Angeles: The Museum of Contemporary Art; Cambridge, Mass.: MIT Press, 2007.

Schor, Gabriele, ed. *Held Together With Water: Art from the Sammlung Verbund*. Ostfildern, Germany: Hatje Cantz, 2007.

Sladen, Mark, and Ariella Yedgar, eds. *Panic Attack! Art in the Punk Years*. London: Barbican Art Gallery, 2007.

2008

Eskildsen, Ute, ed. *Street & Studio: An Urban History of Photography*. London: Tate Publishing, 2008.

Govan, Michael, et al. *The Broad Contemporary Art Museum at the Los Angeles County Museum of Art: BCAM/LACMA/2008*. Los Angeles: Los Angeles County Museum of Art, 2008.

2009

Aletti, Vince, and Judy Ditner, eds. *Dress Codes: The Third ICP Triennial of Photography and Video*. New York: International Center of Photography, 2009.

Eklund, Douglas. *The Pictures Generation, 1974–1984*. New York: The Metropolitan Museum of Art; New Haven, Conn.: Yale University Press, 2009.

Gingeras, Alison M., and Francesco Bonami, eds. *Mapping the Studio: Artists from the Francois Pinault Collection*. Venice: Palazzo Grassi; Milan: Mondadori Electa, 2009.

Respini, Eva. *Into the Sunset: Photography's Image of the American West*. New York: The Museum of Modern Art, 2009.

2010

Blessing, Jennifer, and Nat Trotman. *Haunted: Contemporary Photography/Video/Performance*. New York: Solomon R. Guggenheim Museum, 2010.

Butler, Cornelia, and Alexandra Schwartz, eds. *Modern Women: Women Artists at the Museum of Modern Art*. New York: The Museum of Modern Art, 2010.

Cooke, Lynne, and Douglas Crimp, eds. *Mixed Use, Manhattan: Photography and Related Practices, 1970s to the Present*. Madrid: Museo Nacional Centro de Arte Reina Sofía; Cambridge, Mass.: MIT Press, 2010.

Gioni, Massimiliano, and Judy Ditner, eds. *10,000 Lives*. Gwangju, Korea: Gwangju Biennale Foundation, 2010.

Koons, Jeff. *Skin Fruit: Selections from the Dakis Joannou Collection*. New York: New Museum, 2010.

Lewis, Sarah Elizabeth, and Daniel Belasco. *The Dissolve: Eighth International Biennial Exhibition*. Santa Fe: SITE Santa Fe, 2010.

Schneider, Eckhard. *Sexuality and Transcendence*. Kiev: Pinchuk Art Centre, 2010.

Schor, Gabriele. *Donna: Avanguardia Femminista negli anni '70 dalla Sammlung Verbund di Vienna*. Rome: Galleria Nazionale d'Arte Moderna, 2010.

2011

Curiger, Bice. *ILLUMInations: La Biennale di Venezia*. Venice: La Biennale, 2011.

Mosquera, Gerardo, ed. *1000 caras / 0 caras / 1 rostro: Cindy Sherman, Thomas Ruff, Frank Montero*. Madrid: La Fábrica Editorial and Fundación Telefónica, 2011.

Posner, Helaine, et al. *The Deconstructive Impulse: Women Artists Reconfigure the Signs of Power, 1973–1990*. Purchase, N.Y.: Neuberger Museum of Art; New York: DelMonico Books/Prestel, 2011.

Articles, Essays, Interviews, and Reviews

1976

Willig, Nancy Tobin. "Ms. Sherman Stars as Cast in Photo Essay on Herself." *Buffalo Courier-Express*, August 18, 1976, 29.

1979

Crimp, Douglas. "Pictures." *October* 8 (Spring 1979): 75–88.

1980

Bishop, Joseph. "Desperate Character." *Real Life Magazine* 4 (Summer 1980): 8–10.

Crimp, Douglas. "The Photographic Activity of Postmodernism." *October* 15 (Winter 1980): 91–101.

Grundberg, Andy. "Artbreakers: Cindy Sherman." *Soho News*, September 17, 1980, 37.

Lifson, Ben. "Photography: Masquerading." *Village Voice*, March 31, 1980, 77.

Owens, Craig. "The Allegorical Impulse: Toward a Theory of Postmodernism, Part 2." *October* 13 (Summer 1980): 58–80.

Zimmer, William. "Where Buffalo Roams." *Soho News*, July 16, 1980, 24.

1981

"Cindy Sherman: Untitled Film Stills." *Paris Review* 82 (Winter 1981): 133–39.

Flood, Richard. "Cindy Sherman, Metro Pictures." *Artforum* 19, no. 7 (March 1981): 80.

Grundberg, Andy. "Cindy Sherman: A Playful and Political Post-Modernist." *New York Times*, November 22, 1981, D35.

Karmel, Pepe. "Photography: Song of Myself." *Soho News*, November 24, 1981, 56.

Lifson, Ben. "Photography: Fashionable Features." *Village Voice*, December 2, 1981, 102.

Smith, Roberta. "Spacewalk." *Village Voice*, November 18, 1981, 98.

1982

Bellavance, Guy. "Dessaisissement et réappropriation: de l'émergence du 'photographique' dans l'art américain." *Parachute* 29 (December/January/February 1982–83): 9–17.

Berland, Dinah. "The Many Faces of Cindy Sherman." *L.A. Reader*, October 15, 1982, 14, 18.

"Cindy Sherman." *File Magazine* 5, no. 3 (Spring 1982): 22–25.

Gambrell, Jamey. "Cindy Sherman." *Artforum* 20, no. 6 (February 1982): 85–86.

Howell, John, and Shelley Rice. "Cindy Sherman's Seductive Surfaces." *Alive* 1, no. 2 (September/October 1982): 20–25.

Knight, Christopher. "Photographer with an Eye on Herself." *Los Angeles Herald Examiner*, October 10, 1982, E5.

Linker, Kate. "Melodramatic Tactics." *Artforum* 21, no. 1 (September 1982): 30–32.

Rhodes, Richard. "Cindy Sherman's 'Film Stills.'" *Parachute* 28 (September/October/November 1982): cover, 4–7.

Ristorcelli, Jacques, and Paul Pouvreau. "Les autoportraits de Cindy Sherman." *Cahiers du Cinema* 332 (February 1982): 13–14.

Schjeldahl, Peter. "Shermanettes." *Art in America* 70, no. 3 (March 1982): 110–11.

Squiers, Carol. "The Difference between Fibs and Fictions." *Village Voice*, November 2, 1982, 82.

Taylor, Paul. "Rosalind Krauss." *Art & Text* 8 (1982): 31–37.

1983

Foster, Hal. "The Expressive Fallacy." *Art in America* 71, no. 1 (January 1983): 80–84, 137.

Goldberg, Vicki. "Portrait of a Photographer as a Young Artist." *New York Times*, October 23, 1983, sec. 2, 29.

Linker, Kate. "Cindy Sherman." *Artforum* 21, no. 5 (January 1983): 79.

Marzorati, Gerald. "Imitation of Life." *Art News* 82, no. 7 (September 1983): cover, 78–87.

Nilson, Lisbet. "Q & A: Cindy Sherman." *American Photographer* 11, no. 3 (September 1983): 70–77.

"Scene Stealers." *Life*, May 1983, 10–11, 14, 16.

Schjeldahl, Peter. "Falling in Style: The New Art and Our Discontents." *Vanity Fair*, March 1983, 115–16, 252.

Smith, Roberta. "Art." *Village Voice*, November 29, 1983, 119.

Starenko, Michael. "What's an Artist to Do? A Short History of Postmodernism and Photography." *Afterimage* 10 (January 1983): 4–5.

Williamson, Judith. "Images of 'Woman': Judith Williamson Introduces the Photography of Cindy Sherman." *Screen* 24, no. 6 (November/December 1983): 102–16.

1984

Evans-Clark, Phillip. "Cindy Sherman: Metro Pictures." *Art Press* 77 (January 1984): 46.

Gambrell, Jamey. "Marginal Acts." *Art in America* 72, no. 3 (March 1984): 115–19.

Grundberg, Andy. "Self Portrait Minus Self." *New York Times Book Review*, July 22, 1984, 11–12.

Krauss, Rosalind. "A Note on Photography and the Simulacral." *October* 31 (Winter 1984): 49–68.

Liebman, Lisa. "Cindy Sherman, Metro Pictures." *Artforum* 22, no. 7 (March 1984): 95.

Morris, Diana. "Cindy Sherman." *Women Artists News* 10, no. 1 (November 1984): 18–19.

Robotham, Rosemary. "One-Woman Show: Cindy Sherman Puts Her Best Face Forward." *Life*, June 1984, 14–15, 18, 22.

1985

Dorfman, Elsa. "Mistress of Disguise." *Women's Review of Books* 2, no. 11 (August 1985): 13–14.

Grundberg, Andy. "Cindy Sherman's Dark Fantasies Evoke a Primitive Past." *New York Times*, October 20, 1985, 31.

Indiana, Gary. "Enigmatic Makeup." *Village Voice*, October 22, 1985, 41.

Marzorati, Gerald. "Self-Possessed." *Vanity Fair*, October 1985, 112–13.

Sischy, Ingrid. "On Location." *Artforum* 24, no. 4 (December 1985): 4–5.

Sussler, Betsy. "An Interview with Cindy Sherman." *Bomb* 12 (Spring/Summer 1985): 30–33.

Taylor, Paul. "Cindy Sherman." *Flash Art* 124 (October/November 1985): 78–79.

Van Damme, Leo. "Cindy Sherman: I Don't Want to Be a Performer." *Arte Factum* 2, no. 9 (June/August 1985): 15–21.

1986

Frascella, Larry. "Cindy Sherman's Tales of Terror." *Aperture* 103 (Summer 1986): 48–53.

Samore, Sam. "Playing it Again." *Exposure* 21, no. 2 (1986): 4–7.

1987

Brenson, Michael. "Art: Whitney Shows Cindy Sherman Photos." *New York Times*, July 24, 1987, C31.

Grundberg, Andy. "The 80's Seen through a Postmodern Lens." *New York Times*, July 5, 1987, sec. 2, 25, 29.

———. "Camera Culture in a Postmodern Age." In Kathleen McCarthy Gauss and Andy Grundberg, *Photography and Art: Interactions since 1946*, 207–15. Fort Lauderdale, Fla.: Museum of Art; Los Angeles: Los Angeles County Museum of Art, 1987.

Haus, Mary Ellen. "Cindy Sherman: Metro Pictures, Whitney Museum of American Art." *Art News* 86, no. 8 (October 1987): 167–68.

Indiana, Gary. "Untitled (Cindy Sherman Confidential)." *Village Voice*, June 2, 1987, 87.

Smith, Roberta. "Art: Cindy Sherman at Metro Pictures." *New York Times*, May 8, 1987, C27.

1988

Siegel, Jeanne. "Cindy Sherman." In *Art Talk: The Early 80s*, 269–84. New York: Da Capo Press, 1988.

1989

MacDonald, Erik. "Dis-seminating Cindy Sherman: The Body and the Photograph." *Art Criticism* 5, no. 2 (1989): 35–40.

Rimanelli, David. "Cindy Sherman, Metro Pictures." *Artforum* 27, no. 10 (Summer 1989): 137.

Schor, Mira. "From Liberation to Lack." *Heresies* 6, no. 24 (1989): 15–21.

Taylor, Paul. "Face to Face with Cindy Sherman." *Tension* 17 (August 1989): 28–32.

1990

Collins, Glenn. "A Portraitist's Romp through Art History." *New York Times*, February 1, 1990, C17, C20.

Grundberg, Andy. "The Crisis of the Real," "Cindy Sherman, Continued: Grimm, But Still Playful," and "Cindy Sherman: A Playful and Political Postmodernist." In *Crisis of the Real: Writings on Photography, 1974–1989*, 1–17, 123–25, and 119–22, respectively. New York: Aperture, 1990.

Rimanelli, David. "Cindy Sherman: Metro Pictures." *Artforum* 28, no. 9 (May 1990): 187.

Schjeldahl, Peter. "Portrait: She is a Camera." *7 Days*, March 28, 1990, 17–20.

Smith, Roberta. "Art: A Course in Portraiture by an Individualist with a Camera." *New York Times*, January 5, 1990, C19.

1991

Bryson, Norman. "The Ideal and the Abject: Cindy Sherman's Historical Portraits." *Parkett* 29 (1991): 91–93.

Dickhoff, Wilfried. "Untitled #179." *Parkett* 29 (1991): 108–11.

Jauch, Ursula Pia. "I am Always the Other: Cindy Sherman's One Shot Lives." *Parkett* 29 (1991): 78–81.

Jelinkek, Elfriede. "Nebenschauplätze." *Parkett* 29 (1991): 82–90.

Klinger, Linda S. "Where's the Artist? Feminist Practice and Poststructural Theories of Authorship." *Art Journal* 50, no. 2 (Summer 1991): 39–47.

Mulvey, Laura. "A Phantasmagoria of the Female Body: The Work of Cindy Sherman." *New Left Review* 188 (July/August 1991): 137–50.

Sischy, Ingrid. "Photography: Let's Pretend." *New Yorker*, May 6, 1991, 86–96.

Solomon-Godeau, Abigail. "Photography after Art Photography," "Living with Contradictions: Critical Practices in the Age of Supply-Side Aesthetics," and "Sexual Difference: Both Sides of the Camera." In *Photography at the Dock: Essays on Photographic History, Institutions, and Practices*, 103–23, 124–48, and 256–80, respectively. Minneapolis: University of Minnesota Press, 1991.

———. "Suitable for Framing: The Critical Recasting of Cindy Sherman." *Parkett* 29 (1991): 112–15.

Williams, Hugo. "Her Dazzling Career: Cindy Sherman, Saatchi Collection." *Times Literary Supplement* (London), January 11, 1991, 10.

1992

Hagen, Charles. "Cindy Sherman: Metro Pictures." *New York Times*, April 24, 1992, C32.

Lichtenstein, Therese. "Cindy Sherman." *Journal of Contemporary Art* 5, no. 2 (1992): 78–88.

1993

Avgikos, Jan. "Cindy Sherman: Burning Down the House." *Artforum* 31, no. 5 (January 1993): 74–79.

Krauss, Rosalind. "Cindy Sherman's Gravity: A Critical Fable." *Artforum* 32, no. 1 (September 1993): 163–64, 206.

1994

Avgikos, Jan. "To Hell and Back Again." *Women's Art* 59 (1994): 38–39.

Doy, Gen. "Cindy Sherman: Theory and Practice." In John Roberts, ed., *Art Has No History! The Making and Unmaking of Modern Art*, 257–77. London and New York: Verso, 1994.

Greenberg, Emily B. "Cindy Sherman and the Female Grotesque." *Art Criticism* 9, no. 2 (1994): 49–55.

Jones, Amelia. "Postfeminism, Feminist Pleasures, and Embodied Theories of Art." In Joanna Frueh, Cassandra L. Langer, and Arlene Raven, eds., *New Feminist Criticism: Art, Identity, Action*, 16–41. New York: Harper Collins, 1994.

Lacy, Suzanne. "Affinities: Thoughts on an Incomplete History." In Norma Broude and Mary D. Garrad, eds., *The Power of Feminist Art: The American Movement of the 1970s, History and Impact*, 264–74. New York: Harry N. Abrams, 1994.

Menard, Andrew. "Cindy Sherman: The Cyborg Disrobes." *Art Criticism* 9, no. 2 (1994): 38–48.

Russo, Antonella, "Picture This." *Art Monthly*, no. 181 (November 1994): 8–11.

Schor, Mira. "Backlash and Appropriation." In Norma Broude and Mary D. Garrad, eds., *The Power of Feminist Art: The American Movement of the 1970s, History and Impact*, 248–63. New York: Harry N. Abrams, 1994.

1995

Garber, Frederick. "Generating the Subject: The Images of Cindy Sherman." In *Repositionings: Readings of Contemporary Poetry, Photography, and Performance Art*, 190–211. University Park: Pennsylvania State University Press, 1995.

Howell, George. "Anatomy of an Artist." *Art Papers* 19, no. 4 (July/August 1995): 2–7.

Johnson, Ken. "Cindy Sherman, Metro Pictures." *Art in America* 83, no. 5 (May 1995): 112–13.

Kimmelman, Michael. "At the Met with Cindy Sherman, Portraitist in the Halls of her Artistic Ancestors." *New York Times*, May 19, 1995, C1, C7.

Wakefield, Neville. "Cindy Sherman, Metro Pictures." *Artforum* 33, no. 8 (April 1995): 89.

1996

Foster, Hal. "Obscene, Abject, Traumatic." *October* 78 (Fall 1996): 106–24.

Krauss, Rosalind. "*Informe* without Conclusion." *October* 78 (Fall 1996): 89–105.

1997

Fuku, Noriko. "A Woman of Parts." *Art in America* 85, no. 6 (June 1997): 74–81, 125.

Heiferman, Marvin. "In Front of the Camera, Behind the Scene: Cindy Sherman's *Untitled Film Stills*." *MoMA*, no. 25 (Summer 1997): 16–19.

Molesworth, Helen. "The Comfort of Objects." *Frieze* 36 (September/October 1997): 45–47.

Muschamp, Herbert. "Knowing Looks: Cindy Sherman's Sixty-Nine '70s." *Artforum* 35, no. 10 (Summer 1997): 106–11.

Smith, Roberta. "Film Starlet Cliches, Genuine and Artificial at the Same Time." *New York Times*, June 27, 1997, B1, B25.

1998

Kline, Katy. "In or Out of the Picture: Claude Cahun and Cindy Sherman." In Whitney Chadwick, ed., *Mirror Images: Women, Surrealism, and Self-Representation*, 67–80. Cambridge, Mass.: MIT Press, 1998.

1999

Frankel, David. "Cindy Sherman, Metro Pictures." *Artforum* 48, no. 3 (November 1999): 136.

Schjeldahl, Peter. "Valley of the Dolls: Cindy Sherman's Return to Form." *New Yorker*, June 7, 1999, 94–95.

Seidner, David. "Cindy Sherman." In *Artists at Work: Inside the Studios of Today's Most Celebrated Artists*, 192–99. New York: Rizzoli, 1999.

2000

Dalton, Jennifer. "Look at Me: Self-Portrait Photography after Cindy Sherman." *PAJ: A Journal of Performance and Art* 22, no. 3 (September 2000): 47–56.

Dickhoff, Wilfried. "Cindy Sherman: Portraits of Becoming Ano(r)mal." In *After Nihilism: Essays on Contemporary Art*, 225–29. Cambridge and New York: Cambridge University Press, 2000.

Kimmelman, Michael. "Art in Review: Cindy Sherman." *New York Times*, November 24, 2000, E36.

Tomkins, Calvin. "Her Secret Identities." *New Yorker*, May 15, 2000, 74–83.

2001

Schwabsky, Barry. "Cindy Sherman." *Artforum* 39, no. 1 (January 2001): 132.

2002

Jones, Amelia. "The 'Eternal Return': Self Portrait Photography as a Technology of Embodiment." *Signs* 27, no. 4 (Summer 2002): 947–78.

2003

Berne, Betsy. "Studio: Cindy Sherman." *Tate Arts and Culture* 5 (May/June 2003): 36–42.

Frankel, David. "Cindy Sherman Talks to David Frankel." *Artforum* 41, no. 7 (March 2003): 54–55, 259–60.

Glueck, Grace. "Cindy Sherman: 'Centerfolds, 1981.'" *New York Times*, May 23, 2003, E36.

Haus, Mary. "Robert Longo Talks to Mary Haus: '80s Then." *Artforum* 41, no. 7 (March 2003): 238–39.

Hicklin, Aaron. "Face to Face with Cindy Sherman, America's Greatest Living Artist." *Sunday Herald Magazine* (Edinburgh), November 30, 2003, 6–12.

Kimmelman, Michael. "Gallery: Unambiguously Cindy." *New York Times Magazine*, October 5, 2003, sec. 6, 32.

Nesbit, Molly. "Bright Light, Big City: The '80s without Walls." *Artforum* 41, no. 8 (April 2003): 184–89, 245–48.

2004

Marques, Adriana. "Cindy Sherman Inside and Out." *Aperture* 174 (Spring 2004): 8.

Smith, Roberta. "The Ever-Shifting Selves of Cindy Sherman, Girlish Vamp to Clown." *New York Times*, May 28, 2004, E33.

2005

Harrison, Helen A. "Lives in Art: A View from Both Sides of the Camera, Turning Dress-Up into Fine Art." *New York Times*, September 18, 2005, sec. 14 (Long Island Weekly), 12, 14.

Kaufman, Jason Edward. "Lens Life: Unmasking Iconic Photographer Cindy Sherman." *Art and Antiques* 28, no. 9 (September 2005): 50–54.

2006

Bousteau, Fabrice. "Cindy Sherman: Photographe de Grotesques." *Beaux Arts Magazine* 263 (May 2006): 46–51.

Danto, Arthur. "Cindy Sherman's Unfolding Vision." *Art Press* 323 (May 2006): 24–31.

Murray, Derek Conrad, and Soraya Murray. "Uneasy Bedfellows: Canonical Art Theory and the Politics of Identity." *Art Journal* 65, no. 1 (Spring 2006): 22–39.

Schor, Gabriele. "Cindy's Original Scene: *Doll Clothes*, Cindy Sherman's Early Film." *Parkett* 78 (2006): 24–28.

2007

Burton, Johanna. "1000 Words: Cindy Sherman Talks About 'A Play of Selves,' 1976." *Artforum* 45, no. 5 (July 2007): 232–33.

2008

Fried, Michael. "Three Beginnings." In *Why Photography Matters as Art as Never Before*, 5–25. New Haven, Conn.: Yale University Press, 2008.

Hershkovits, David. "In Your Face?" *Paper*, November 2008, 54–60.

Horyn, Cathy. "When Is a Fashion Ad Not a Fashion Ad?" *New York Times*, April 10, 2008, G1, G5.

Saltz, Jerry. "Sherman's March of Time: The Original Chameleon Shows Her Characters' Aging—And Is Reborn." *New York*, November 23, 2008, 76–77.

Stevens, Mark. "How I Made It: Cindy Sherman on Her 'Untitled Film Stills.'" *New York*, April 7, 2008, 78–79.

Tomkins, Calvin. "Cindy Sherman." In *The Lives of the Artists*, 21–45. New York: Henry Holt, 2008.

2009

Allsop, Laura. "The 'Real' Cindy Sherman." *Art Review* 31 (April 2009): 70–75.

Arifa, Akbar. "Being Cindy Sherman." *The Independent* (London), April 16, 2009, 14.

Darwent, Charles. "Cindy Sherman, Sprüth Magers, London." *The Independent* (London), April 19, 2009, 56–57.

Evans, Sarah. "There's No Place Like Hallwalls: Alternative-space Installations in an Artists' Community." *Oxford Art Journal* 32, no. 1 (March 2009): 95–119.

Frankel, David. "Cindy Sherman: Metro Pictures." *Artforum* 47, no. 6 (February 2009): 186.

Januszczak, Waldemar. "Cindy Sherman: I'm Every Woman." *Times* (London), April 12, 2009, 14–15.

Schjeldahl, Peter. "Alien Emotions: Pictures Art Revisited." *New Yorker*, May 4, 2009, 74–75.

2010

Buck, Louisa. "Portraits of the Artist as Surgically-Enhanced Society Matrons." *Art Newspaper* 18, no. 202 (May 2009): 48.

Liu, Jui-Ch'i. "Female Spectatorship and the Masquerade: Cindy Sherman's Untitled Film Stills." *History of Photography* 34, no. 1 (February 2010): 79–89.

Poostchi, Becky. "Cindy: Blonde & Beyond." *POP*, Autumn/Winter 2010, n.p.

2011

Galenson, David. "The Unique Value of Cindy Sherman." *The Huffington Post*, June 6, 2011, http://www.huffingtonpost.com/david-galenson/the-unique-value-of-cindy_b_871803.html.

Hattenstone, Simon. "Cindy Sherman: Me, Myself and I." *The Guardian* (London), January 15, 2011, Weekend section, 12.

Index

Photograph Credits

Courtesy Eleanor Antin and Ronald Feldman Fine Arts, New York © 2012 Eleanor Antin: page 17, fig. 6

© 2012 The Estate of Diane Arbus, LLC: page 74

© 2012 Archiv Alfred and Gertrud Arndt, Darmstadt: page 22, fig. 15

Courtesy Artes Magnus, Inc.: page 41

© 2012 Artists Rights Society (ARS), New York / ADAGP, Paris: page 38

© 2012 John Baldessari; photography © 2012 Matt Flynn: page 26, fig. 18

Art © 2012 Lynda Benglis / Licensed by VAGA, New York: page 30

© 2012 Estate of Claude Cahun: page 22, fig. 13

© 2012 Lee Friedlander: page 27

© 2012 Robert Gober: page 39, fig. 28

Courtesy the Hallwalls Collection, The Poetry Collection of the University Libraries, University at Buffalo, The State University of New York: page 20

© 2012 The Robert Heinecken Trust: page 26, fig. 19

© 2012 Janus Films / Photofest: page 72

Photo: Nathan Keay © 2012 Museum of Contemporary Art Chicago: page 81

Courtesy Jeff Koons and Gagosian Gallery © 2012 Jeff Koons: page 37

© 2012 Suzy Lake; courtesy Paul Petro Contemporary Art, Toronto: page 16

© 2012 Sherrie Levine: page 28

© 2012 Man Ray Trust / Artists Rights Society (ARS), New York / ADAGP, Paris: page 22, fig. 14

© 2012 The Metropolitan Museum of Art / Art Resource, New York: page 22, fig. 12

© 2012 Bruce Nauman / Artists Rights Society (ARS), New York; photography © 2012 The Art Institute of Chicago: page 46

© 2012 Photofest: page 77, fig. 5

© 2012 Die Photographische Sammlung; SK Stiftung Kultur – August Sander Archiv, Cologne / Artists Rights Society (ARS), New York: page 21, fig. 11

© 2012 Richard Prince: page 26, fig. 17

© 2012 Charles Ray: page 39, fig. 29

Scala / Art Resource, New York: page 42, fig. 33

Scala / Ministero per i Beni e le Attività Culturali / Art Resource, New York: page 42, fig. 32; page 43

© 2012 Marsie, Emanuelle, Damon and Andrew Scharlatt, Hannah Wilke Collection and Archive, Los Angeles: page 17, fig. 5

© 2012 Cindy Sherman and Juergen Teller: page 34

Courtesy Sprüth Magers, London; photography © 2012 Stephen White: page 48

Courtesy Strand Releasing: page 40; page 77, fig. 6

© 2012 Jeff Wall: page 29

Trustees of
The Museum of Modern Art